FLOWER FLASH

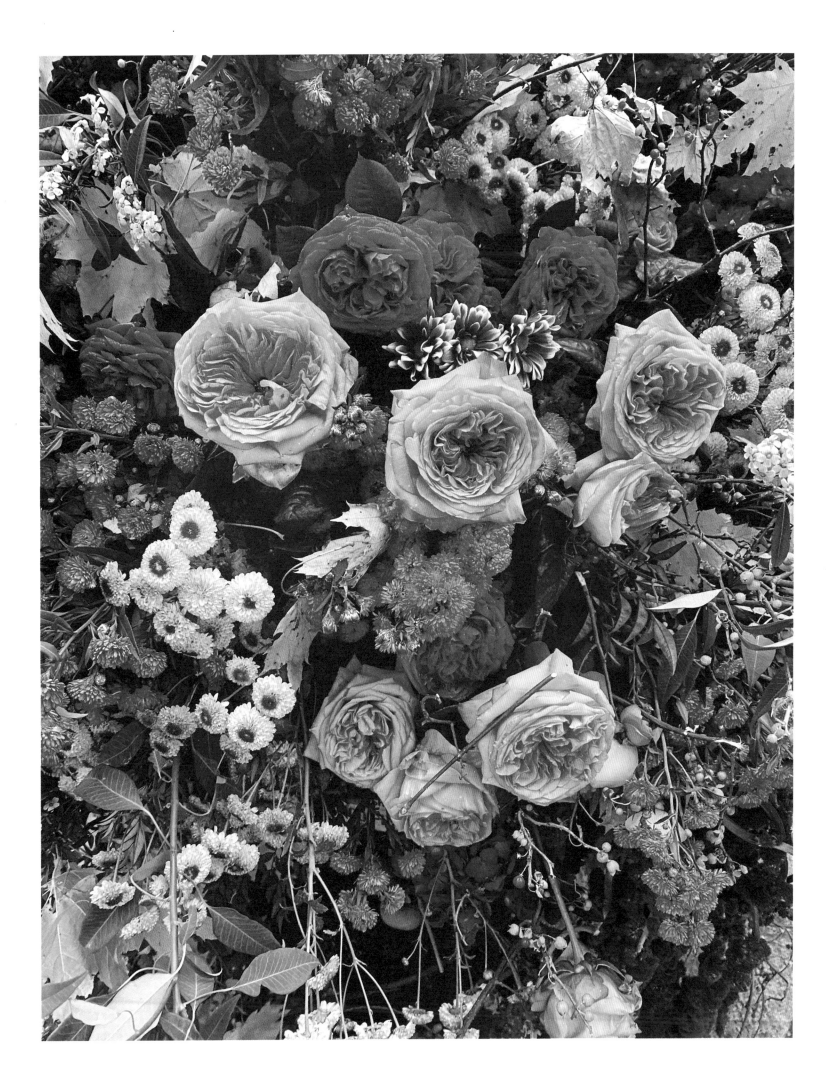

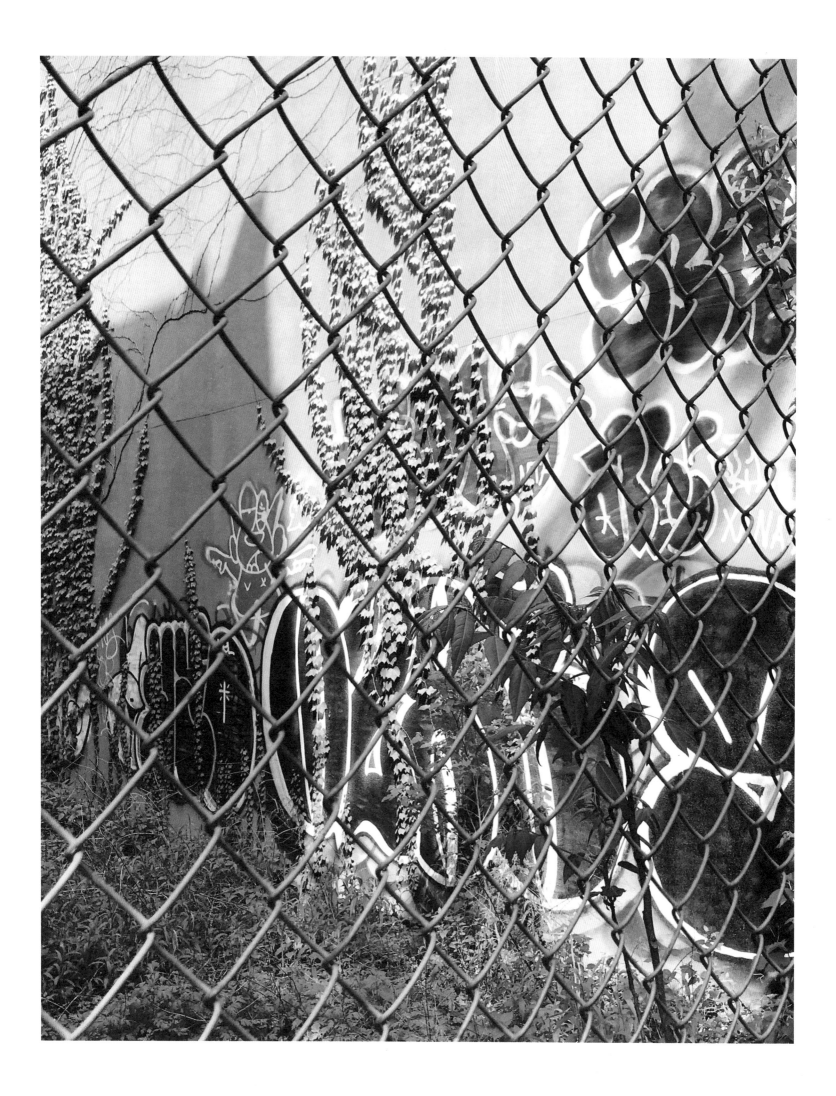

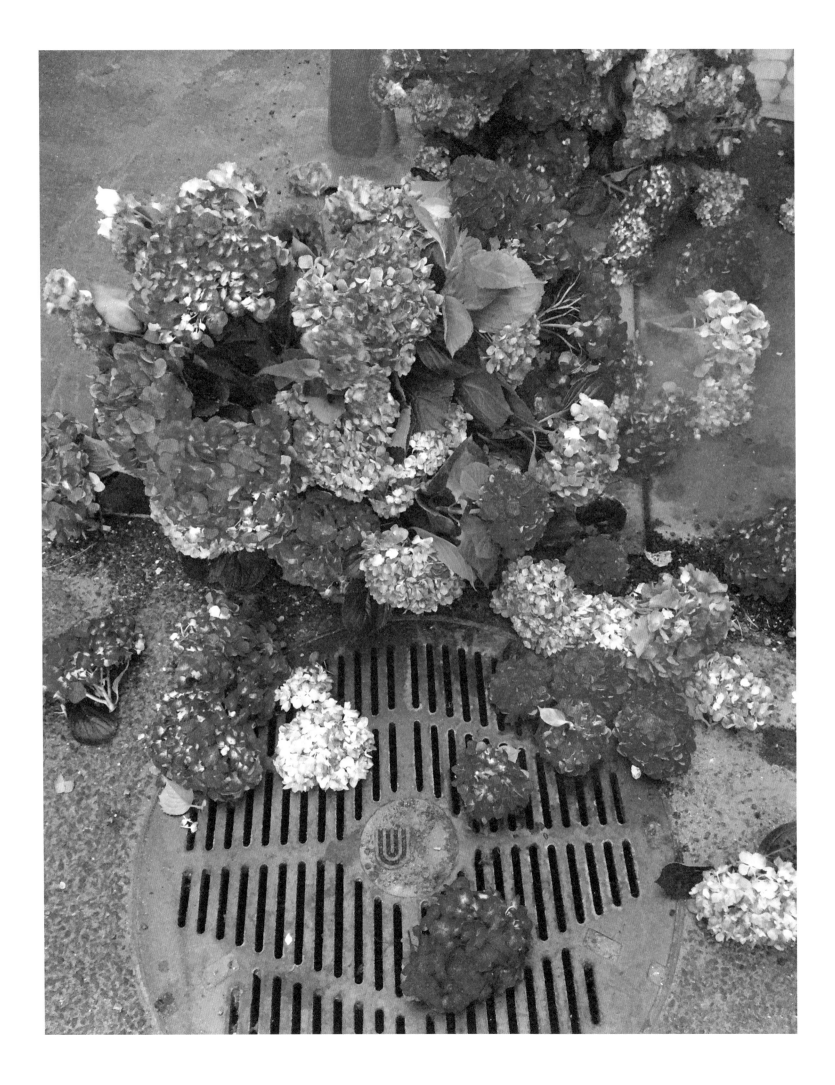

"HAPPINESS...
NOT IN
ANOTHER
PLACE BUT
THIS PLACE,
NOT FOR
ANOTHER
HOUR
BUT THIS
HOUR."

—WALT WHITMAN

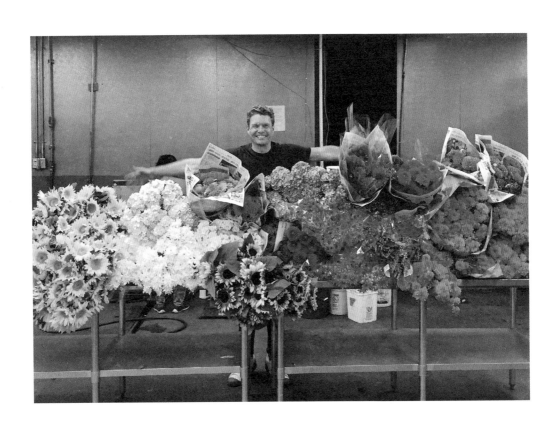

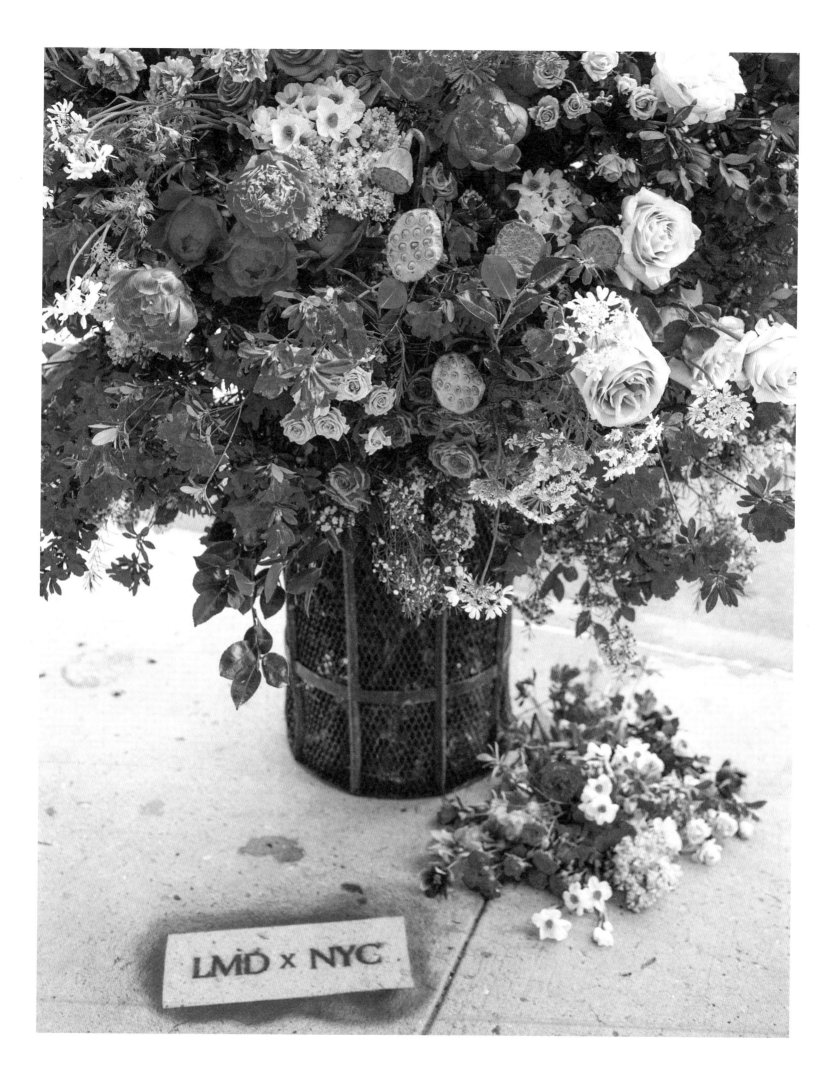

Lewis Miller
New York City
2016–2021

Principal photography by
Irini Arakas Greenbaum

FLOWER FLASH

MONACELLI

Introduction

12 Chasing Beauty and
 Giving It Back
 by Lewis Miller

16
THE FIRST
FLASH

30
BEAUTY
BEFORE
DAWN

164
BEAUTY IN
THE DARK

Our Community

230 The Flower Flashes
 through Your Eyes

Photographer's Note

234 Capturing the Flower Flashes
 by Irini Arakas Greenbaum

236 Acknowledgments
238 Credits

It's five a.m. on a brisk autumn morning and I'm scouring the New York flower market for the last clutch of flowers before jumping into the Lewis Miller Design van with my driver, Manny. Cruising up Sixth Avenue, we discuss the Stoics and philosophy, timing our route to hit only green lights along the way.

We pass a dark Bryant Park and weave through a hushed Midtown and an empty Central Park. I love this town at predawn, before the first rays of sunlight, before the masses of commuters and tourists show up. It's my favorite city at my favorite time of day, and I'm about to do one of my favorite things: arrange flowers—fast! Adrenaline mixed with a tinge of anxiety (what I'm about to do isn't technically legal) washes over me as we arrive at our destination.

Shoving armloads of foliage into a trash can and packing it full of fluffy amber dahlias is a far cry from producing a tony wedding at the New York Public Library. But turning my craft on its head has allowed me to share my infatuation with flowers with my fellow New Yorkers. Surprising them with Nature's glory for no other reason than to bring beauty into their lives is a great way to start my day.

I have been chasing beauty my whole life. As a kid growing up in central California, and even as an adult, I've never quite fit in. Be it Modesto or Manhattan, I'm an introvert who was lousy at sports and awkward at social interactions. Flowers have always been my sanctuary. In my family, after church on Sunday, we would have company over. The women would be in the kitchen, the men in the living room, and I would be in the dining room doing what I loved best, decorating the table with freshly cut blossoms. Between both worlds, oblivious to both worlds, and very happy in my mission: to change the energy of my environment and to create something beautiful. I needed beauty in my life then as much as I do now.

Historical art—like this still life by Flemish artist Jan van Kessel the Elder and the paintings and prints that appear throughout this book—is for me a source of never-ending inspiration. It's an important part of the Lewis Miller Design ecosystem and a key element of the Flower Flashes' DNA.

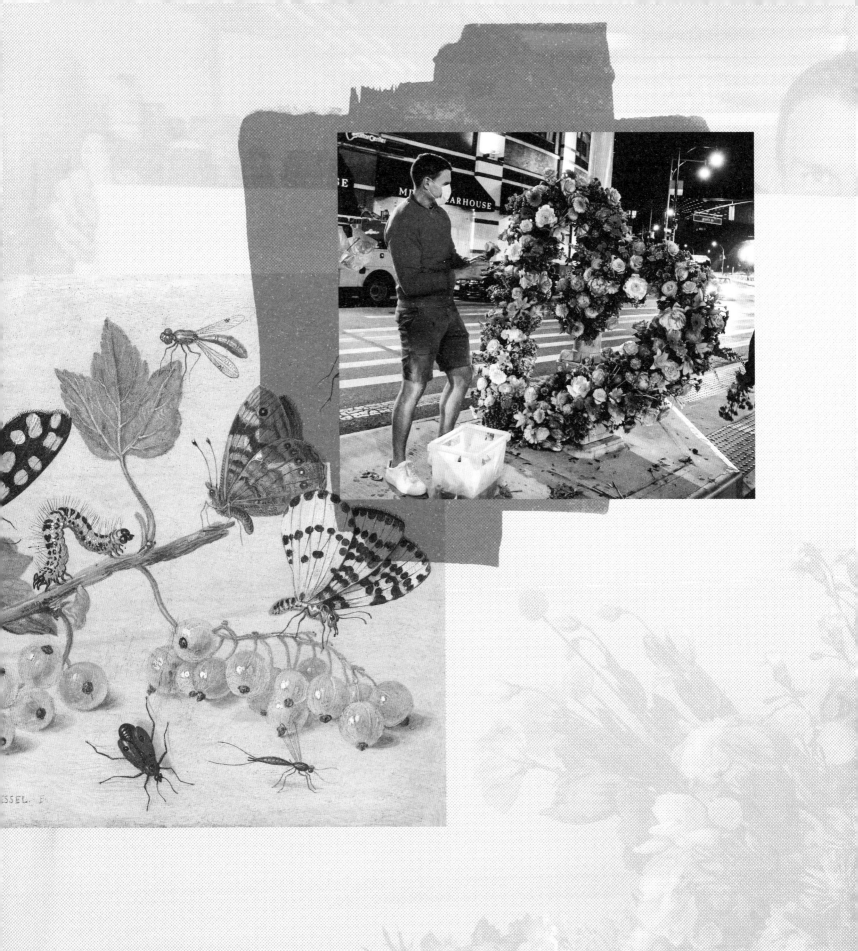

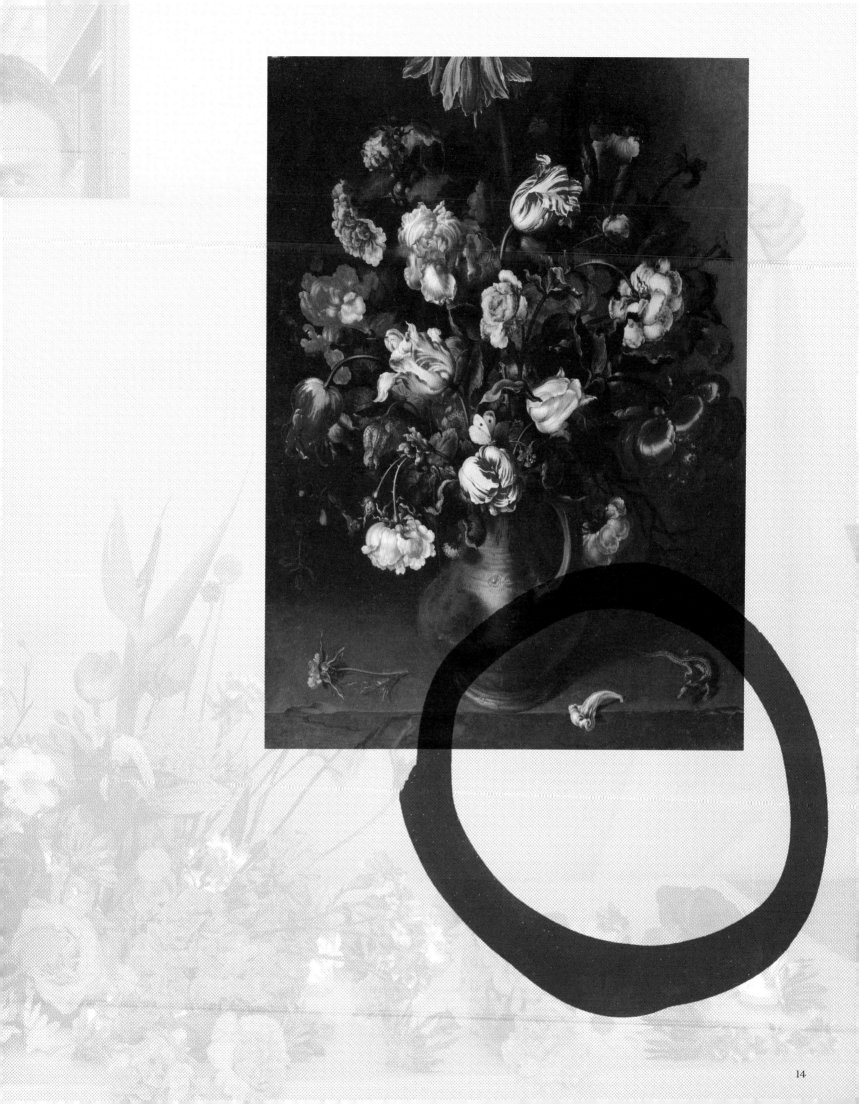

Fast-forward a decade. I moved to New York City at twenty-five and several years later started my own company. Never one to fully submit to the urban experience, I created as close to a country life in a metropolitan setting as possible with a business that brings nature by the truckload into board-rooms, ballrooms, and brownstones. Producing lavish events and transforming the energy of a space with flowers has become my profession. I rely on my discerning clients to give me insight into their style, a base onto which I can build a design. Simply put, I can bolster their aesthetic and put my best spin on what they deem beautiful; however, this way of working subjugates flowers to the whims of others. And it doesn't truly reflect me or my creative pursuits. When pressed to define my own vision, a few words come to mind: *Abundance. Contrast. Joy. Folly. Energy.*

Flowers are a medium like no other. They exist to be beauti-ful, to attract butterflies and bees. It's a simple but astounding life's mission. Yet all too often this profound essence is suffocated under the weight of other meaning. We humans assign arbitrary significance to almost everything and in the process snuff out the true purpose of that thing; flowers are not spared this imposition. Gladiolas can be dismissed as ghastly, lilies as rancid, and carna-tions as tacky. Such horrible words to describe flowers, and it doesn't stop there. The cacophony of derogatory remarks is end-less: cheap, garish, weedy, "too country," gaudy, pretentious . . . It can make the most ambitious flower lover hesitant to create anything for fear of damnation from the Taste Gods.

The Flower Flash is my antidote to all that! Flower Flashes celebrate all the good that flowers embody and have to offer us mortals. In a Flash, every flower benefits equally from a sort of floral democracy and like most democracies, the Flash's success is largely dependent on the hardworking, unsung flowers that support the more delicate and fashionable blooms. Precious sweet peas share company with unloved carnations, chrysanthemums make nice with English garden roses. And it makes sense that this is the recipe for a successful Flash, because New York City, the birthplace of these random acts of beauty, is built on the same principle. Like a true Flower Flash, Gotham City is a glorious mash-up of all kinds of people and personalities.

This book presents a collage of LMD's visual DNA as well as a comprehensive reference of the Flower Flashes that my team and I have made over the last four years. Modern-day life is not easy, and contrary to popular perception, Manhattan is not a twenty-four-hour glam fest. As we go through life wearing many hats, overextending ourselves, and multitasking at every step, we need to be reminded to—pardon the cliché—stop and smell the roses. Since the roads aren't lined with roses, the Flower Flashes will be.

THE
FIRST
FLASH

Gifting flowers to the people of New York City. It's an idea that had been knocking around in my brain for a while. I love my job as a floral designer. My team and I create many lavish and memorable events for wonderful clients that not only stay with them and their guests for a lifetime, but also leave a lasting impression on us. To put it simply, I am in the business of fantasy and flowers, transforming key moments in my clients' lives into magical, everlasting memories. But over the years, I began to feel unsettled. The reality was that no matter how exquisite the flowers I brought to these celebrations were, they were destined to be enjoyed by only a lucky few.

I felt a strong urge to do something for *all* my fellow New Yorkers, in a meaningful way that was true to who I am and what I do.

It was during this period, in fall 2016, that Irini Arakas Greenbaum, my director of special projects, asked me what needed to change in order for me to feel fulfilled professionally. We discussed whether contentment can lead to complacency. In my case, yes! Work was busy, my team was amazing, clients were happy. But something was missing and I knew the answer lived somewhere in the idea of making a gesture of goodwill. I thought back to an experience I'd had walking home from work. I was leaving my studio and heading to the subway with an armful of peonies. The flowers were on their last glorious legs, big and fluffy with blown-out petals. I noticed people staring, and they weren't staring at me! They were looking at the blossoms, and I could see the sheer hunger in their eyes; these men and women were starved for beauty. Flowers had become like wallpaper or furniture to me. Working with them every day, I became desensitized to their allure and attraction. But standing on a crowded subway with these showstopping peonies, watching heads crane and turn just to catch a glimpse of these blooms . . . Recalling this, something inside me clicked. How better to counter my professional norm of throwing extravagant parties for my fortunate clients than by giving something just as gorgeous to the everyday New Yorker?

The Flower Flash was born.

On the morning of October 20, 2016, in the thirty minutes before six a.m., when New York was still dark and chilly, my team and I went to work creating our first random act of beauty. Our van bursting with over two thousand recycled flowers—Day-Glo pink, purple, yellow, and orange dahlias and carnations saved from an event the night before—we descended on the John Lennon Memorial in Central Park, a circular mosaic resembling a mandala with one word in the center: IMAGINE.

Quickly and quietly working in the dark, my team and I created a psychedelic halo of flowers. I was nervous. Can you get arrested for beautifying a public space? By the time the flower installation was complete, dawn had begun to take shape and two curious park workers appeared. I held my breath and wondered if my Flowers for New Yorkers project would live and die in under half an hour, its only audience a squirrel and an early morning jogger. But that was not the case. Outfitted with a leaf blower and a broom, the Central Park staff began to lovingly sweep away the autumn leaves falling around our flowers and gave us their approval with a quick thumbs-up.

As we were packing up our supplies and leaving the park, I was amazed at how quickly a crowd formed. I had hoped for smiles, the kind that flash across a face when witnessing a moment of kindness. That was my goal, my vision: to create a positive, emotional response through flowers. And through social media, we saw the fruits of our labor and were instantly rewarded. We watched in real time as our idea was translated into hundreds of smiling selfies and photographs documenting the flowers throughout the course of the day. It was one of the most rewarding and gratifying "events" I had ever produced. Unlike with my day job, there were no clients to please and no expectations to exceed, other than those I placed on myself. And unlike producing events, where the process can be lengthy and at times arduous, this random act of flowers was fast, freeing, and provided an intense dopamine rush. And perhaps the biggest difference was that it was made for all to enjoy, not just a select few. The final result was deliciously imperfect and served no other purpose than to bring a brief moment of joy to someone's day.

I was hooked and delighted and ready for more.

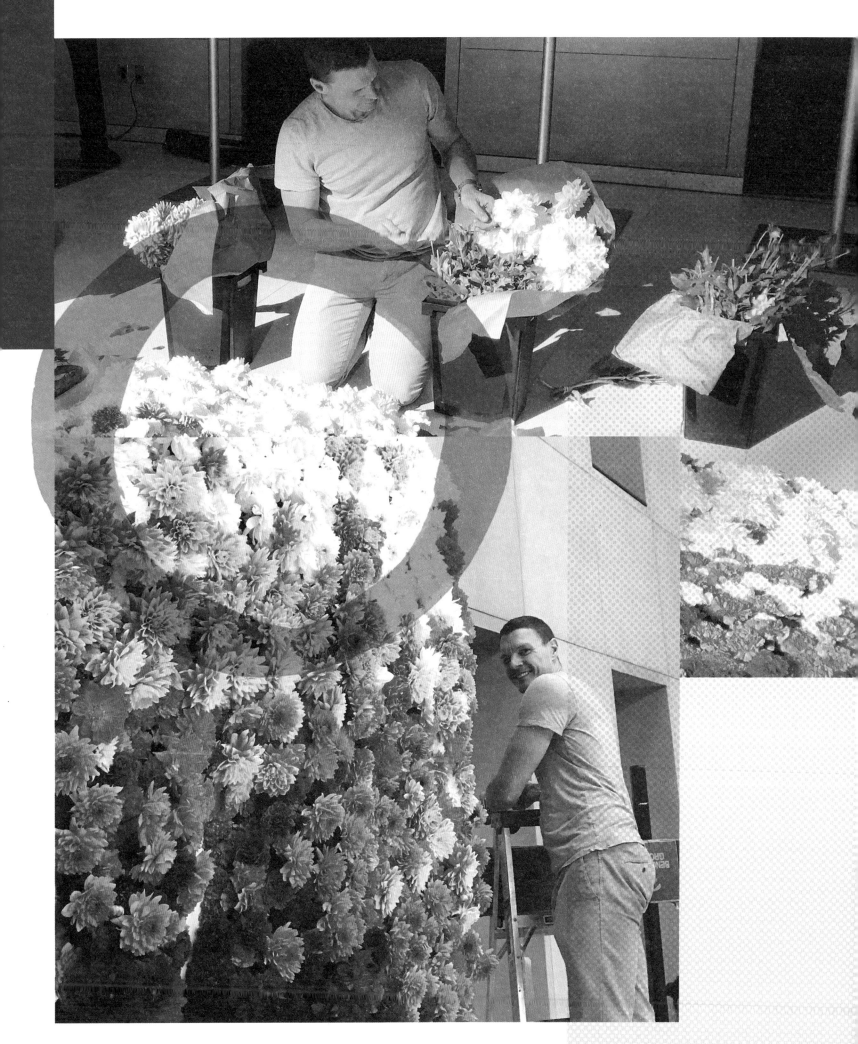

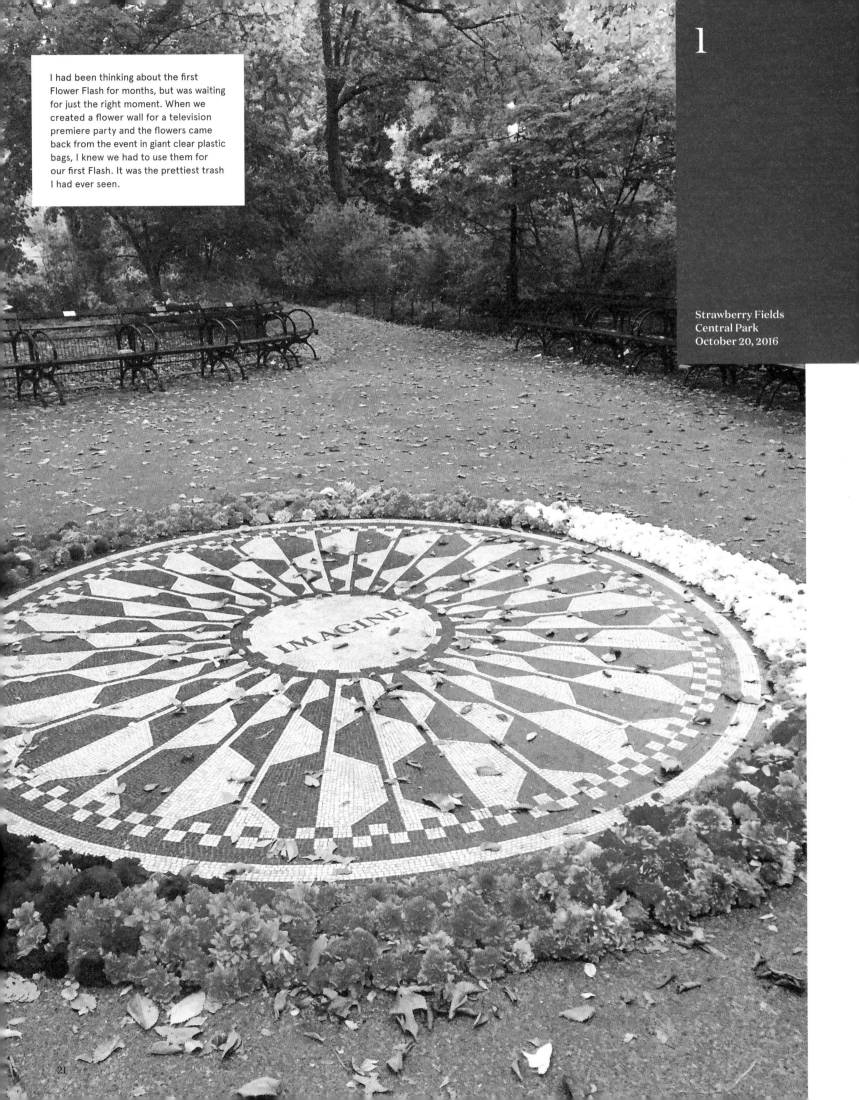

I had been thinking about the first Flower Flash for months, but was waiting for just the right moment. When we created a flower wall for a television premiere party and the flowers came back from the event in giant clear plastic bags, I knew we had to use them for our first Flash. It was the prettiest trash I had ever seen.

1

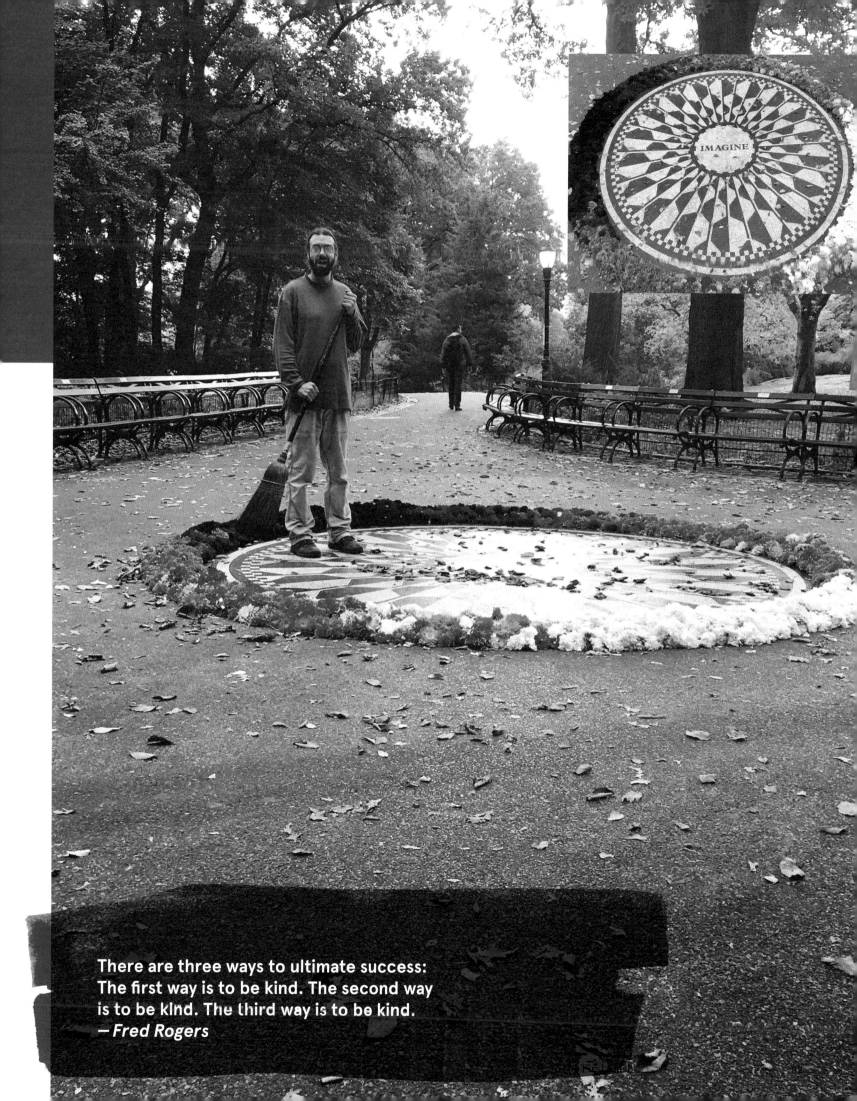

There are three ways to ultimate success:
The first way is to be kind. The second way
is to be kind. The third way is to be kind.
— *Fred Rogers*

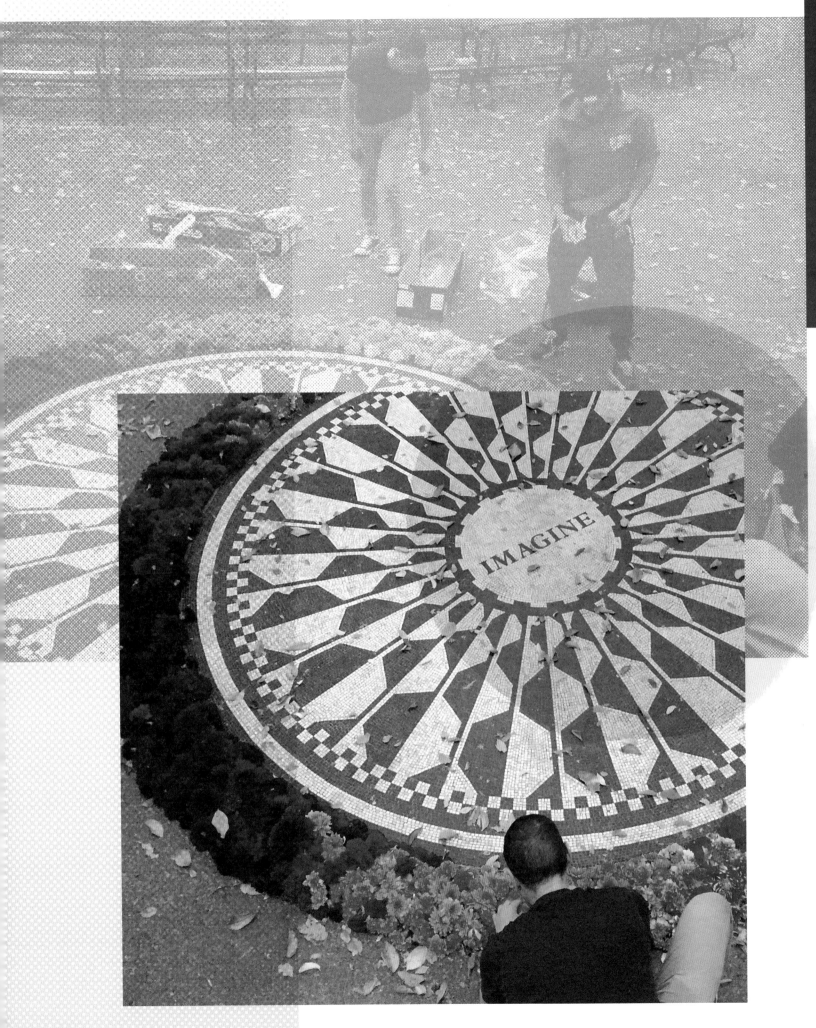

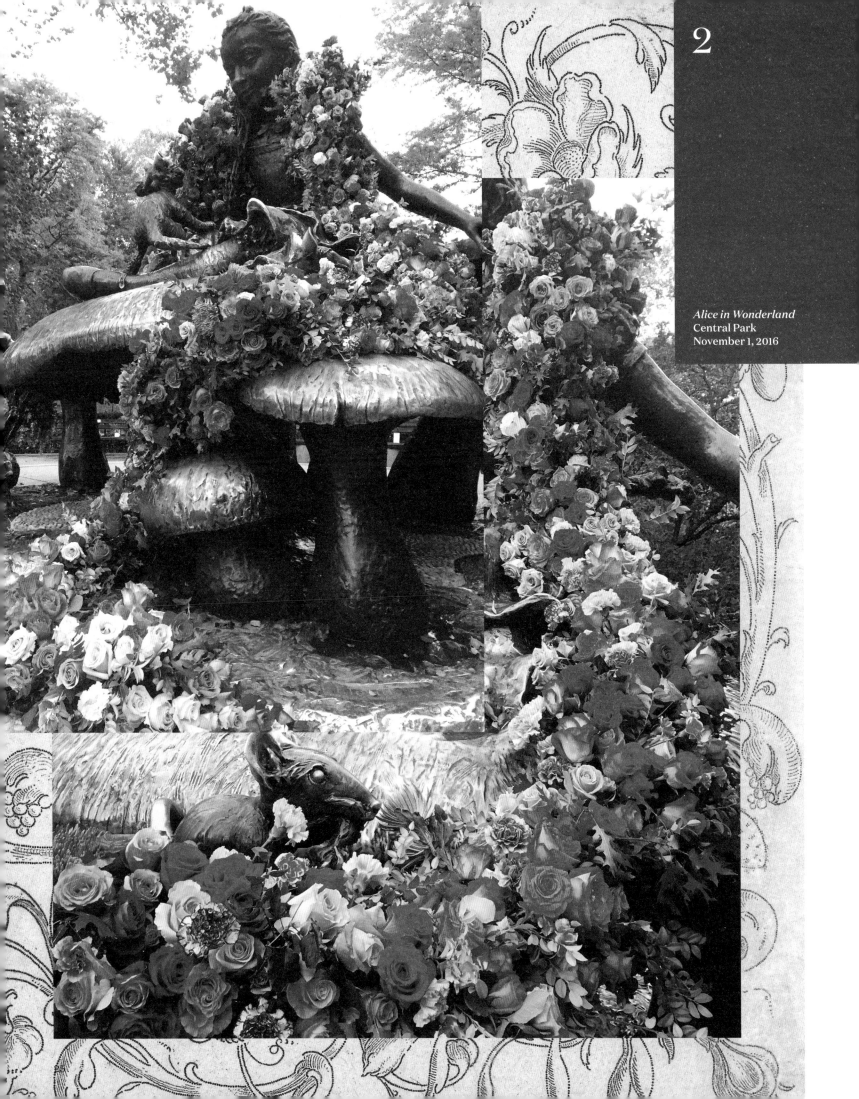

2

Alice in Wonderland
Central Park
November 1, 2016

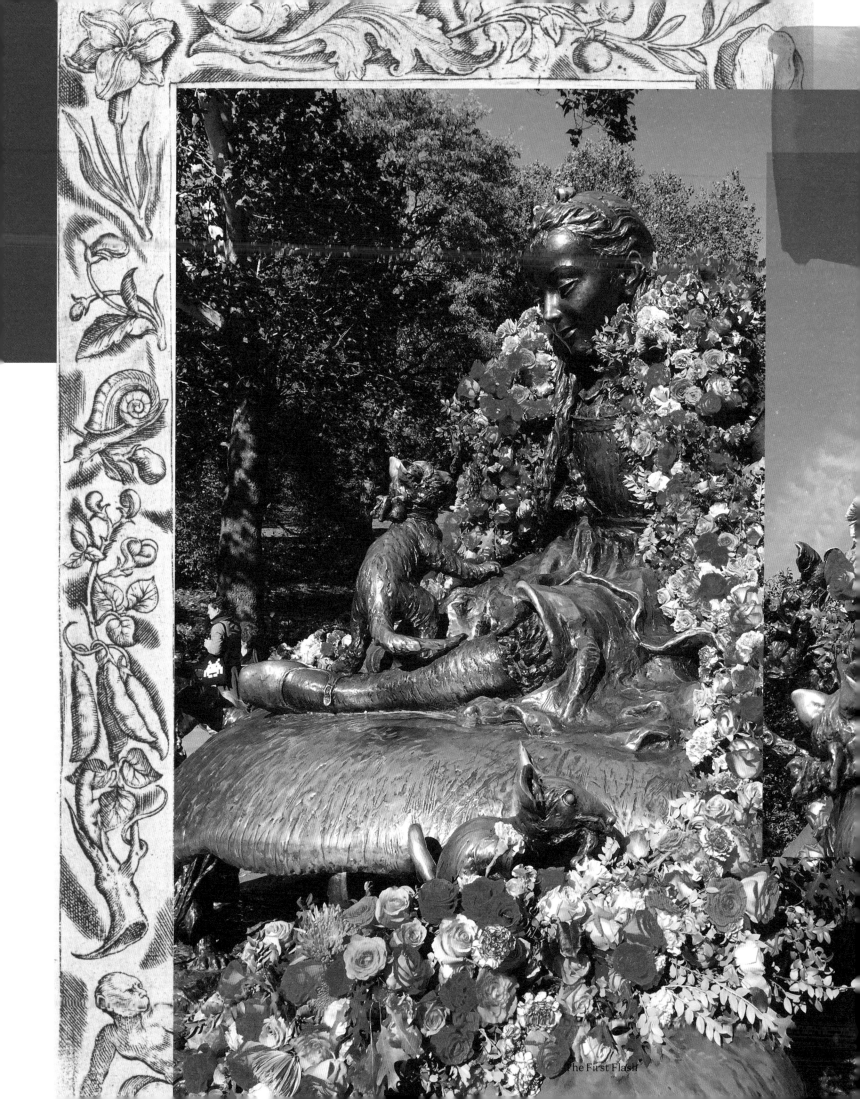

The First Flash

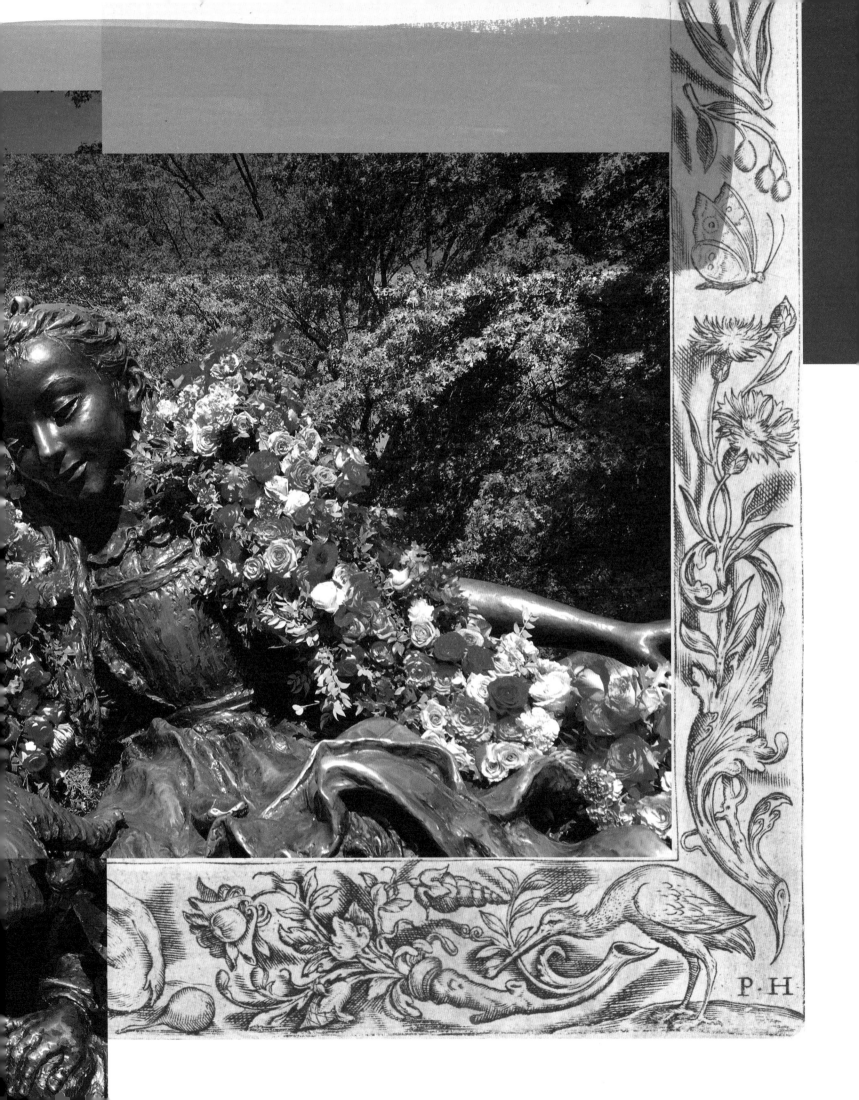

P·H

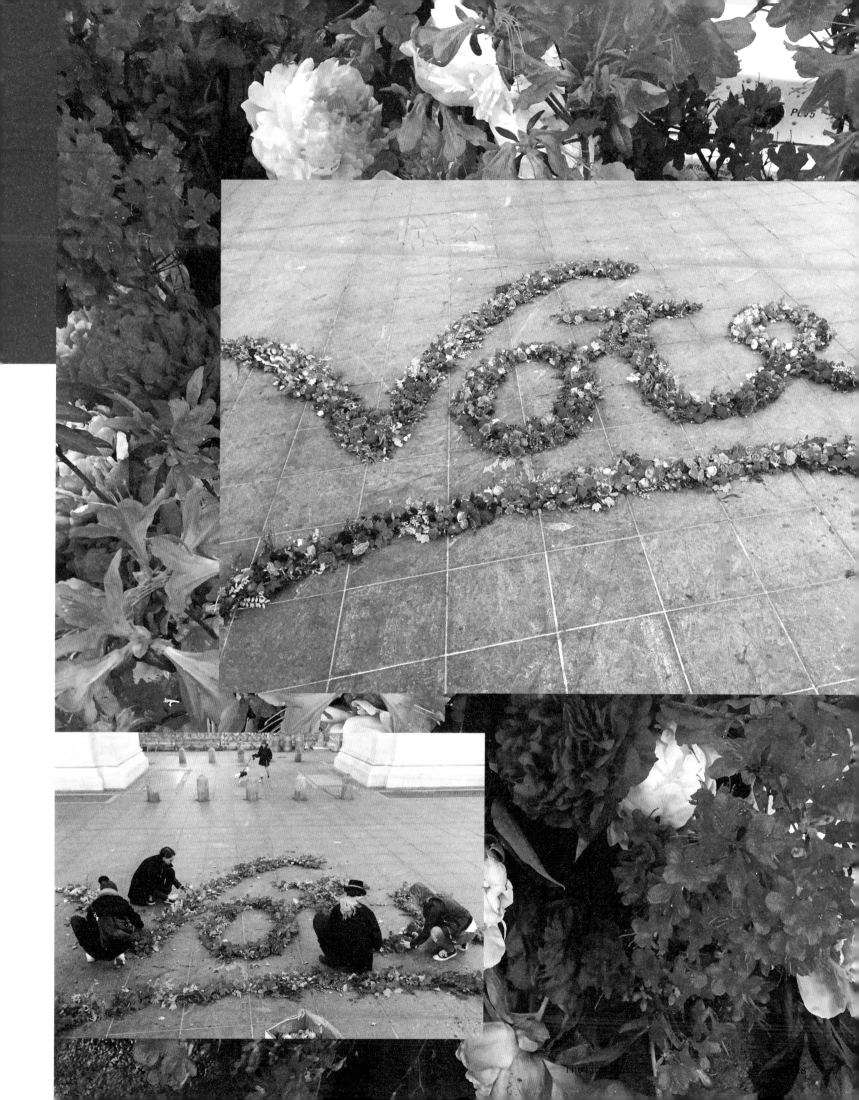

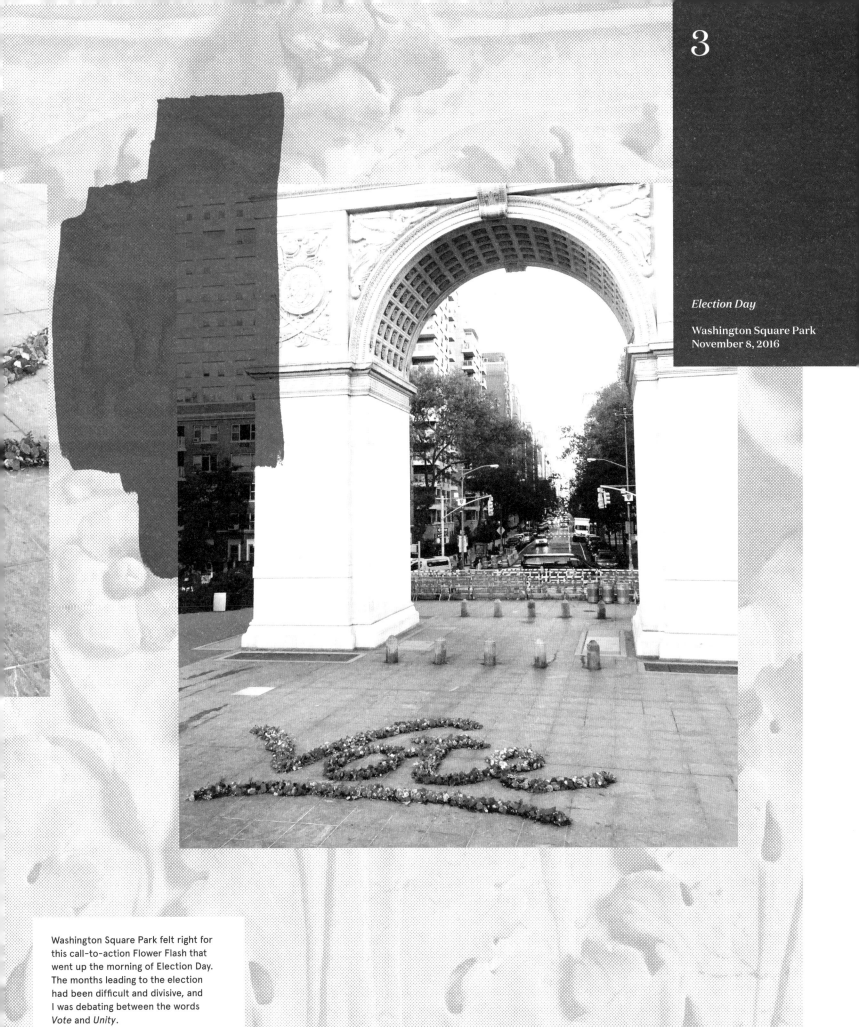

Election Day

Washington Square Park
November 8, 2016

Washington Square Park felt right for this call-to-action Flower Flash that went up the morning of Election Day. The months leading to the election had been difficult and divisive, and I was debating between the words *Vote* and *Unity*.

BEAUTY
BEFORE
DAWN

Chapter Two Beauty Before Dawn

For me, Flower Flash is a noun, a verb, and an adjective at once. A Flower Flash, with its decadent blooms bursting from a trash can and groaning under their own weight, is a noun. *To* Flower Flash, as the words imply, is a verb that denotes spontaneity and swiftness, but it is much more than quickly heaping hydrangea heads next to a steam pipe in a busy avenue. It is visceral, imperfect, and rambunctious, but confident. It relies on a vague plan that might be modified on-site and is only successful if attuned to the surroundings and the moment. It is the polar opposite of designing a posh event. And as an adjective, Flower Flash describes a new approach to the craft of floral design, a style of arrangement that is boisterous, free-form, and a little wild, a departure from the immaculate and a total acceptance of improvisation.

Since that day in Central Park, I have created over ninety Flower Flashes, embracing the garbage and construction and grit of my beloved New York by adorning its trash bins, phone booths, subway entrances, and orange-and-white steam pipes with thousands of vibrant, seasonal blooms. My team and I have Flashed neighborhoods from Harlem to Chinatown. We've Flashed quintessential New York sites such as the Met, the Dakota, and Rockefeller Center, and local favorites like the West Fourth Street Courts. We've made Flashes for International Women's Day and Pride and more. The sheer volume of pink carnations that we deployed for a Valentine's Day Flash was so great, it provided passersby with free flowers for their sweethearts for the entire day, not to mention a steady supply for one entrepreneurial fellow who grabbed a bucketload of blooms, set up shop down the block, and flipped the carnations for a dollar a stem (we New Yorkers love a good side hustle). We've also Flashed Charlottesville. We even kidnapped a trash can in Los Angeles, threw it into the back of a truck, transformed it with blooms, and then plopped it at the foot of a supermodel for *Vogue*. Working in the bright California sun, without the comforting darkness and din of New York City, was nerve-racking, but I love that we could bring our floral street art installations to other cities.

At first, I was reluctant to call these installations "street art." I love art—I'm hugely inspired by Dutch still lifes, botanical drawings, historical patterns, and more—and I'd long had a vision of a city trash can bearing as sumptuous a floral display as a Renaissance urn, but calling myself an artist had always made me cringe. However, as this personal experiment to reconnect me to my craft became a beautiful shared experience with countless New Yorkers who joyously interacted with the Flower Flashes, my reservations disappeared.

As we hit our stride and the Flower Flashes grew in scale and complexity, I was blurring the lines of traditional floristry, decorative arts, and street art to create something not yet classified. My fellow New Yorkers were taking notice and thanks to social media, the Flashes, which last only a few hours in life, were reaching a global and virtually unlimited audience. The positive response was truly overwhelming.

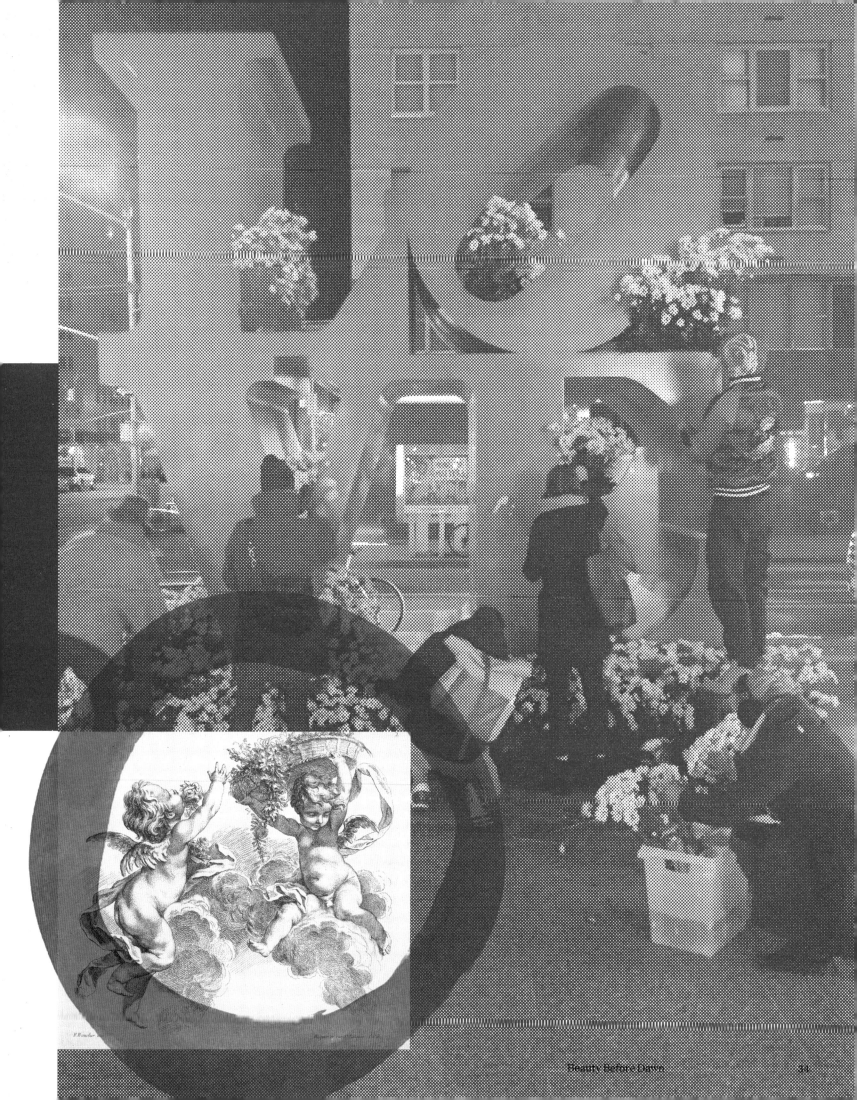

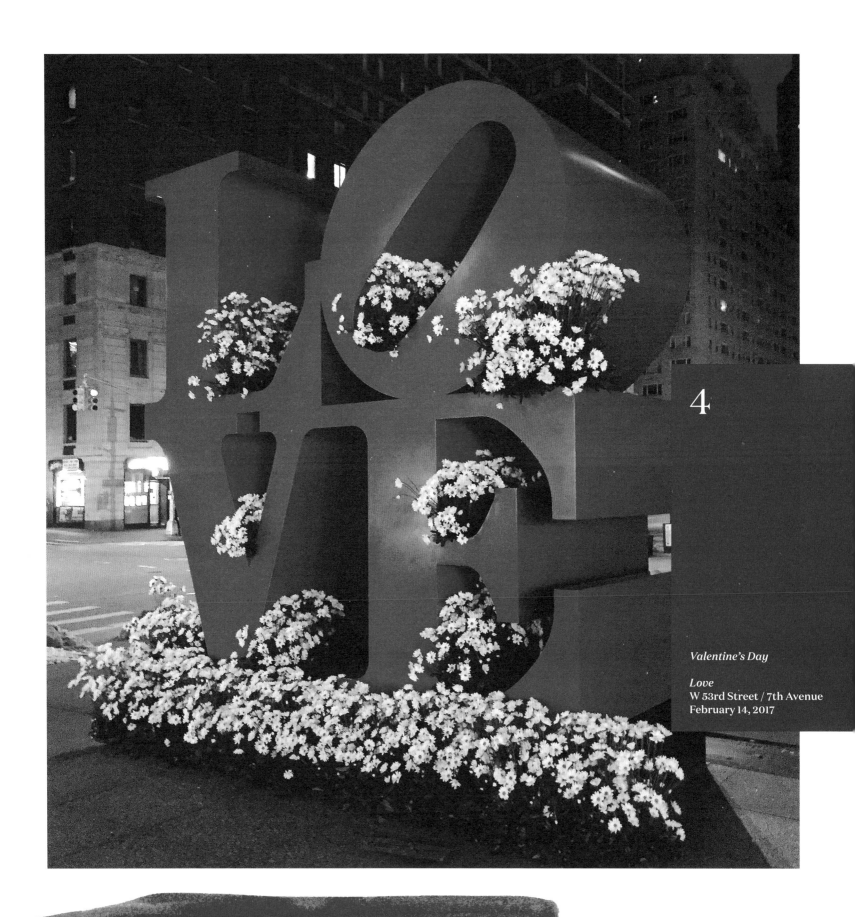

4

Valentine's Day

Love
W 53rd Street / 7th Avenue
February 14, 2017

There's something in the New York air that makes sleep useless; perhaps it's because your heart beats more quickly here than elsewhere.
— *Simone de Beauvoir*

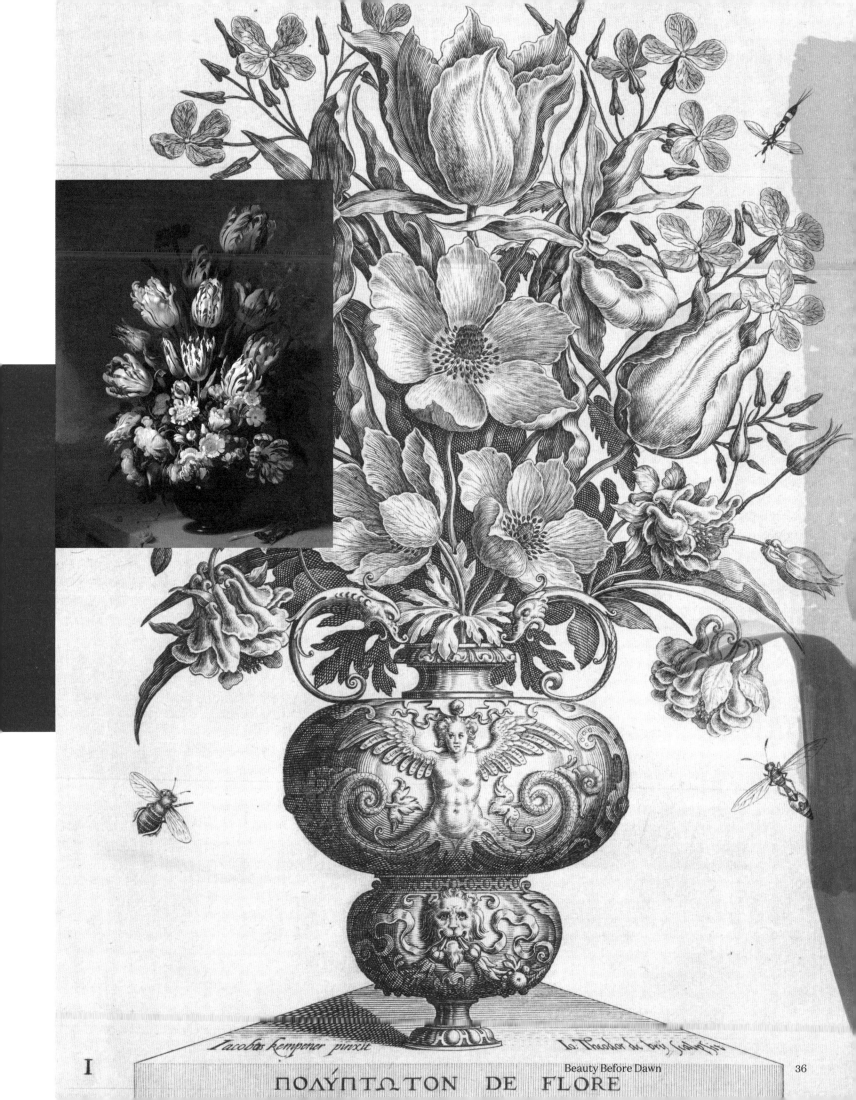

Iacobus kempener pinxit

Io: Theodor de bry sculptsit

I

ΠΟΛΎΠΤΩΤΟΝ DE FLORE

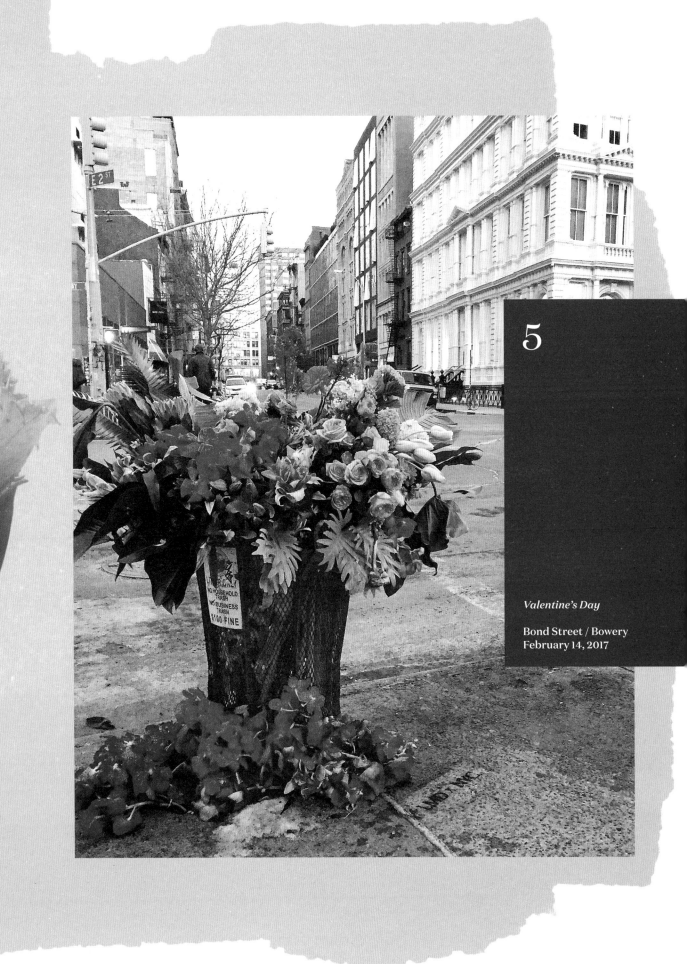

5

Valentine's Day

Bond Street / Bowery
February 14, 2017

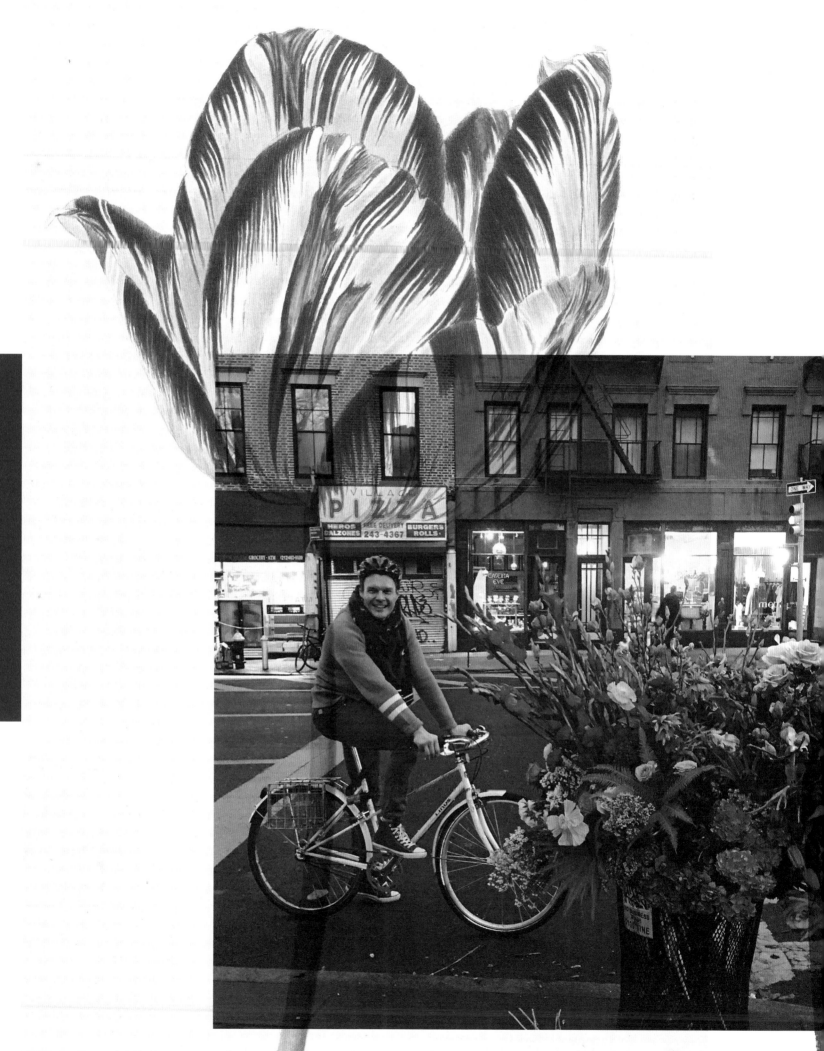

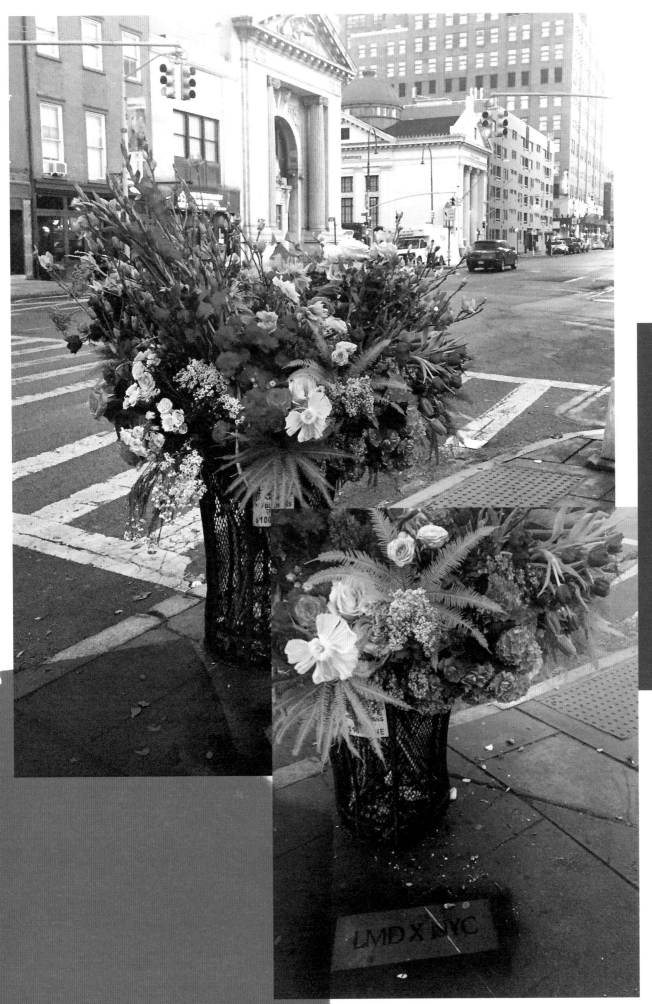

6

Greenwich Avenue /
8th Avenue
February 24, 2017

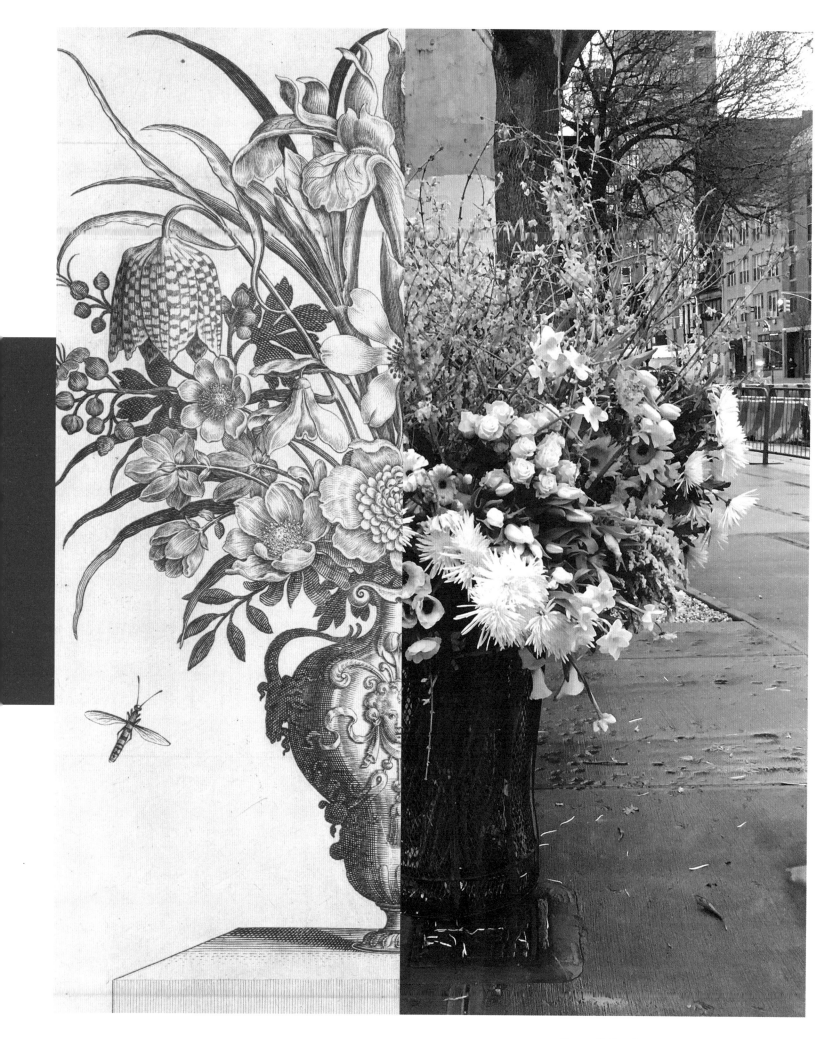

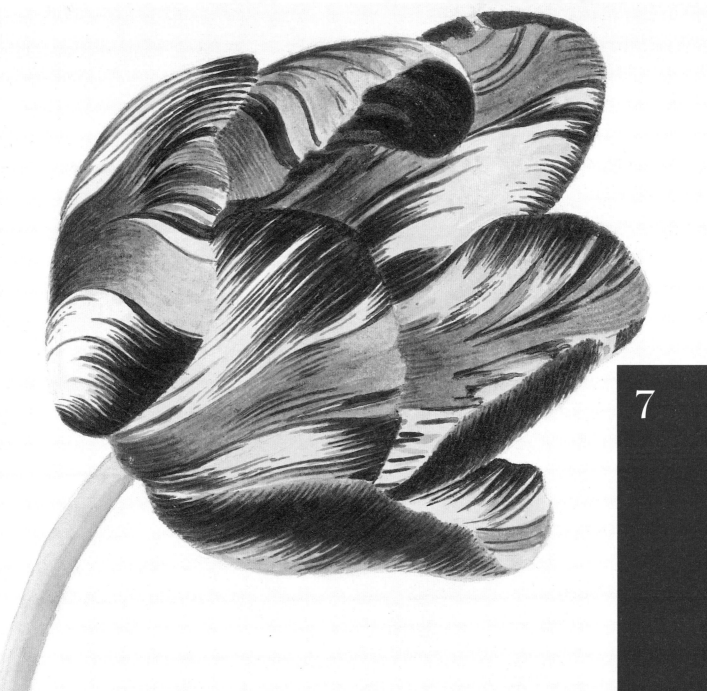

E Houston Street / Bowery
March 8, 2017

I remember telling Irini my idea of putting flowers into a trash can. She didn't look at me like I was crazy, but she was definitely apprehensive about the association of flowers and trash.

This was my third trash can Flash. I was getting bolder and more confident with every can. The Flashes were also physically growing, getting bigger as I was figuring out the mechanics of making each one.

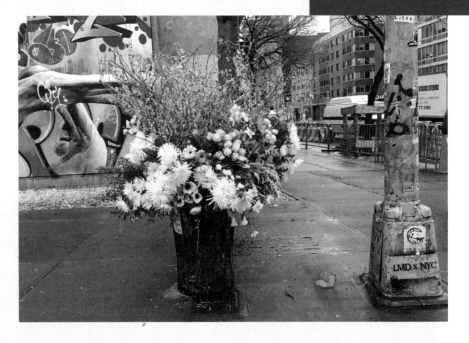

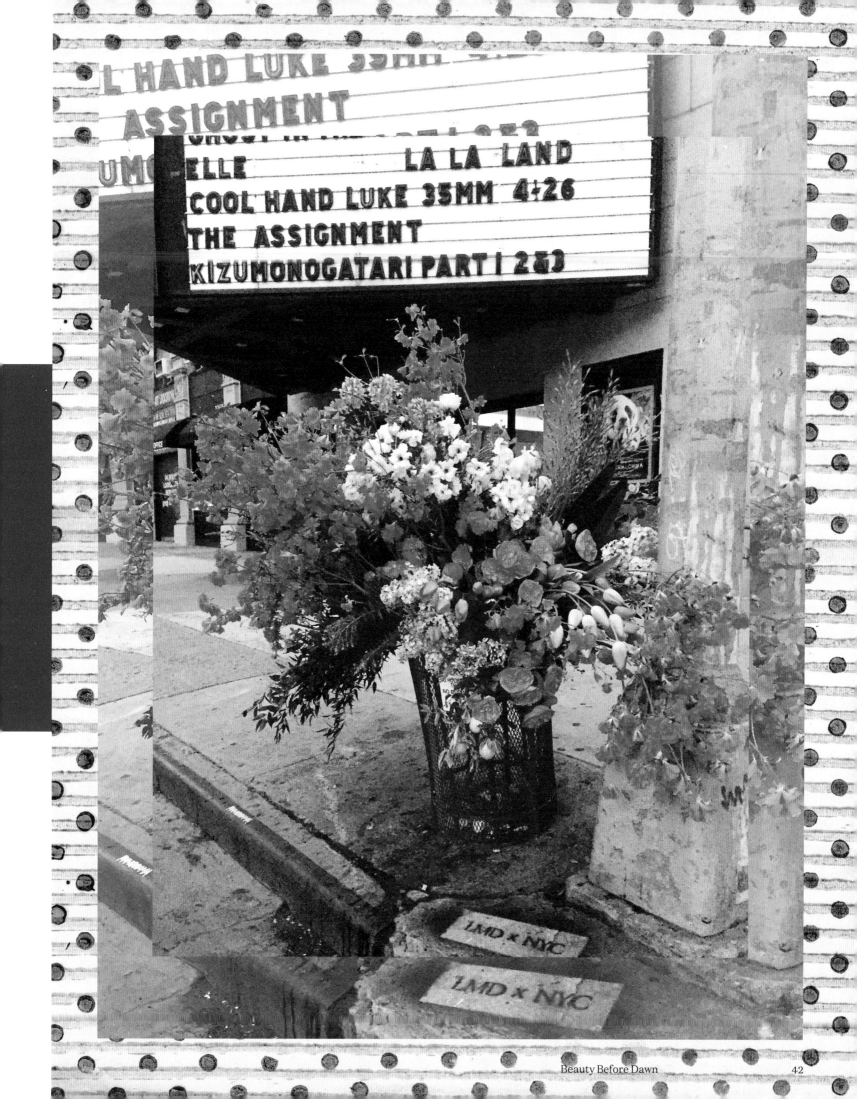

L HAND LUKE 35MM
ASSIGNMENT

UMO ELLE LA LA LAND
COOL HAND LUKE 35MM 4:26
THE ASSIGNMENT
KIZUMONOGATARI PART I 2&3

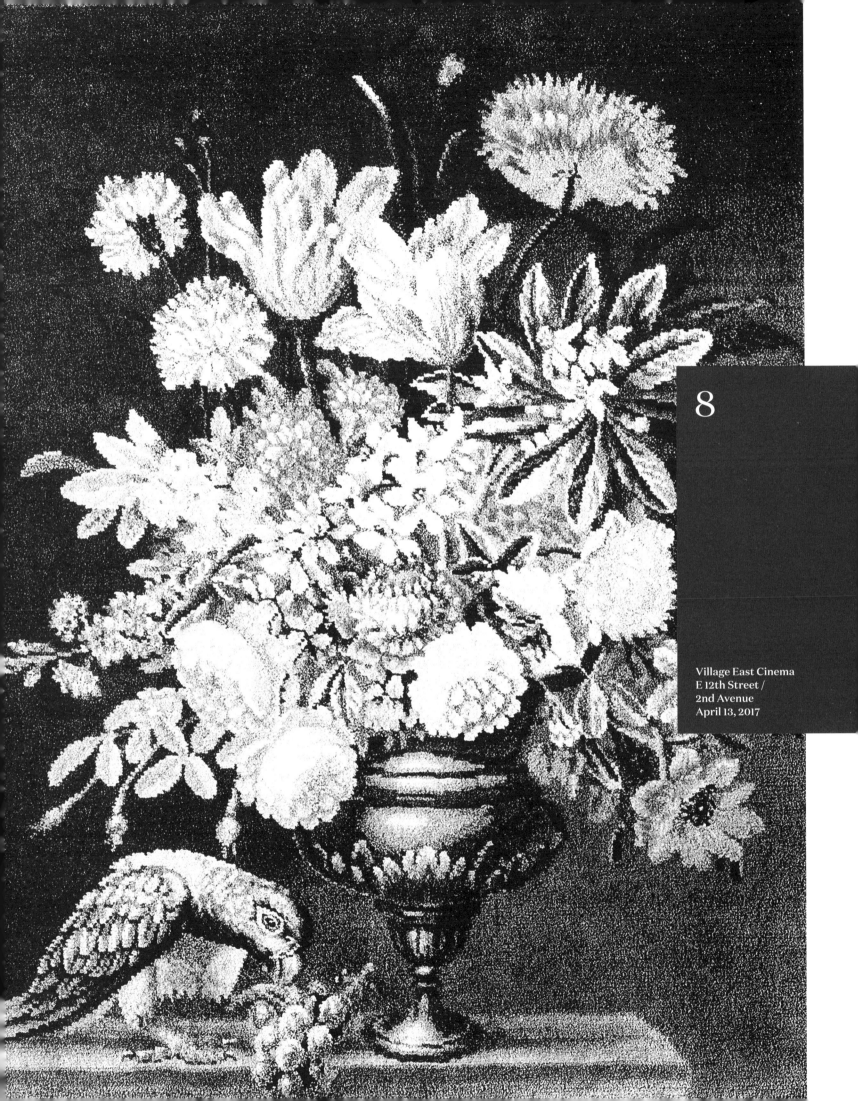

8

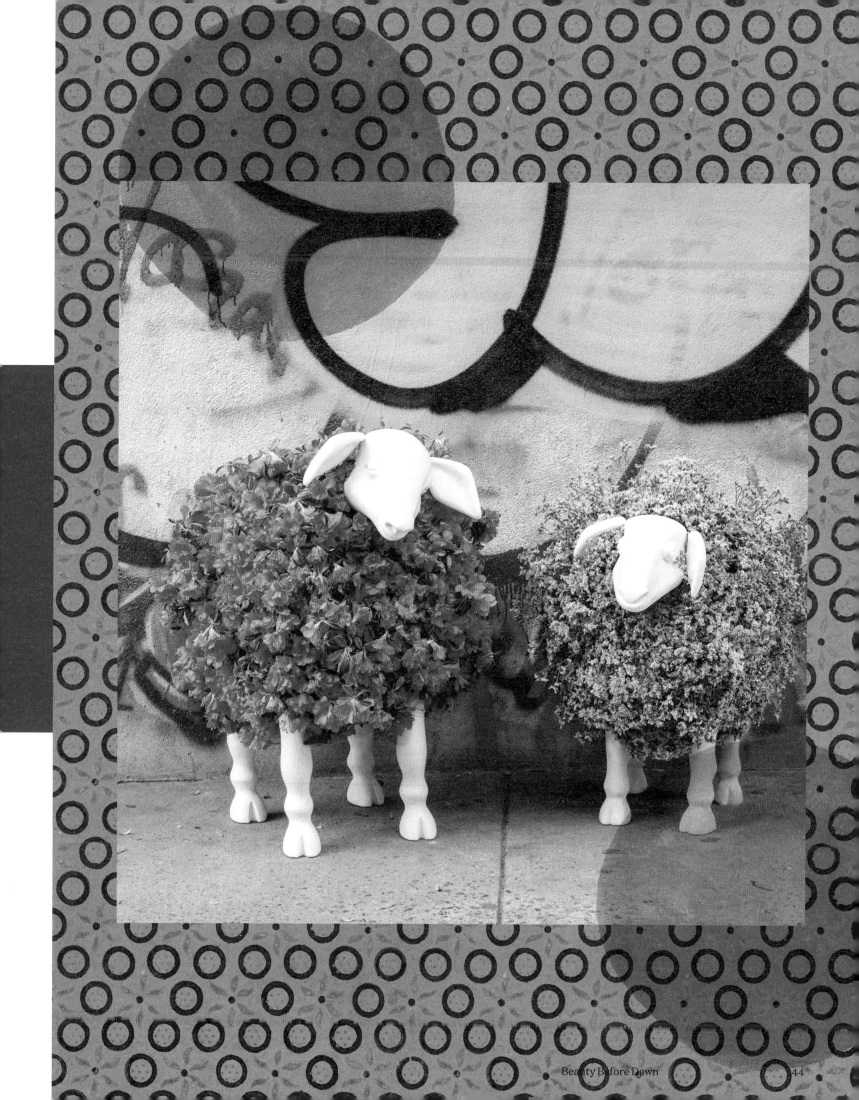

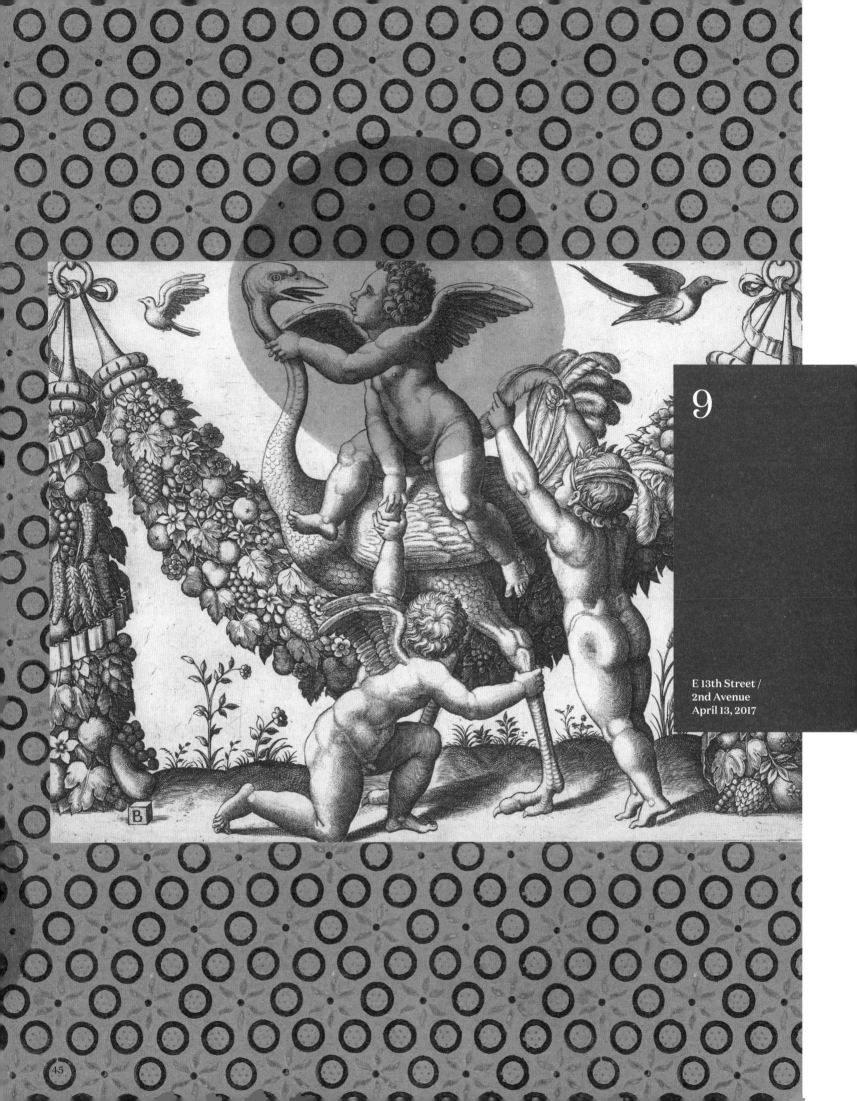

9

E 13th Street /
2nd Avenue
April 13, 2017

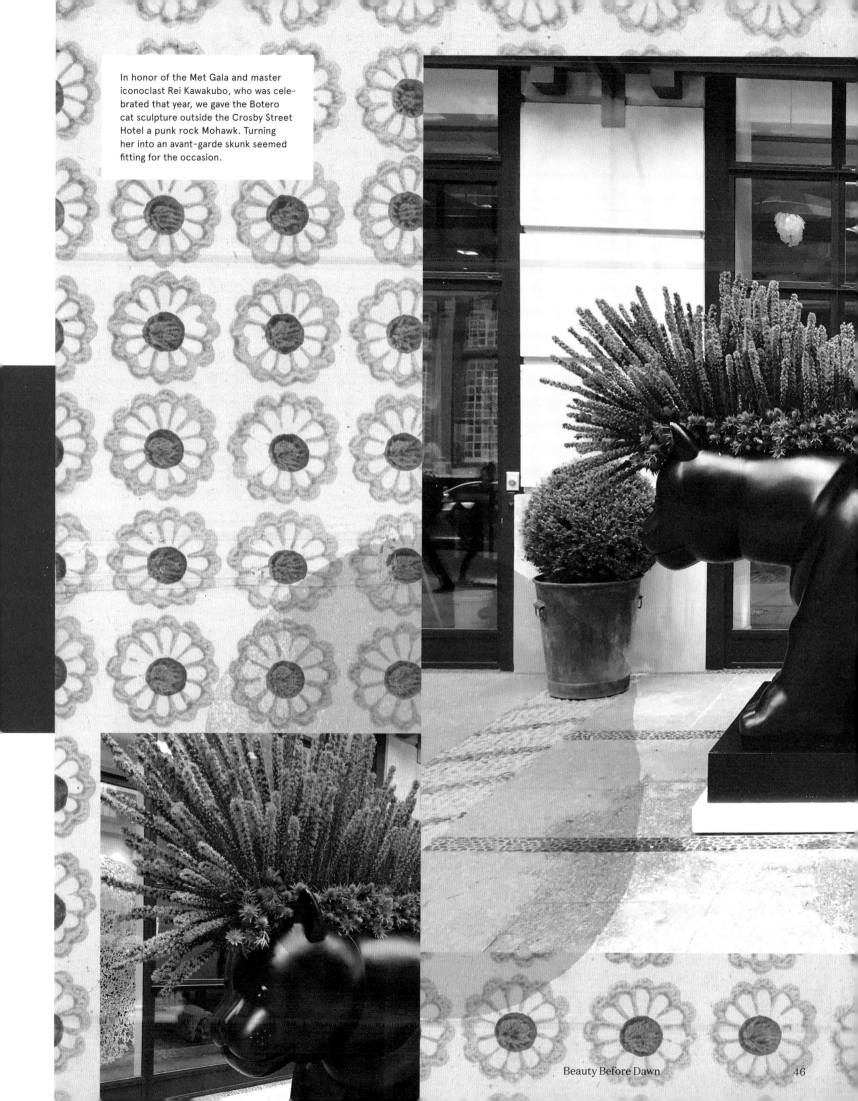

In honor of the Met Gala and master iconoclast Rei Kawakubo, who was celebrated that year, we gave the Botero cat sculpture outside the Crosby Street Hotel a punk rock Mohawk. Turning her into an avant-garde skunk seemed fitting for the occasion.

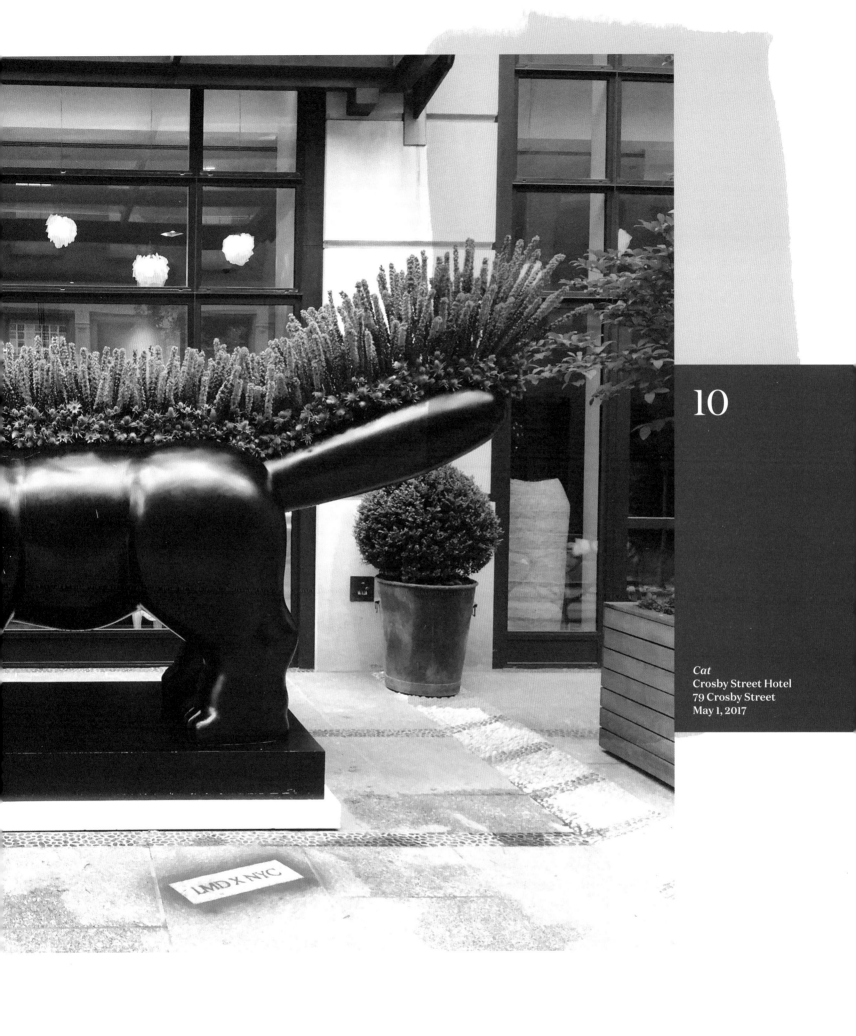

10

Cat
Crosby Street Hotel
79 Crosby Street
May 1, 2017

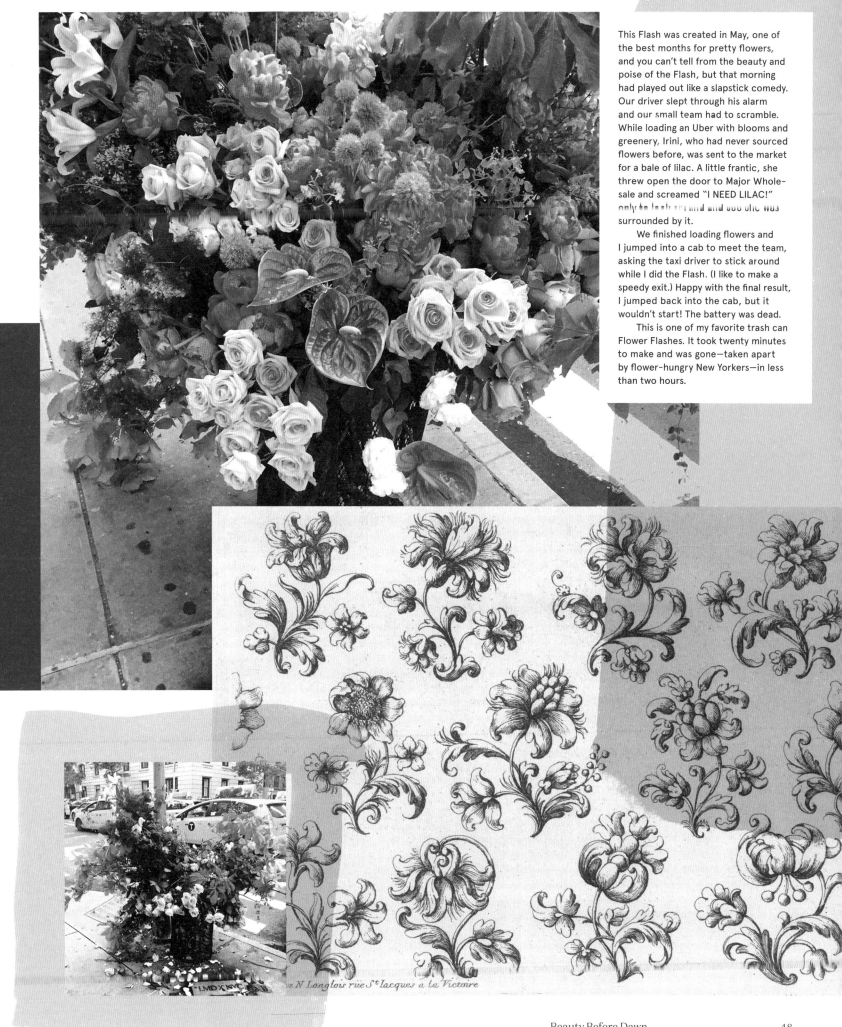

This Flash was created in May, one of the best months for pretty flowers, and you can't tell from the beauty and poise of the Flash, but that morning had played out like a slapstick comedy. Our driver slept through his alarm and our small team had to scramble. While loading an Uber with blooms and greenery, Irini, who had never sourced flowers before, was sent to the market for a bale of lilac. A little frantic, she threw open the door to Major Wholesale and screamed "I NEED LILAC!" only to look around and see she was surrounded by it.

We finished loading flowers and I jumped into a cab to meet the team, asking the taxi driver to stick around while I did the Flash. (I like to make a speedy exit.) Happy with the final result, I jumped back into the cab, but it wouldn't start! The battery was dead.

This is one of my favorite trash can Flower Flashes. It took twenty minutes to make and was gone—taken apart by flower-hungry New Yorkers—in less than two hours.

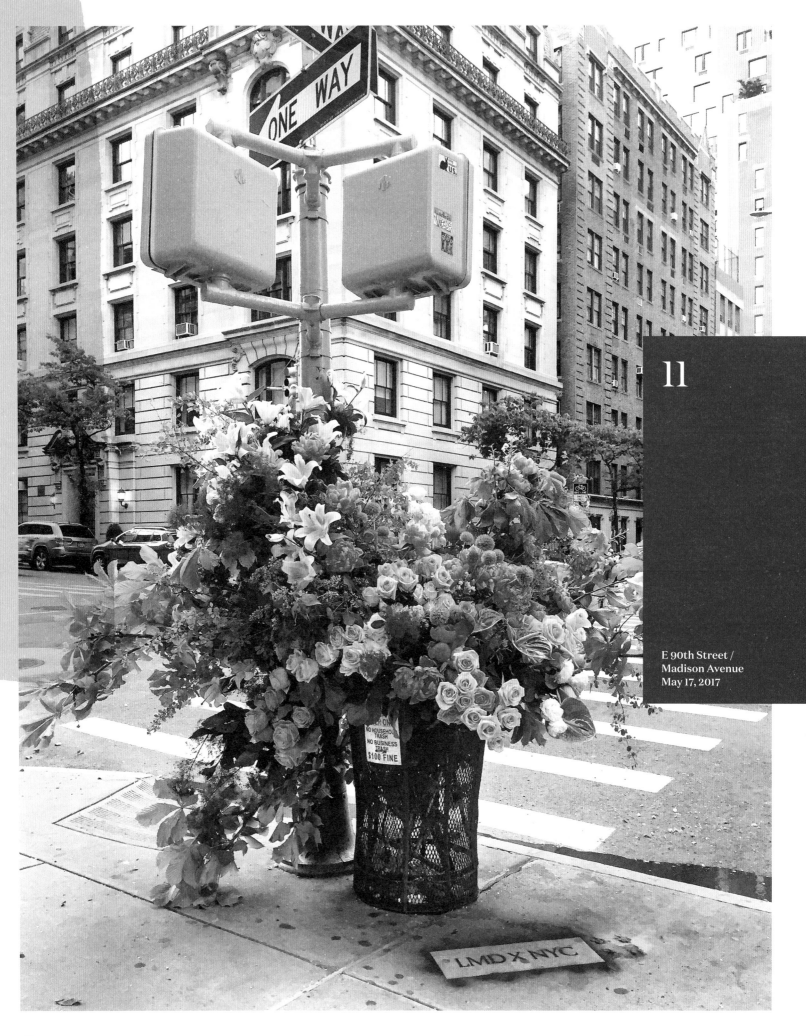

ONE WAY

11

E 90th Street /
Madison Avenue
May 17, 2017

LMD X NYC

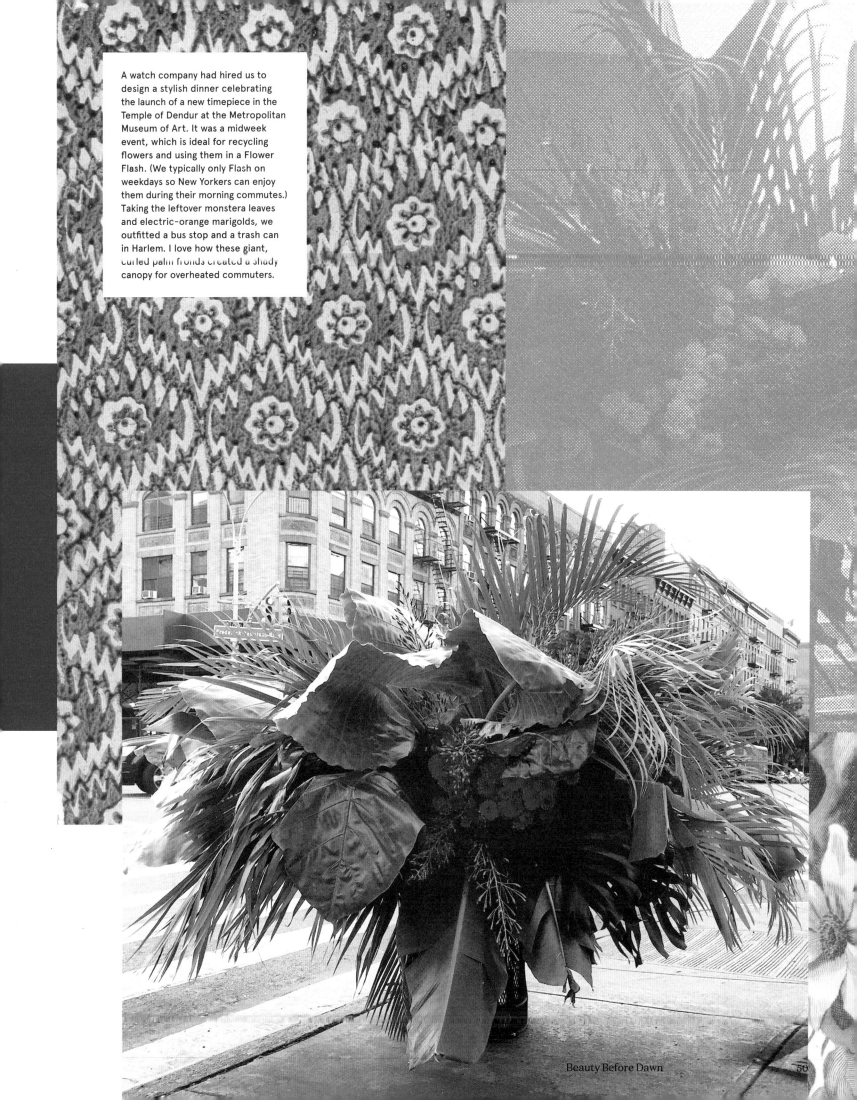

A watch company had hired us to design a stylish dinner celebrating the launch of a new timepiece in the Temple of Dendur at the Metropolitan Museum of Art. It was a midweek event, which is ideal for recycling flowers and using them in a Flower Flash. (We typically only Flash on weekdays so New Yorkers can enjoy them during their morning commutes.) Taking the leftover monstera leaves and electric-orange marigolds, we outfitted a bus stop and a trash can in Harlem. I love how these giant, curled palm fronds created a shady canopy for overheated commuters.

Beauty Before Dawn

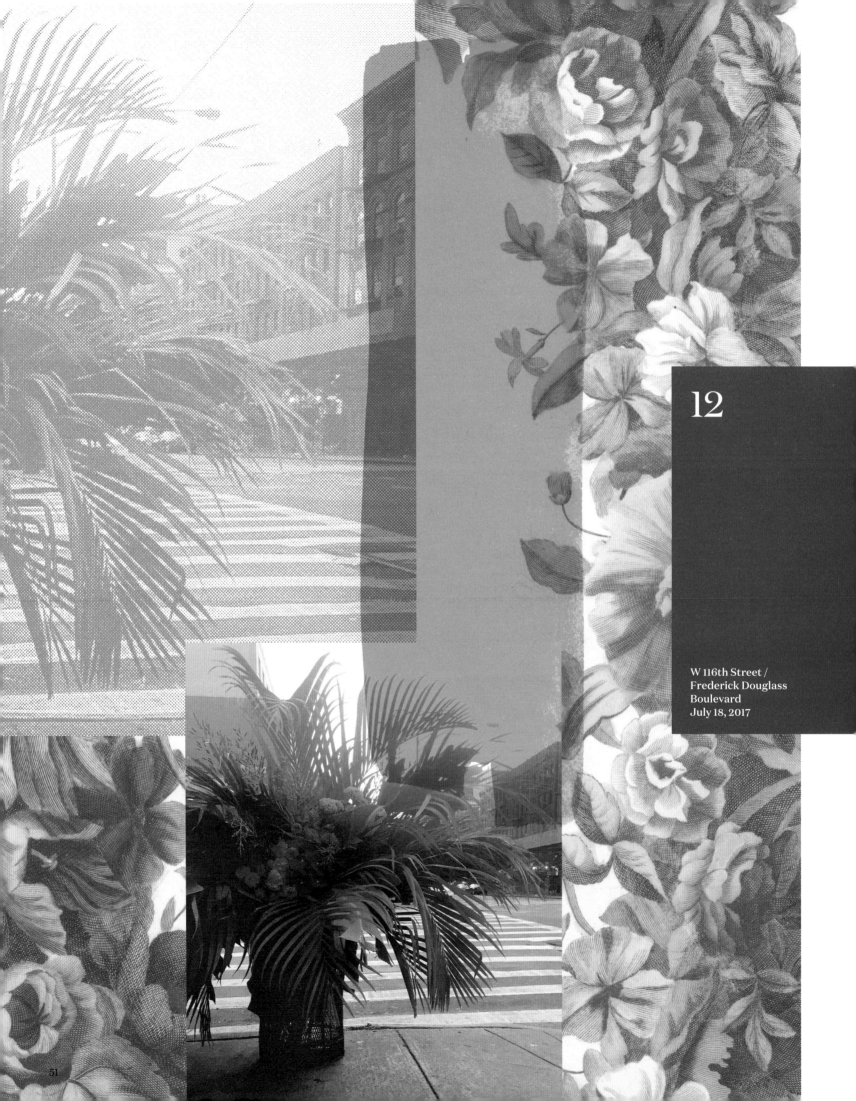

12

W 116th Street /
Frederick Douglass
Boulevard
July 18, 2017

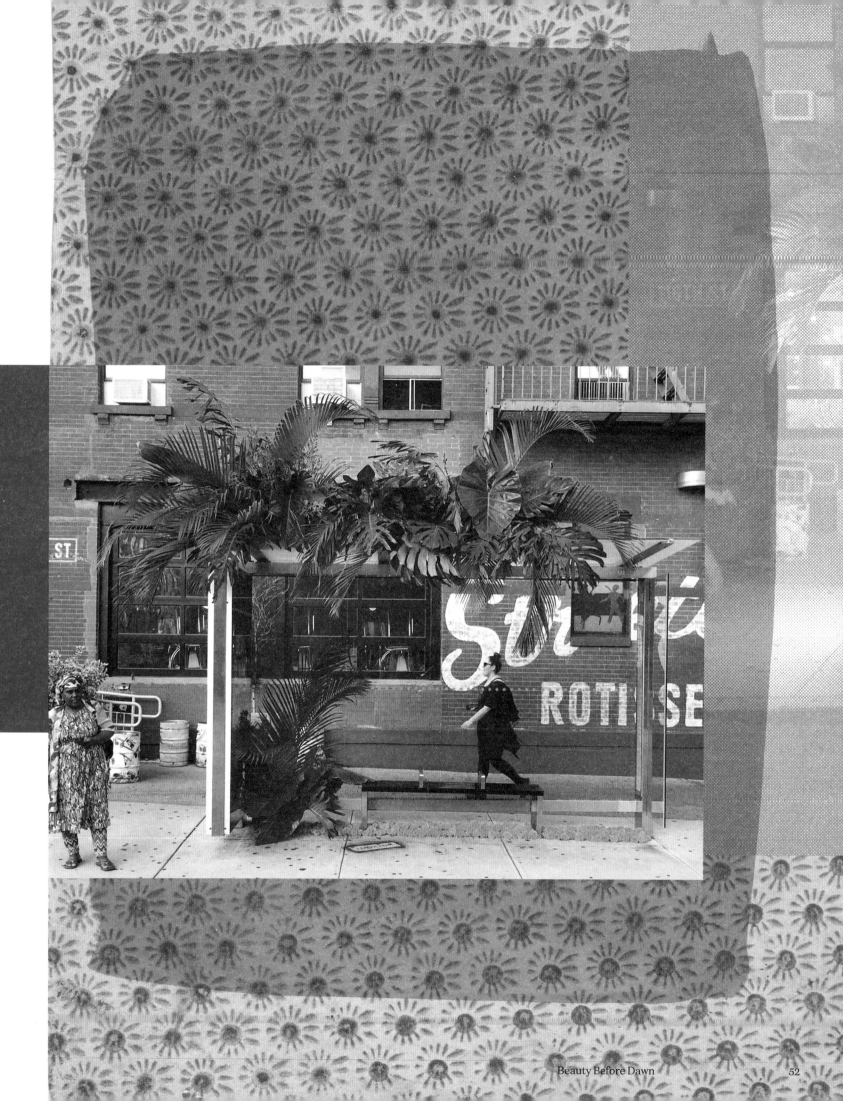

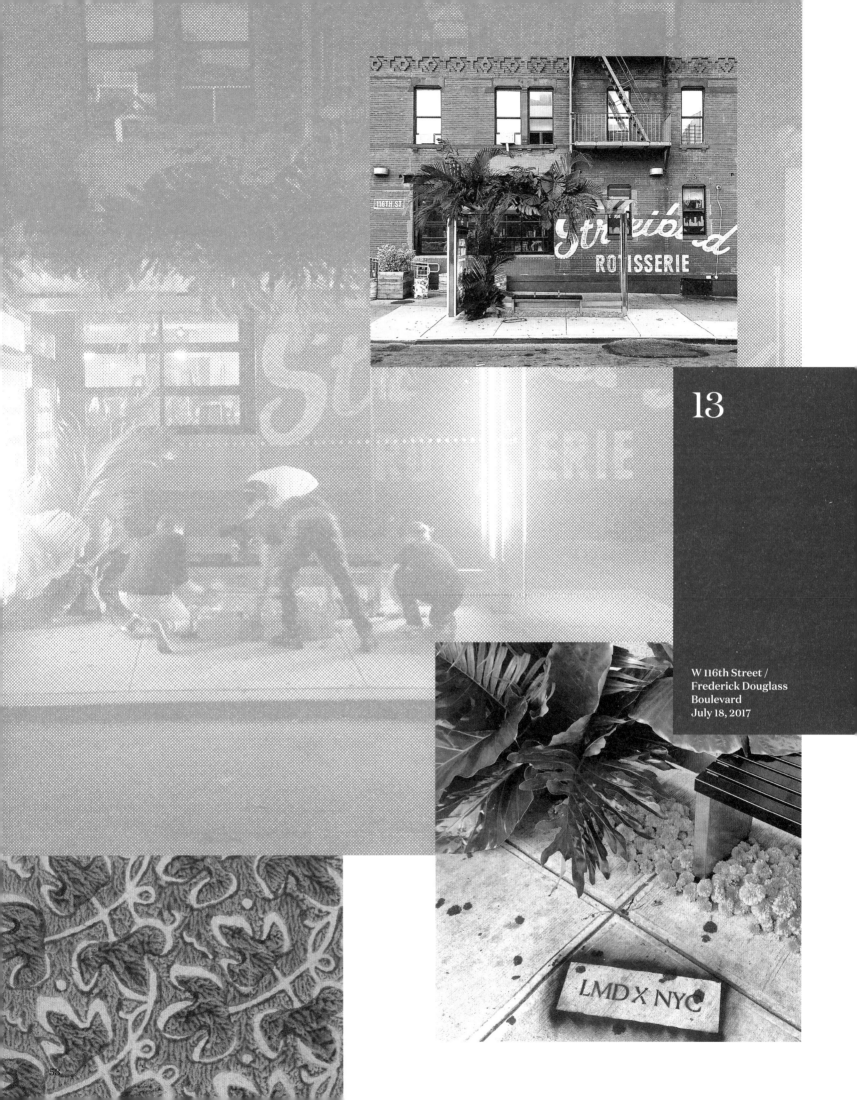

13

W 116th Street /
Frederick Douglass
Boulevard
July 18, 2017

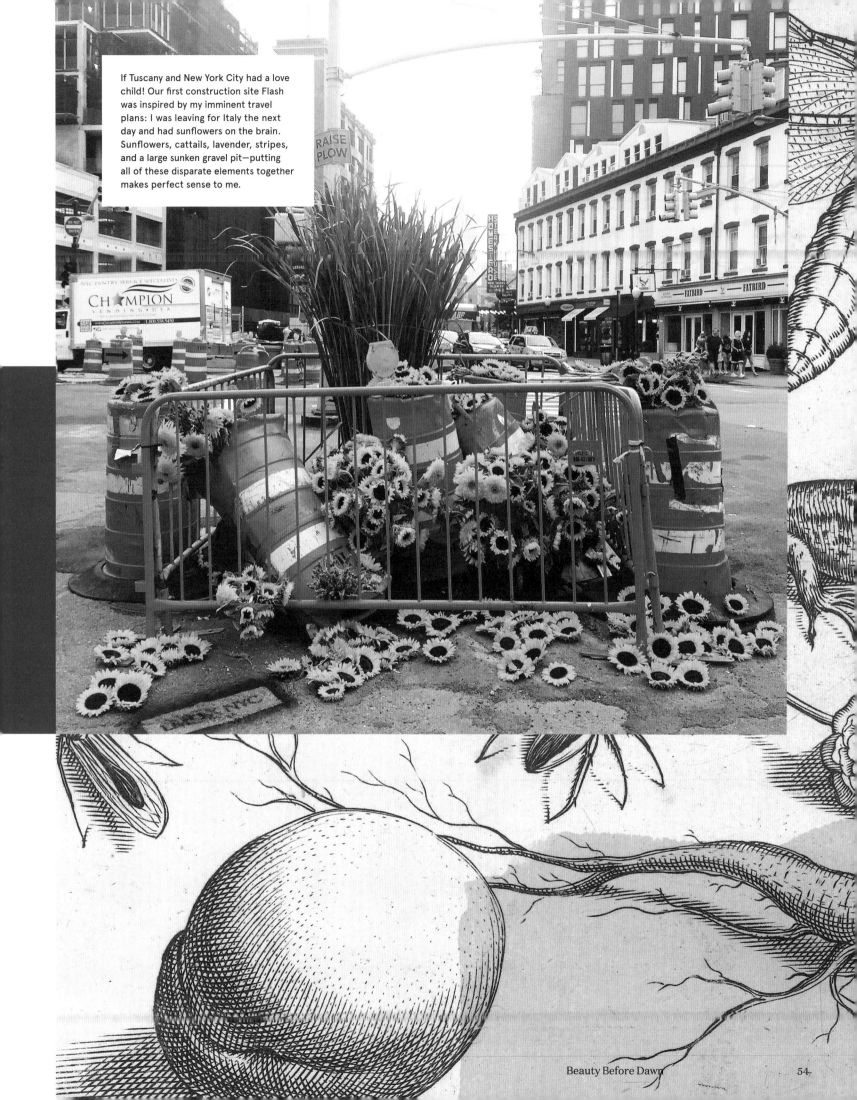

If Tuscany and New York City had a love child! Our first construction site Flash was inspired by my imminent travel plans: I was leaving for Italy the next day and had sunflowers on the brain. Sunflowers, cattails, lavender, stripes, and a large sunken gravel pit—putting all of these disparate elements together makes perfect sense to me.

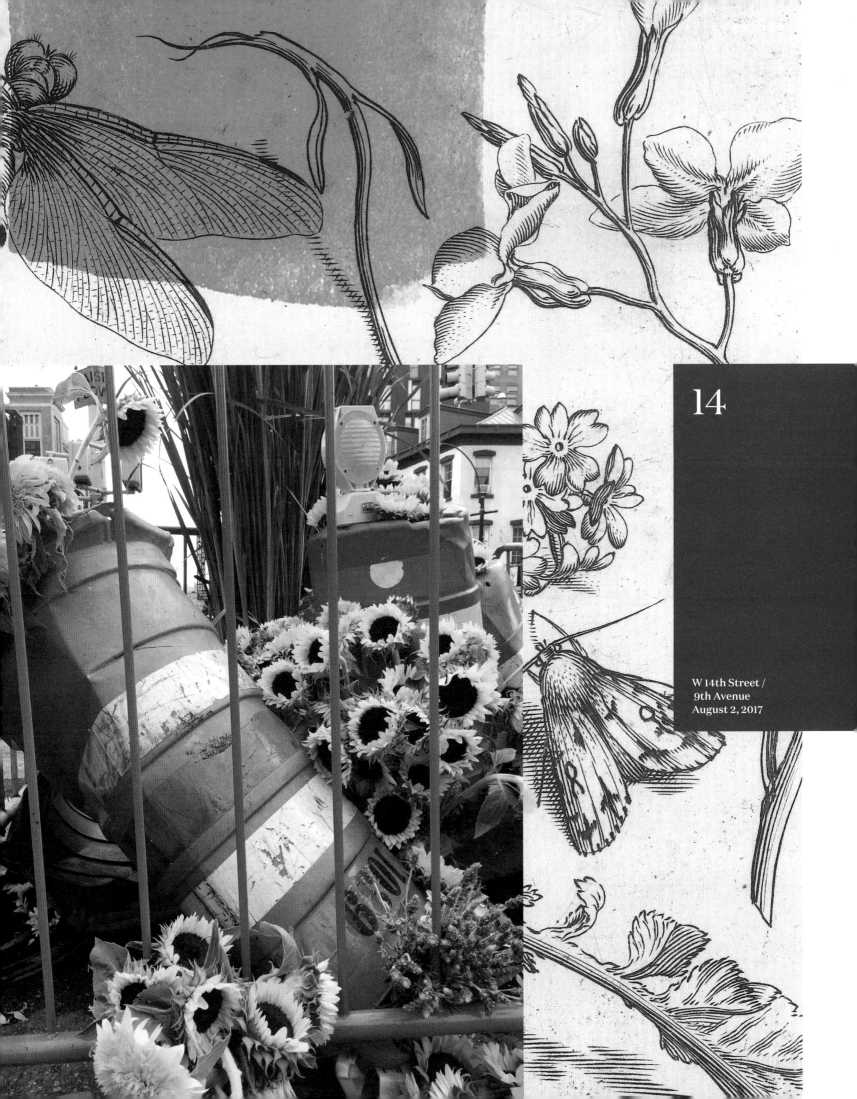

14

W 14th Street /
9th Avenue
August 2, 2017

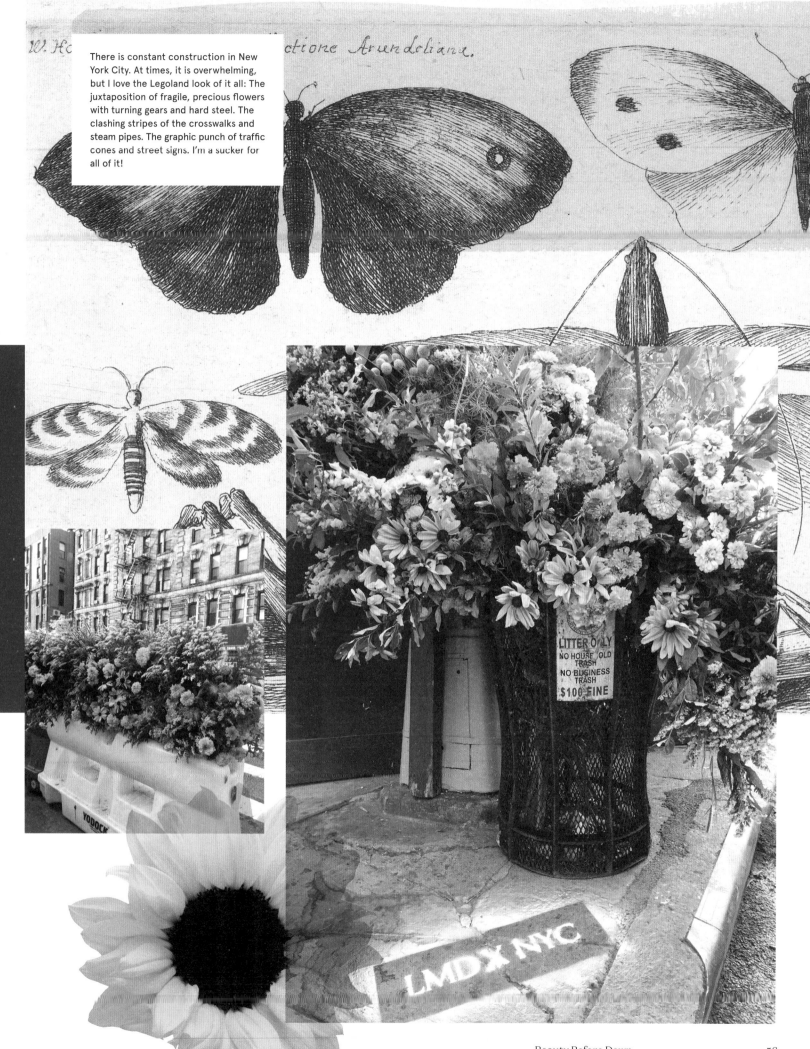

There is constant construction in New York City. At times, it is overwhelming, but I love the Legoland look of it all: The juxtaposition of fragile, precious flowers with turning gears and hard steel. The clashing stripes of the crosswalks and steam pipes. The graphic punch of traffic cones and street signs. I'm a sucker for all of it!

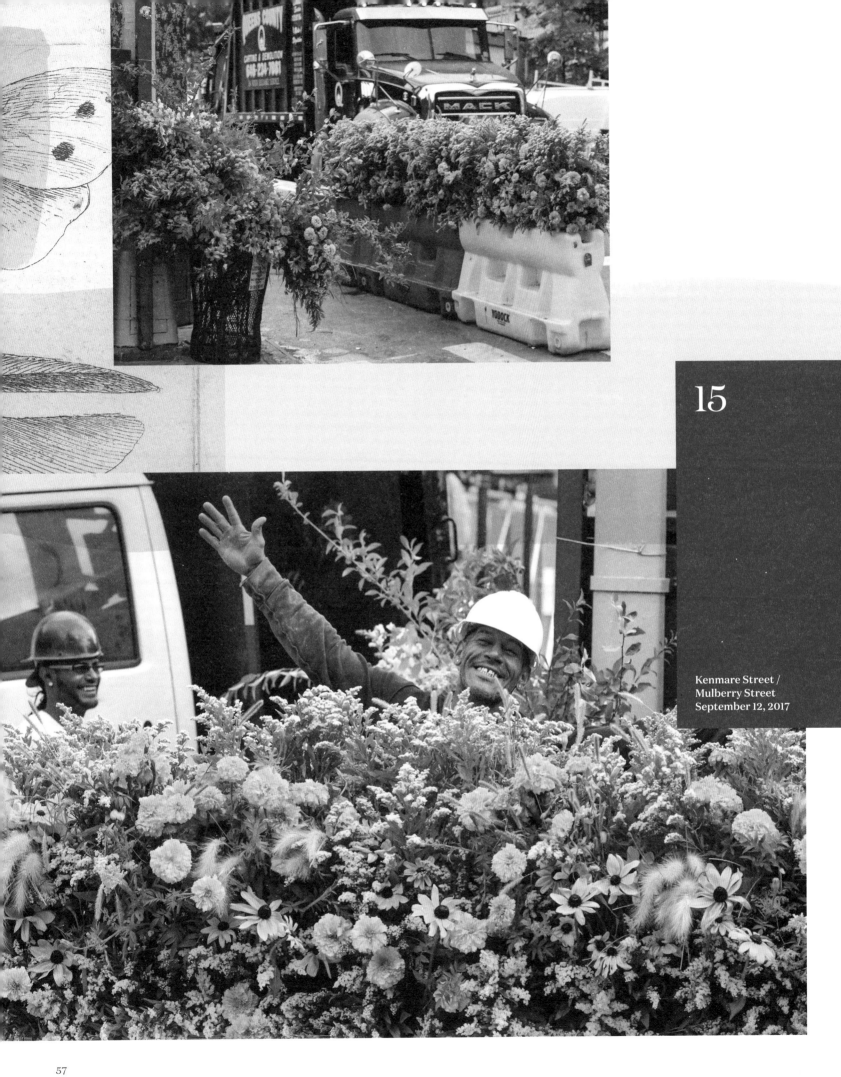

15

Kenmare Street /
Mulberry Street
September 12, 2017

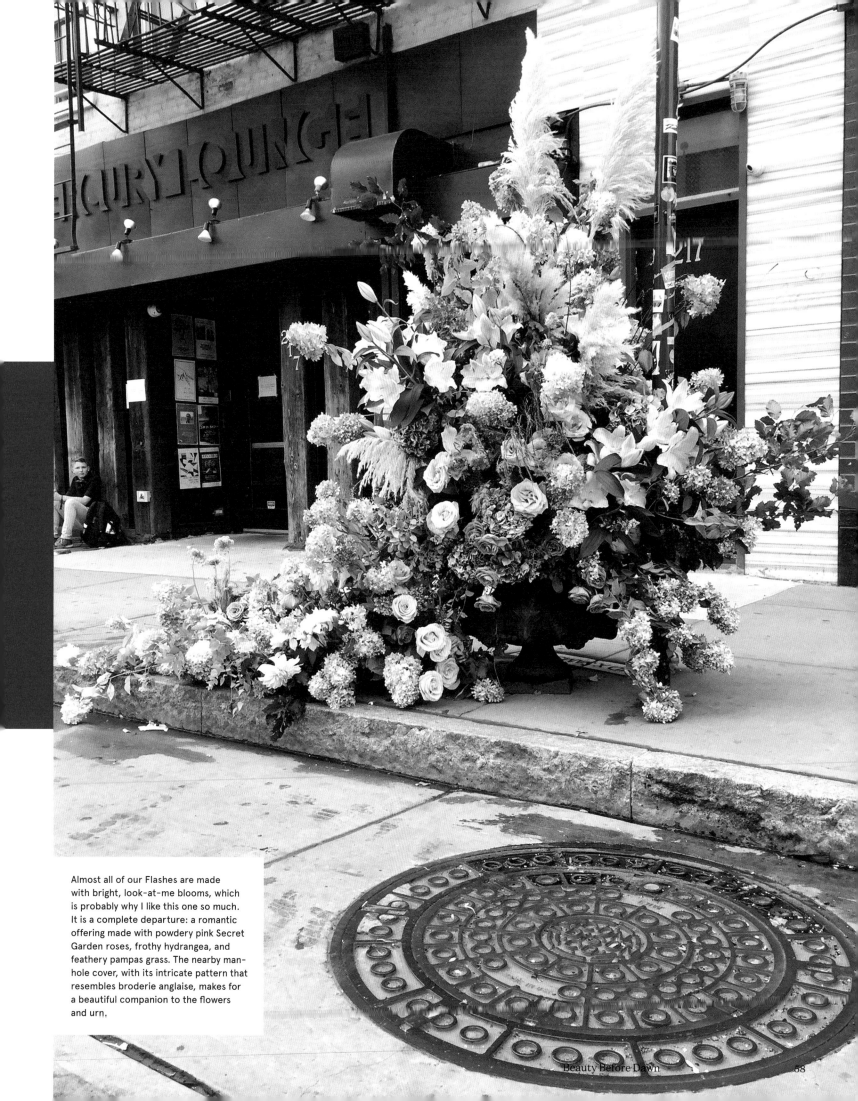

Almost all of our Flashes are made with bright, look-at-me blooms, which is probably why I like this one so much. It is a complete departure: a romantic offering made with powdery pink Secret Garden roses, frothy hydrangea, and feathery pampas grass. The nearby manhole cover, with its intricate pattern that resembles broderie anglaise, makes for a beautiful companion to the flowers and urn.

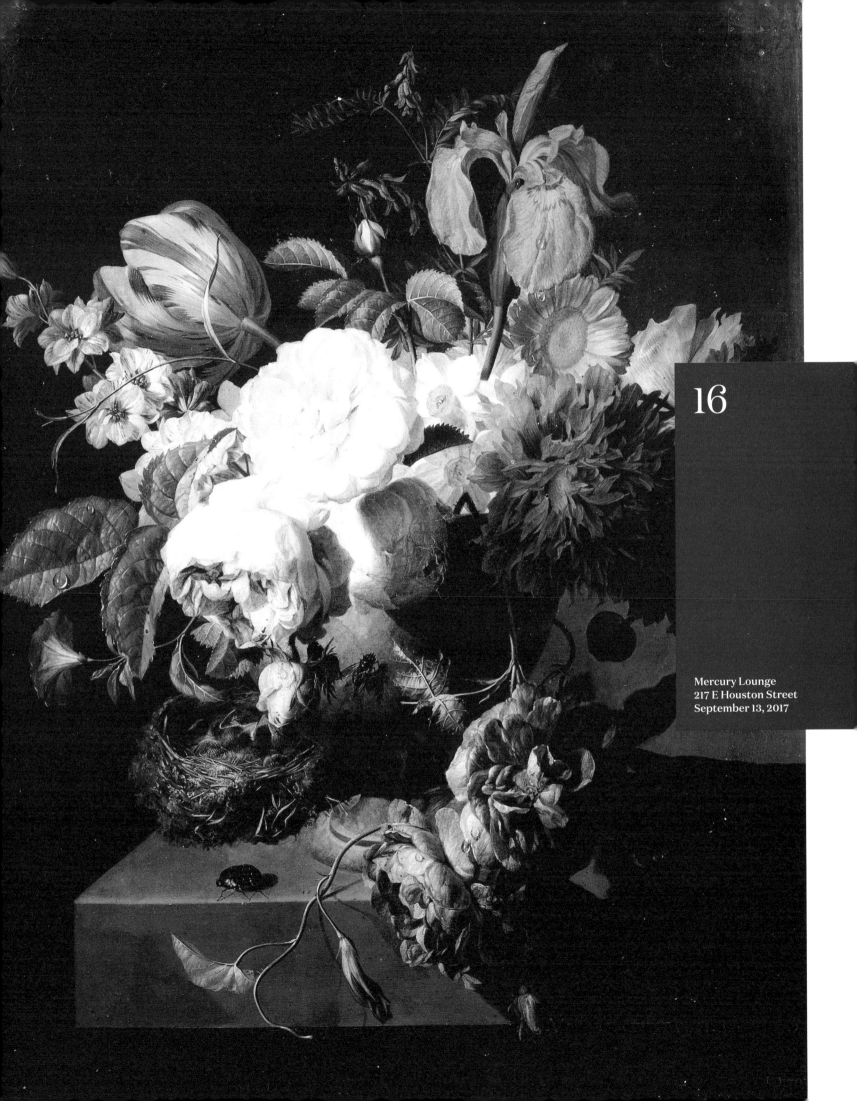

16

Mercury Lounge
217 E Houston Street
September 13, 2017

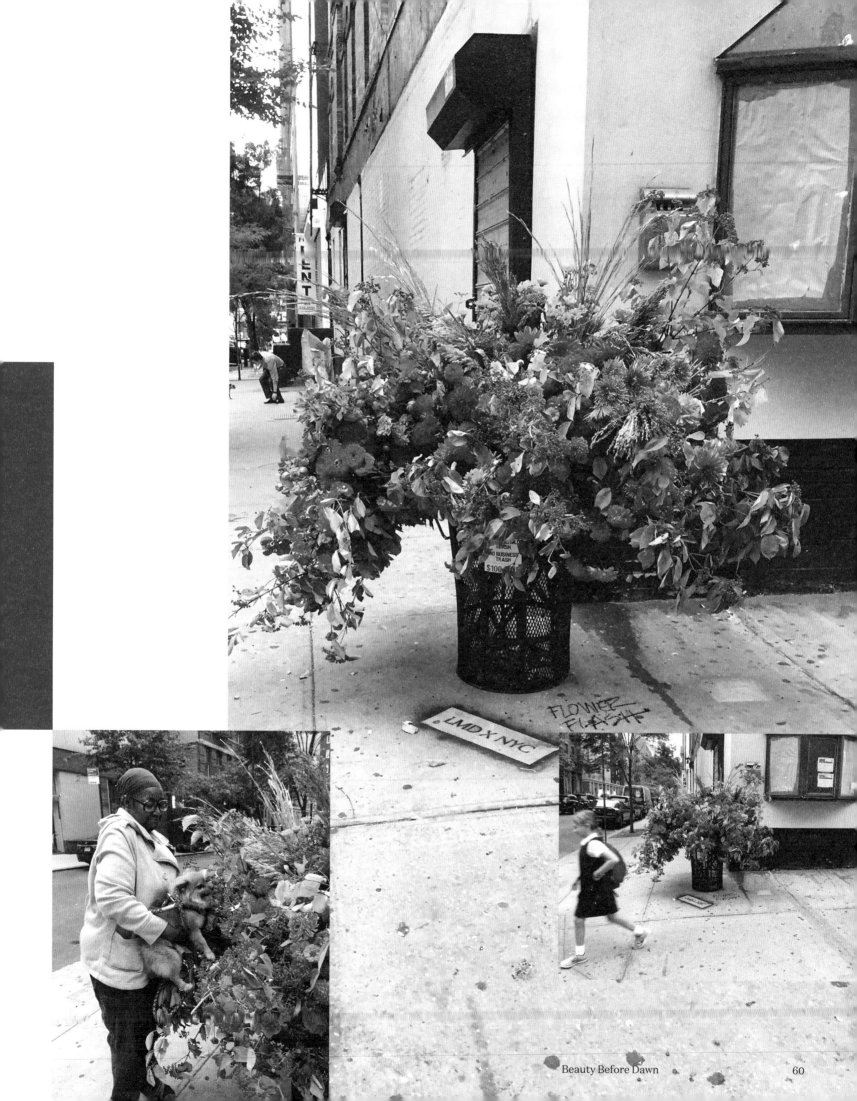

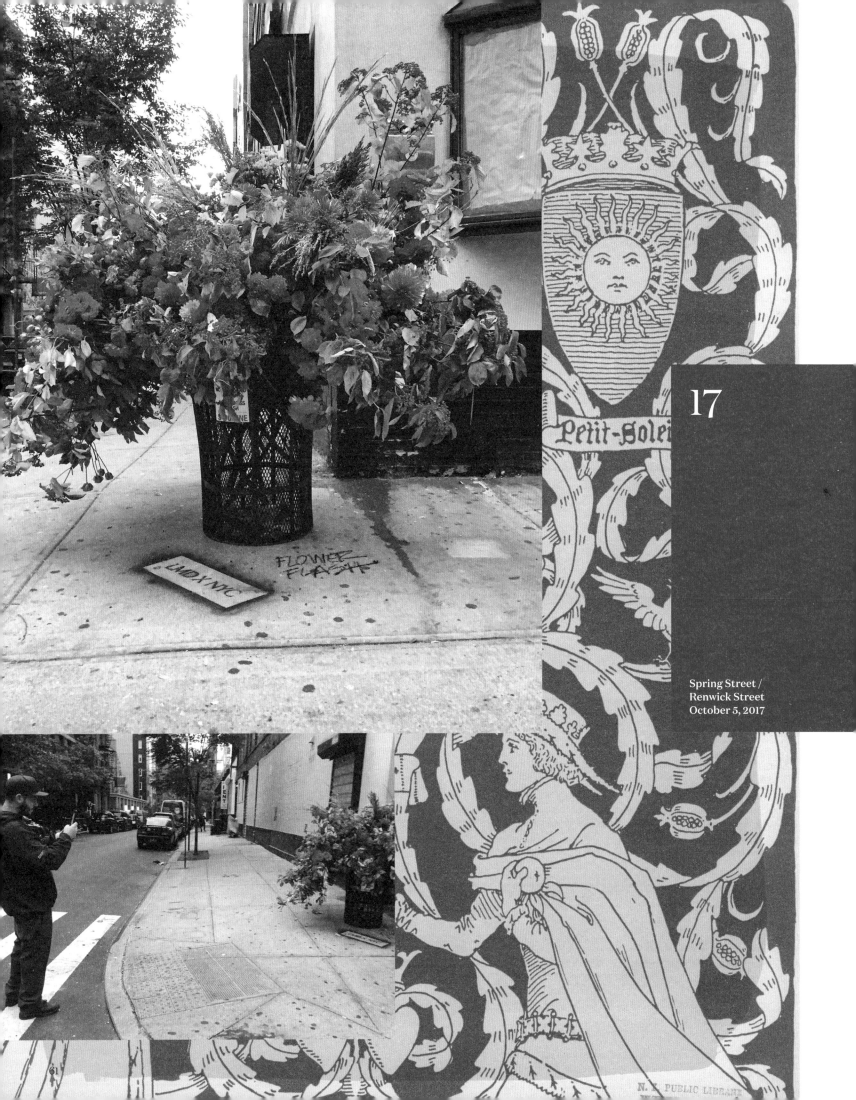

17

Spring Street /
Renwick Street
October 5, 2017

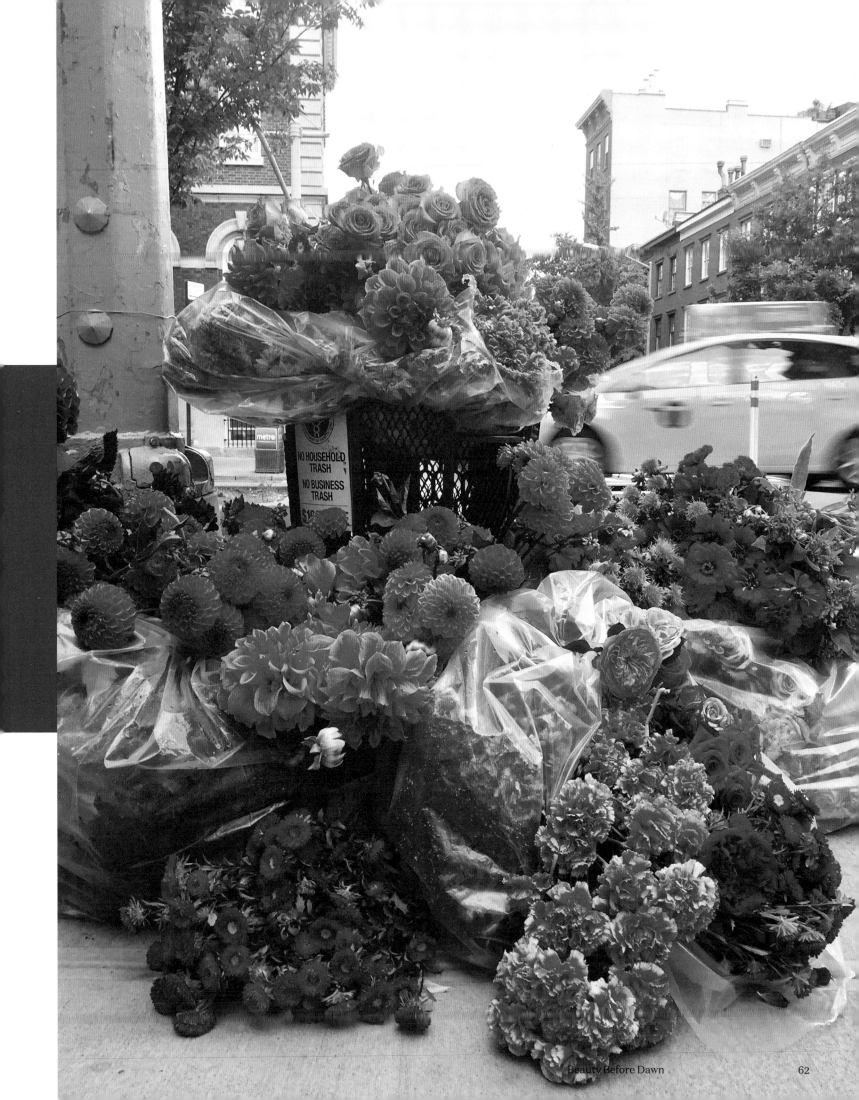

NO HOUSEHOLD
TRASH
NO BUSINESS
TRASH
$10

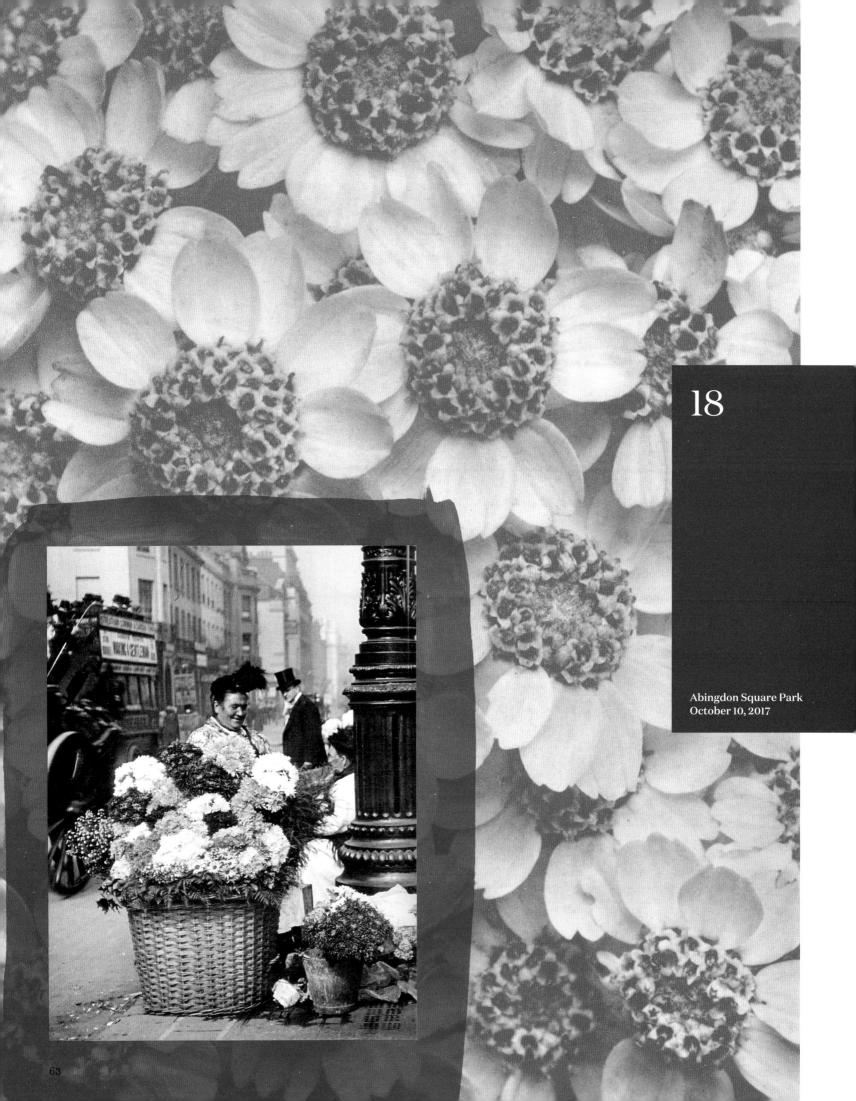

18

Abingdon Square Park
October 10, 2017

63

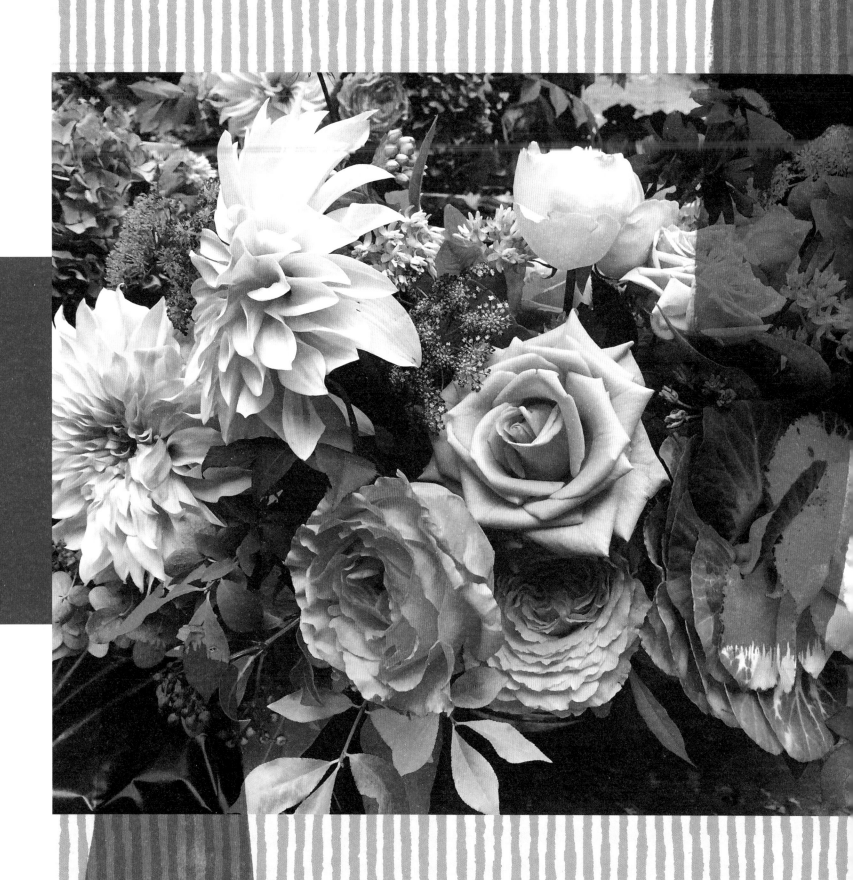

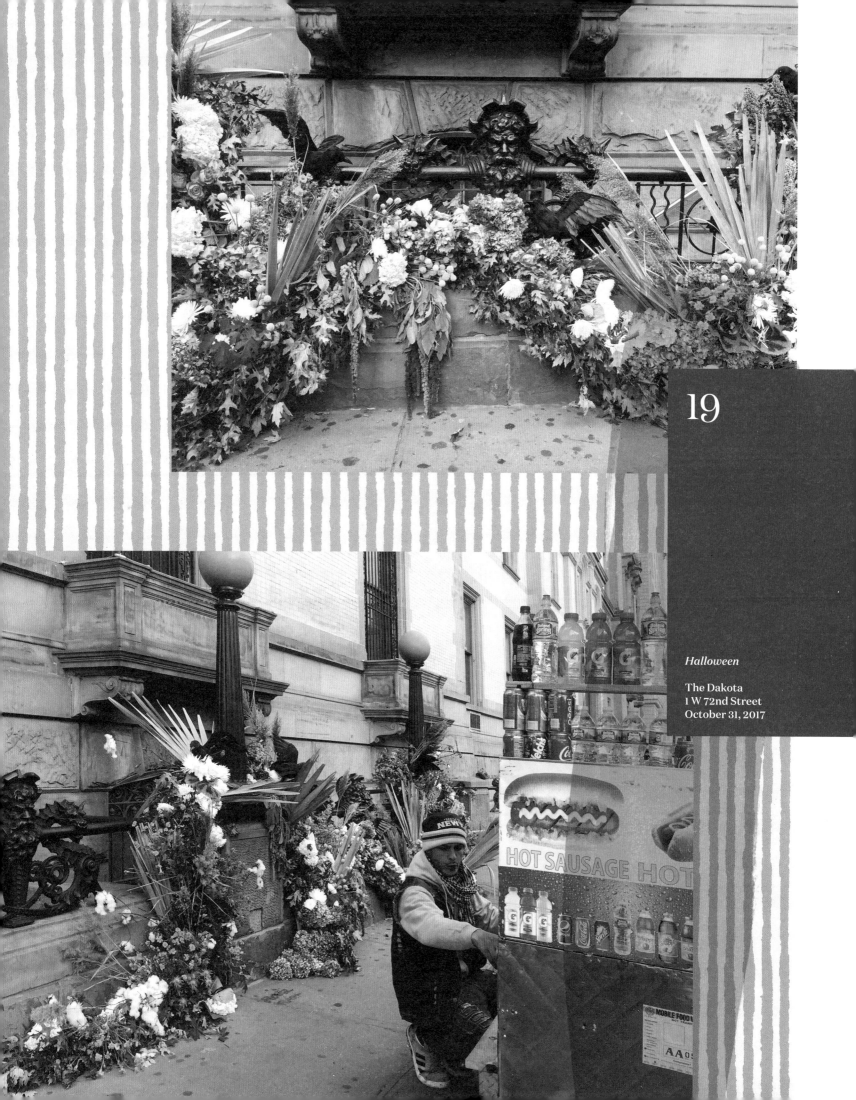

19

Halloween

The Dakota
1 W 72nd Street
October 31, 2017

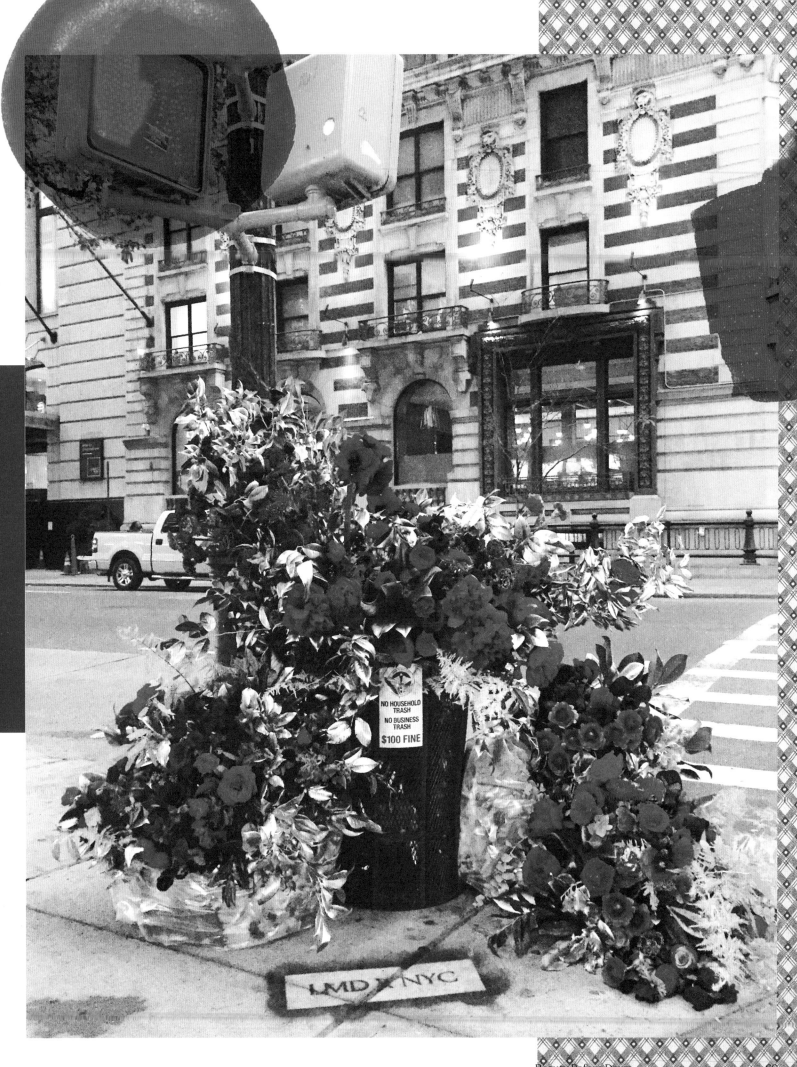

NO HOUSEHOLD
TRASH
NO BUSINESS
TRASH
$100 FINE

LMD X NYC

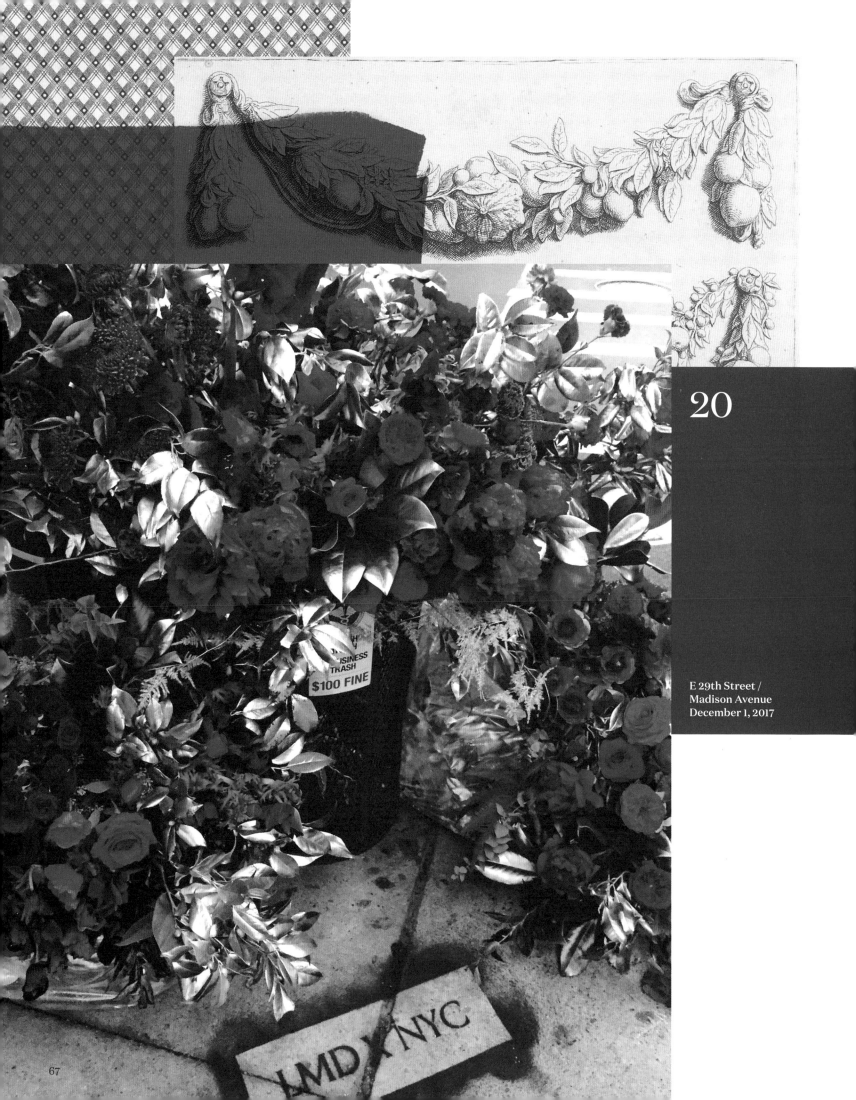

20

BUSINESS TRASH
$100 FINE

LMD X NYC

E 29th Street /
Madison Avenue
December 1, 2017

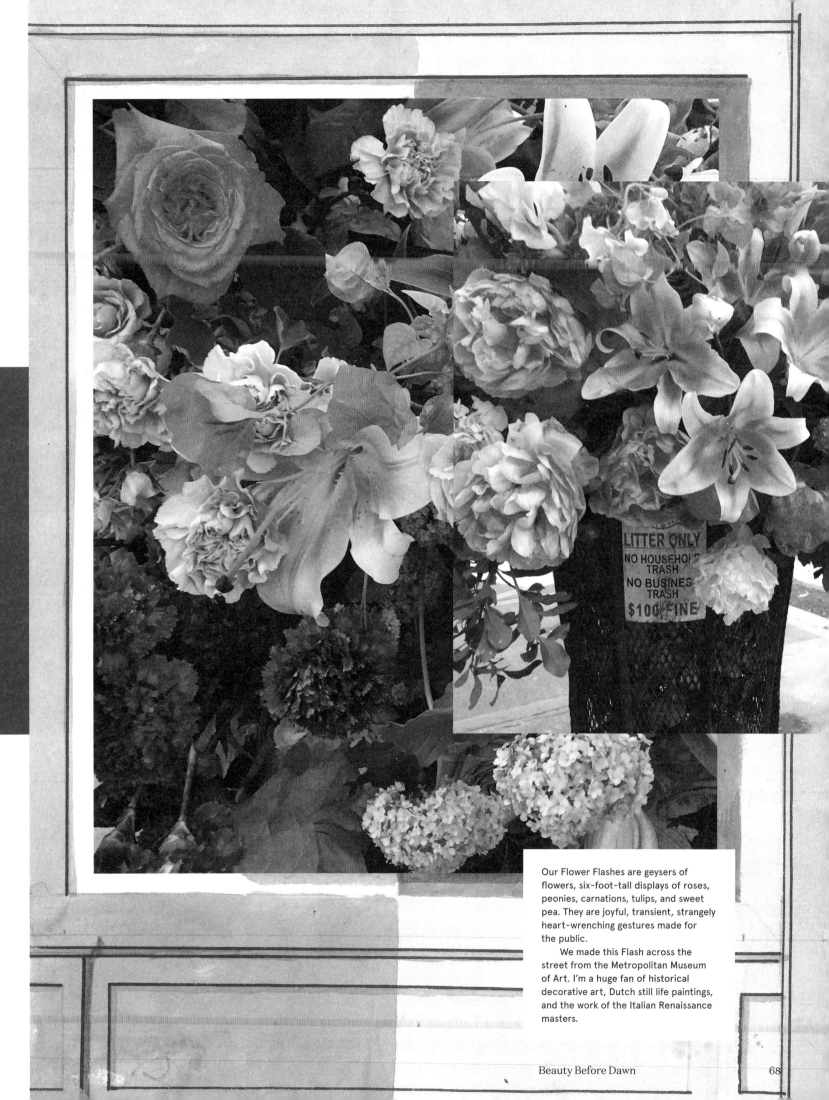

Our Flower Flashes are geysers of flowers, six-foot-tall displays of roses, peonies, carnations, tulips, and sweet pea. They are joyful, transient, strangely heart-wrenching gestures made for the public.

We made this Flash across the street from the Metropolitan Museum of Art. I'm a huge fan of historical decorative art, Dutch still life paintings, and the work of the Italian Renaissance masters.

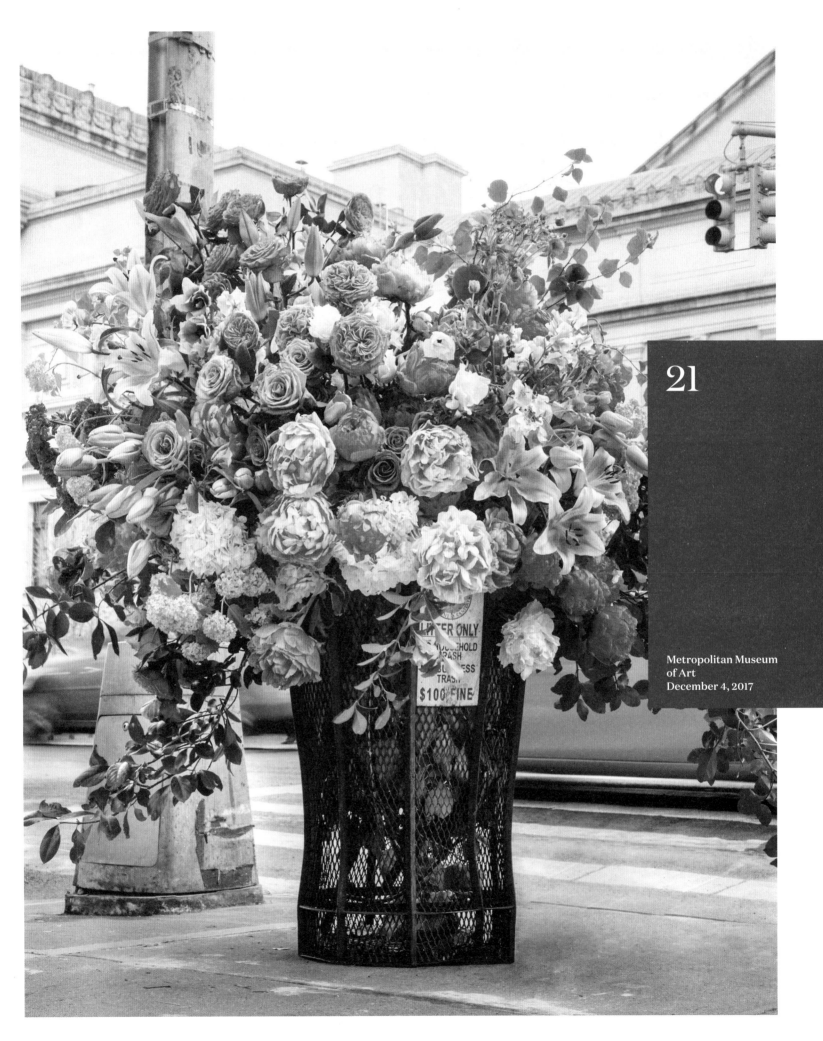

21

Metropolitan Museum
of Art
December 4, 2017

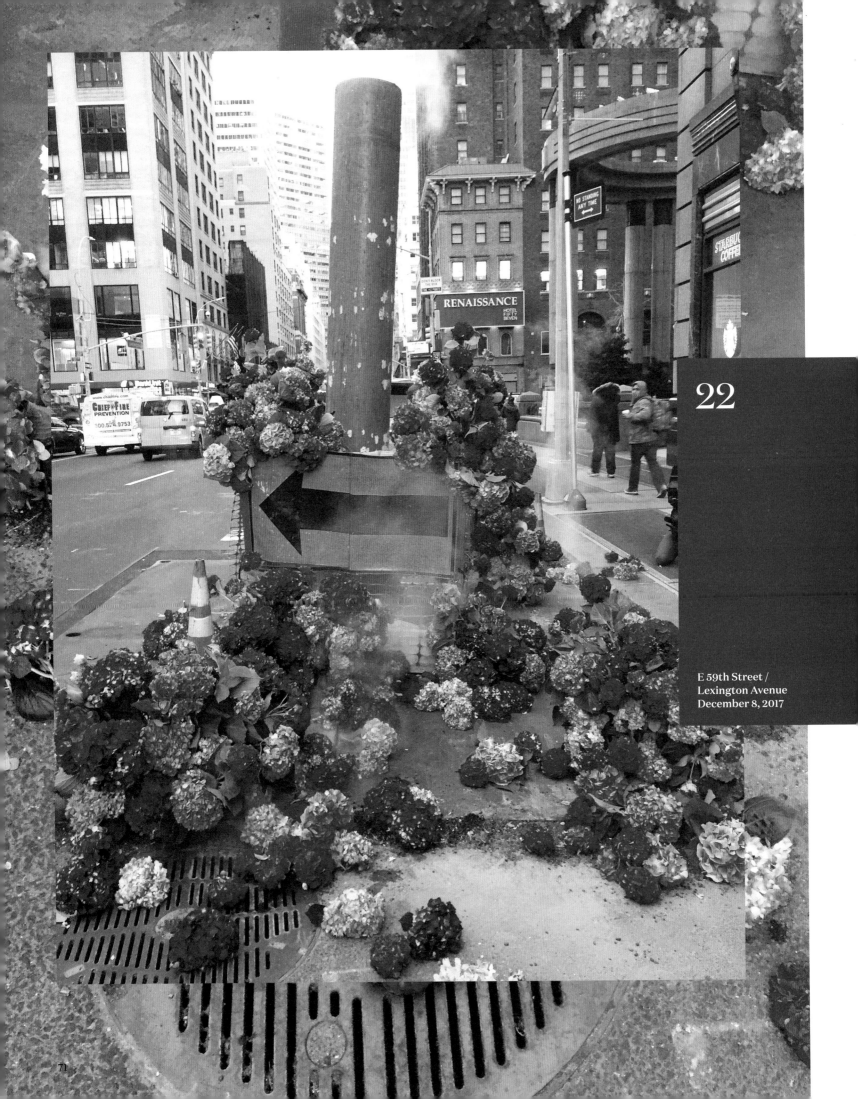

E 59th Street /
Lexington Avenue
December 8, 2017

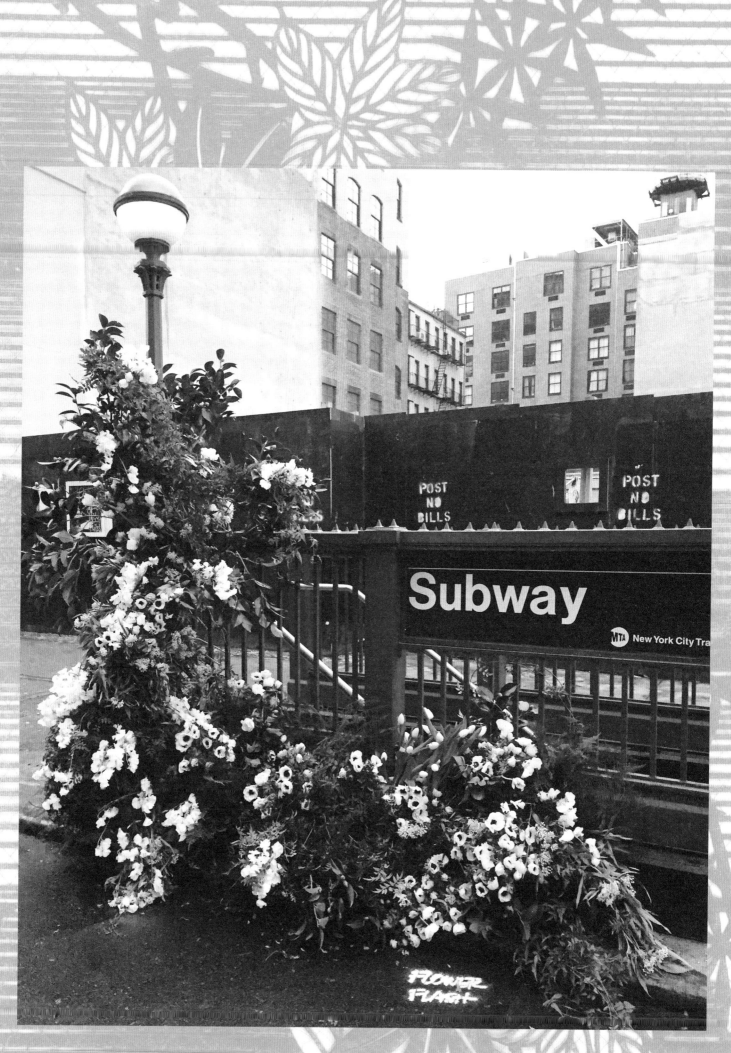

POST NO BILLS

POST NO BILLS

Subway

MTA New York City Tra

FLOWER FLASH

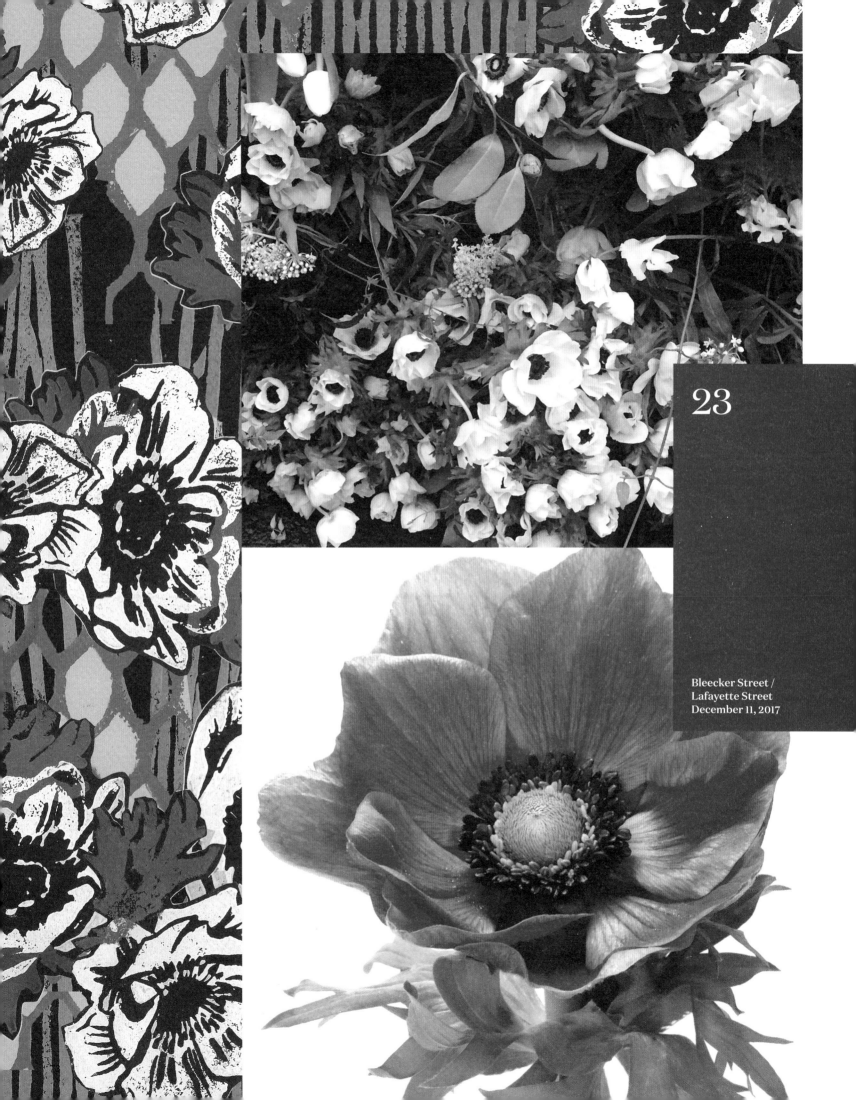

23

Bleecker Street /
Lafayette Street
December 11, 2017

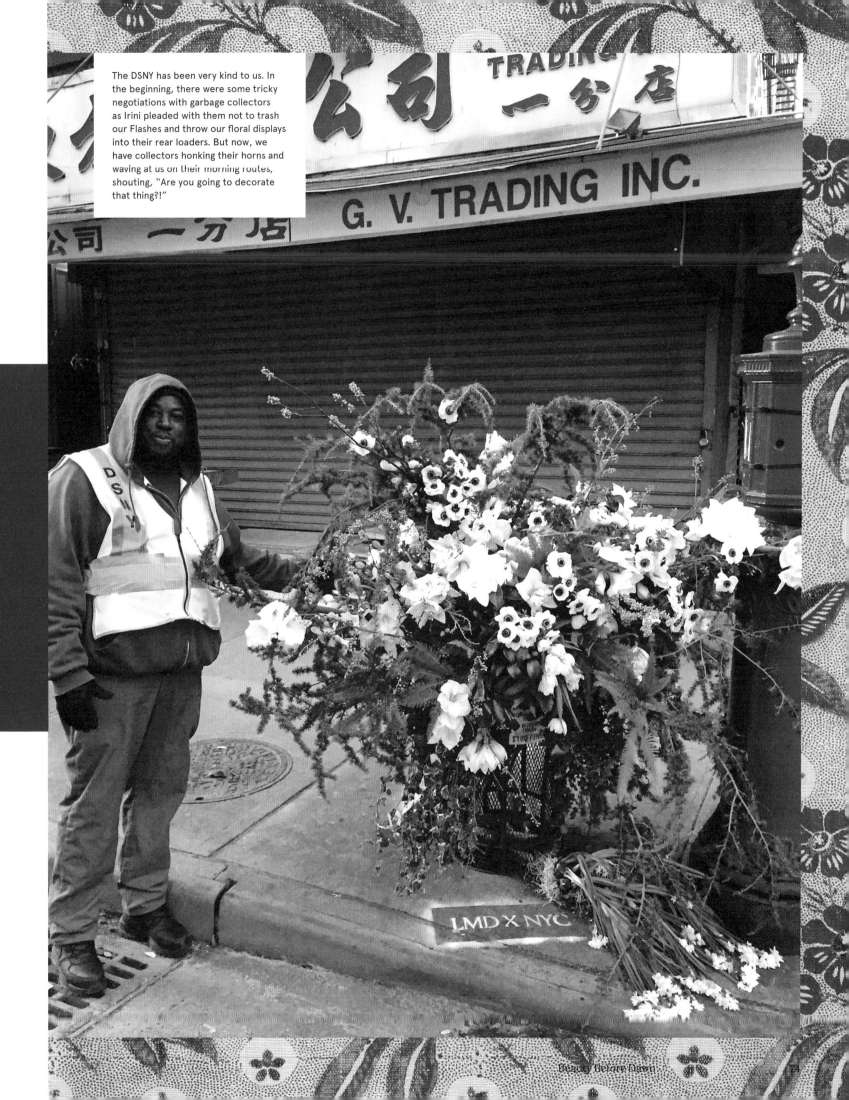

The DSNY has been very kind to us. In the beginning, there were some tricky negotiations with garbage collectors as Irini pleaded with them not to trash our Flashes and throw our floral displays into their rear loaders. But now, we have collectors honking their horns and waving at us on their morning routes, shouting, "Are you going to decorate that thing?!"

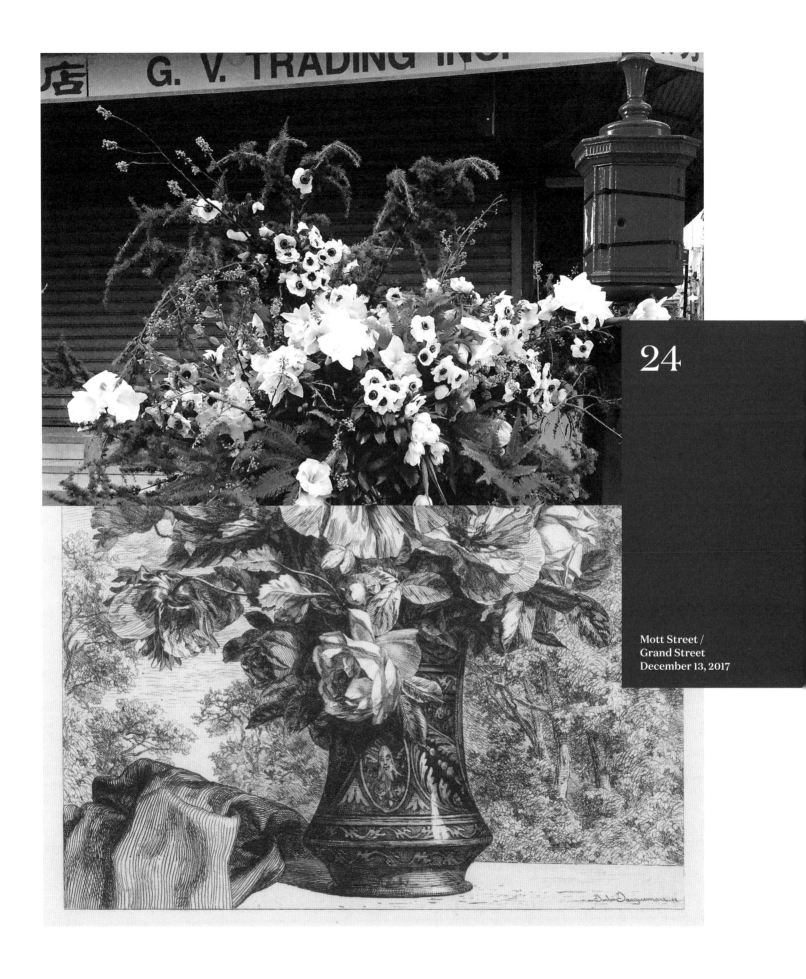

24

Mott Street /
Grand Street
December 13, 2017

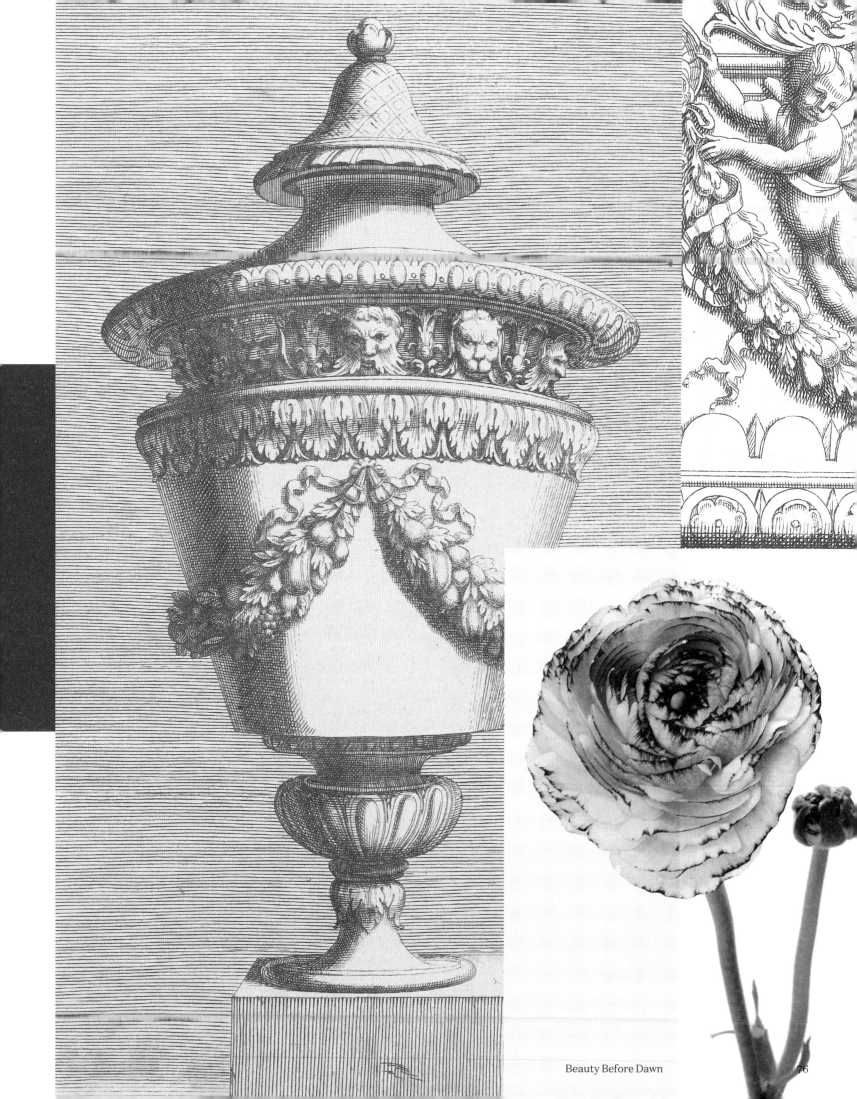

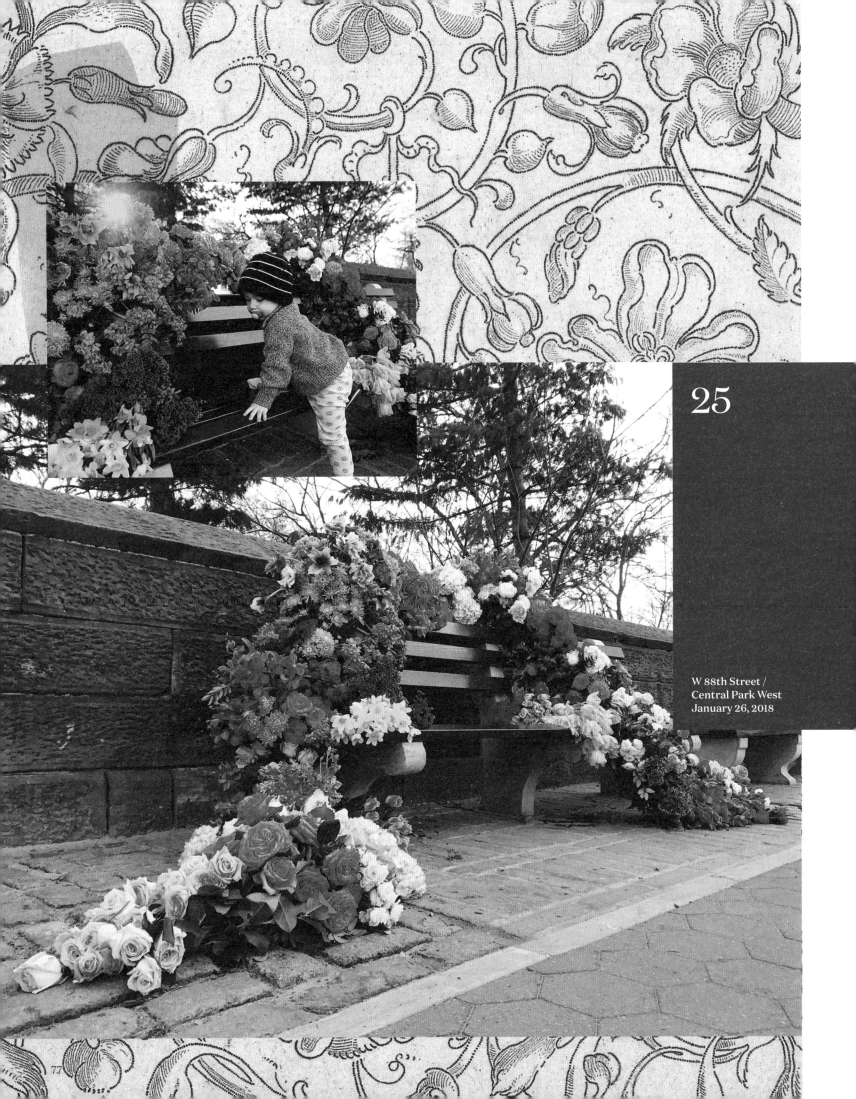

25

W 88th Street /
Central Park West
January 26, 2018

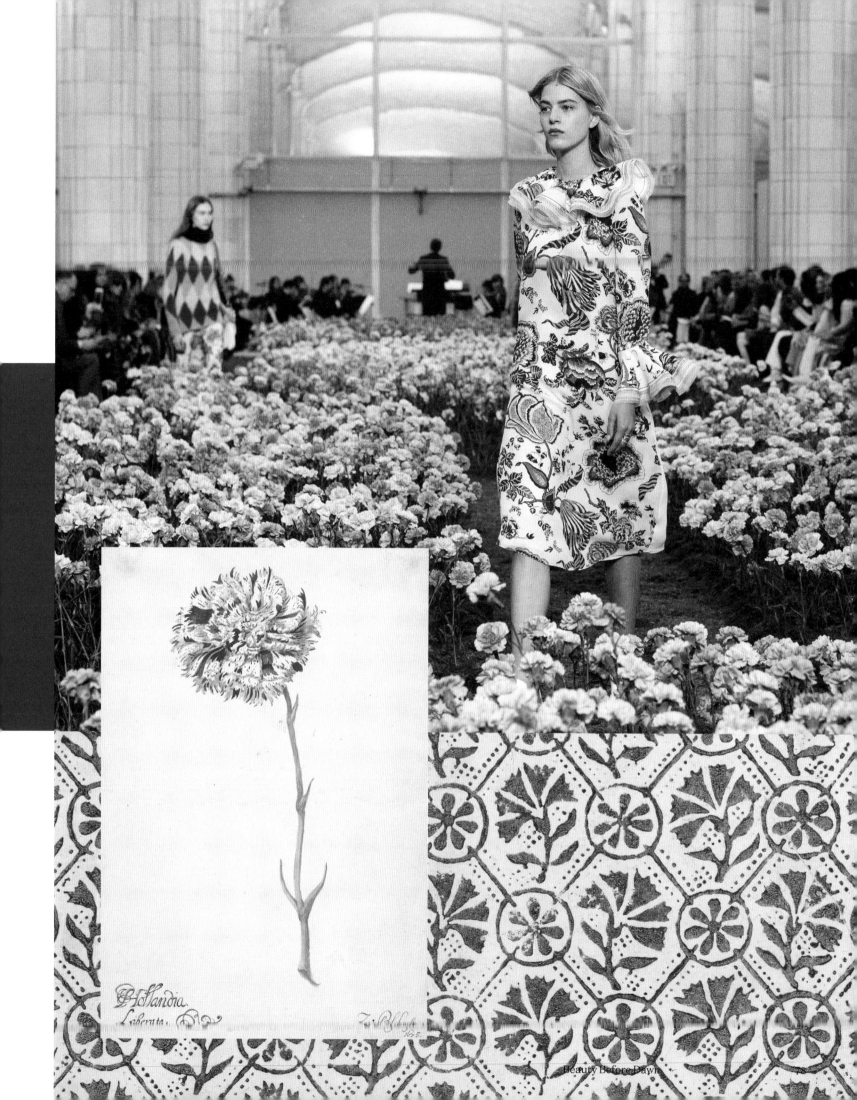

Hollandia.
Laborata.

Beauty Before Dawn

The fashion designer Tory Burch used thousands of pink carnations in her set design for her spring fashion show. I love carnations. The typically unloved flower is one of my favorite blooms. They are wonderfully old-fashioned, long-lasting, have a high petal count, and smell like cloves. It was a spectacular sight, but fashion shows last only about fifteen minutes and fewer than a hundred people typically get invited to these events. Afterward, we received a call from someone on Tory's team: The carnations were about to be pitched! If we could pick them up in less than an hour, they were ours. Did we want them? I had no idea what we were going to do with twelve thousand carnations but the answer was YES!

Now, looking at these photos reminds me of how mutable and ever-changing New York City can be. Sometimes it can feel as ephemeral as a Flower Flash. A few days after we'd created this Flash, Banksy tagged the clock overhead with a giant rat. Not long after that, the empty bank building was demolished altogether.

26

Valentine's Day

W 14th Street /
6th Avenue
February 14, 2018

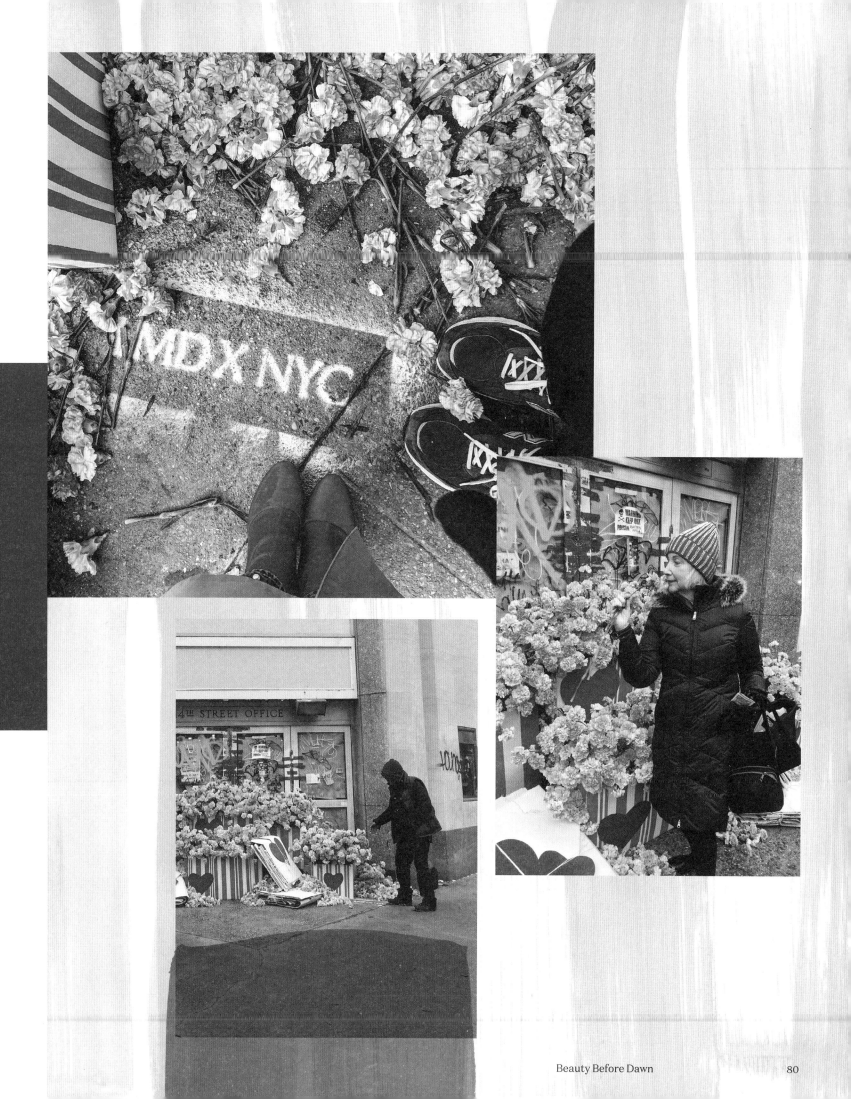

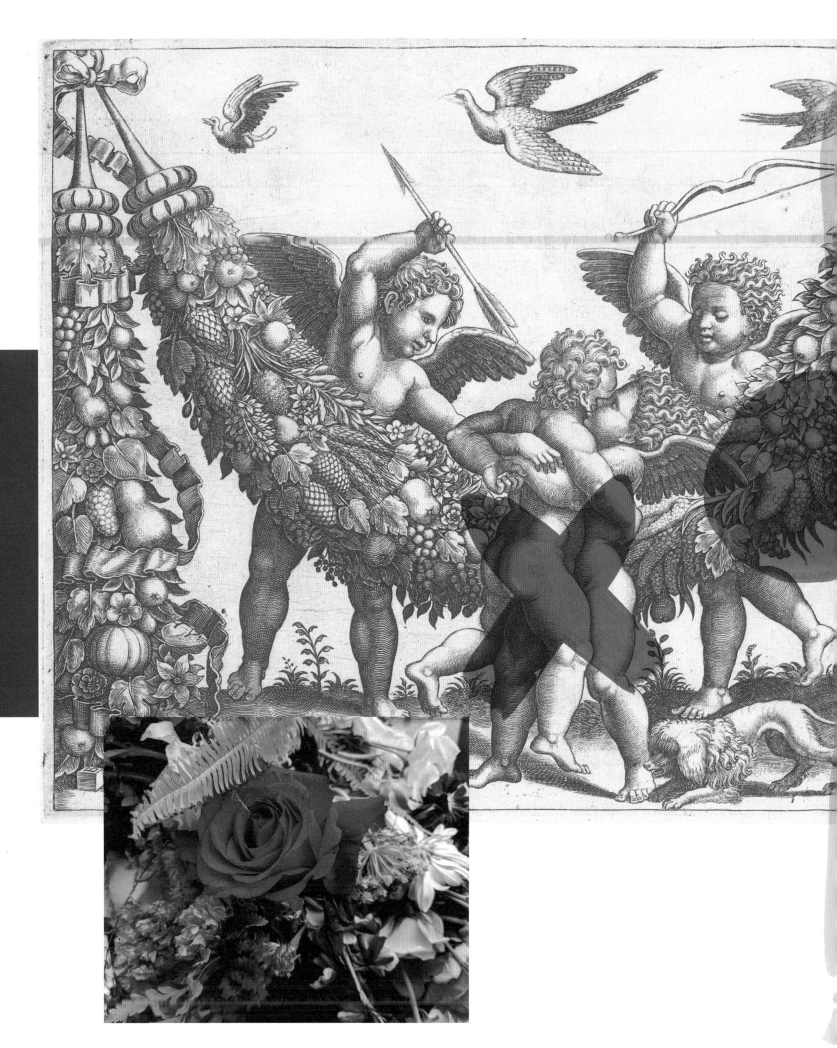

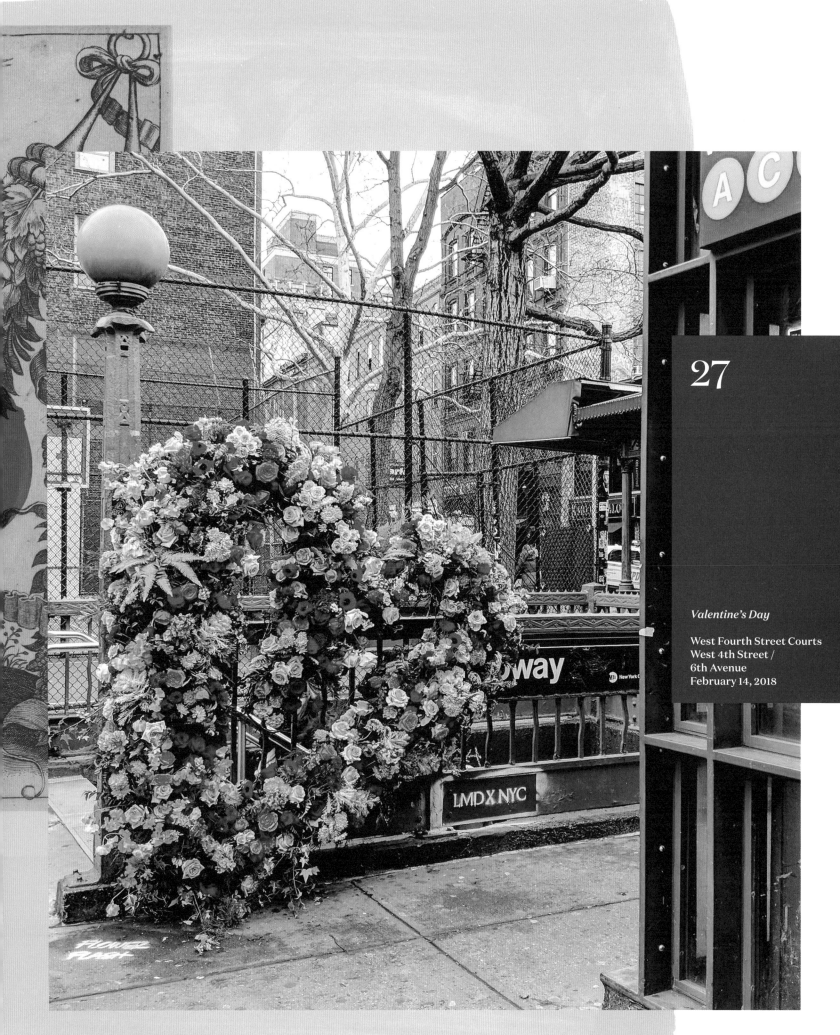

27

Valentine's Day

West Fourth Street Courts
West 4th Street /
6th Avenue
February 14, 2018

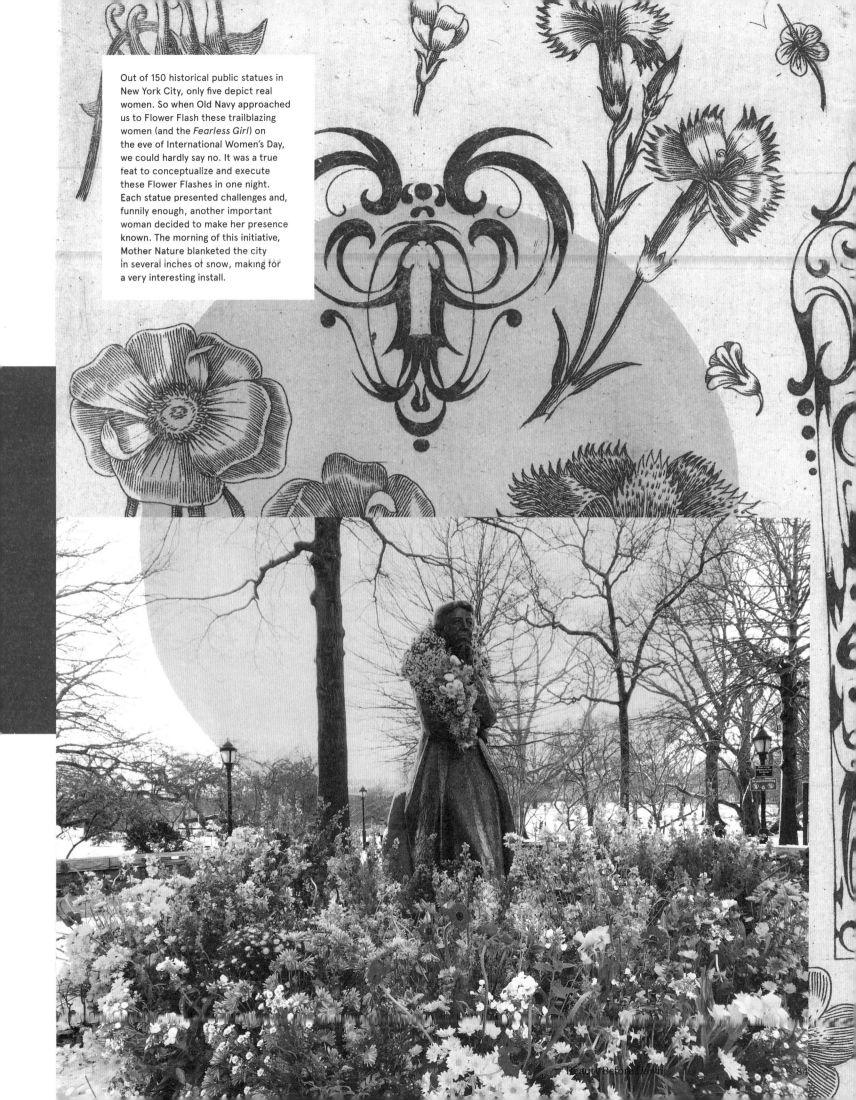

Out of 150 historical public statues in New York City, only five depict real women. So when Old Navy approached us to Flower Flash these trailblazing women (and the *Fearless Girl*) on the eve of International Women's Day, we could hardly say no. It was a true feat to conceptualize and execute these Flower Flashes in one night. Each statue presented challenges and, funnily enough, another important woman decided to make her presence known. The morning of this initiative, Mother Nature blanketed the city in several inches of snow, making for a very interesting install.

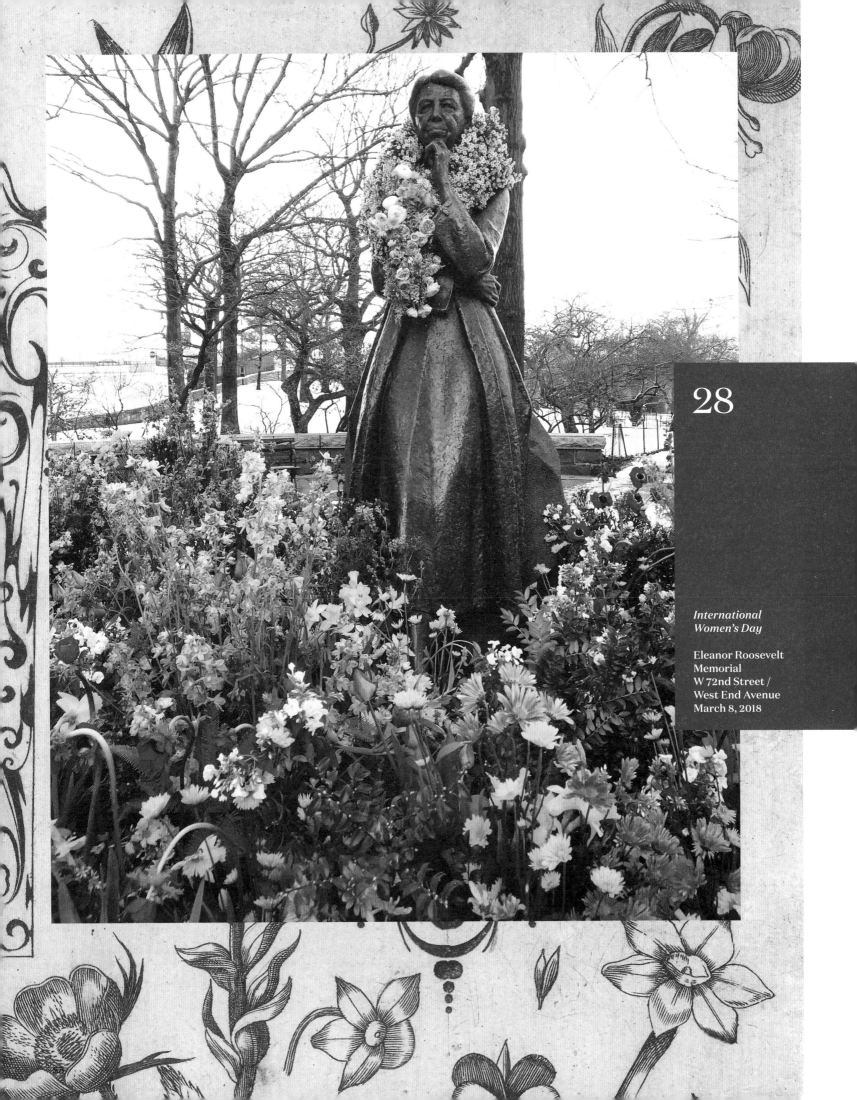

28

International Women's Day

Eleanor Roosevelt
Memorial
W 72nd Street /
West End Avenue
March 8, 2018

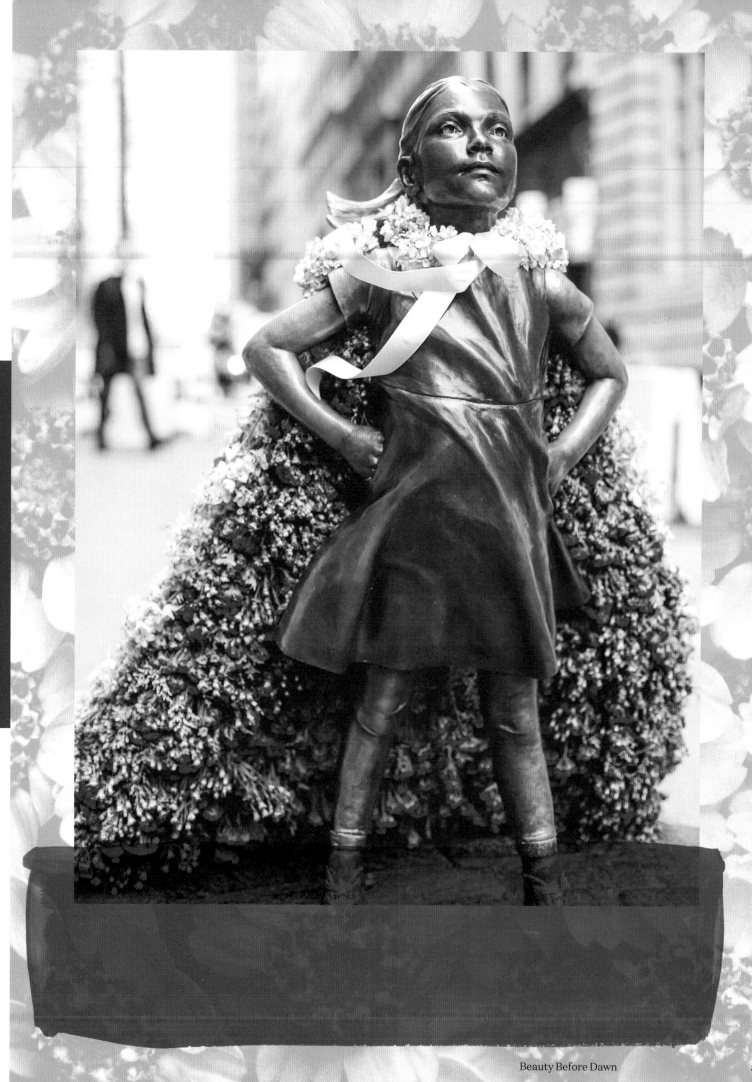

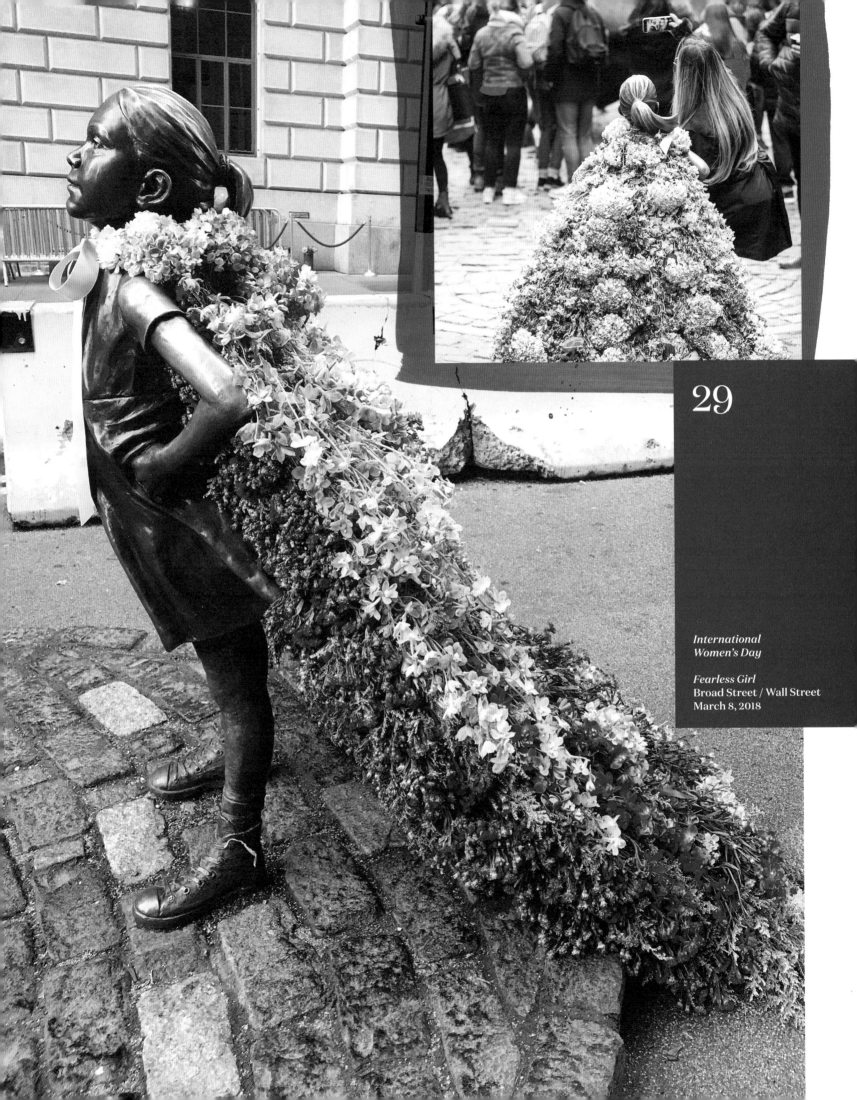

29

International
Women's Day

Fearless Girl
Broad Street / Wall Street
March 8, 2018

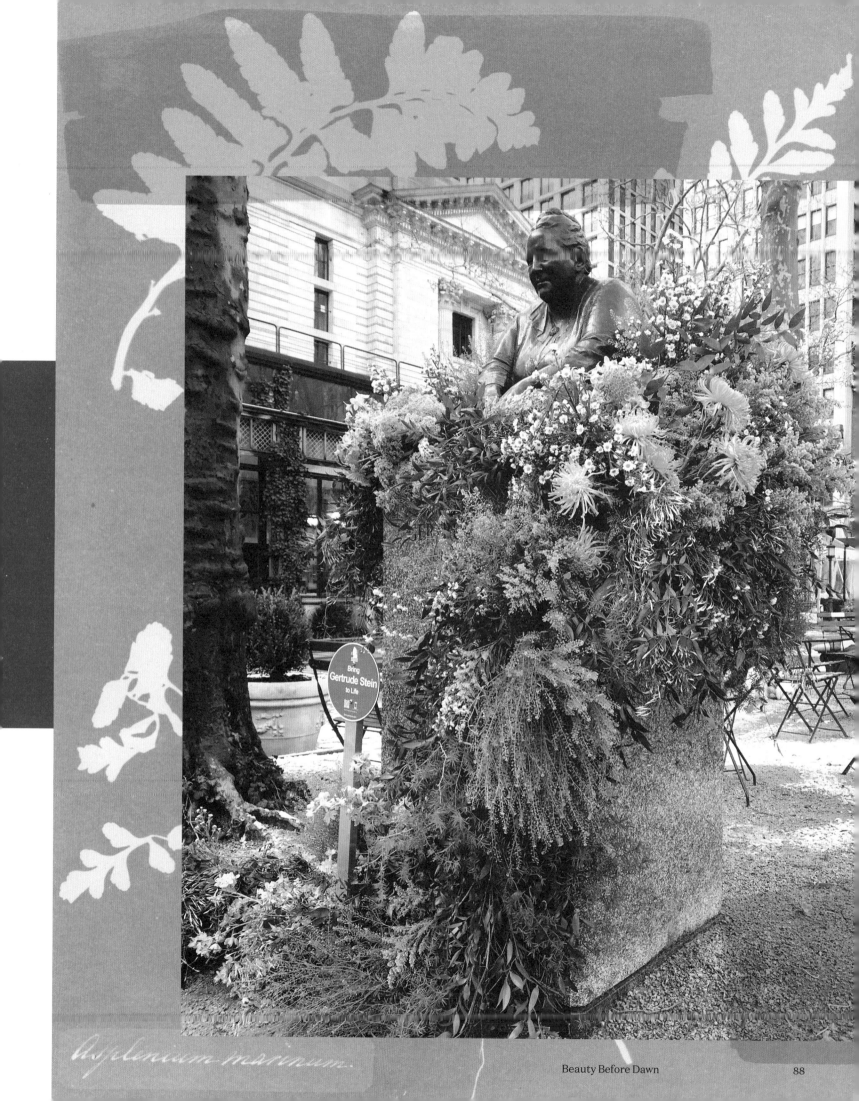

Asplenium marinum.

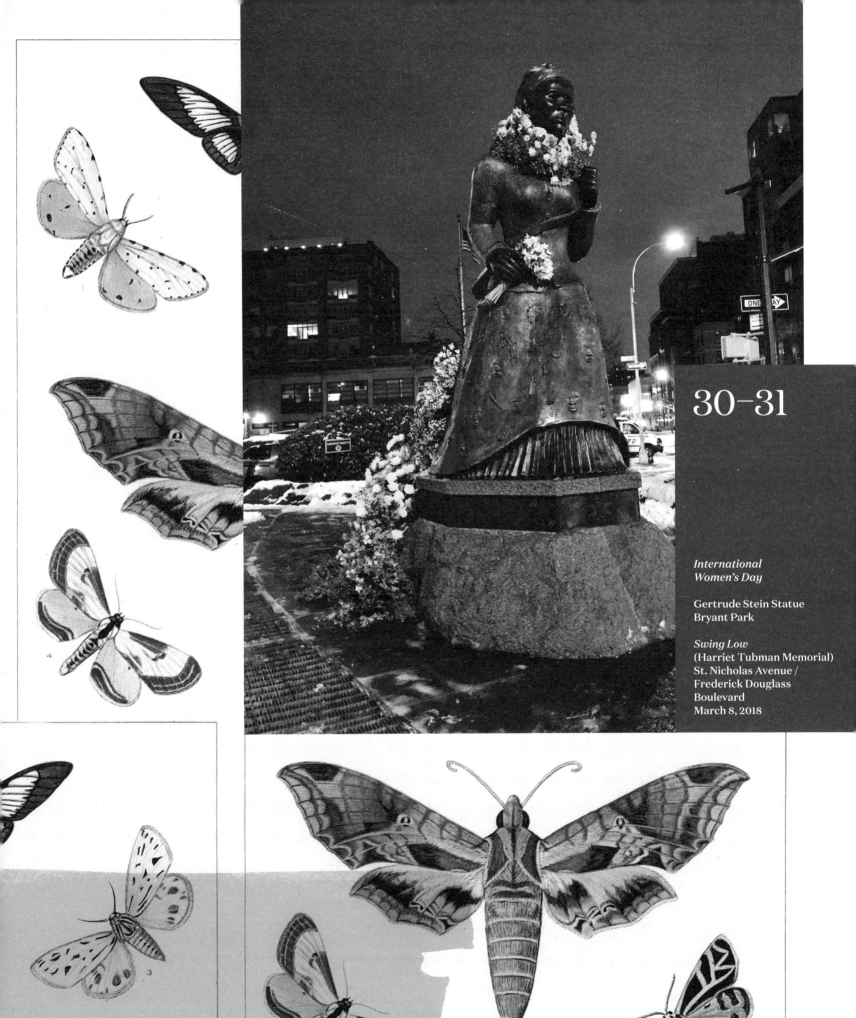

30–31

International Women's Day

Gertrude Stein Statue
Bryant Park

Swing Low
(Harriet Tubman Memorial)
St. Nicholas Avenue /
Frederick Douglass
Boulevard
March 8, 2018

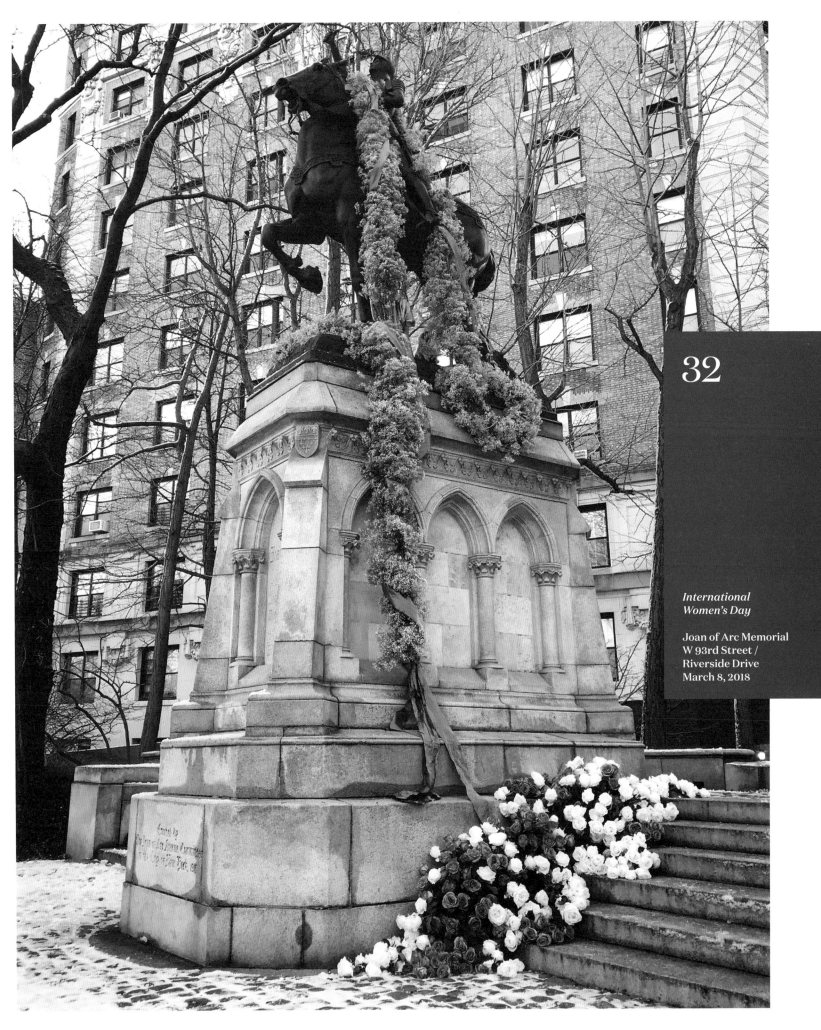

32

*International
Women's Day*

Joan of Arc Memorial
W 93rd Street /
Riverside Drive
March 8, 2018

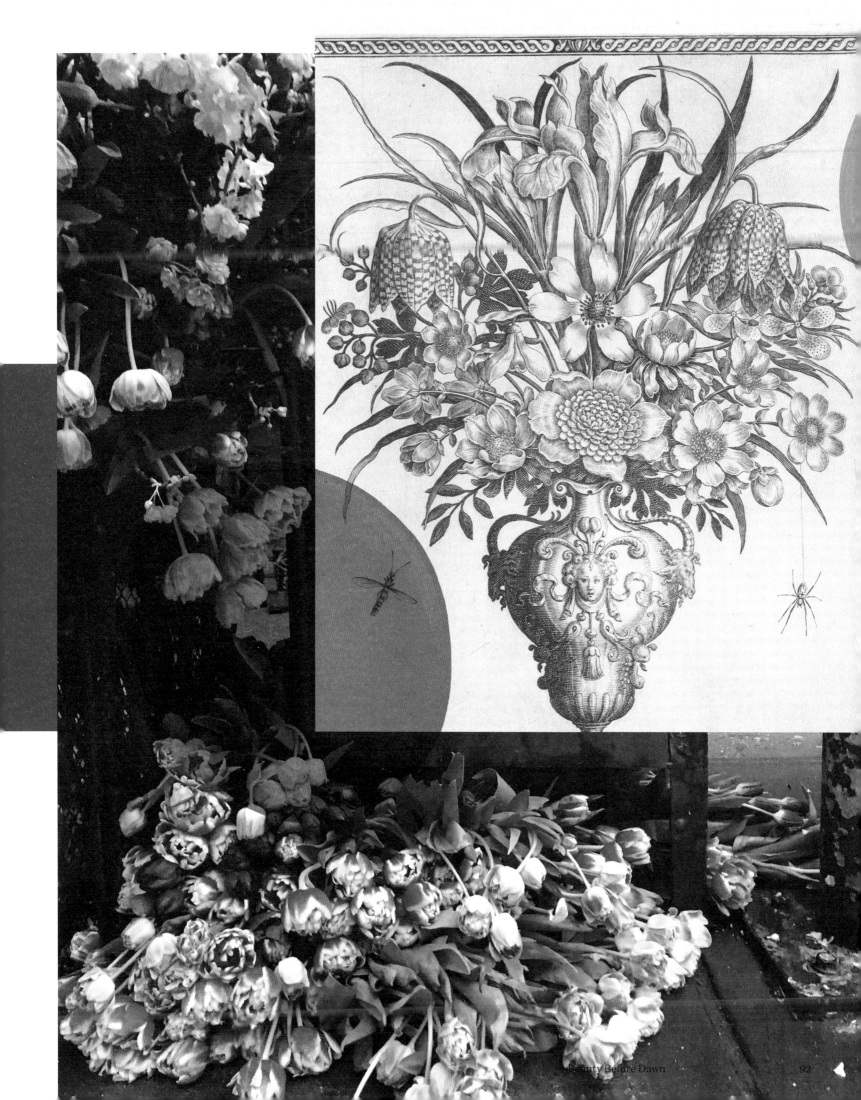

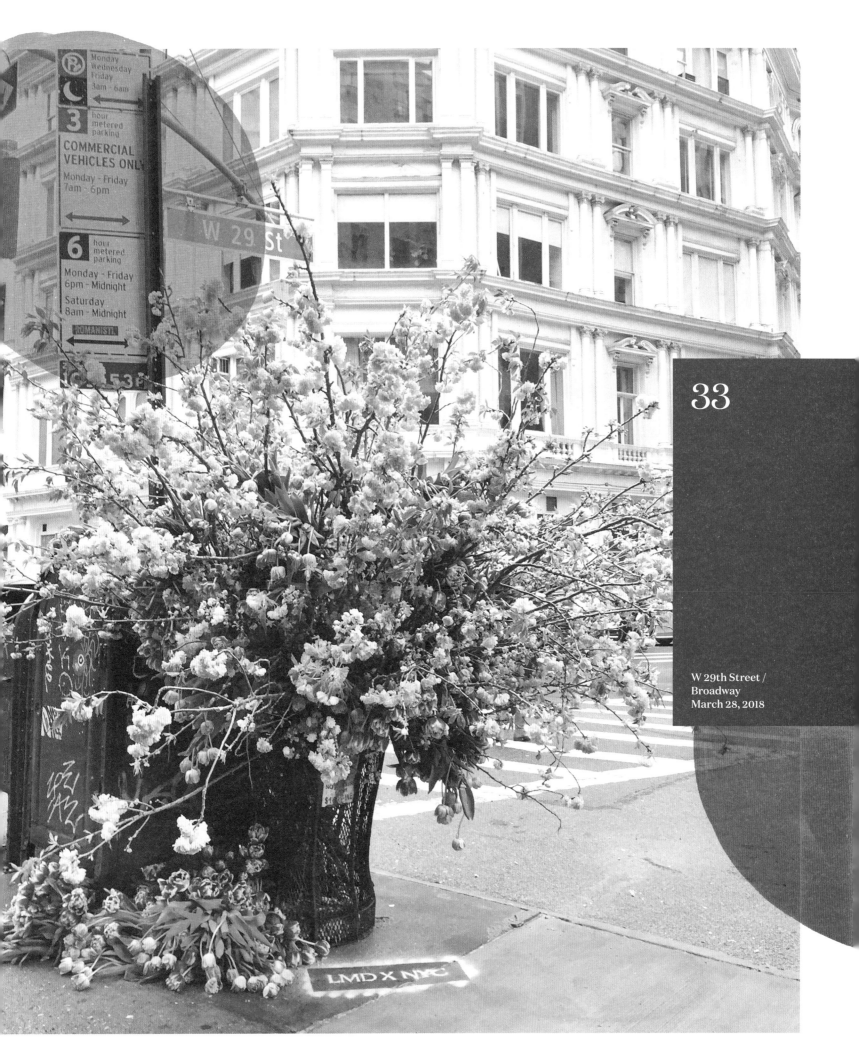

33

W 29th Street /
Broadway
March 28, 2018

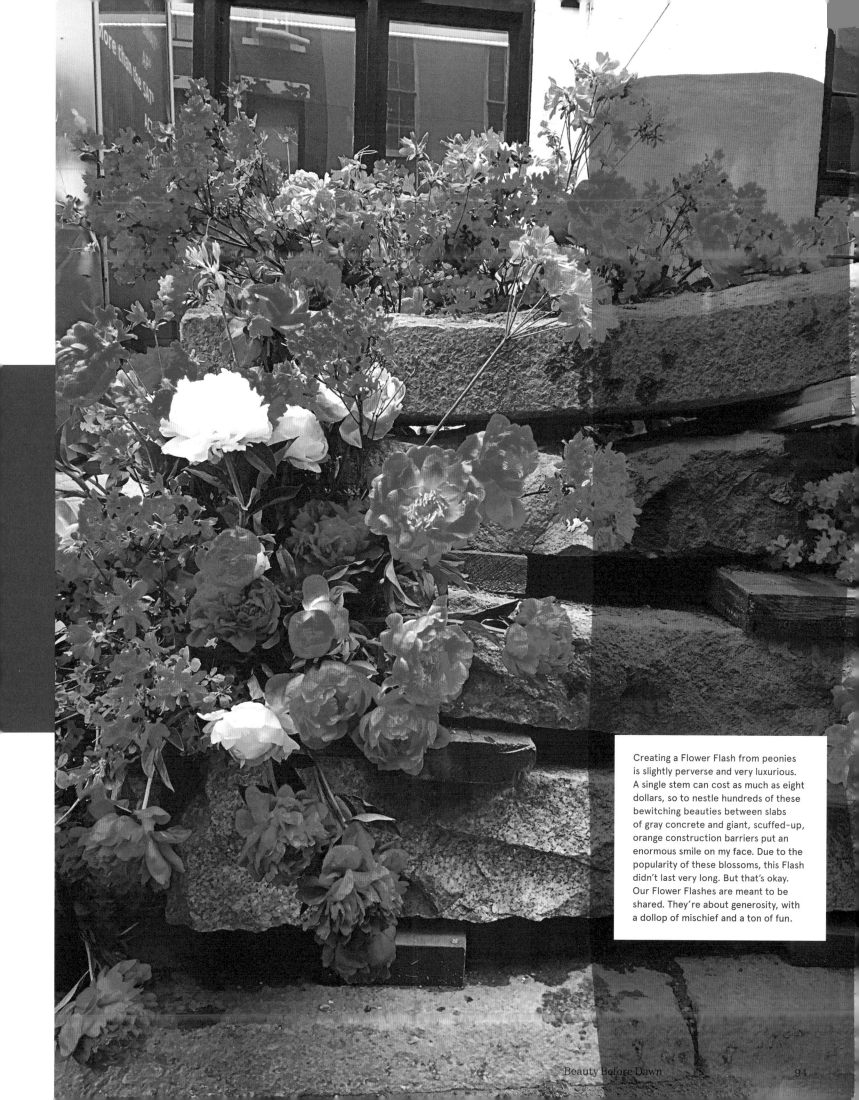

Creating a Flower Flash from peonies is slightly perverse and very luxurious. A single stem can cost as much as eight dollars, so to nestle hundreds of these bewitching beauties between slabs of gray concrete and giant, scuffed-up, orange construction barriers put an enormous smile on my face. Due to the popularity of these blossoms, this Flash didn't last very long. But that's okay. Our Flower Flashes are meant to be shared. They're about generosity, with a dollop of mischief and a ton of fun.

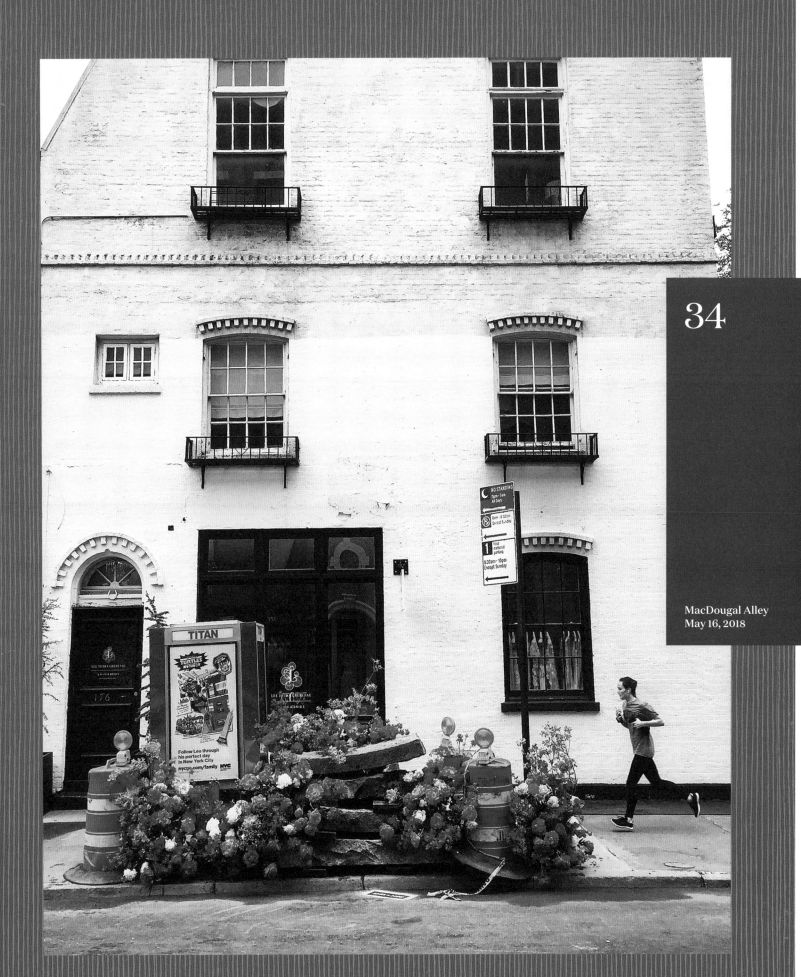

34

MacDougal Alley
May 16, 2018

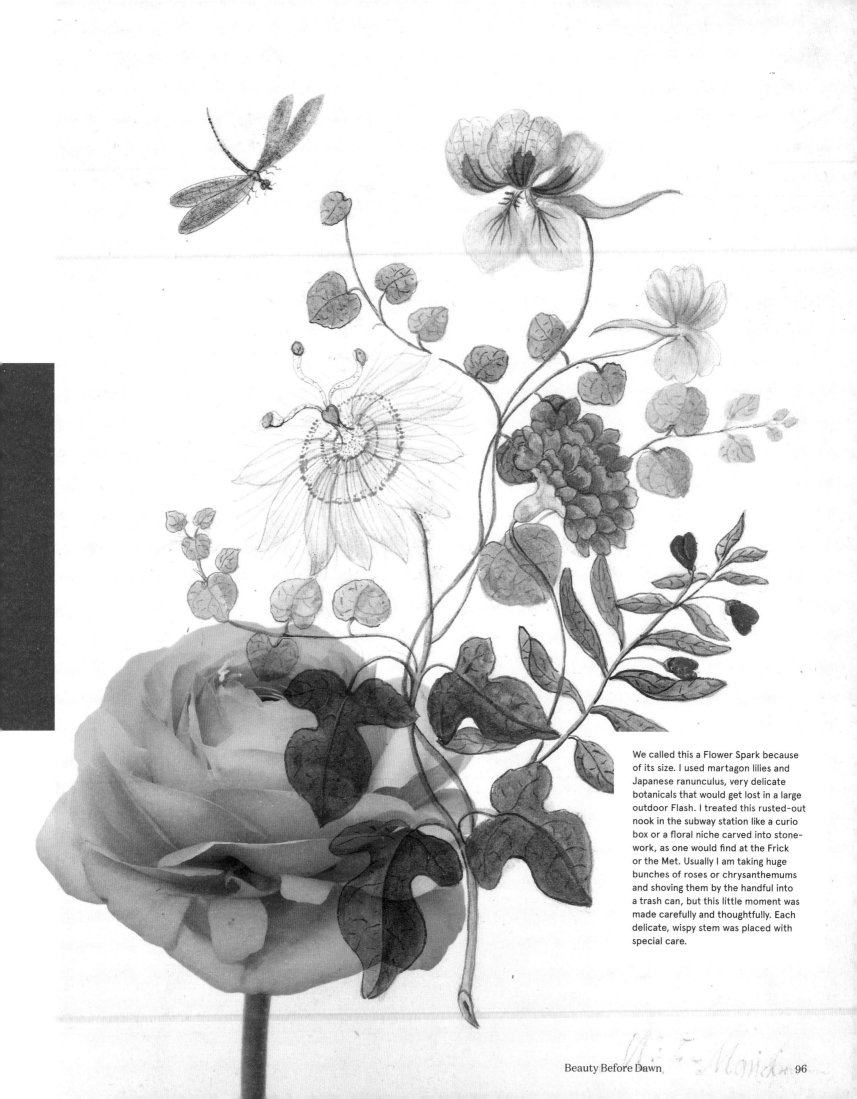

We called this a Flower Spark because of its size. I used martagon lilies and Japanese ranunculus, very delicate botanicals that would get lost in a large outdoor Flash. I treated this rusted-out nook in the subway station like a curio box or a floral niche carved into stone-work, as one would find at the Frick or the Met. Usually I am taking huge bunches of roses or chrysanthemums and shoving them by the handful into a trash can, but this little moment was made carefully and thoughtfully. Each delicate, wispy stem was placed with special care.

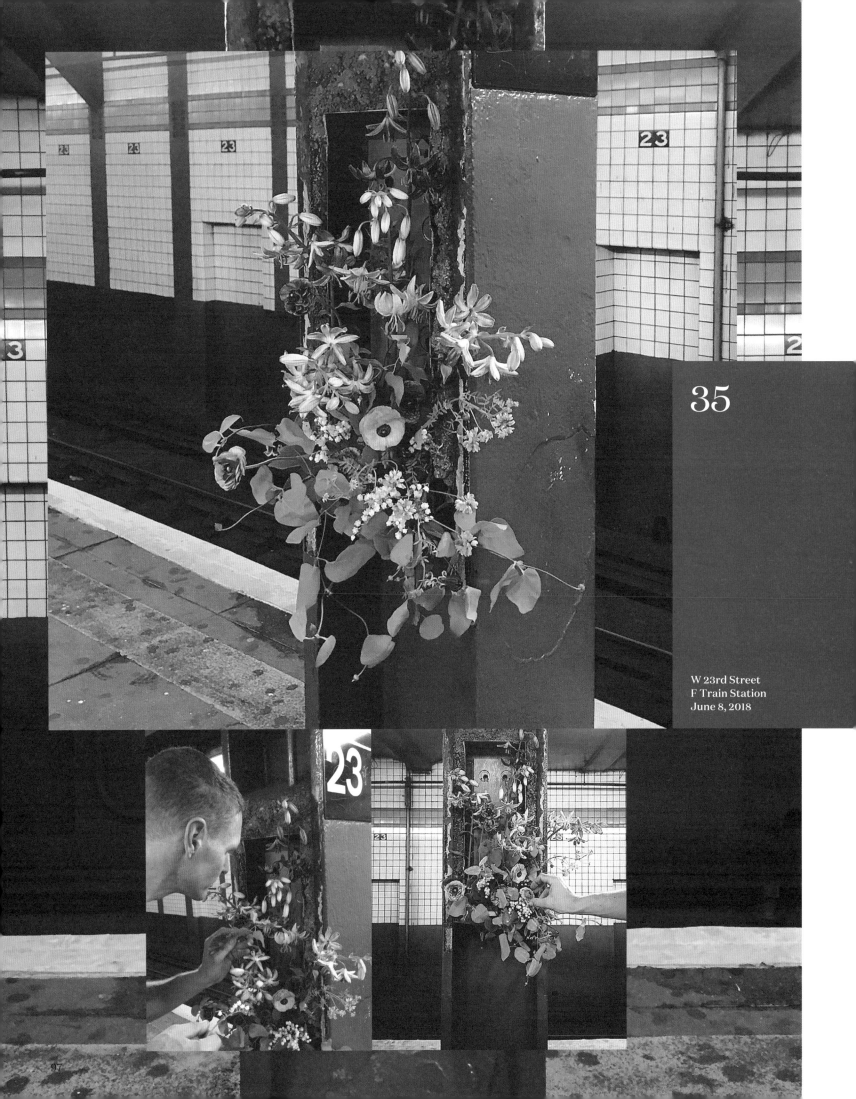

35

W 23rd Street
F Train Station
June 8, 2018

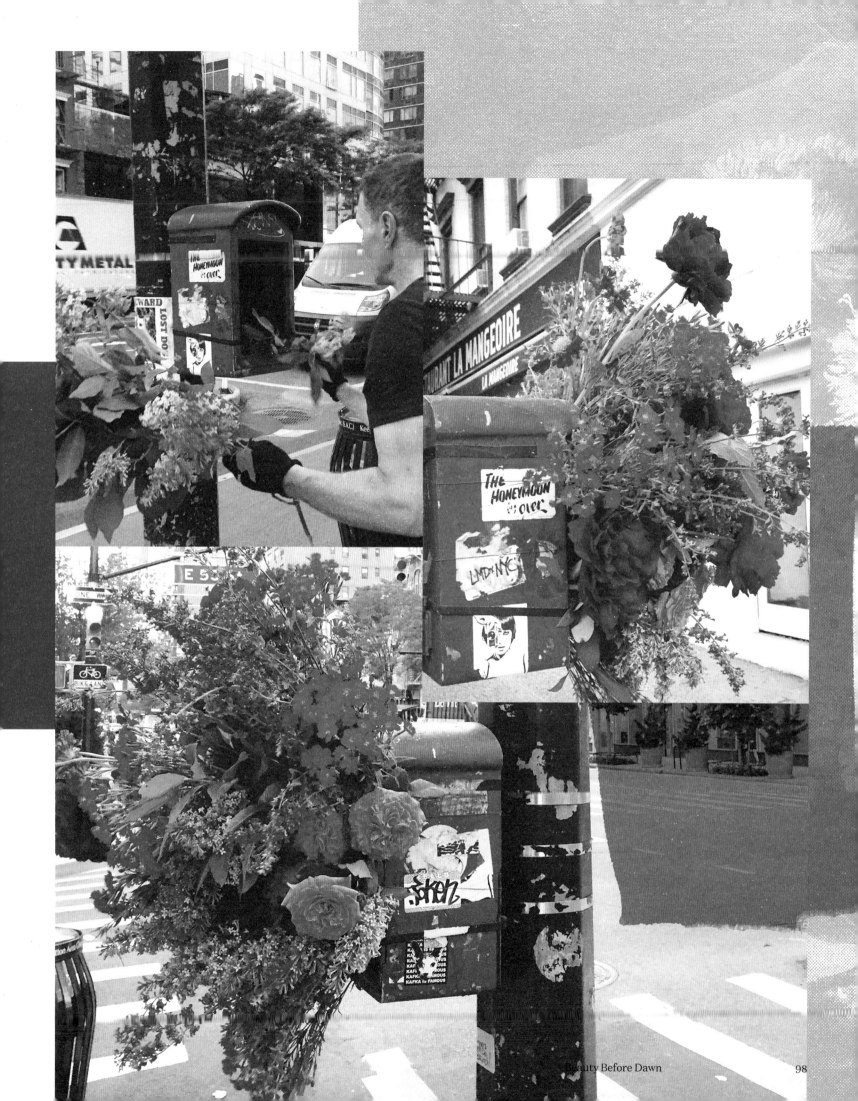

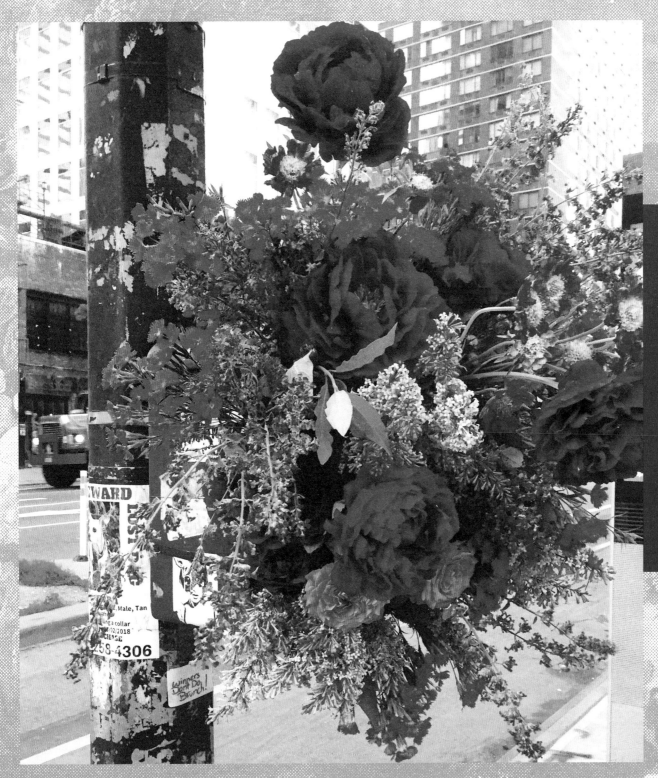

36

E 53rd Street /
2nd Avenue
June 15, 2018

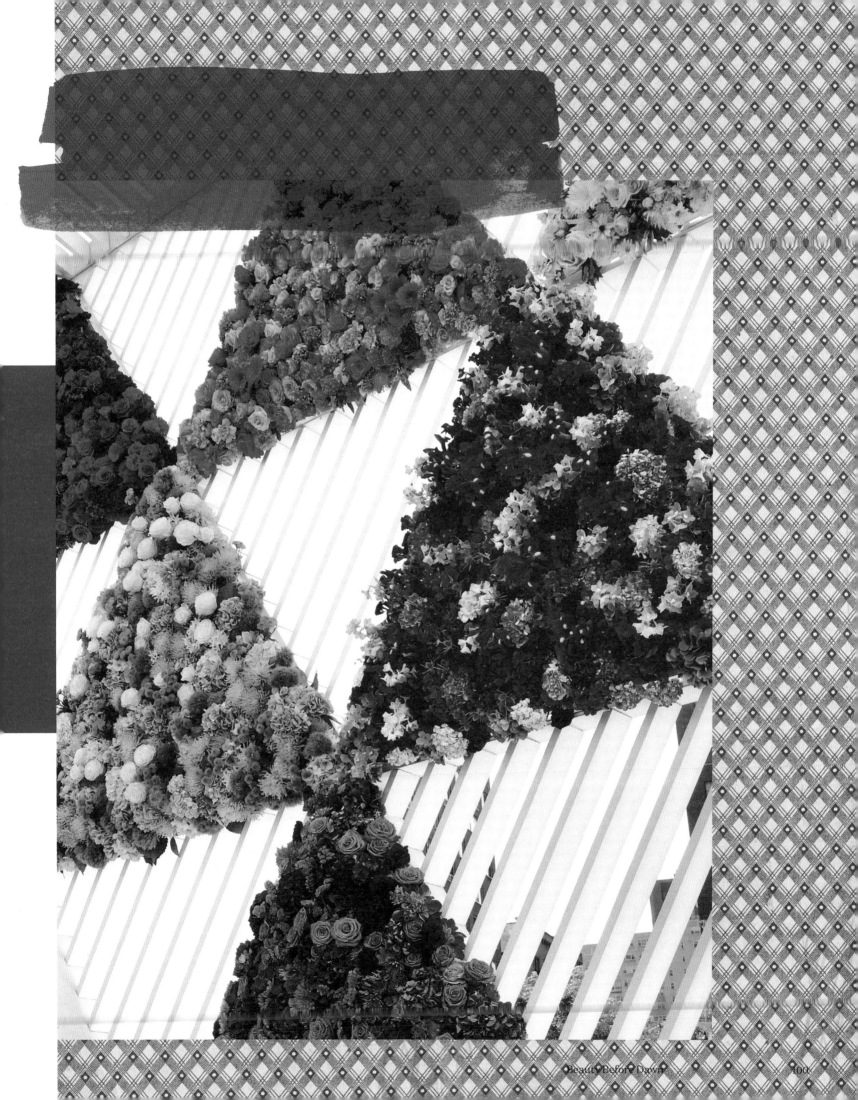

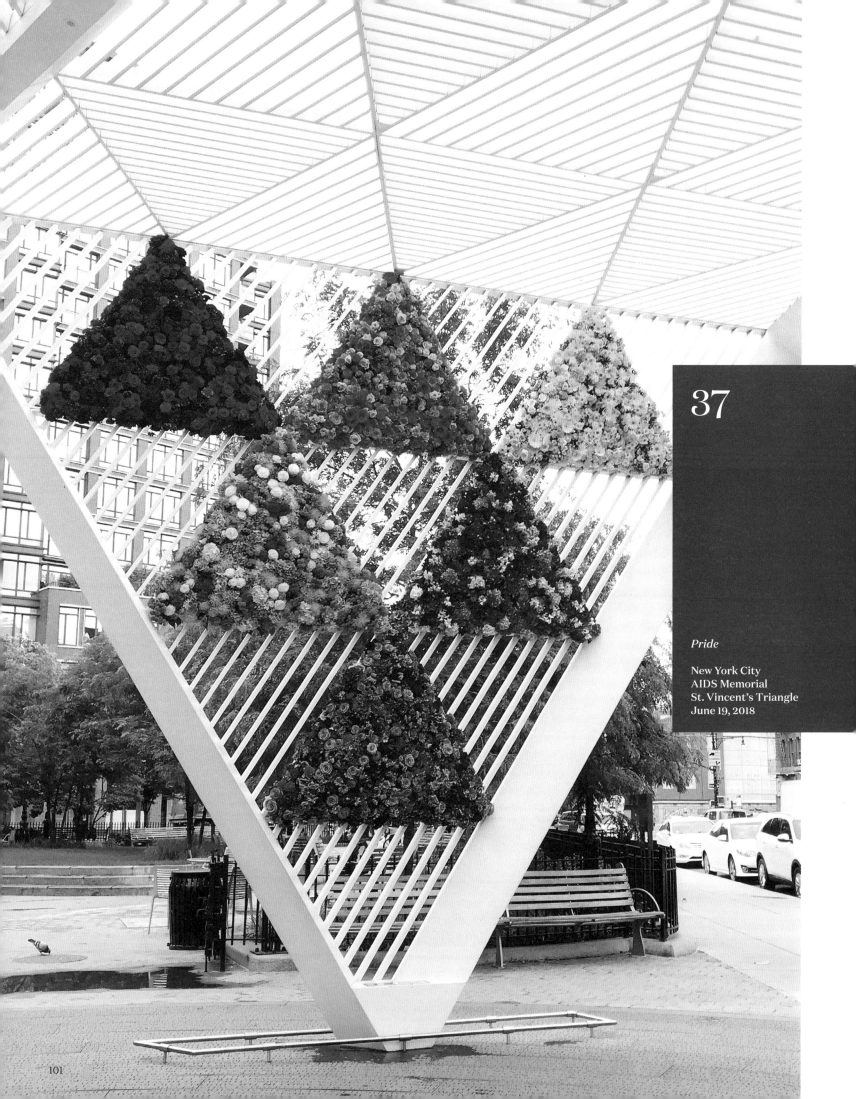

37

Pride

New York City
AIDS Memorial
St. Vincent's Triangle
June 19, 2018

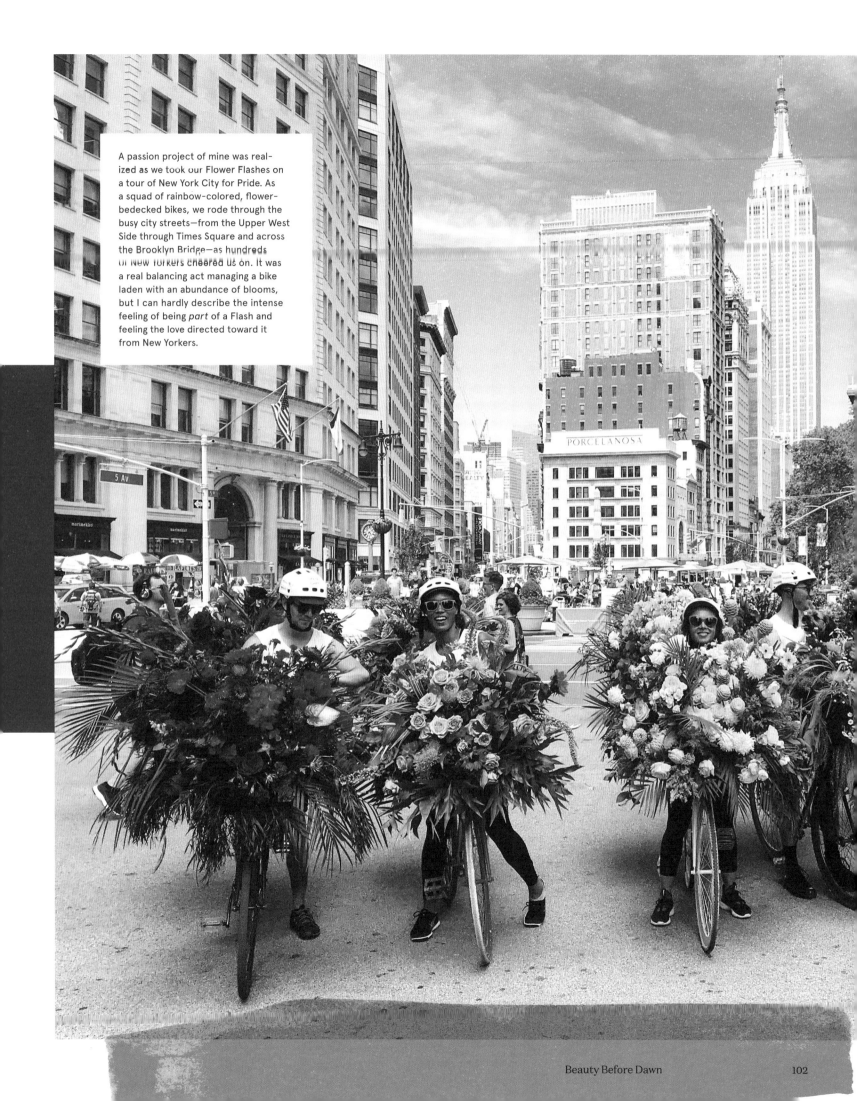

A passion project of mine was realized as we took our Flower Flashes on a tour of New York City for Pride. As a squad of rainbow-colored, flower-bedecked bikes, we rode through the busy city streets—from the Upper West Side through Times Square and across the Brooklyn Bridge—as hundreds of New Yorkers cheered us on. It was a real balancing act managing a bike laden with an abundance of blooms, but I can hardly describe the intense feeling of being *part* of a Flash and feeling the love directed toward it from New Yorkers.

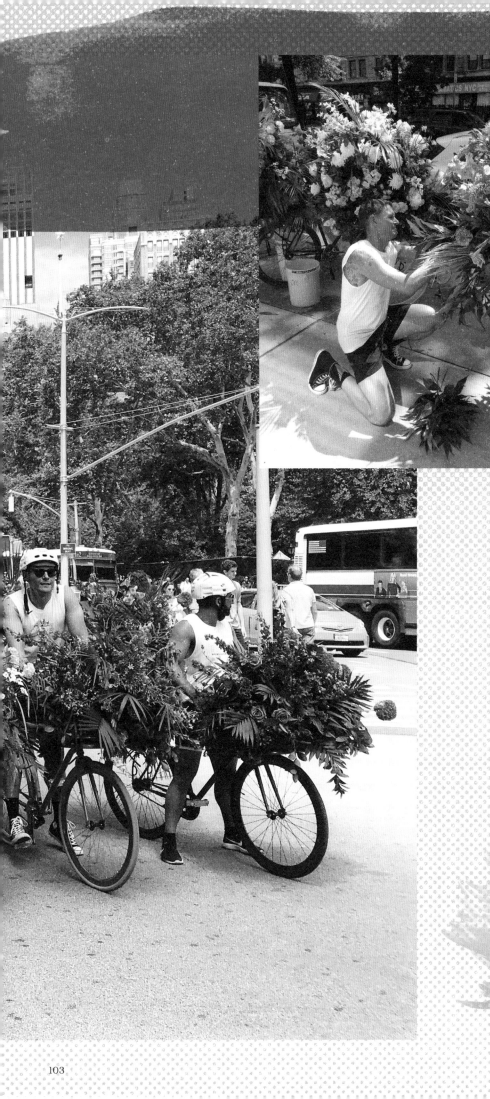

38

Pride

**Upper West Side
to DUMBO
June 21, 2018**

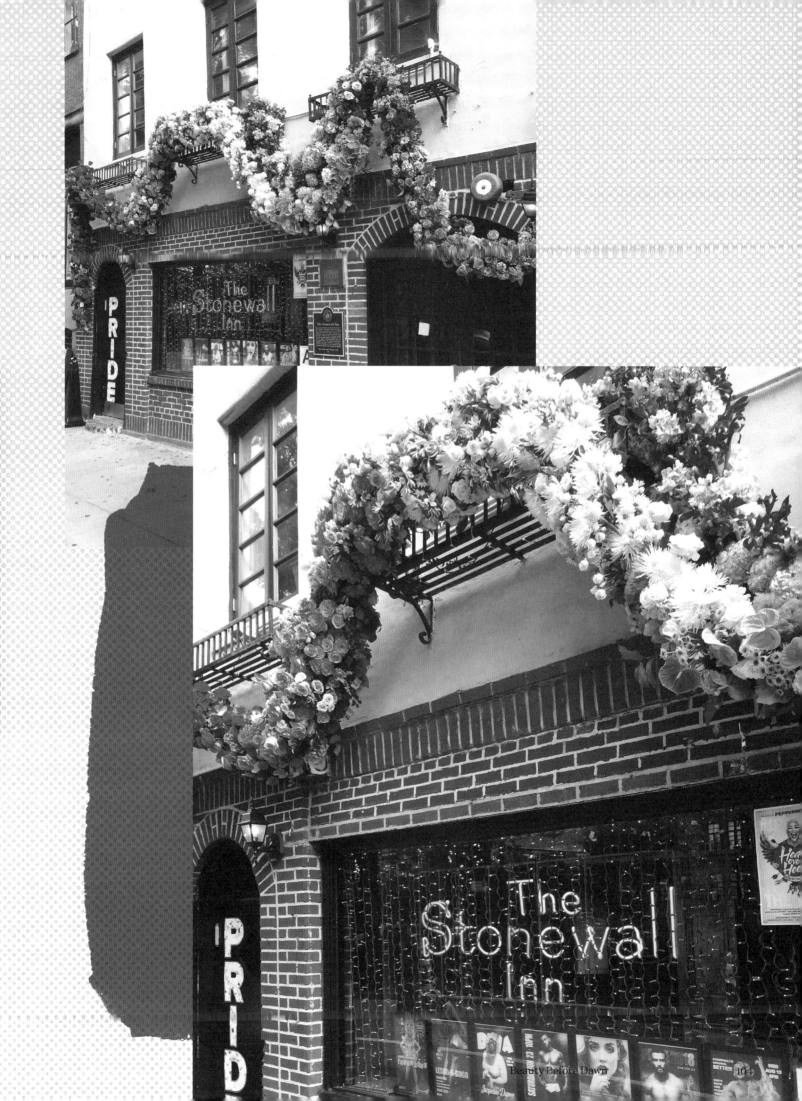

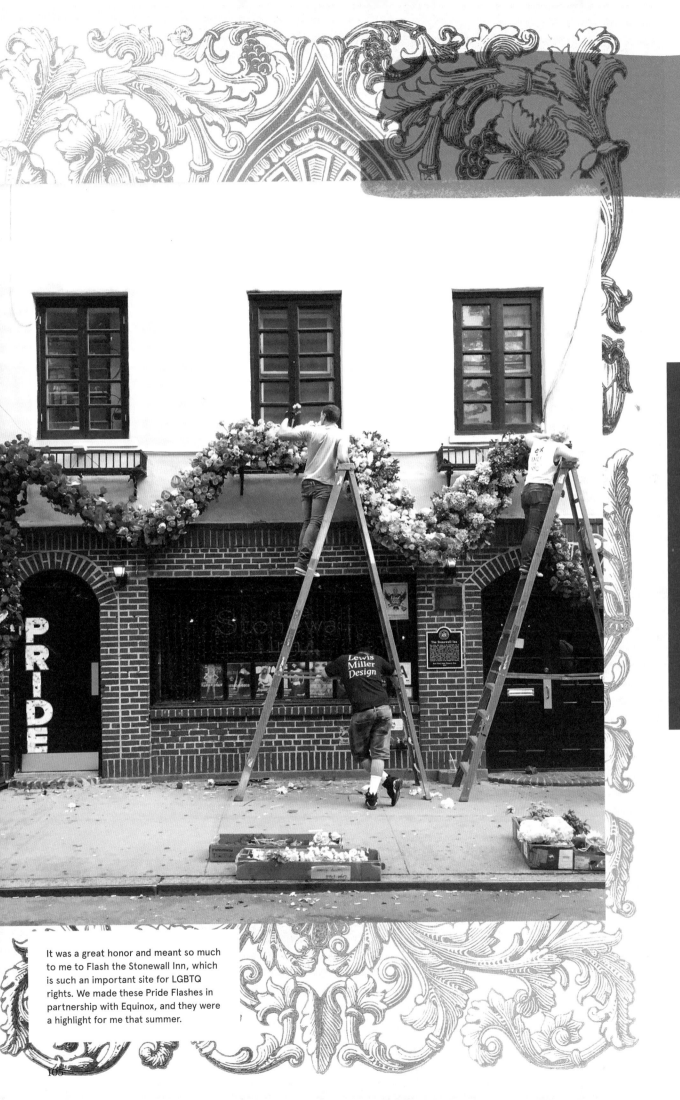

39

Pride

The Stonewall Inn
53 Christopher Street
June 22, 2018

It was a great honor and meant so much to me to Flash the Stonewall Inn, which is such an important site for LGBTQ rights. We made these Pride Flashes in partnership with Equinox, and they were a highlight for me that summer.

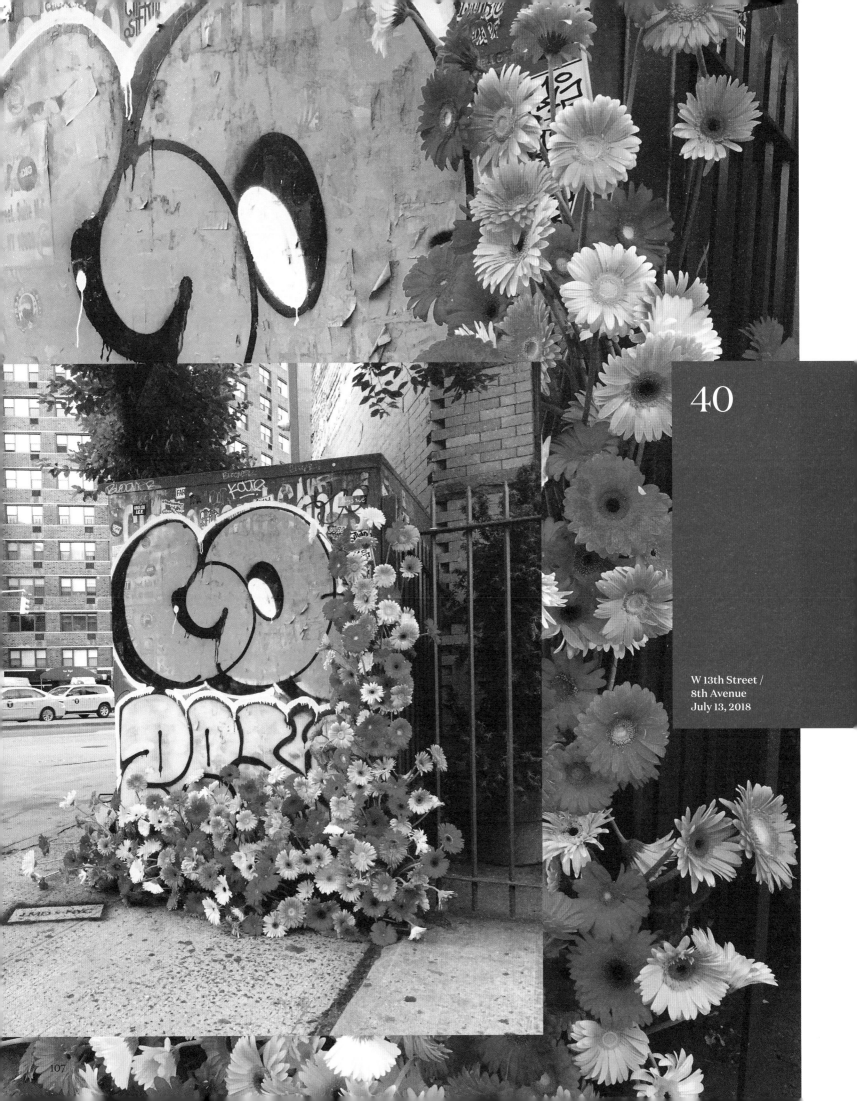

40

W 13th Street /
8th Avenue
July 13, 2018

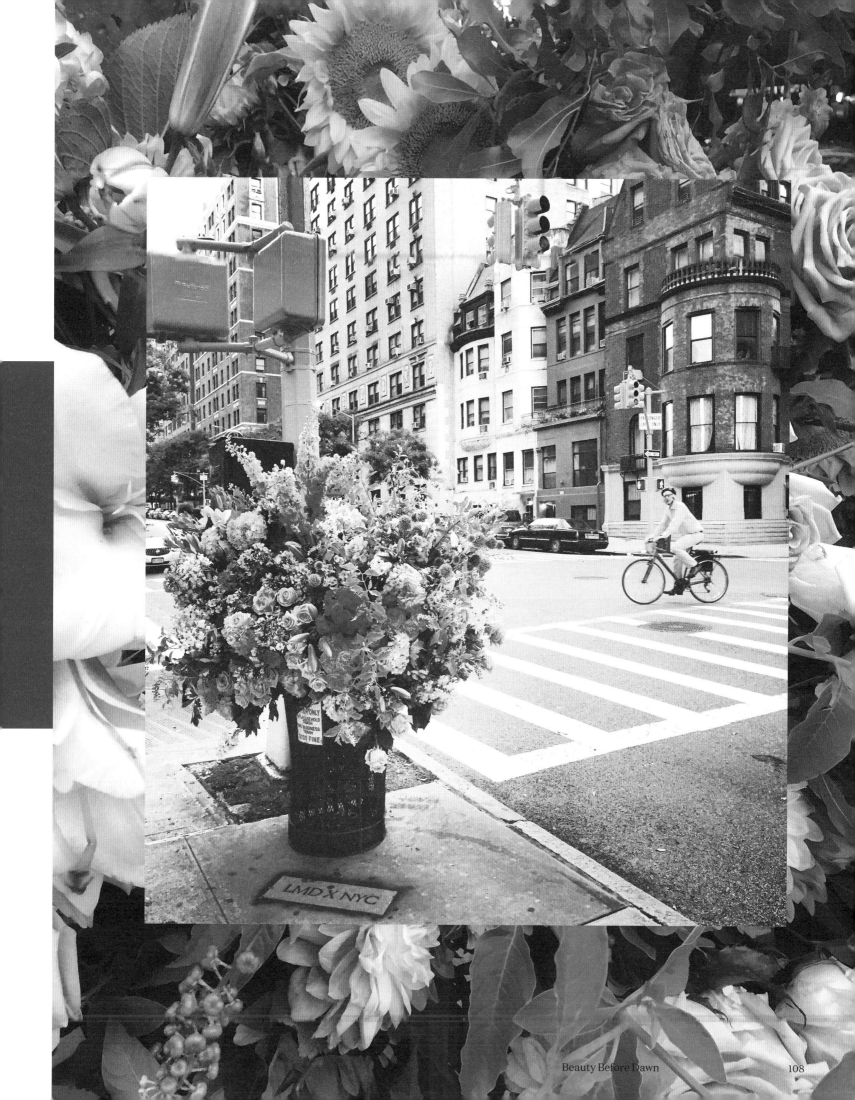

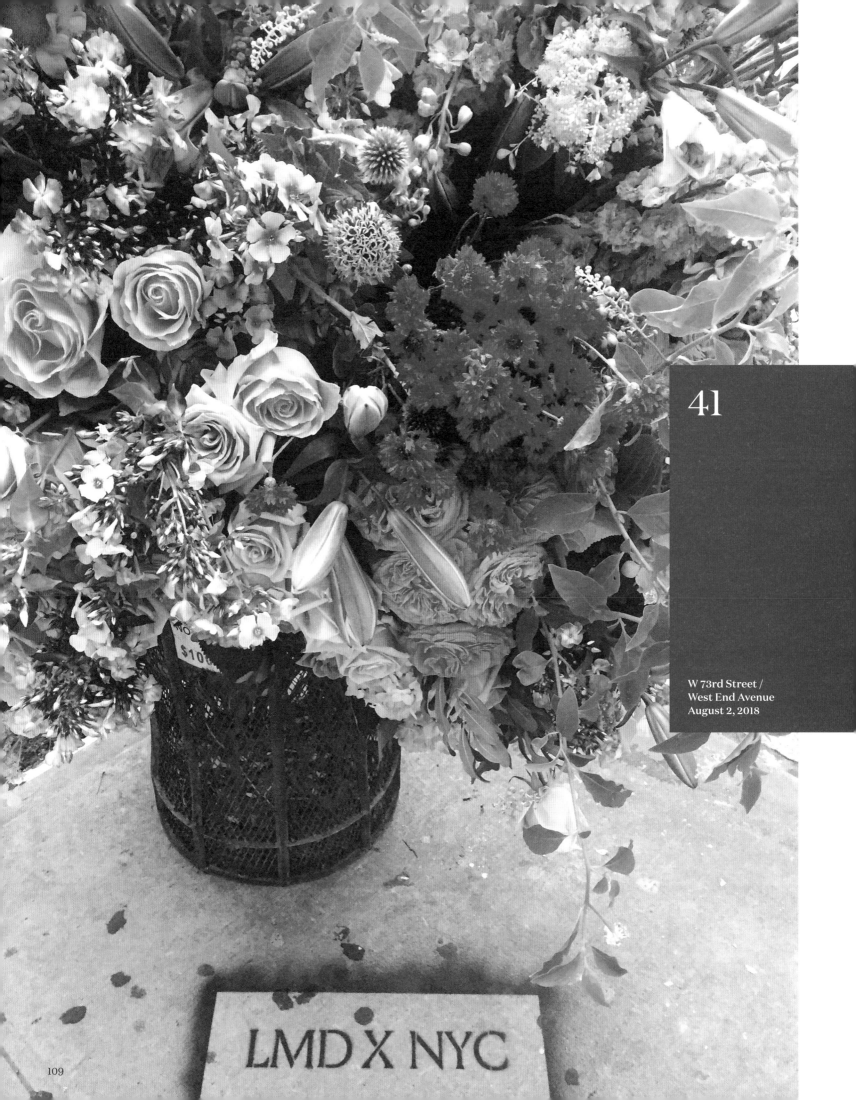

41

W 73rd Street /
West End Avenue
August 2, 2018

LMD X NYC

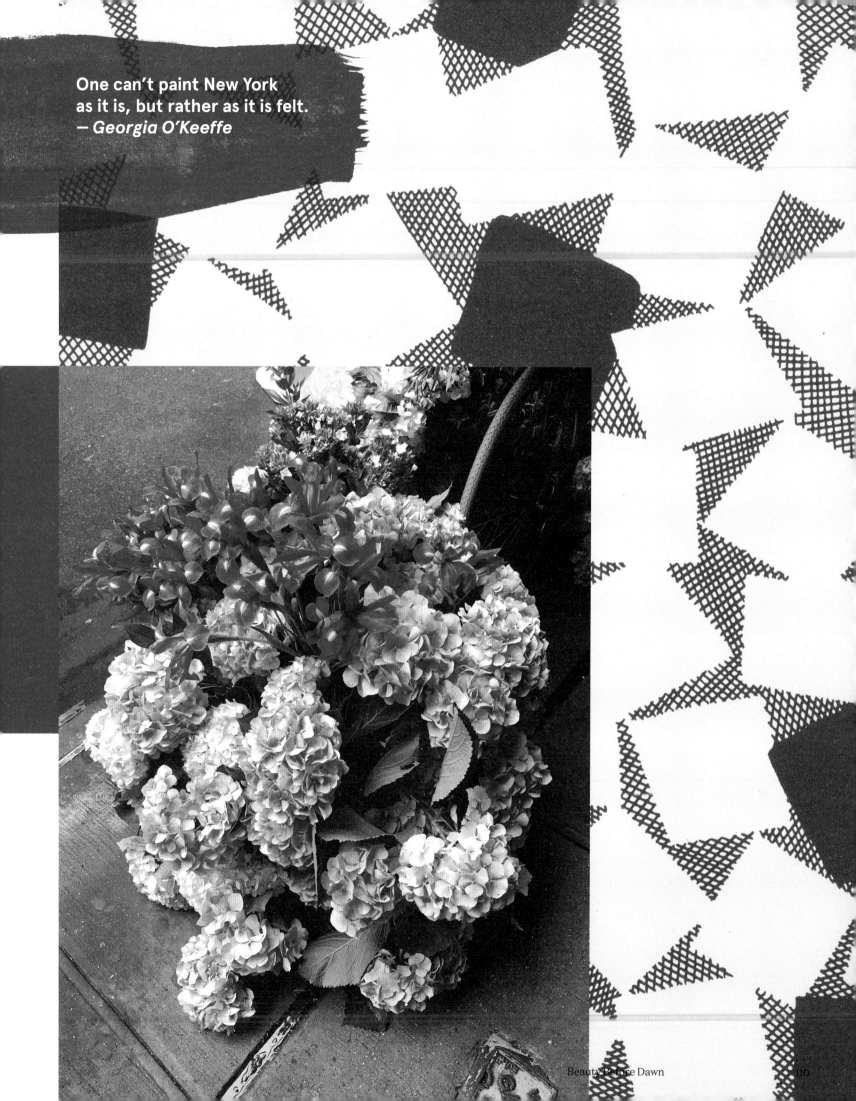

One can't paint New York
as it is, but rather as it is felt.
— *Georgia O'Keeffe*

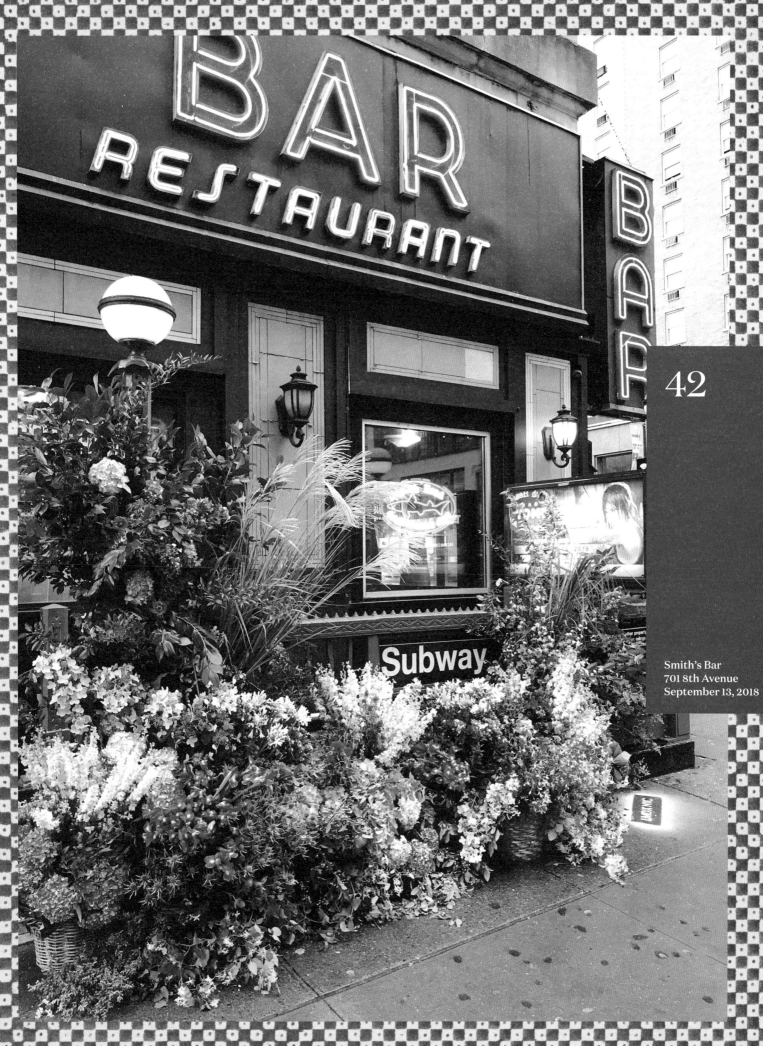

42

Smith's Bar
701 8th Avenue
September 13, 2018

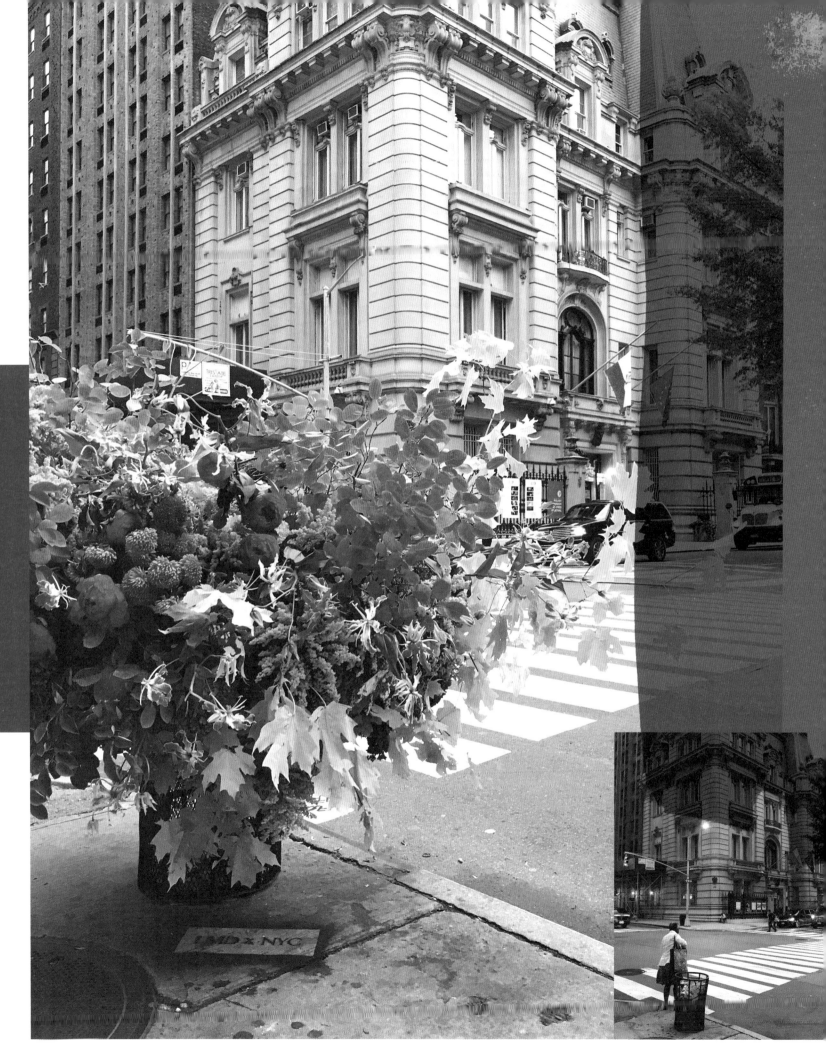

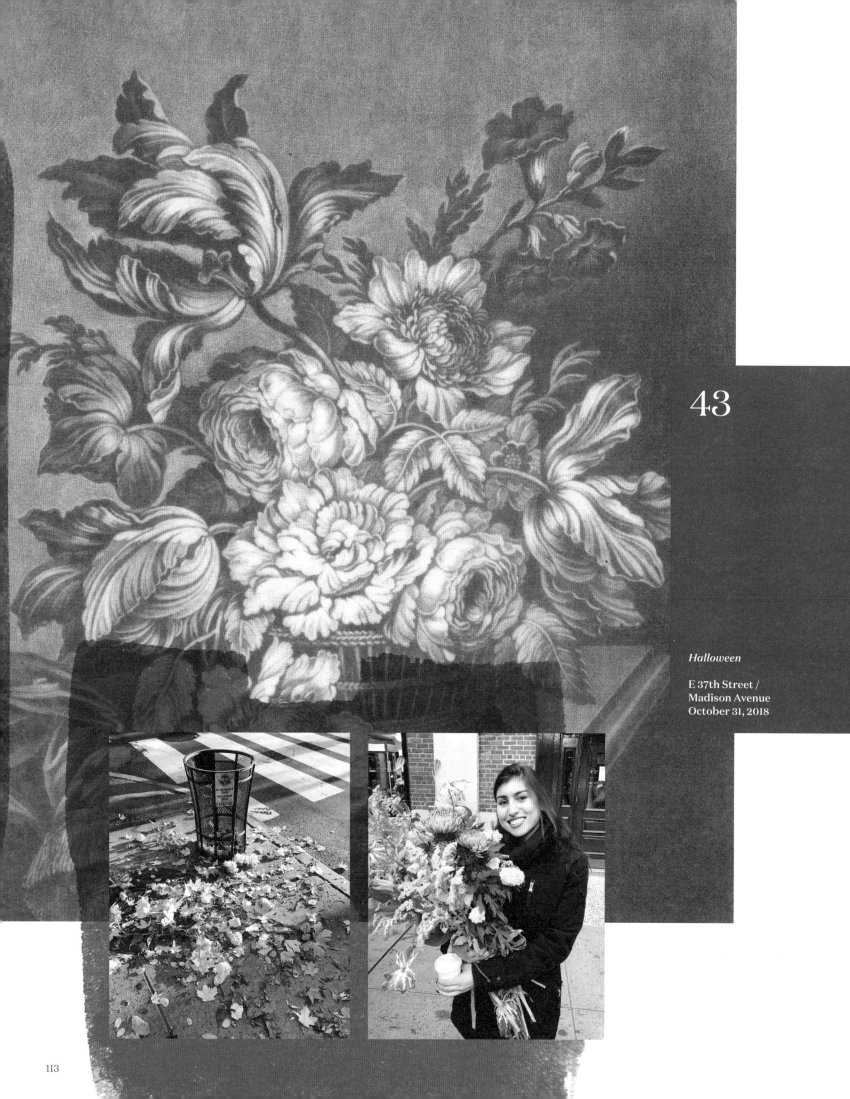

43

Halloween

E 37th Street /
Madison Avenue
October 31, 2018

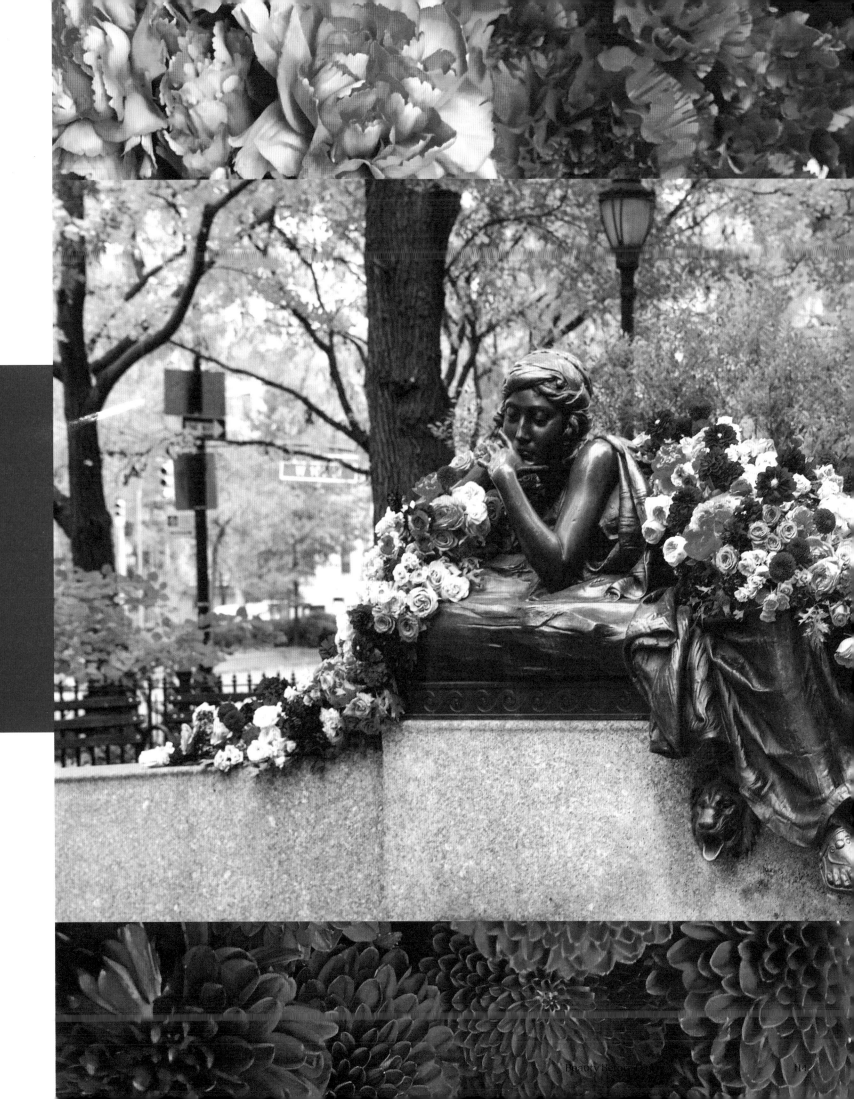

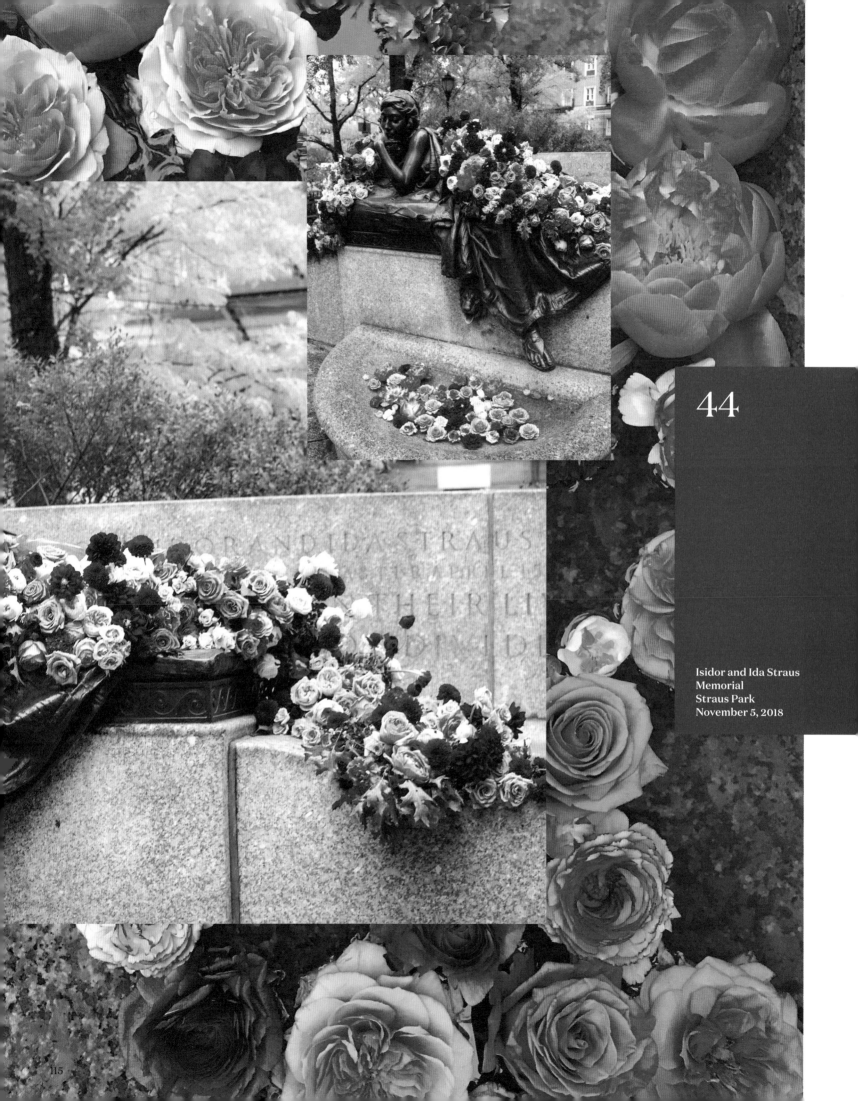

44

Isidor and Ida Straus
Memorial
Straus Park
November 5, 2018

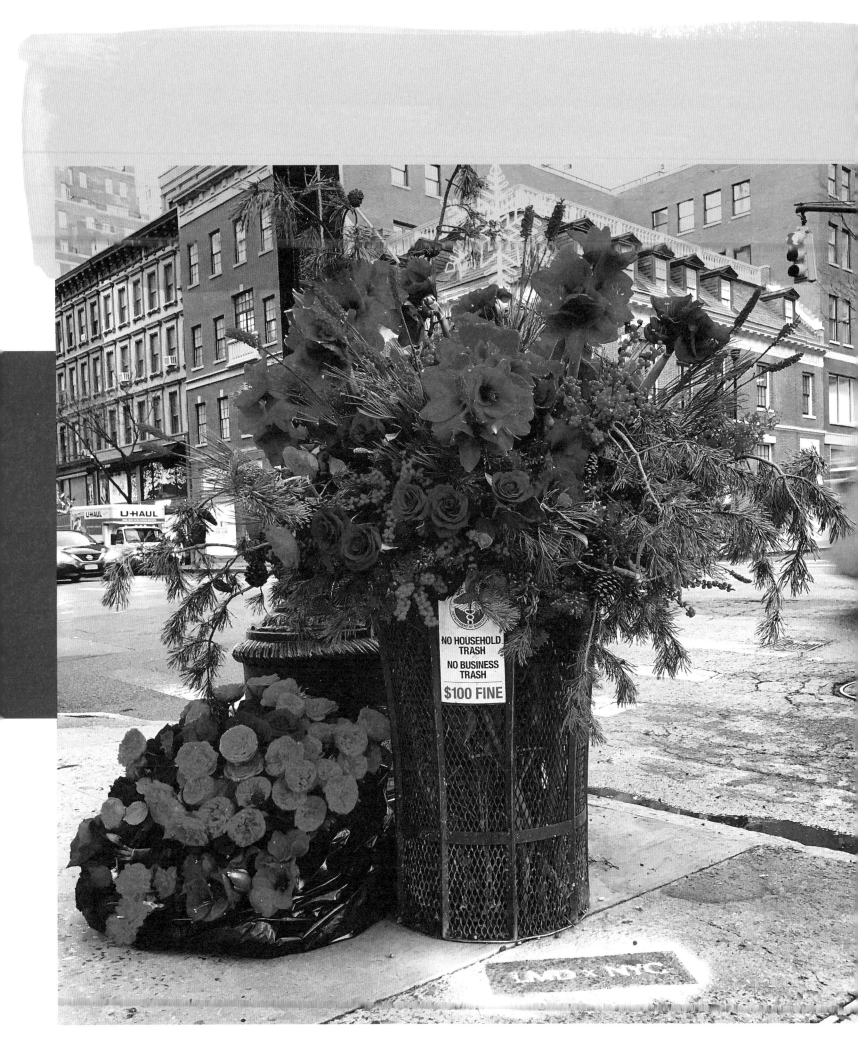

NO HOUSEHOLD
TRASH
NO BUSINESS
TRASH
$100 FINE

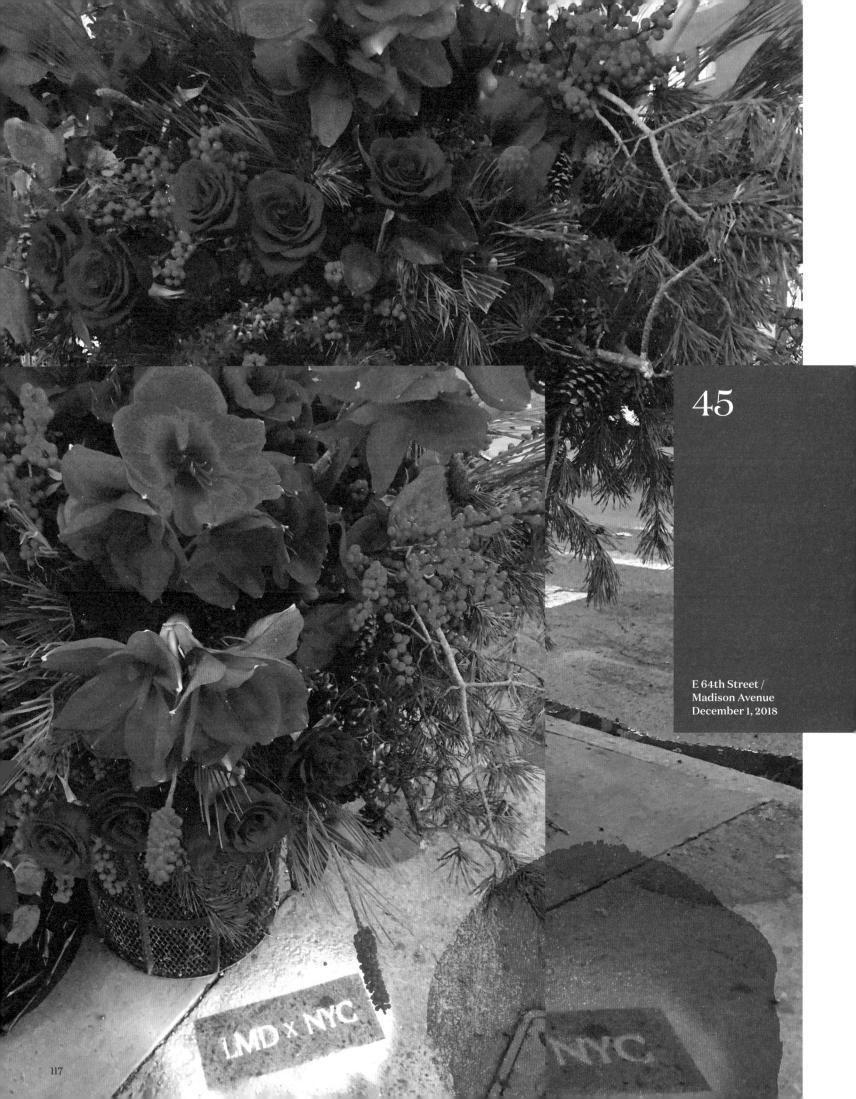

45

E 64th Street /
Madison Avenue
December 1, 2018

LMD x NYC

NYC

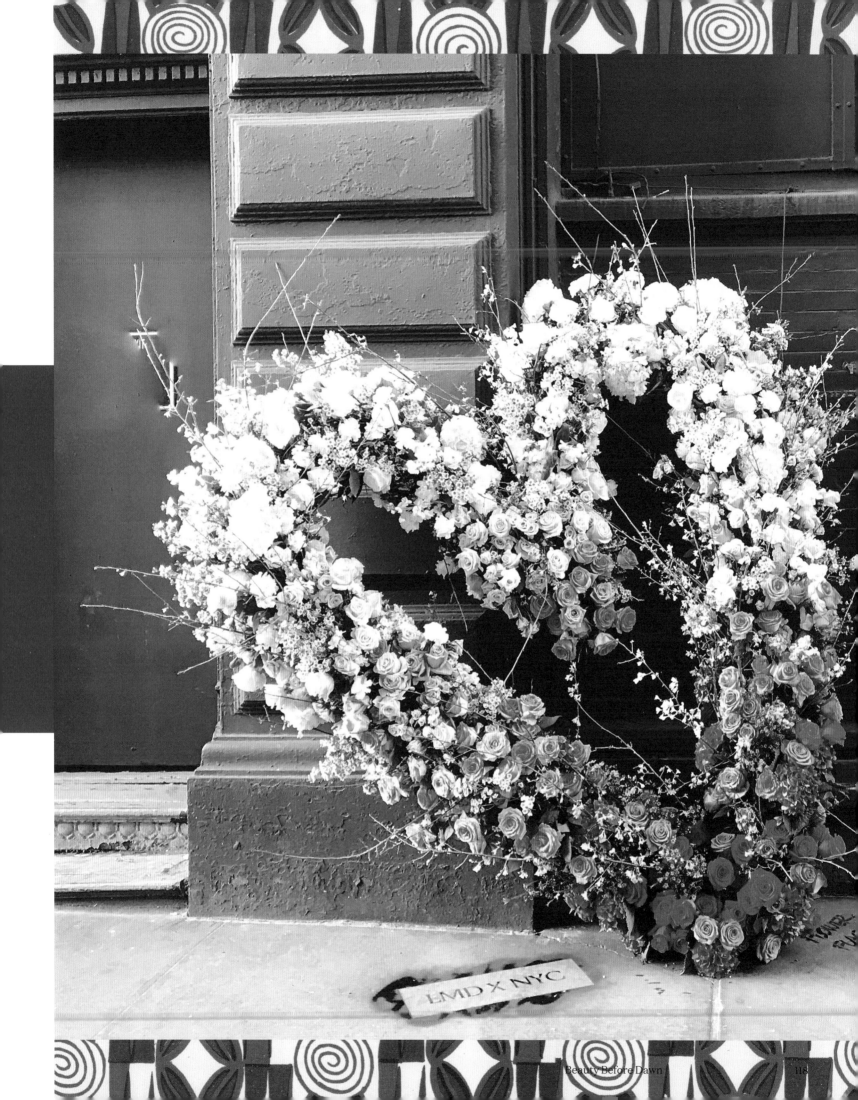

EMD X NYC

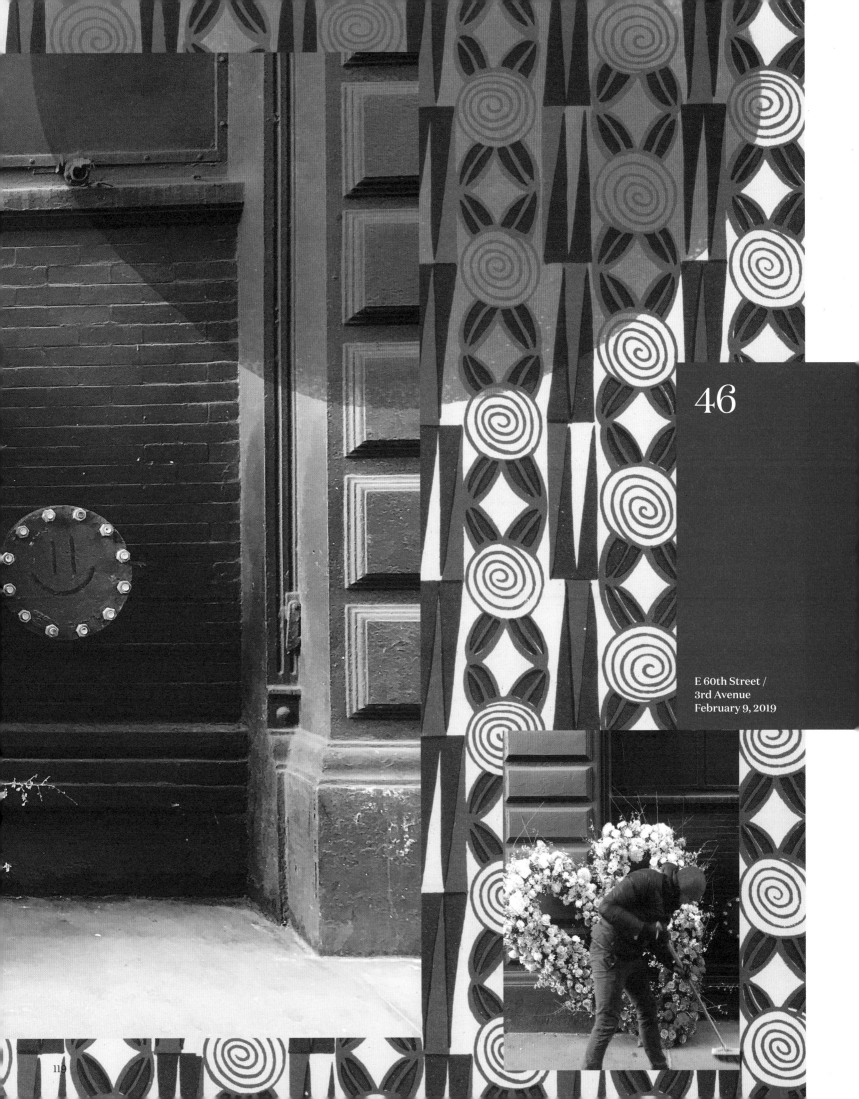

46

E 60th Street /
3rd Avenue
February 9, 2019

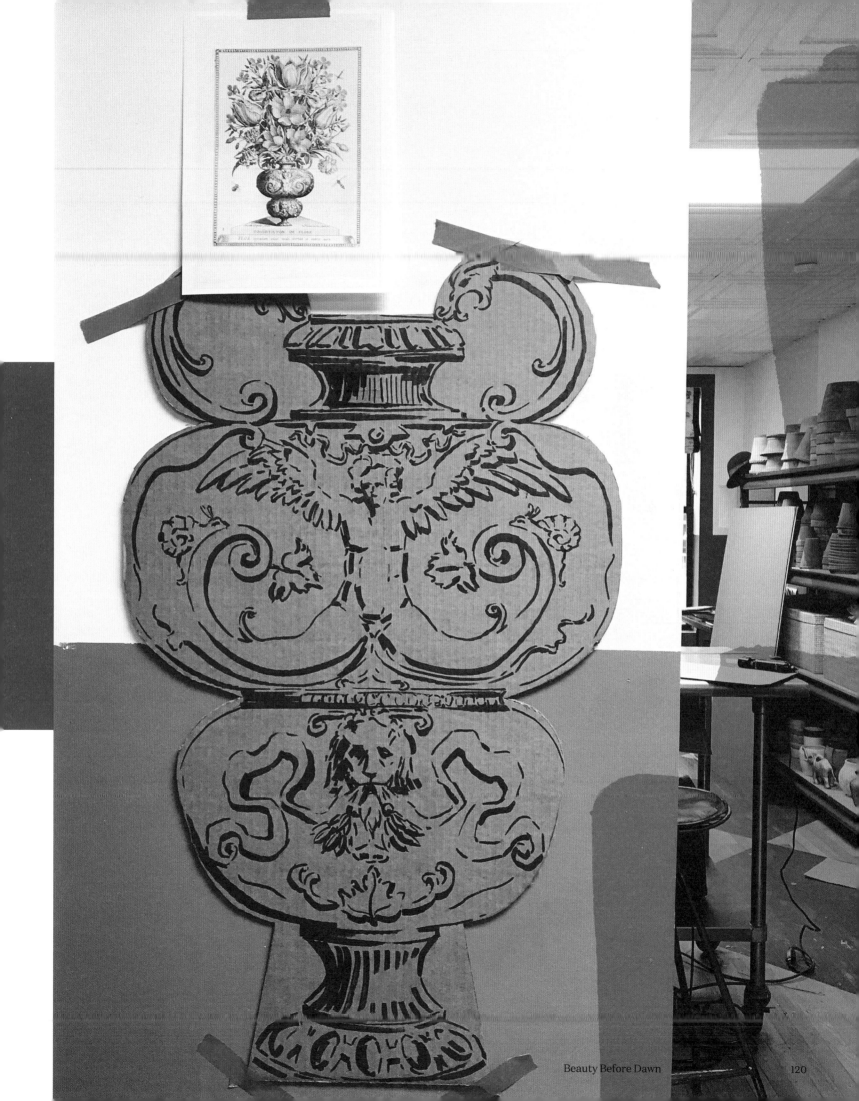

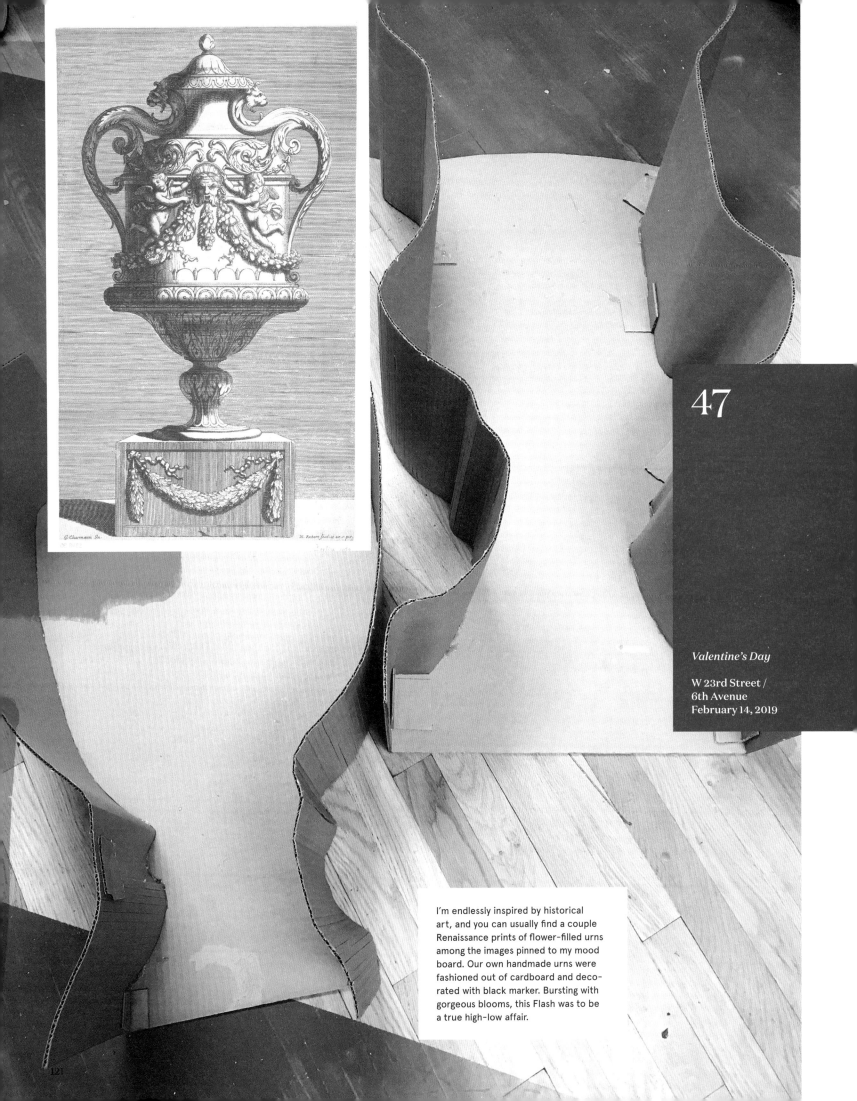

47

Valentine's Day

**W 23rd Street /
6th Avenue
February 14, 2019**

I'm endlessly inspired by historical art, and you can usually find a couple Renaissance prints of flower-filled urns among the images pinned to my mood board. Our own handmade urns were fashioned out of cardboard and decorated with black marker. Bursting with gorgeous blooms, this Flash was to be a true high-low affair.

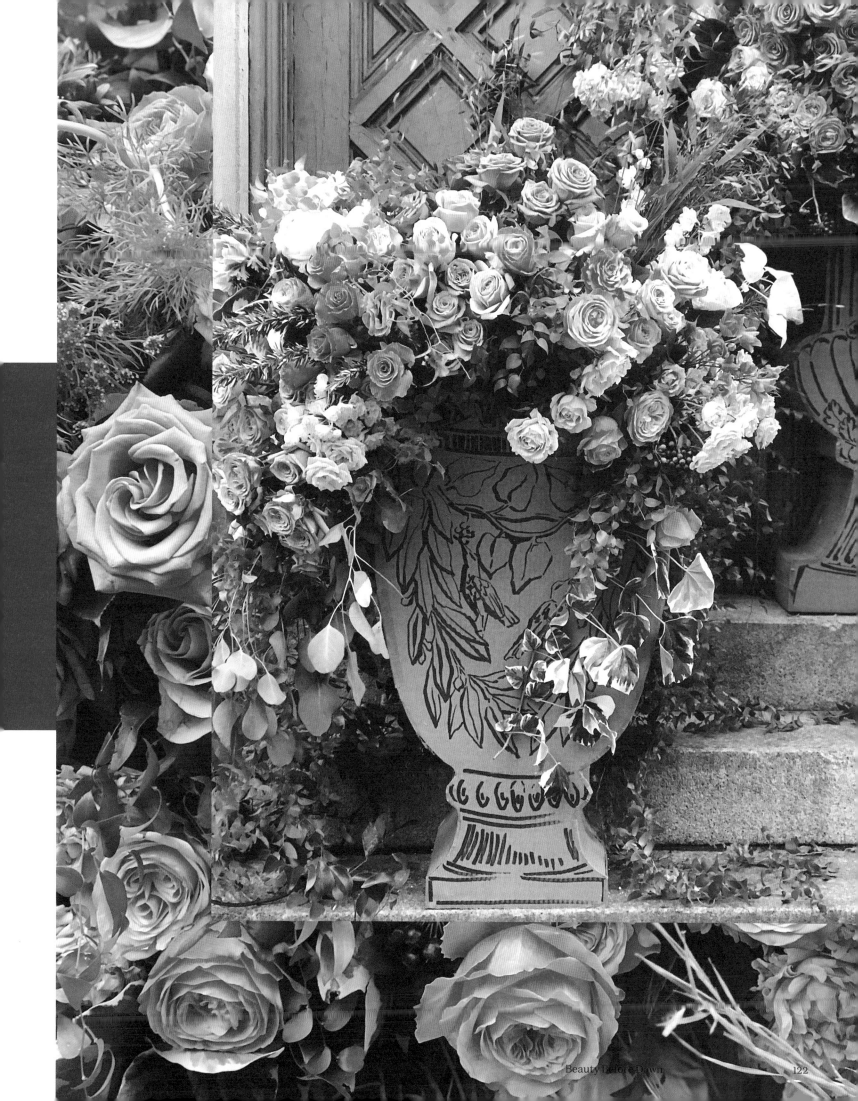

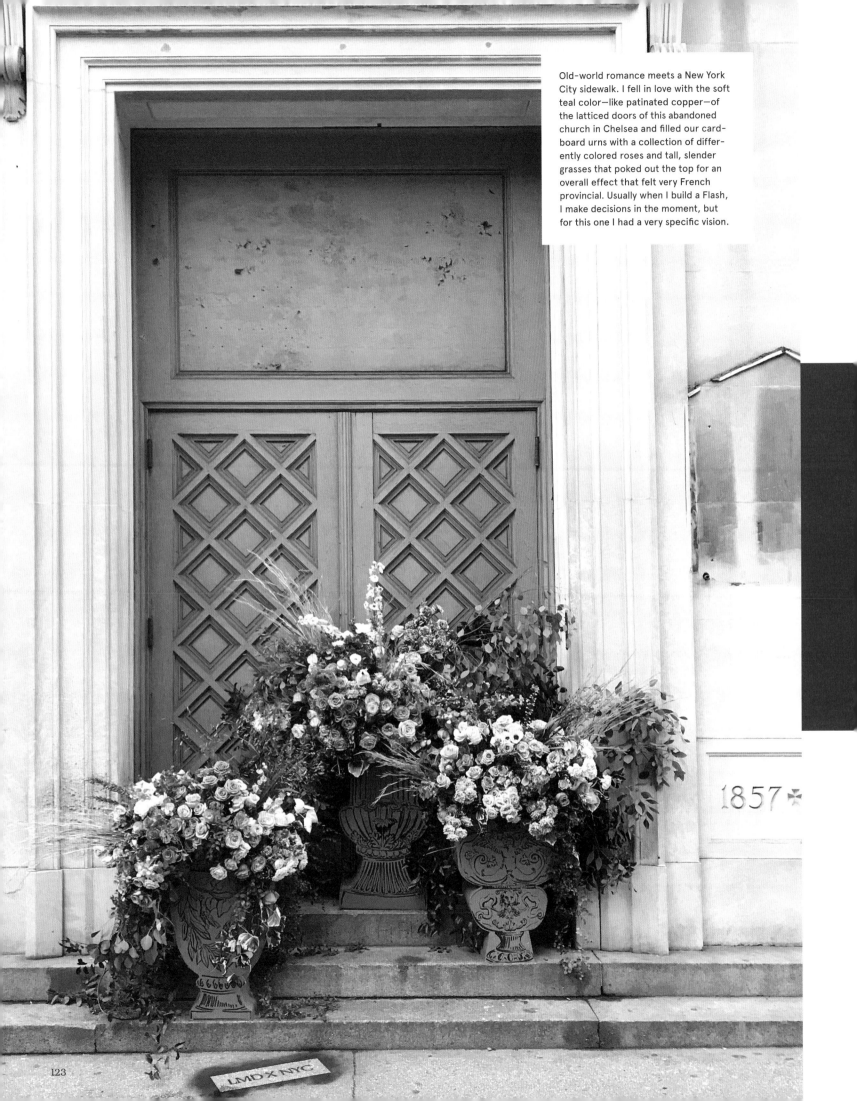

Old-world romance meets a New York City sidewalk. I fell in love with the soft teal color—like patinated copper—of the latticed doors of this abandoned church in Chelsea and filled our cardboard urns with a collection of differently colored roses and tall, slender grasses that poked out the top for an overall effect that felt very French provincial. Usually when I build a Flash, I make decisions in the moment, but for this one I had a very specific vision.

1857

LMD X NYC

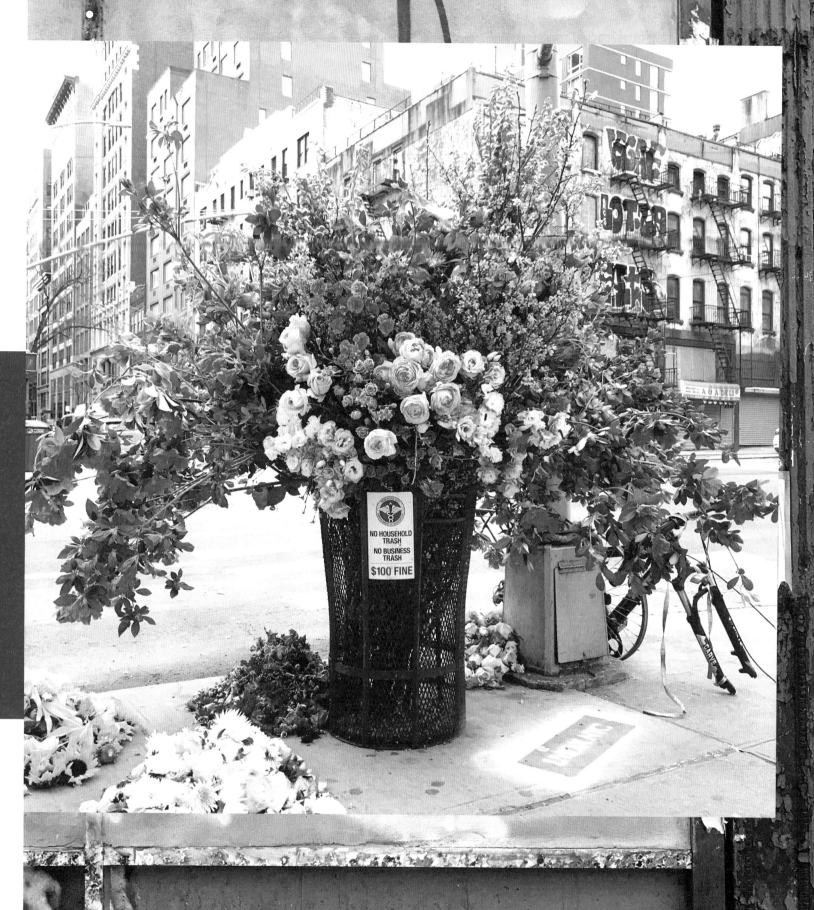

"DON'T GIVE UP . . .

DON'T EVER GIVE UP!"®

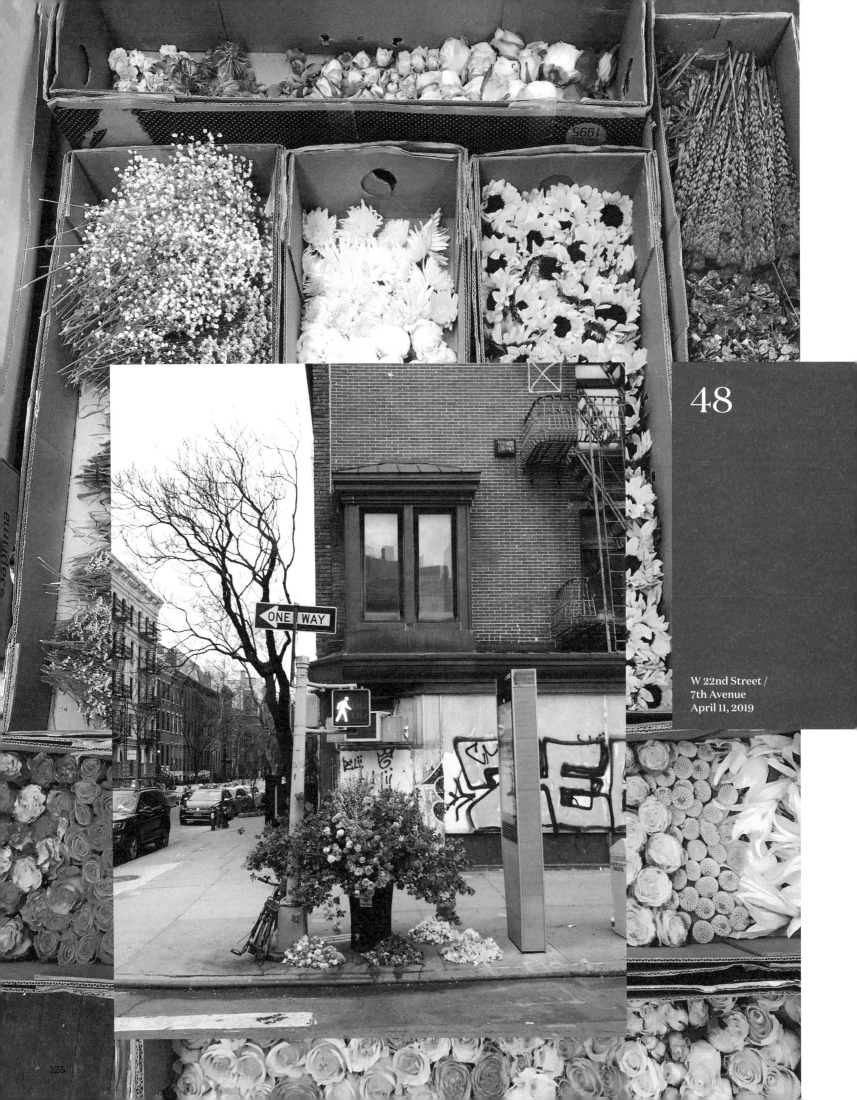

48

W 22nd Street /
7th Avenue
April 11, 2019

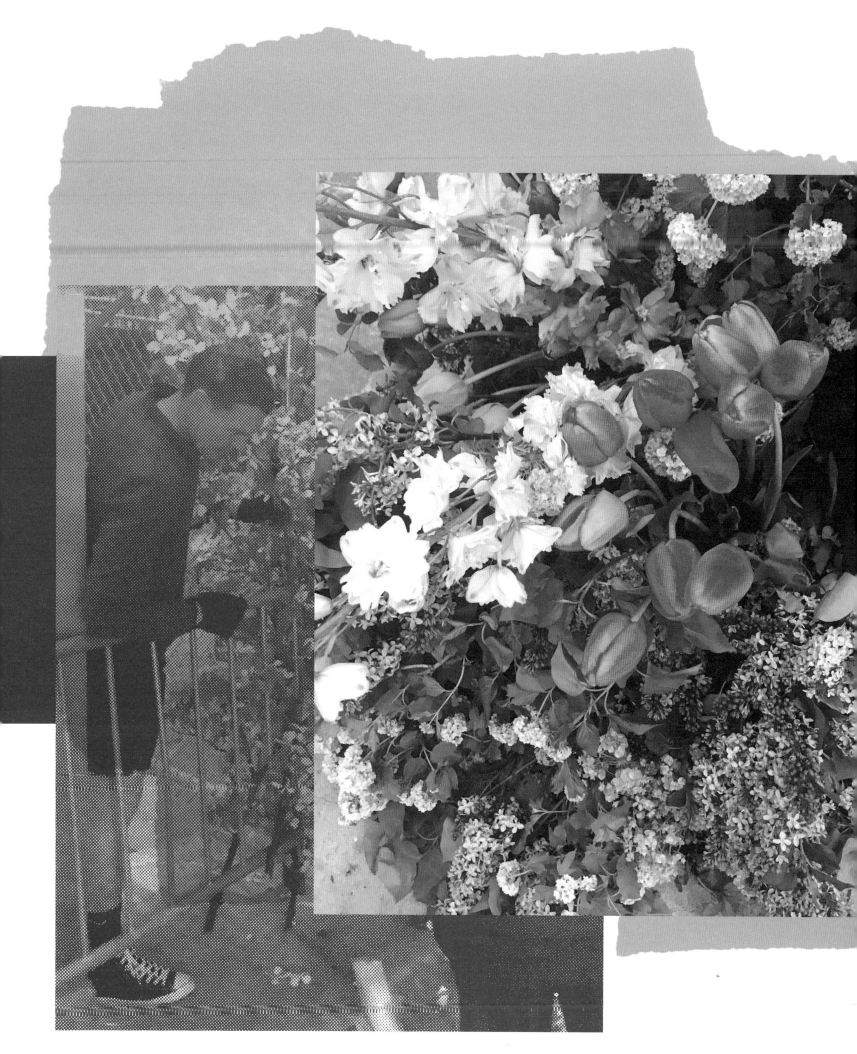

49

Hudson Yards
May 1, 2019

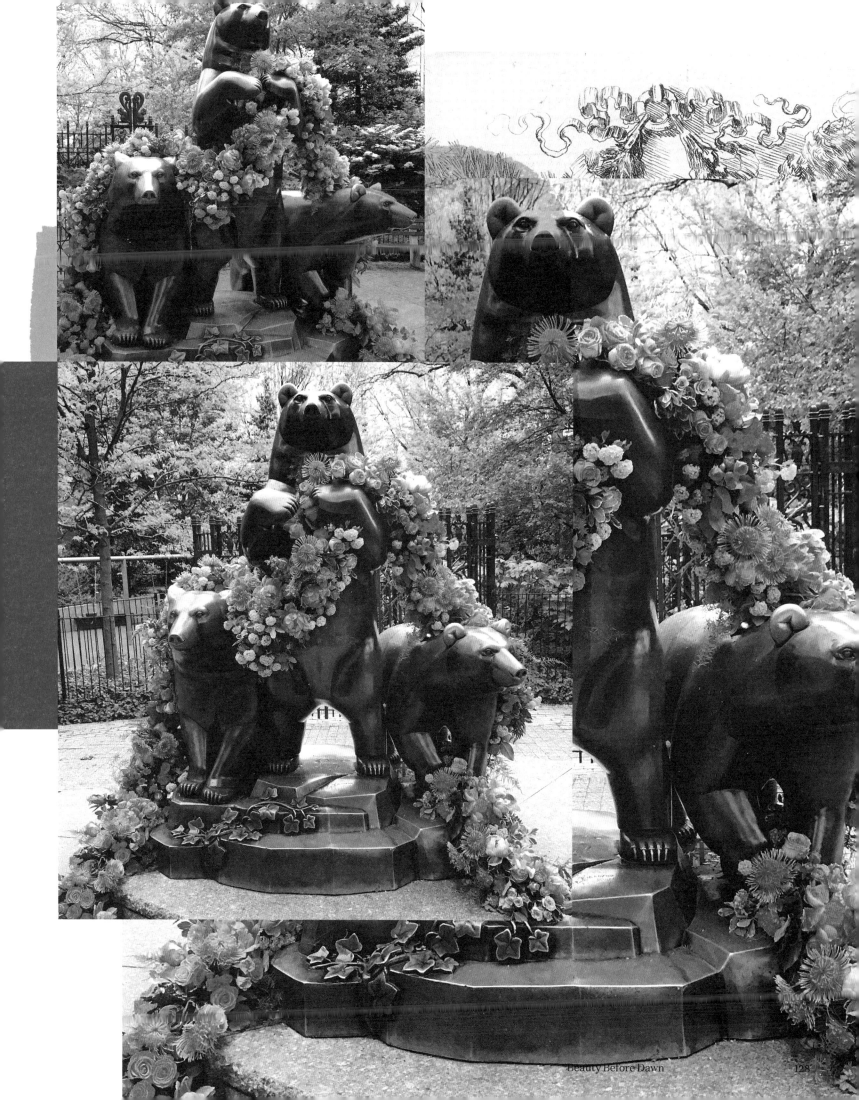

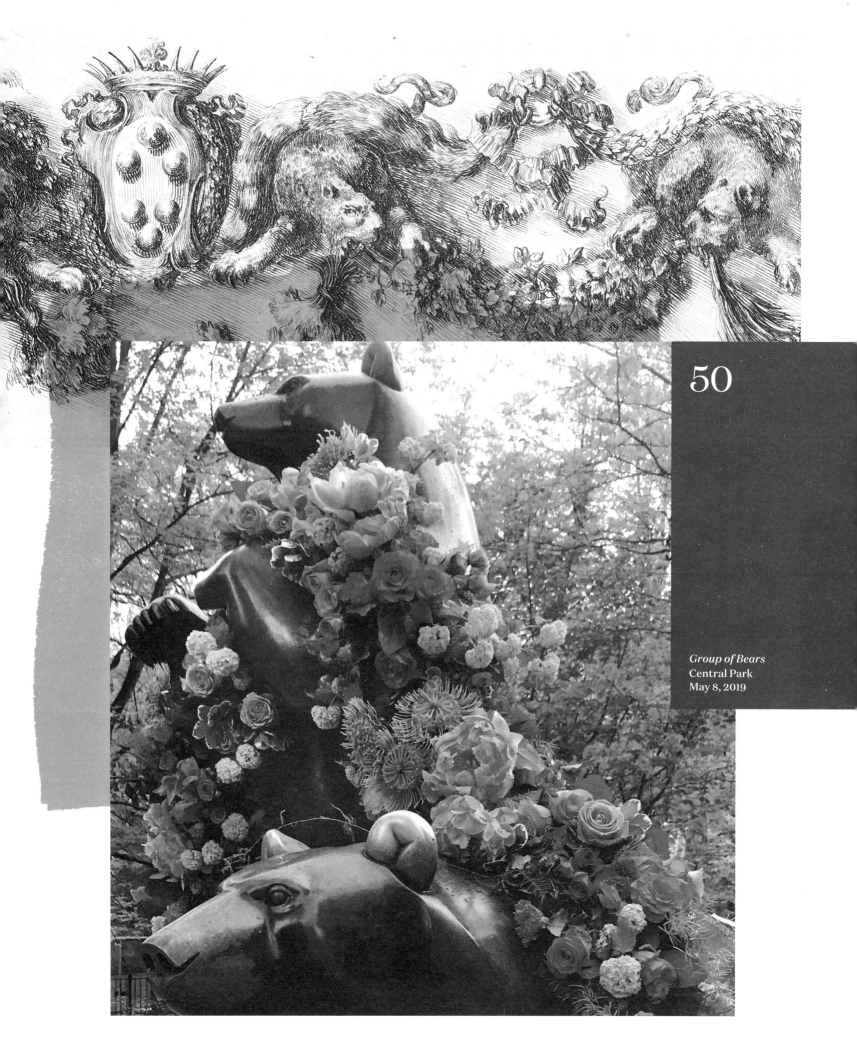

50

Group of Bears
Central Park
May 8, 2019

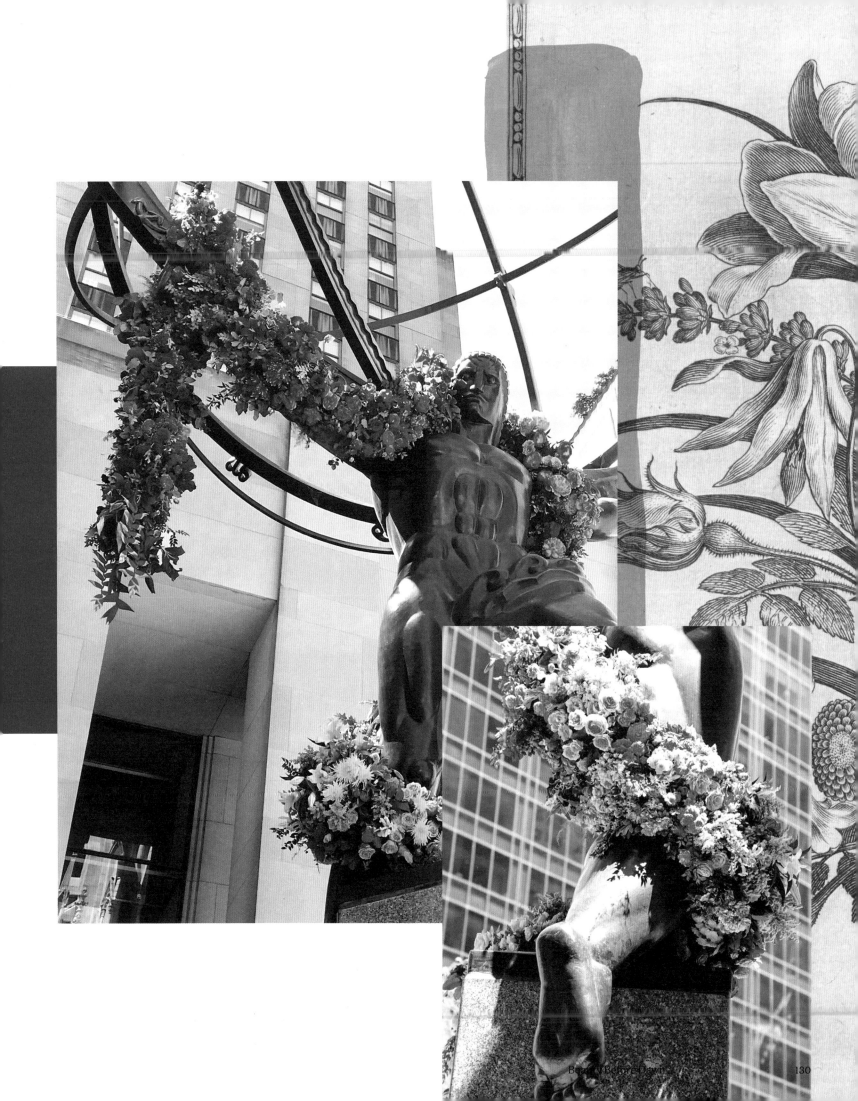

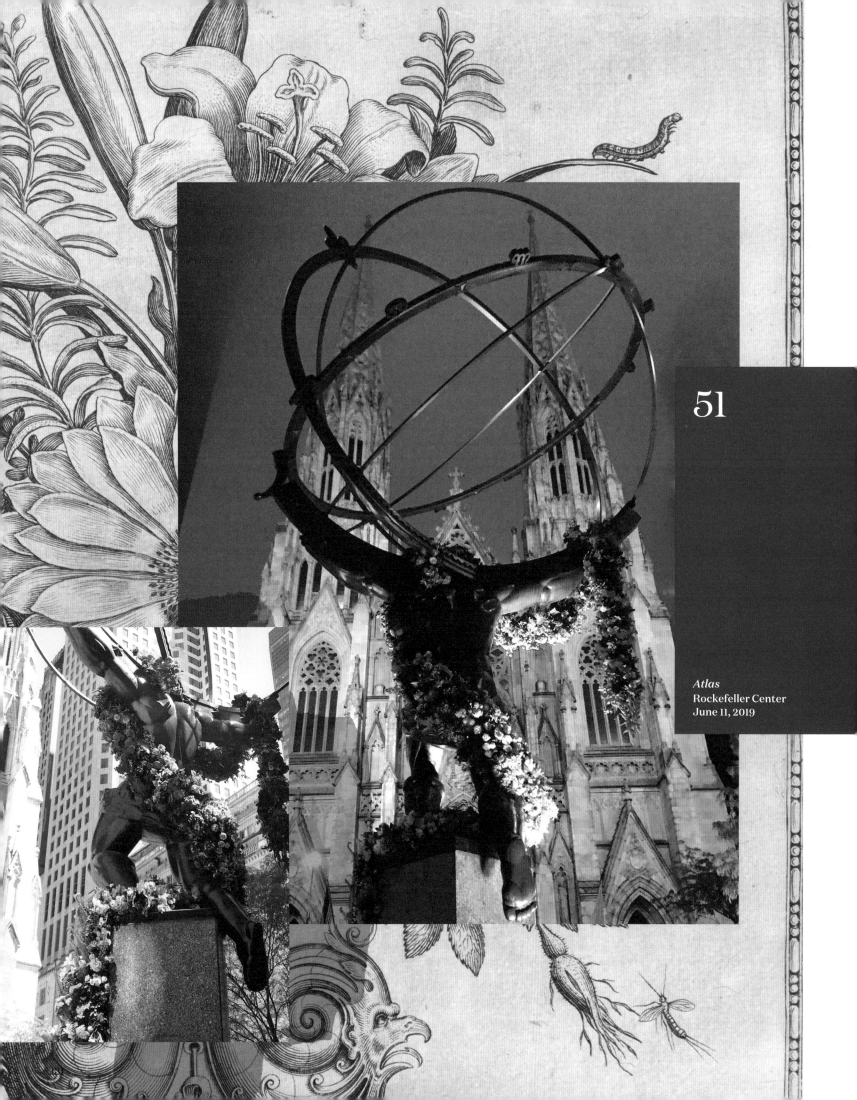

51

Atlas
Rockefeller Center
June 11, 2019

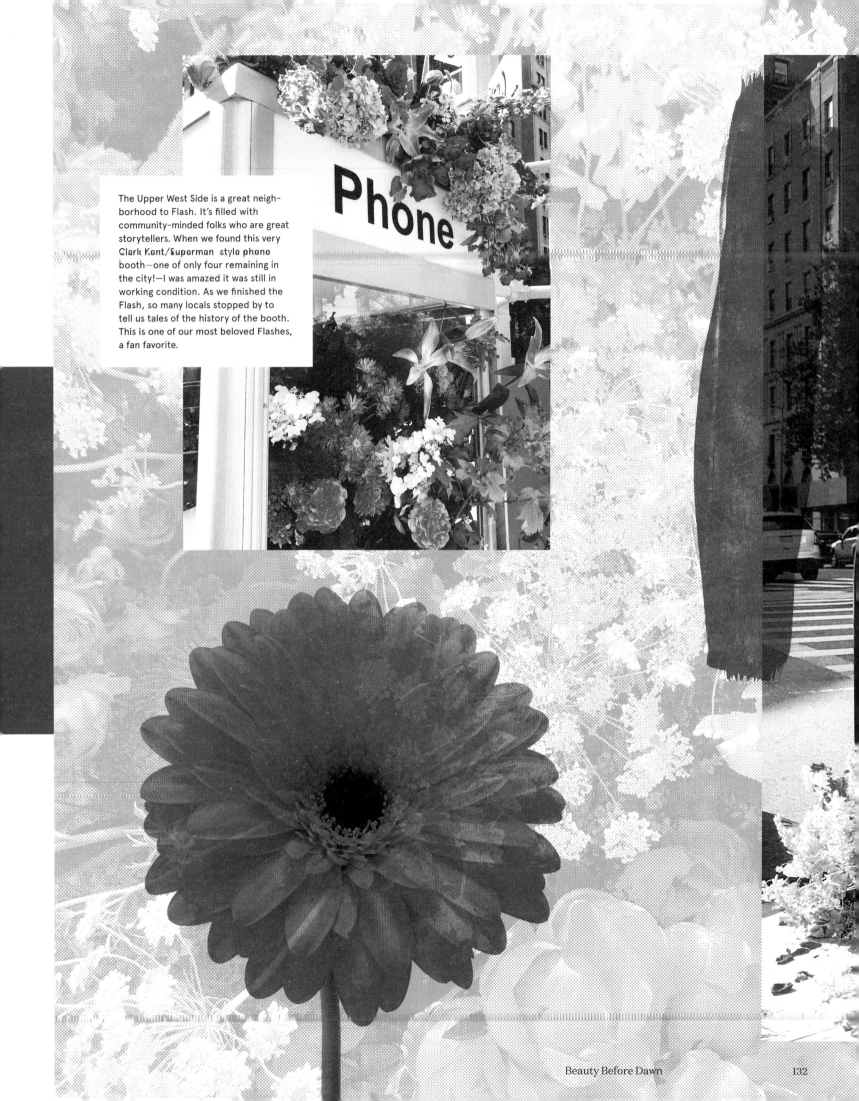

The Upper West Side is a great neigh-borhood to Flash. It's filled with community-minded folks who are great storytellers. When we found this very Clark Kent/Superman style phone booth—one of only four remaining in the city!—I was amazed it was still in working condition. As we finished the Flash, so many locals stopped by to tell us tales of the history of the booth. This is one of our most beloved Flashes, a fan favorite.

Phone

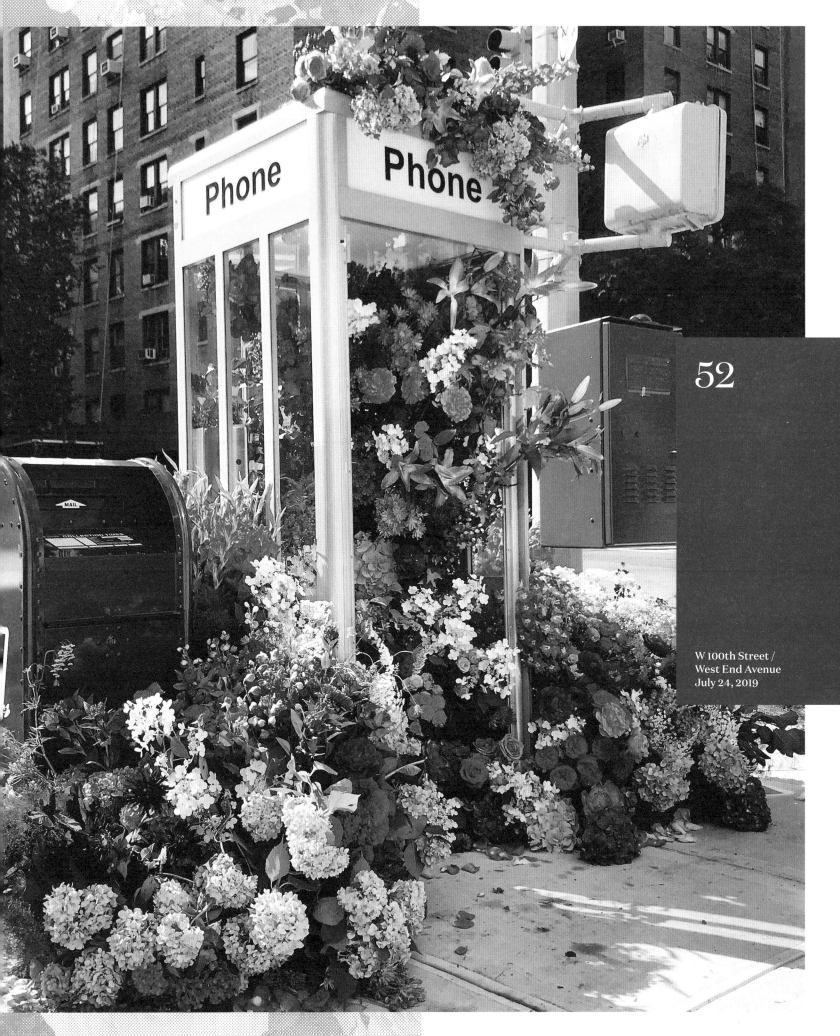

52

W 100th Street /
West End Avenue
July 24, 2019

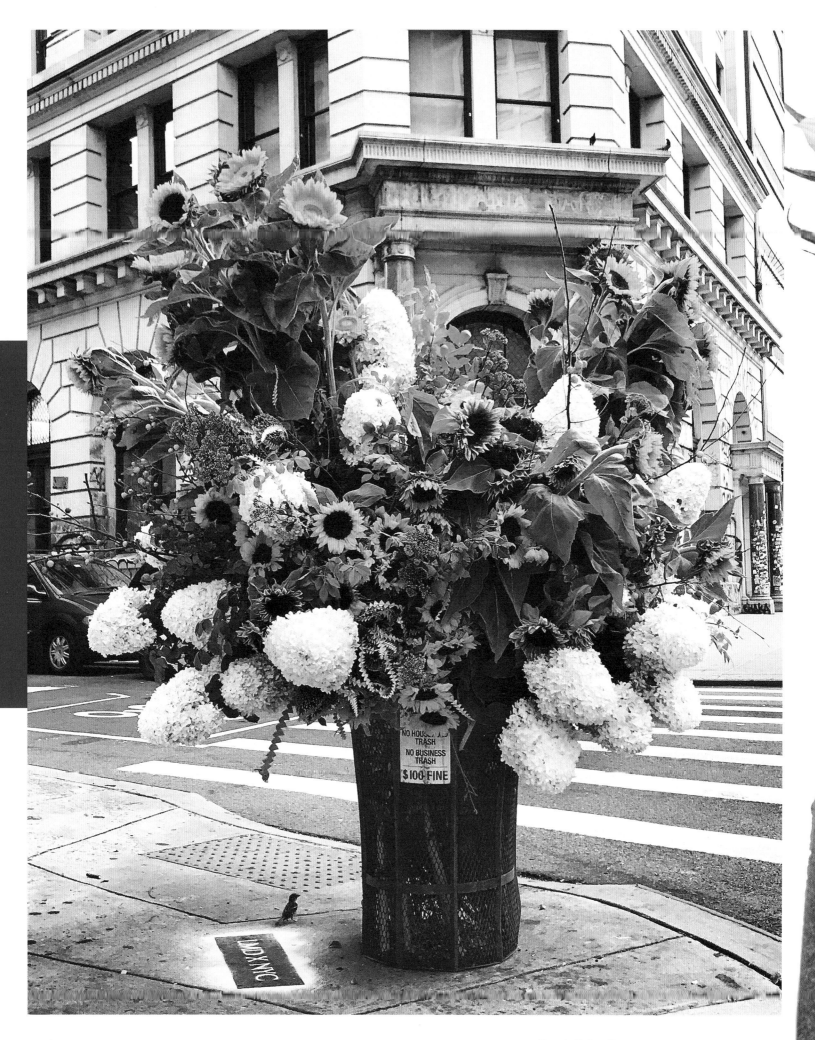

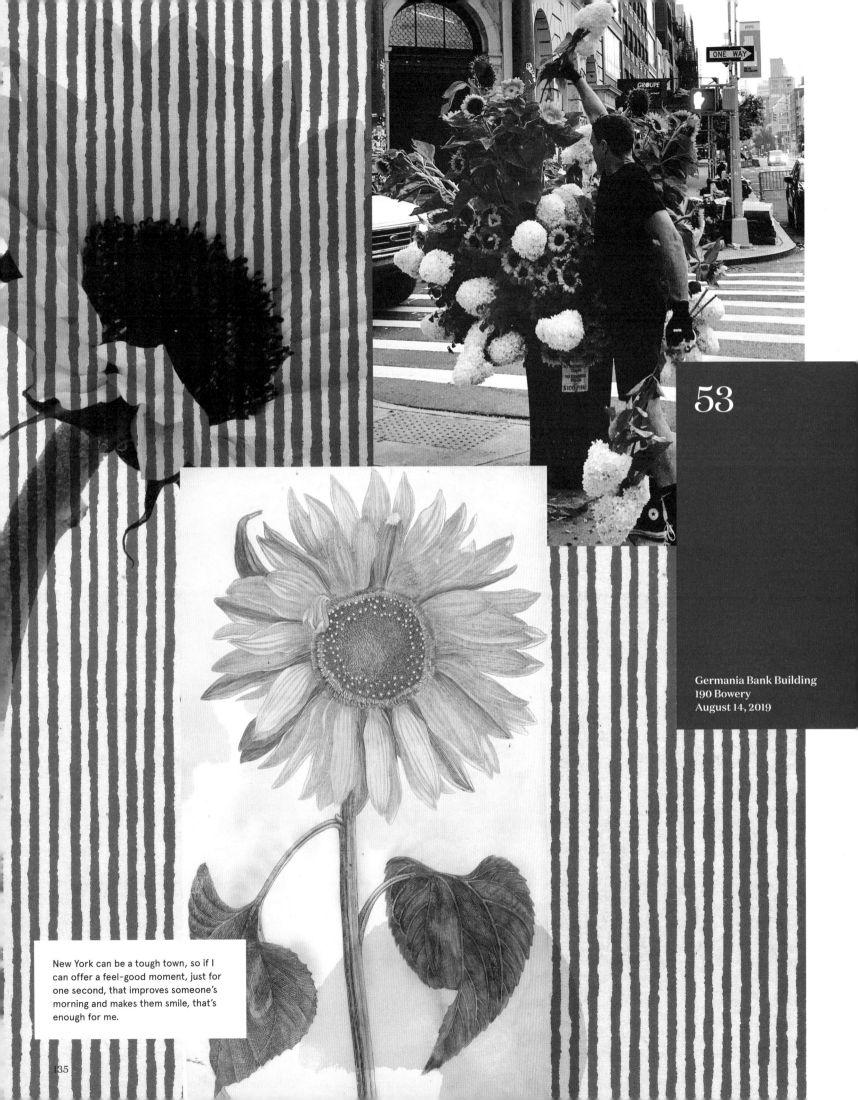

53

Germania Bank Building
190 Bowery
August 14, 2019

New York can be a tough town, so if I can offer a feel-good moment, just for one second, that improves someone's morning and makes them smile, that's enough for me.

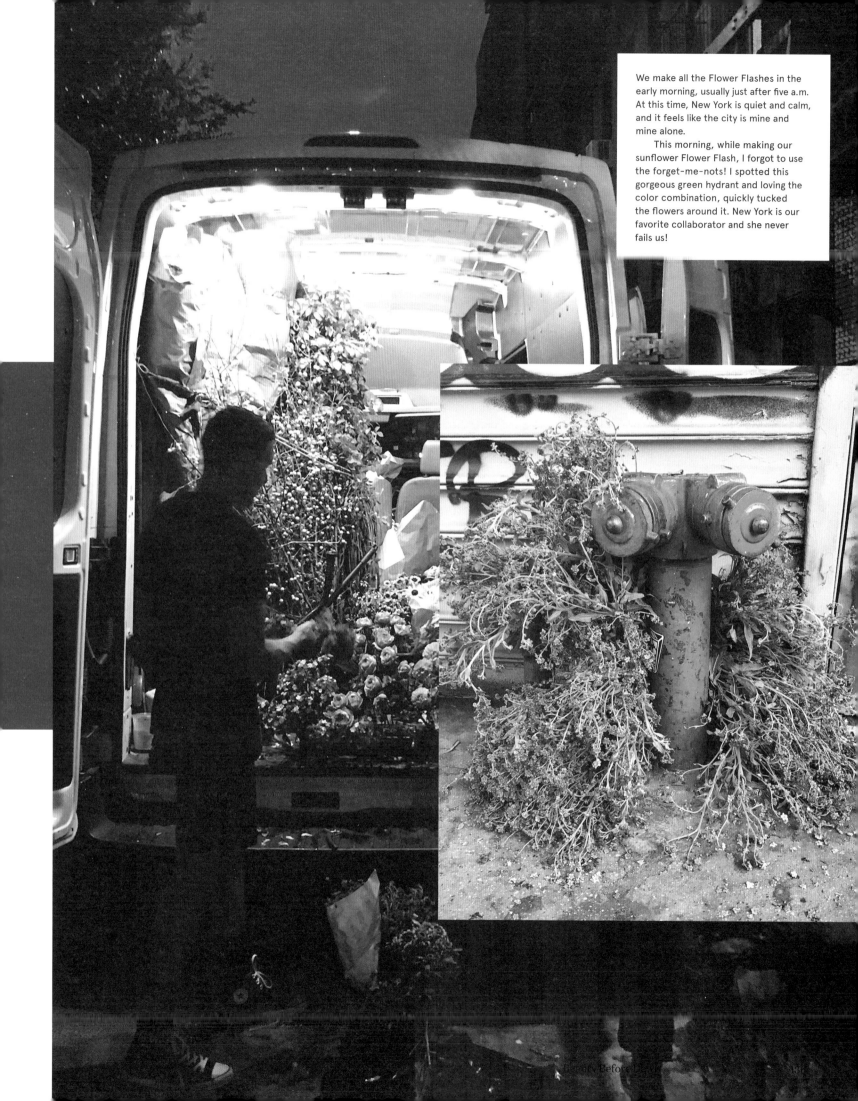

We make all the Flower Flashes in the early morning, usually just after five a.m. At this time, New York is quiet and calm, and it feels like the city is mine and mine alone.

This morning, while making our sunflower Flower Flash, I forgot to use the forget-me-nots! I spotted this gorgeous green hydrant and loving the color combination, quickly tucked the flowers around it. New York is our favorite collaborator and she never fails us!

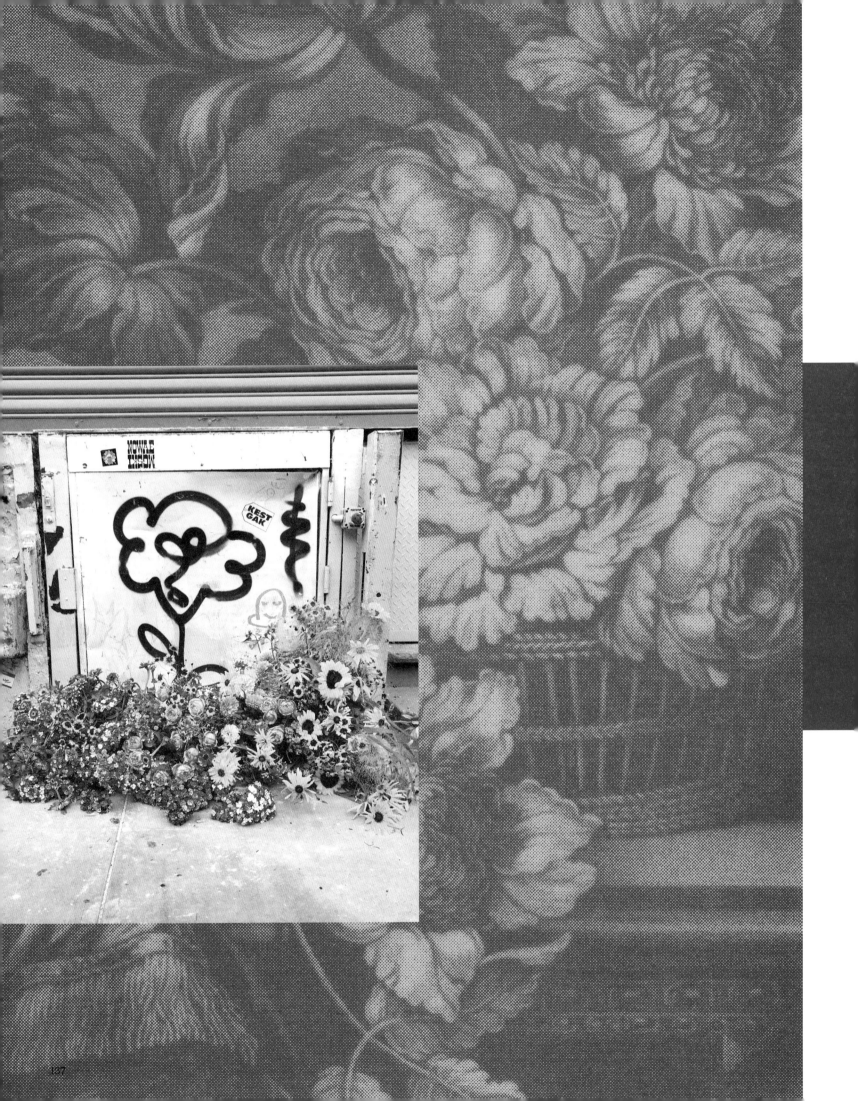

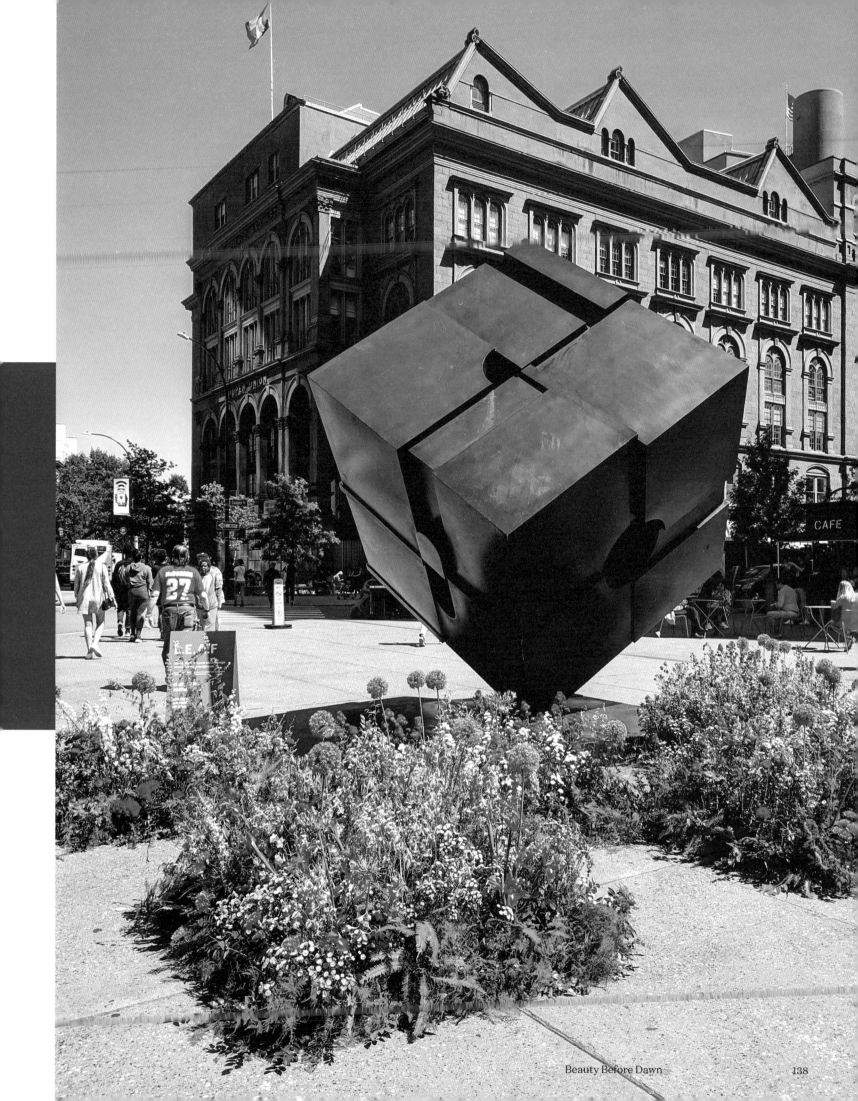

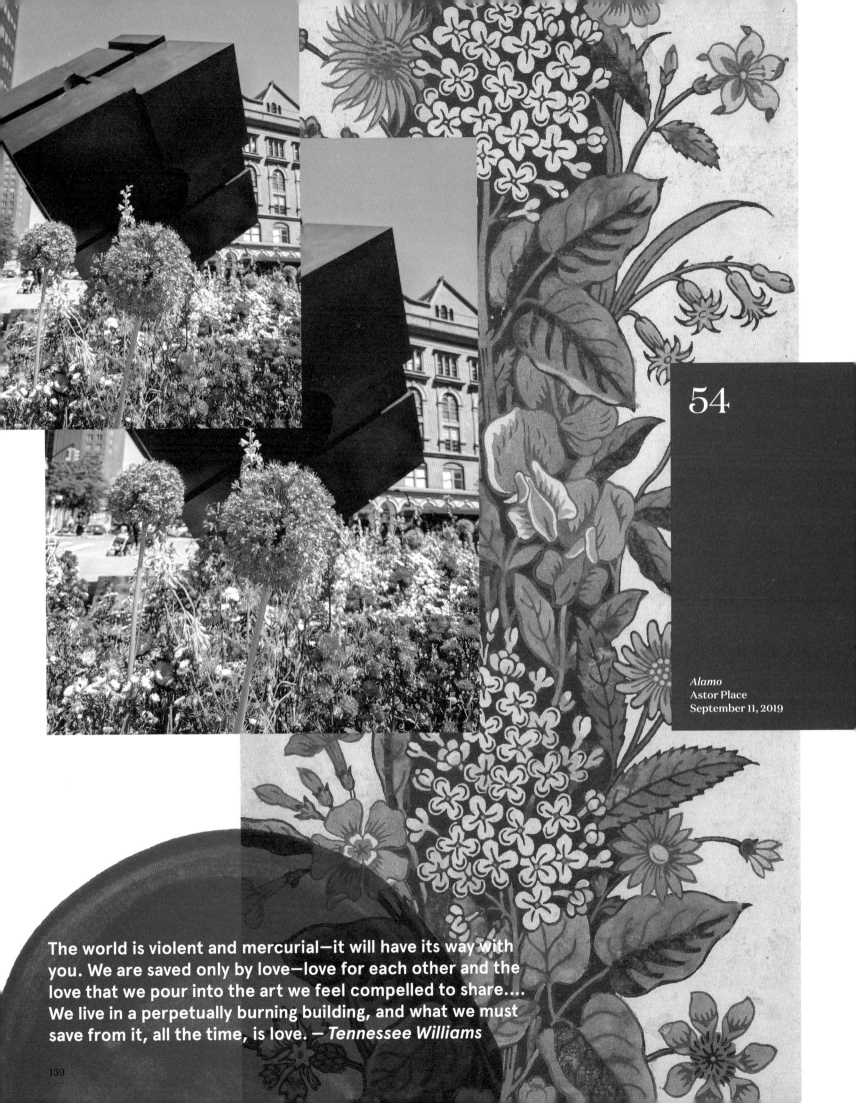

54

Alamo
Astor Place
September 11, 2019

The world is violent and mercurial—it will have its way with you. We are saved only by love—love for each other and the love that we pour into the art we feel compelled to share.... We live in a perpetually burning building, and what we must save from it, all the time, is love. — *Tennessee Williams*

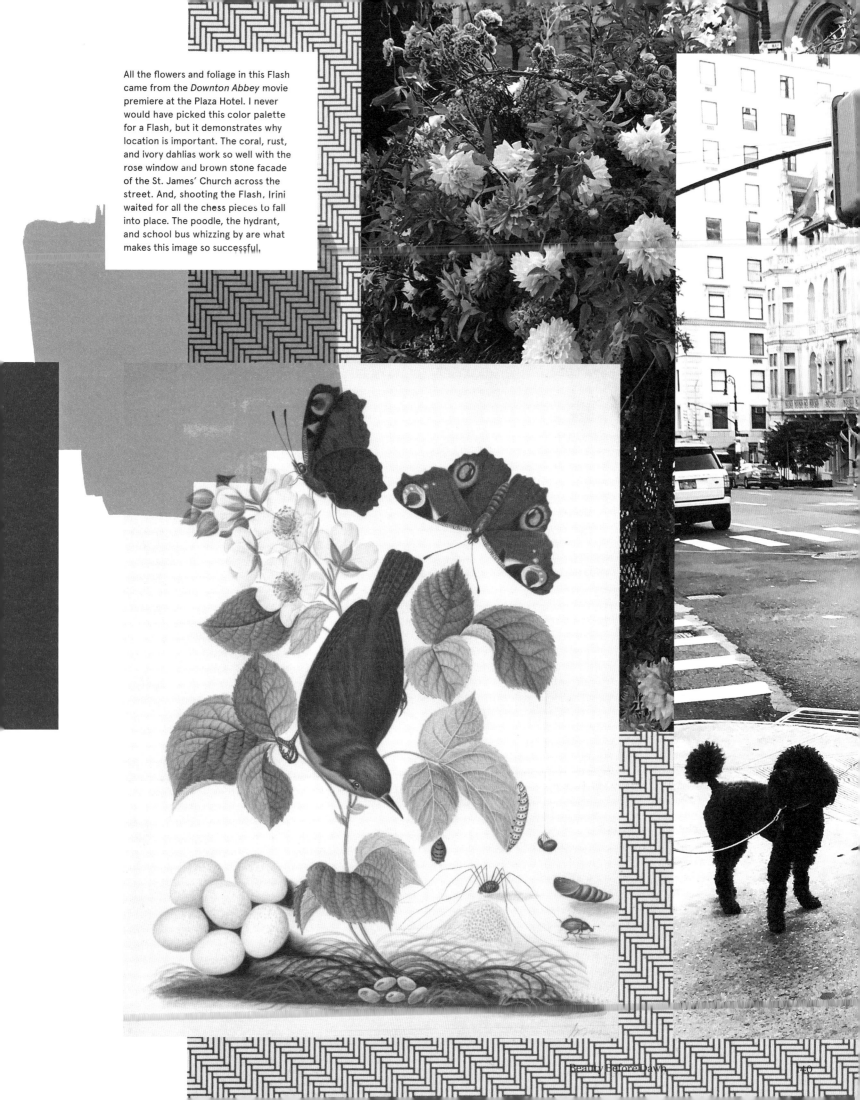

All the flowers and foliage in this Flash came from the *Downton Abbey* movie premiere at the Plaza Hotel. I never would have picked this color palette for a Flash, but it demonstrates why location is important. The coral, rust, and ivory dahlias work so well with the rose window and brown stone facade of the St. James' Church across the street. And, shooting the Flash, Irini waited for all the chess pieces to fall into place. The poodle, the hydrant, and school bus whizzing by are what makes this image so successful.

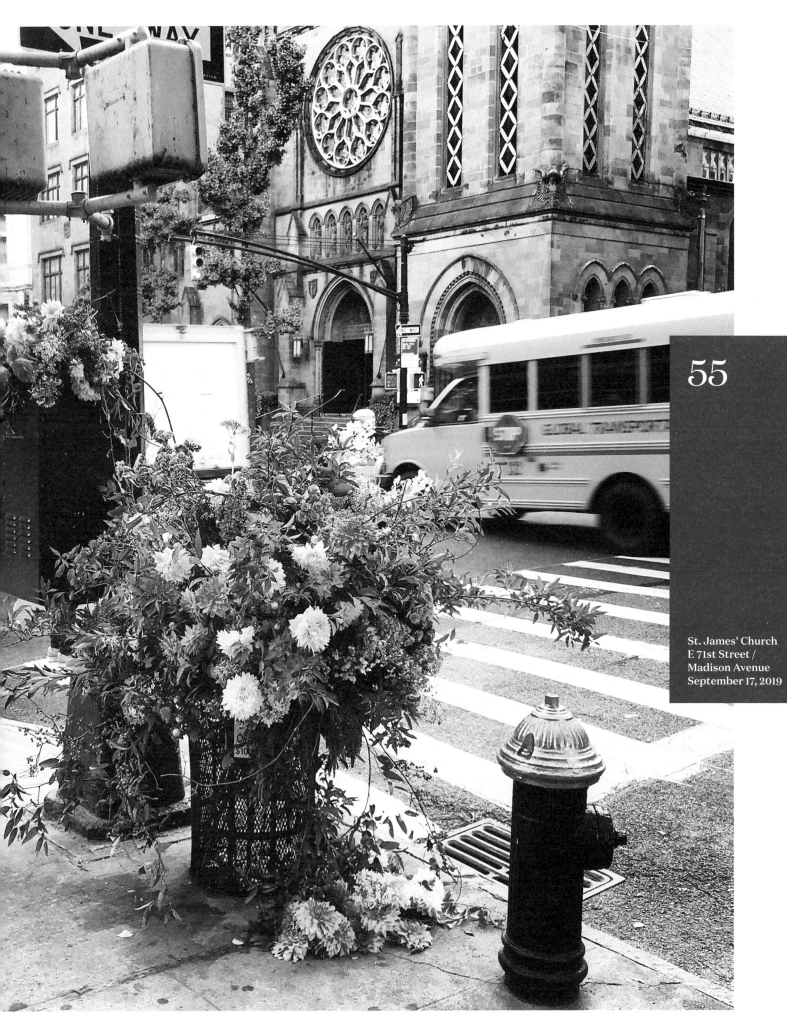

55

St. James' Church
E 71st Street /
Madison Avenue
September 17, 2019

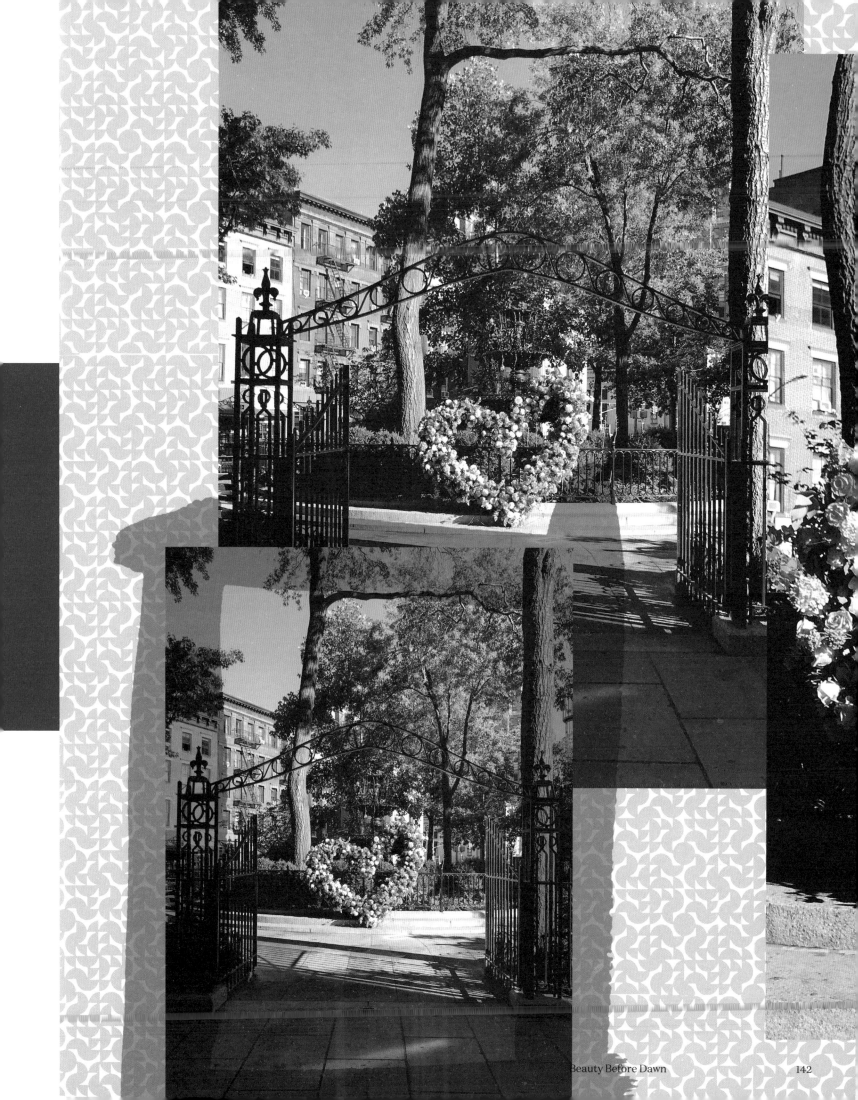

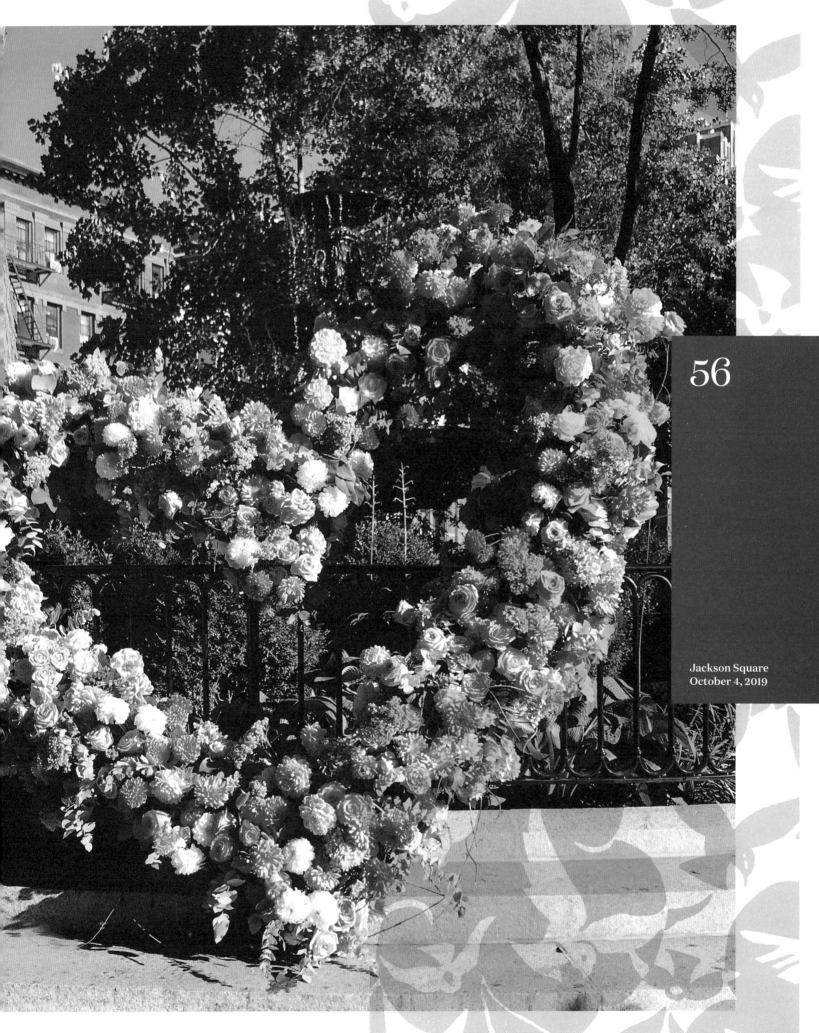

56

Jackson Square
October 4, 2019

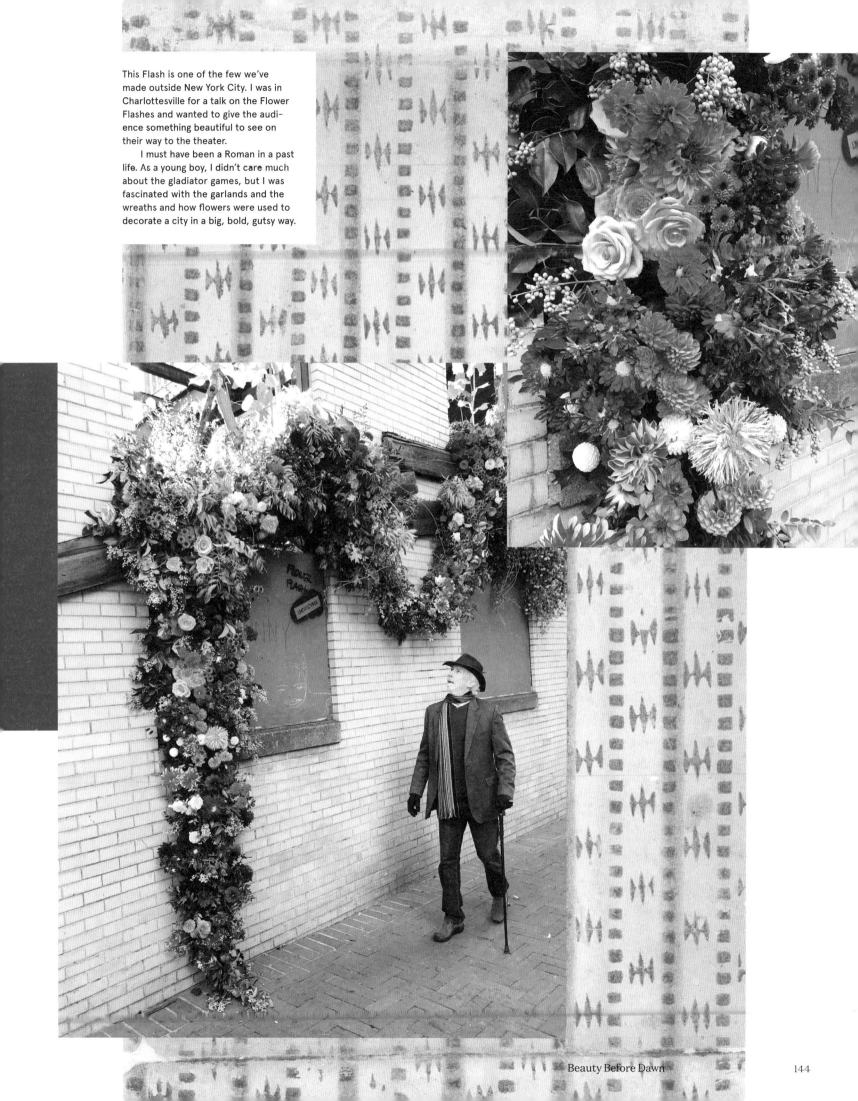

This Flash is one of the few we've made outside New York City. I was in Charlottesville for a talk on the Flower Flashes and wanted to give the audience something beautiful to see on their way to the theater.

I must have been a Roman in a past life. As a young boy, I didn't care much about the gladiator games, but I was fascinated with the garlands and the wreaths and how flowers were used to decorate a city in a big, bold, gutsy way.

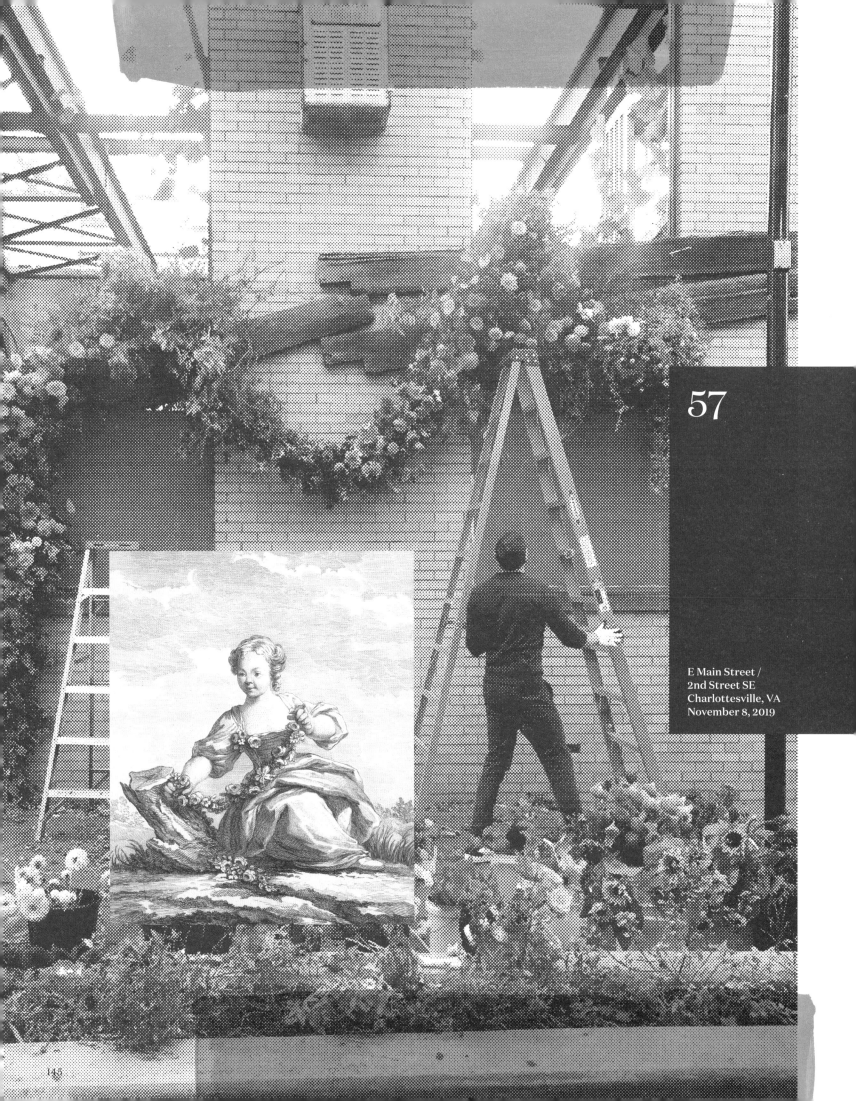

57

E Main Street /
2nd Street SE
Charlottesville, VA
November 8, 2019

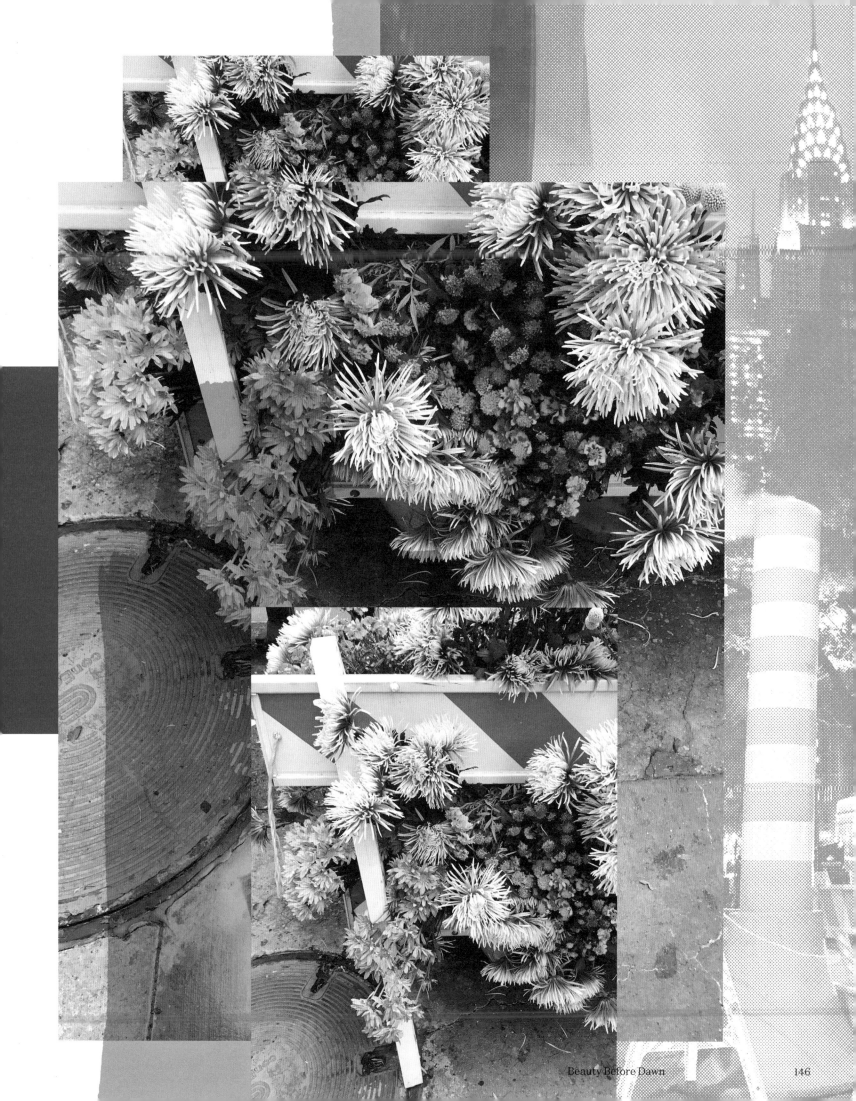

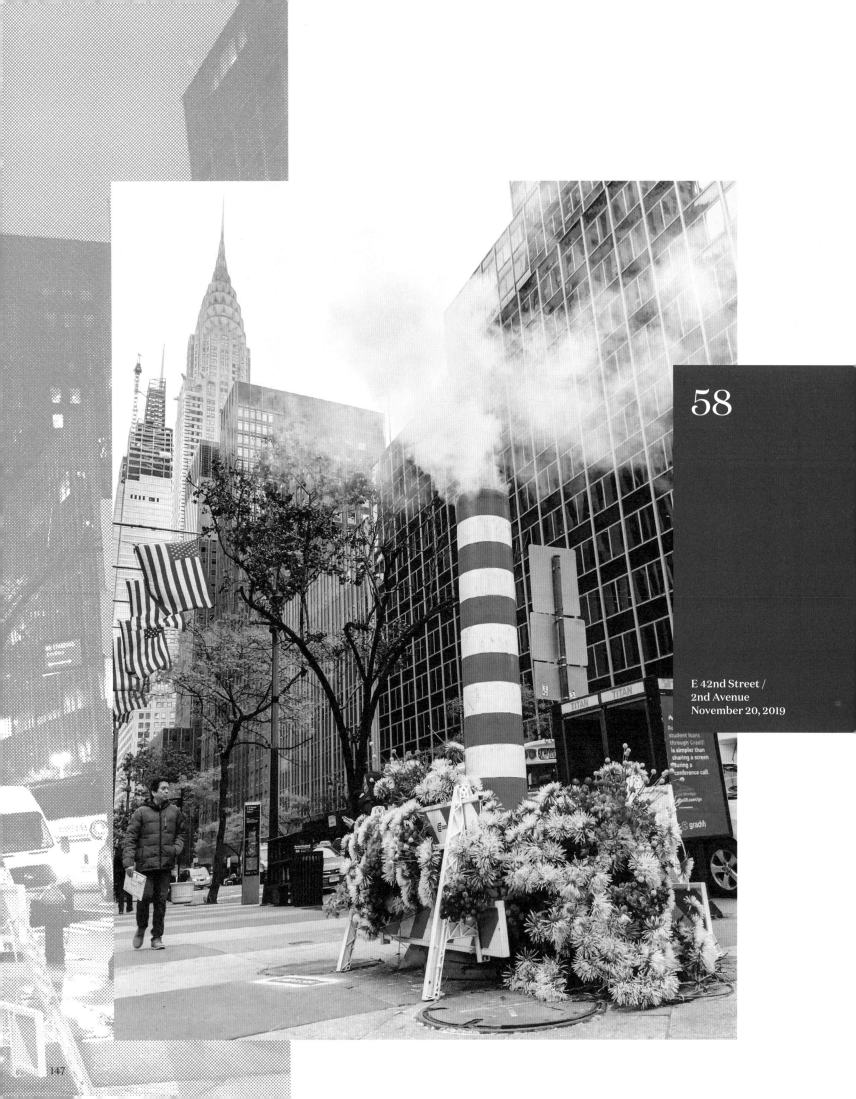

58

E 42nd Street /
2nd Avenue
November 20, 2019

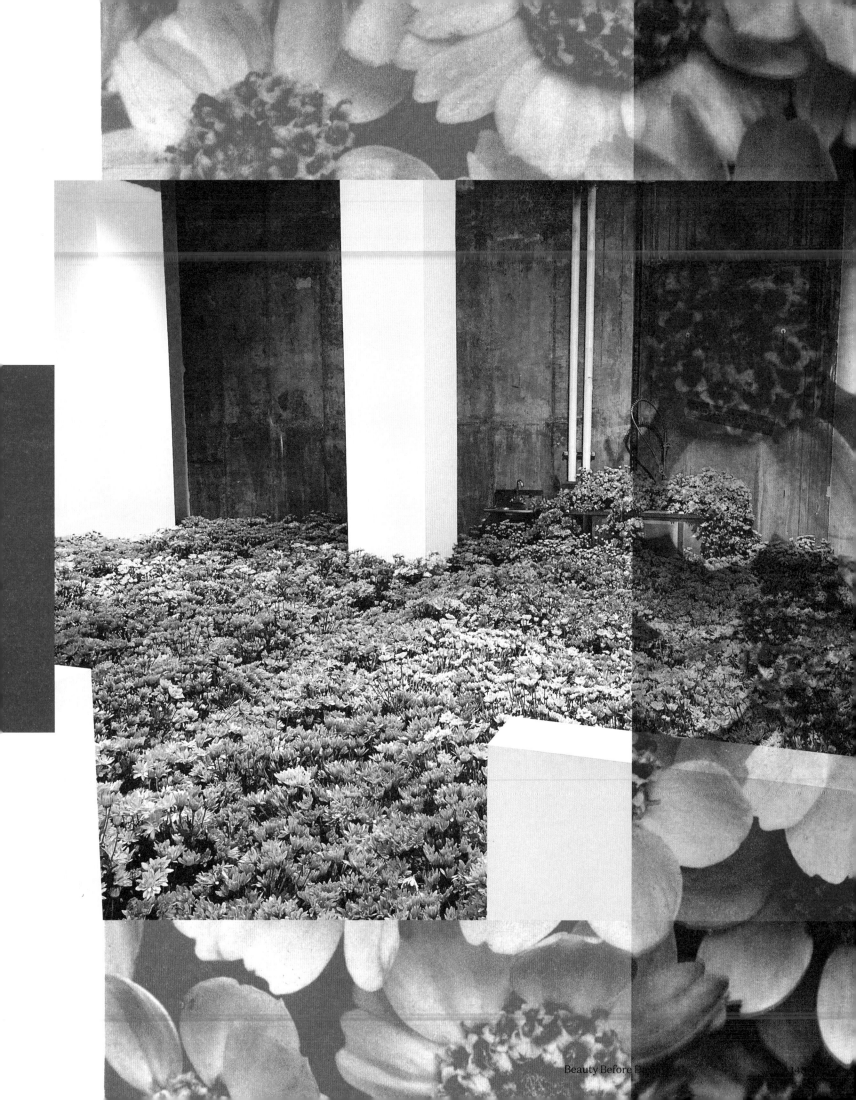

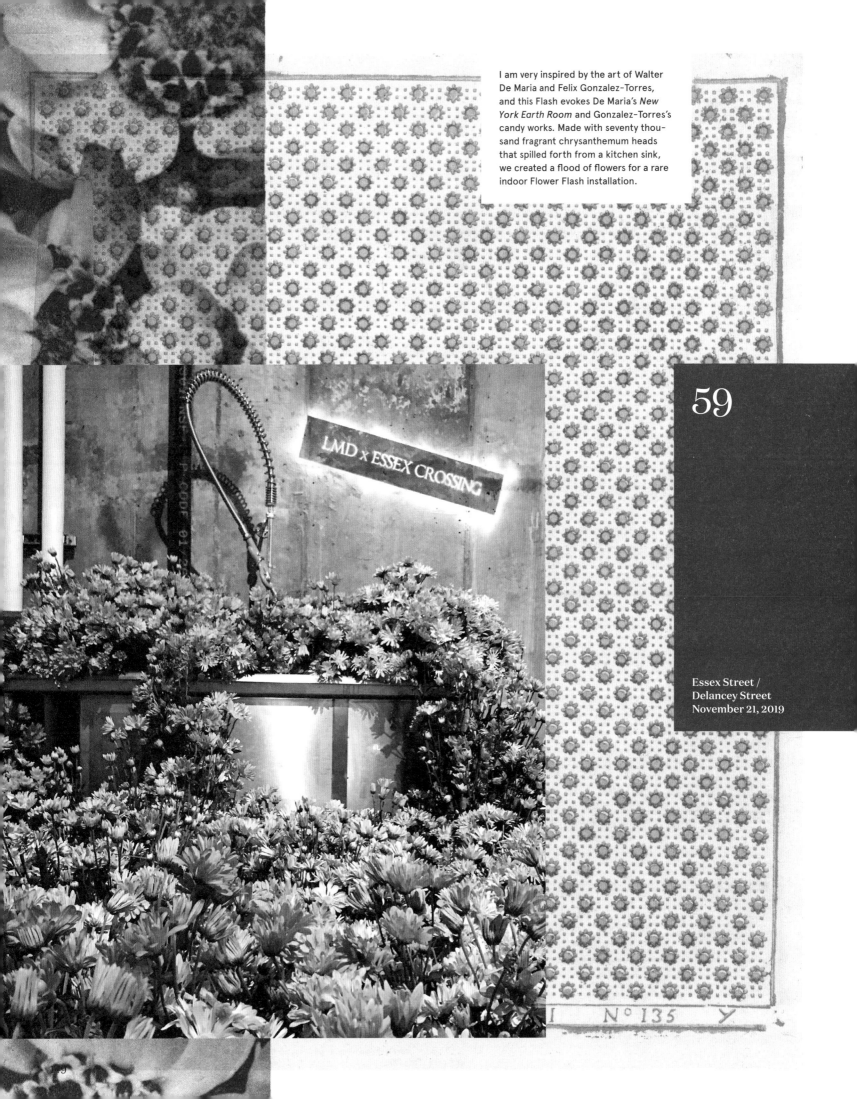

I am very inspired by the art of Walter De Maria and Felix Gonzalez-Torres, and this Flash evokes De Maria's *New York Earth Room* and Gonzalez-Torres's candy works. Made with seventy thousand fragrant chrysanthemum heads that spilled forth from a kitchen sink, we created a flood of flowers for a rare indoor Flower Flash installation.

LMD x ESSEX CROSSING

59

Essex Street /
Delancey Street
November 21, 2019

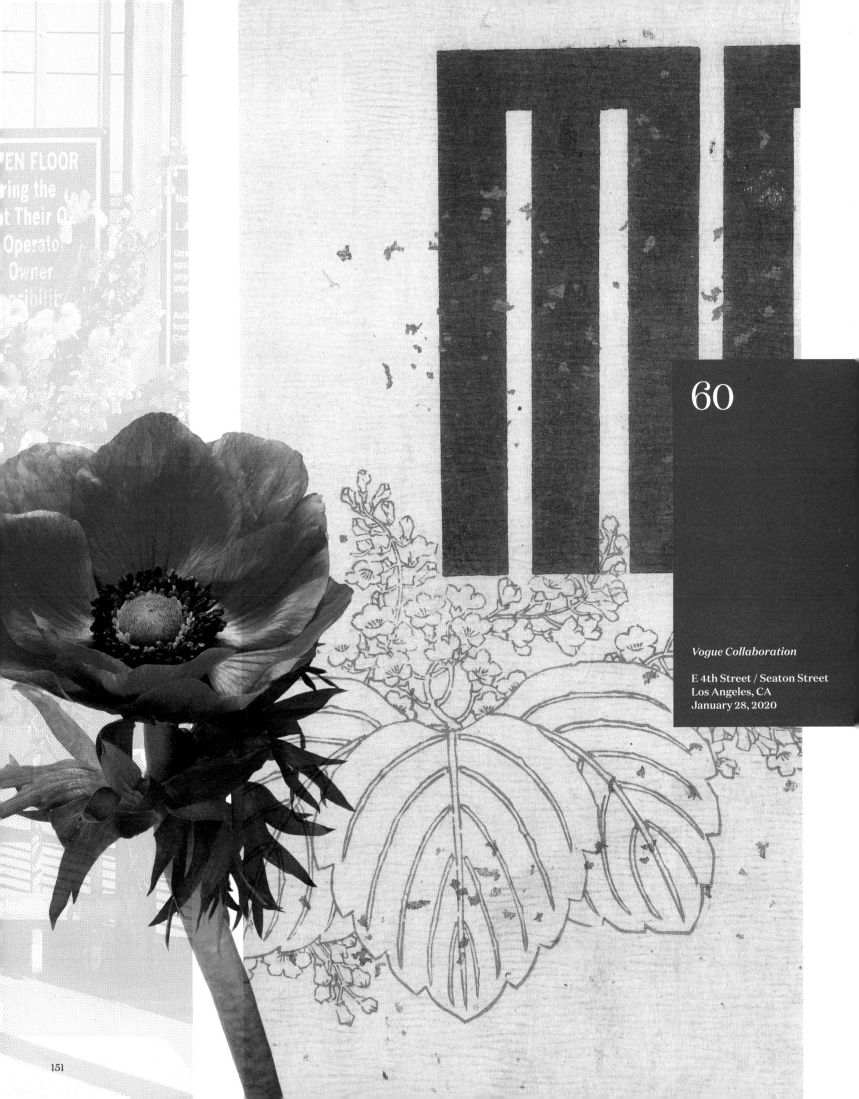

60

Vogue Collaboration

E 4th Street / Seaton Street
Los Angeles, CA
January 28, 2020

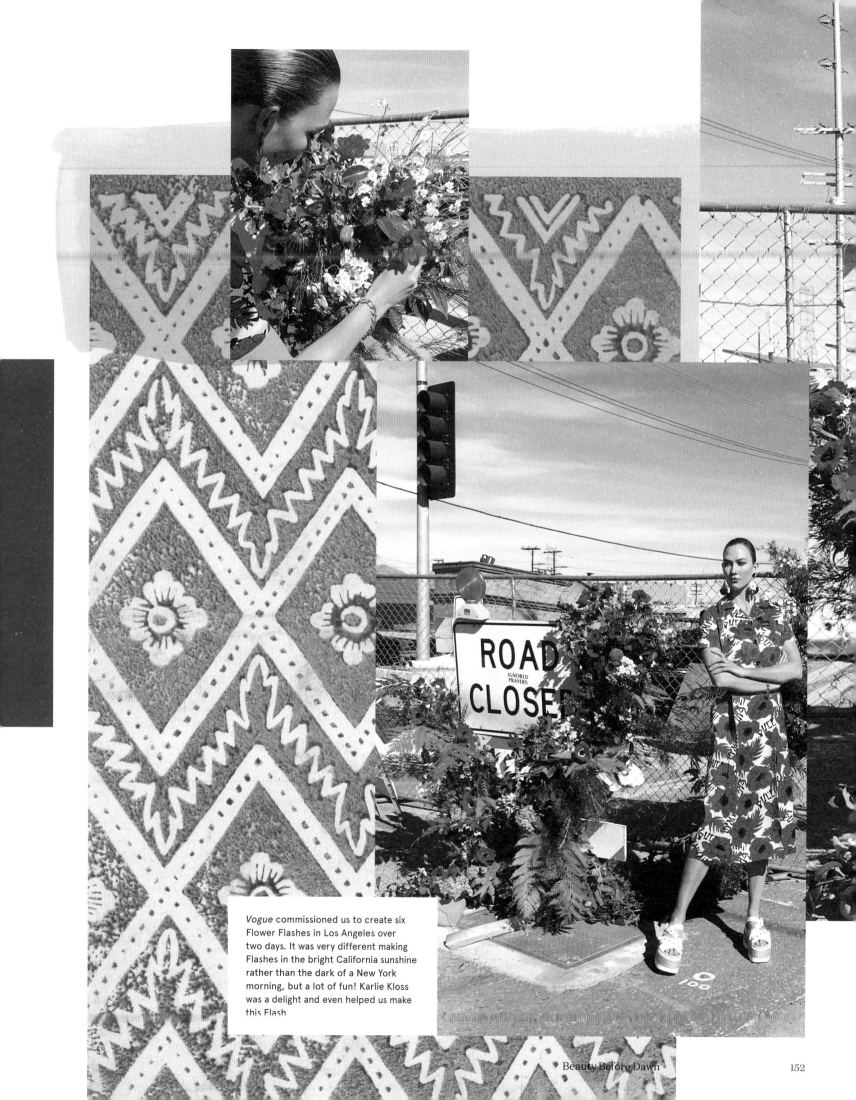

Vogue commissioned us to create six Flower Flashes in Los Angeles over two days. It was very different making Flashes in the bright California sunshine rather than the dark of a New York morning, but a lot of fun! Karlie Kloss was a delight and even helped us make this Flash

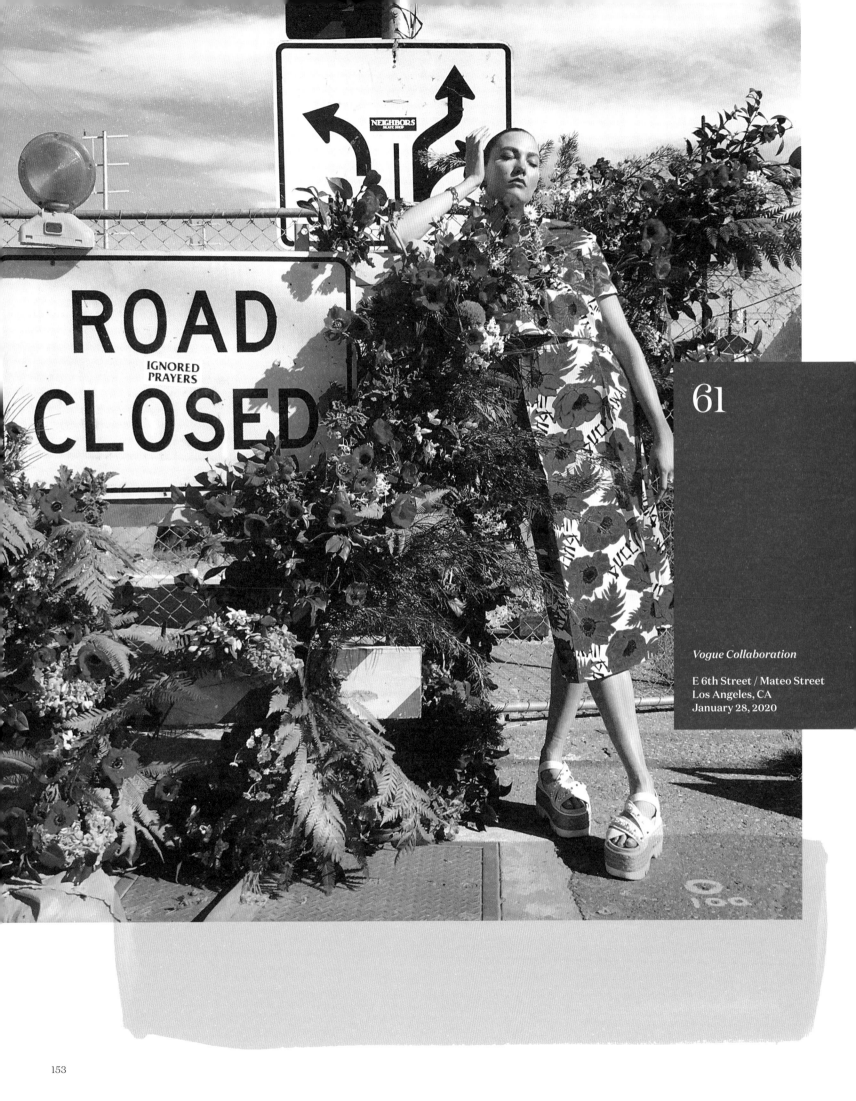

ROAD
IGNORED
PRAYERS
CLOSED

61

Vogue Collaboration

E 6th Street / Mateo Street
Los Angeles, CA
January 28, 2020

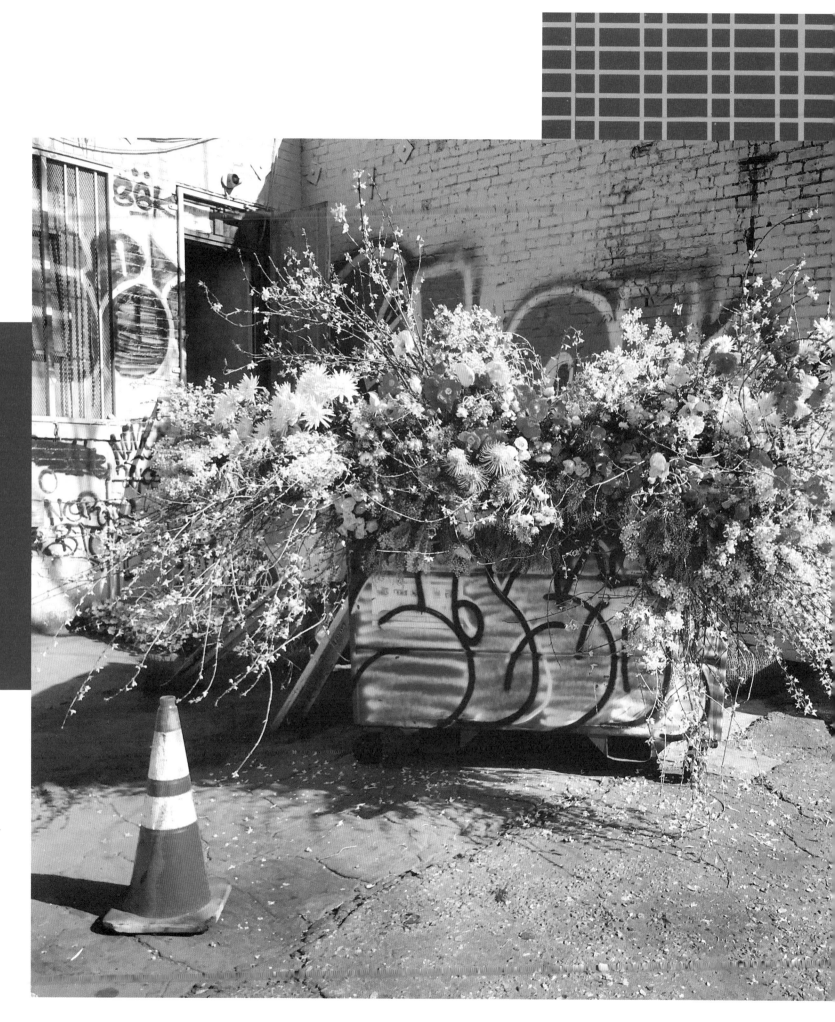

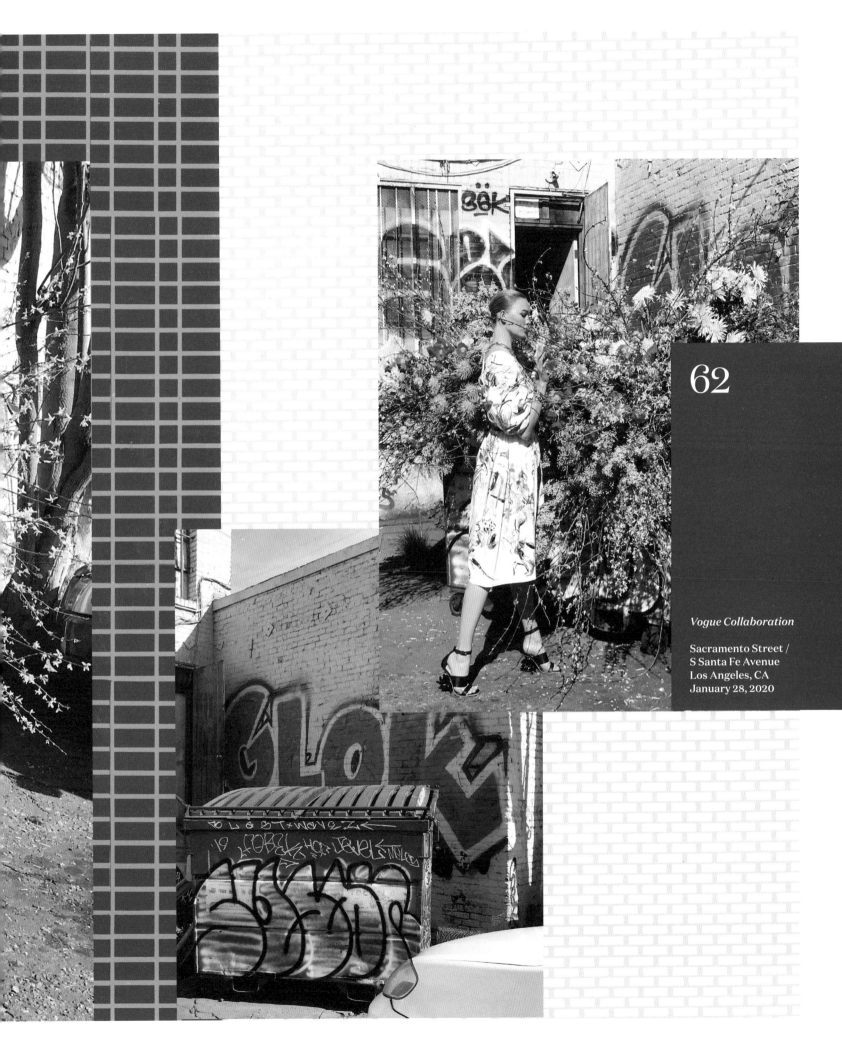

62

Vogue Collaboration

Sacramento Street /
S Santa Fe Avenue
Los Angeles, CA
January 28, 2020

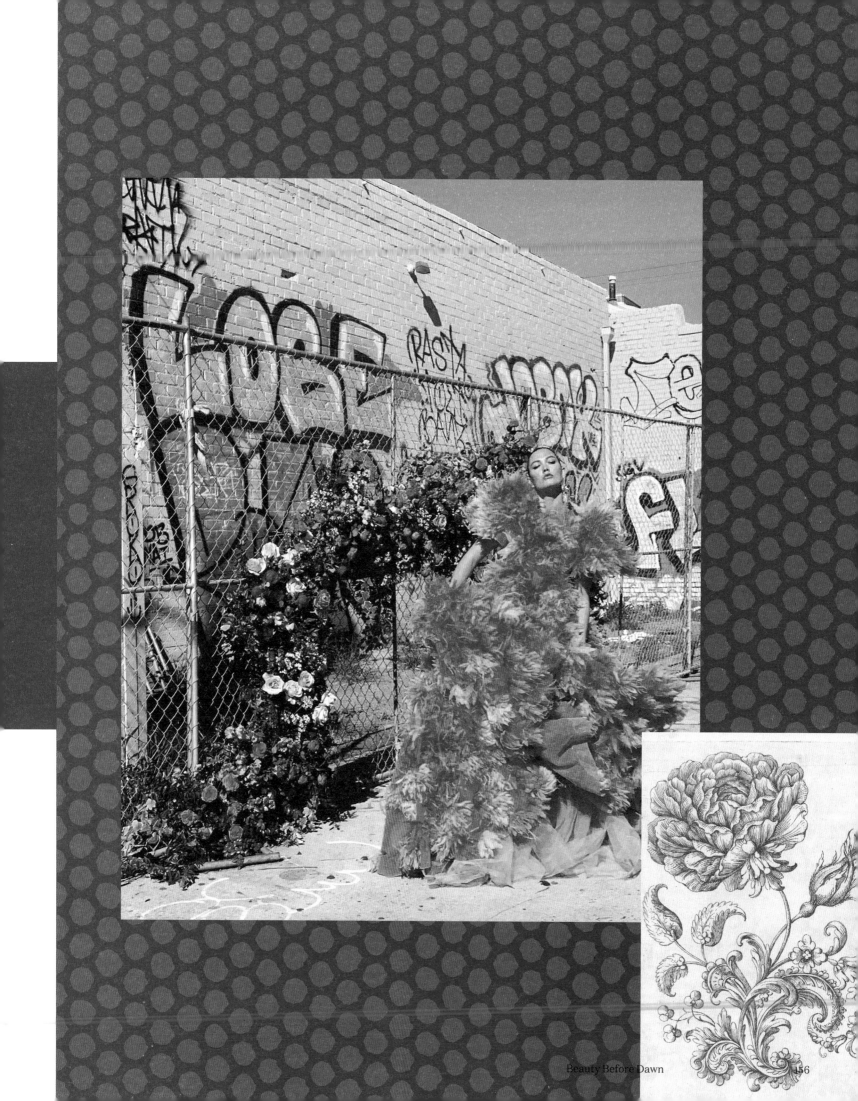

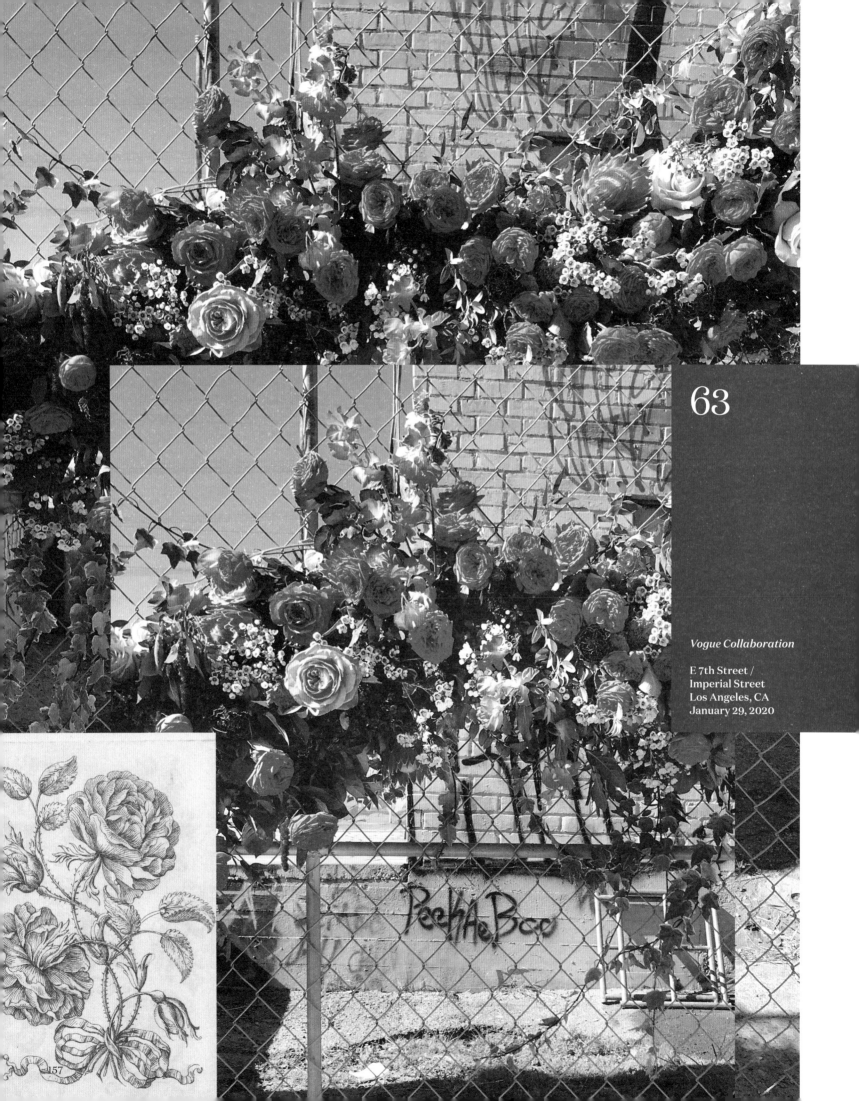

63

Vogue Collaboration

E 7th Street /
Imperial Street
Los Angeles, CA
January 29, 2020

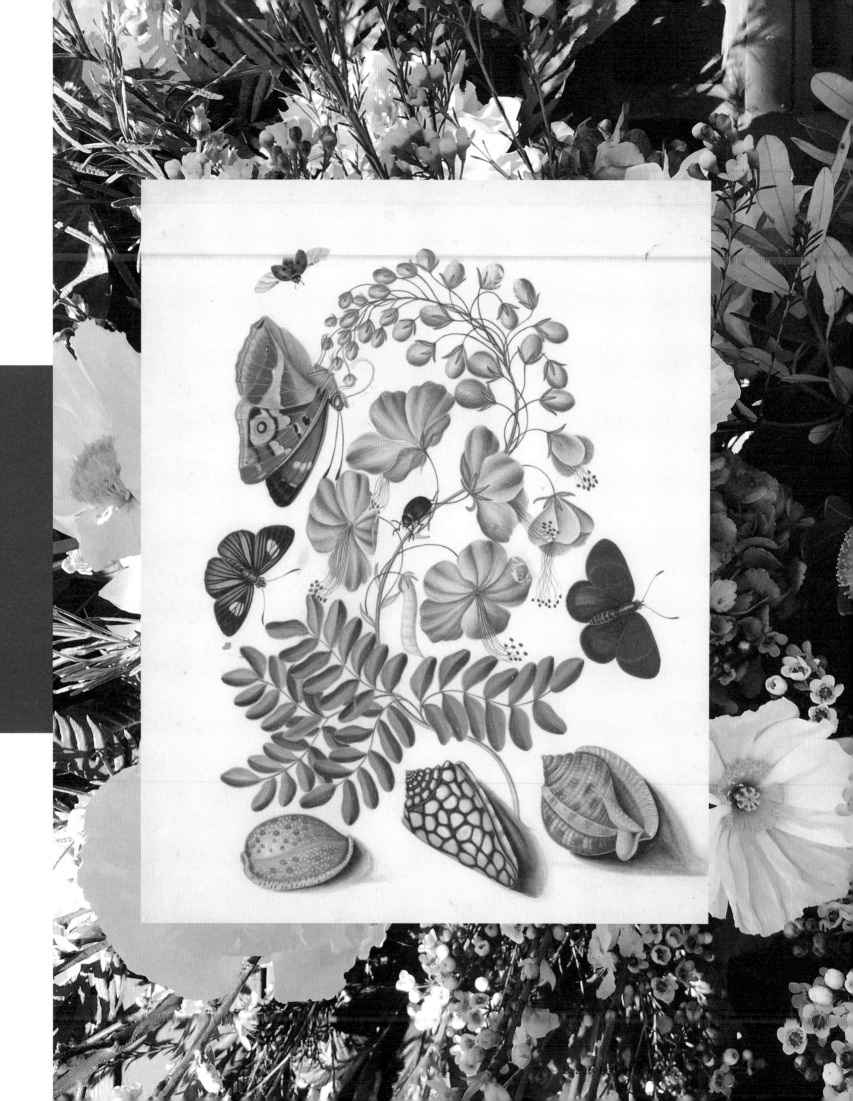

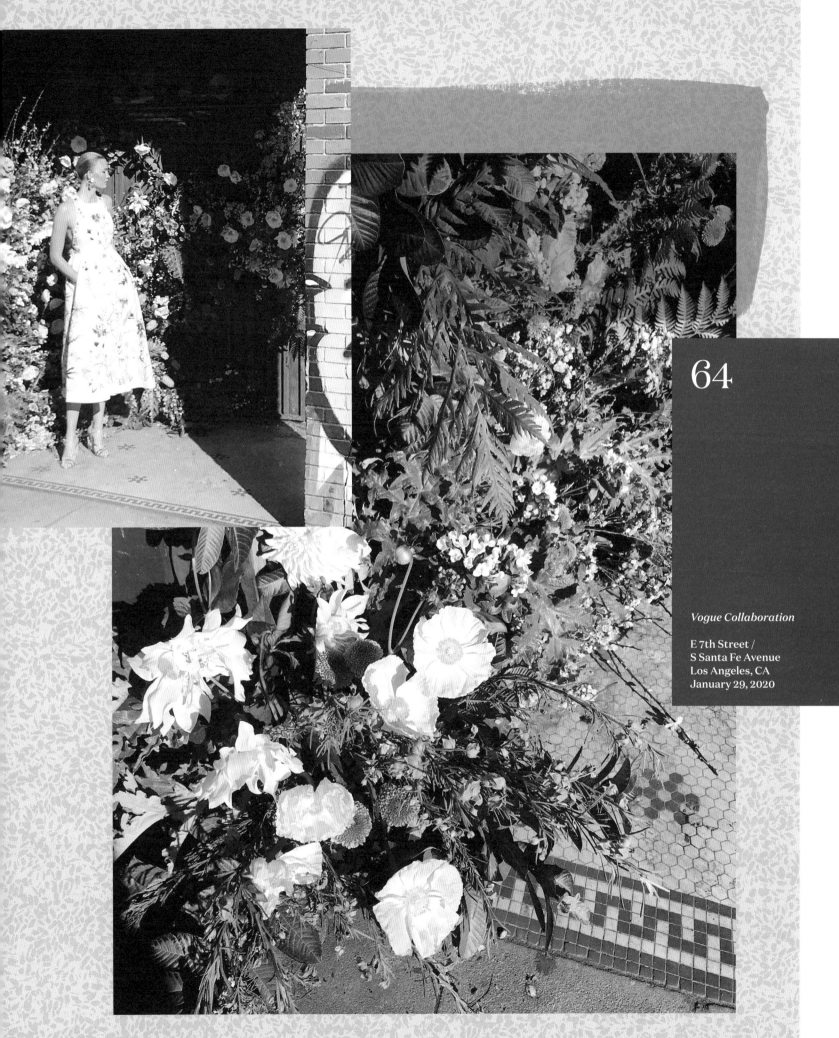

64

Vogue Collaboration

E 7th Street /
S Santa Fe Avenue
Los Angeles, CA
January 29, 2020

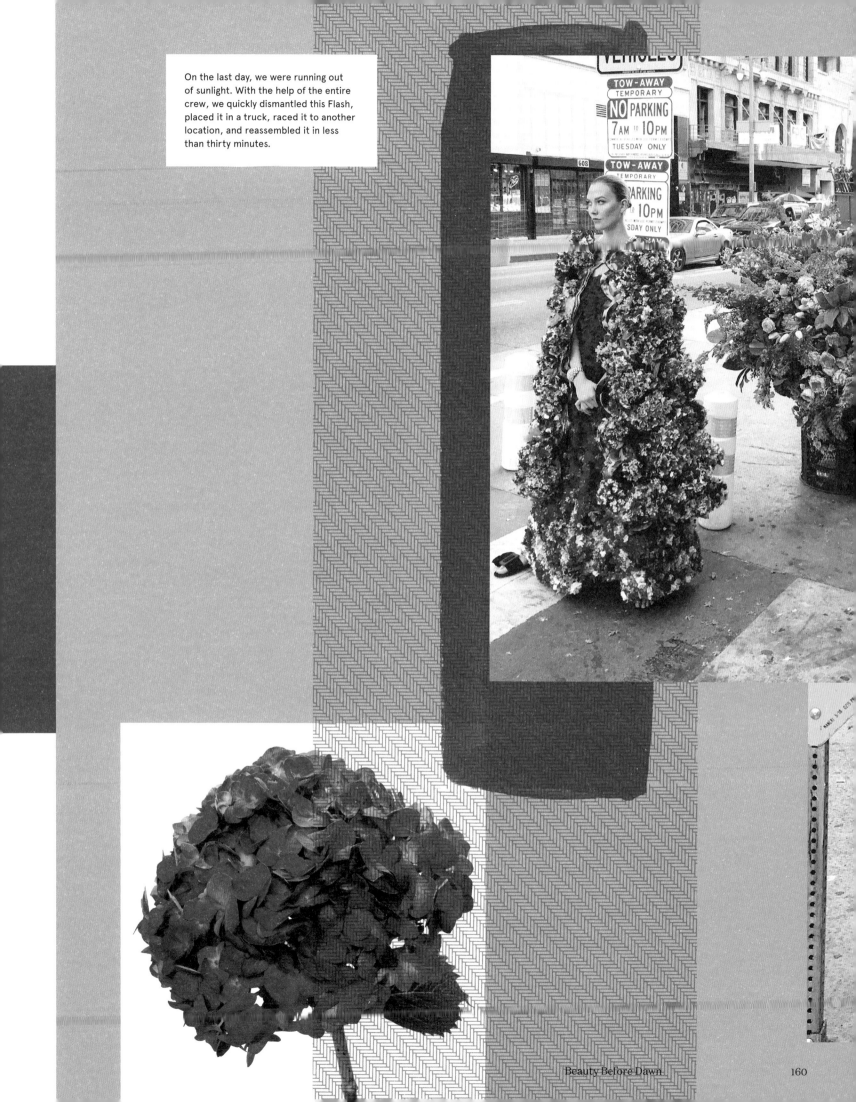

On the last day, we were running out of sunlight. With the help of the entire crew, we quickly dismantled this Flash, placed it in a truck, raced it to another location, and reassembled it in less than thirty minutes.

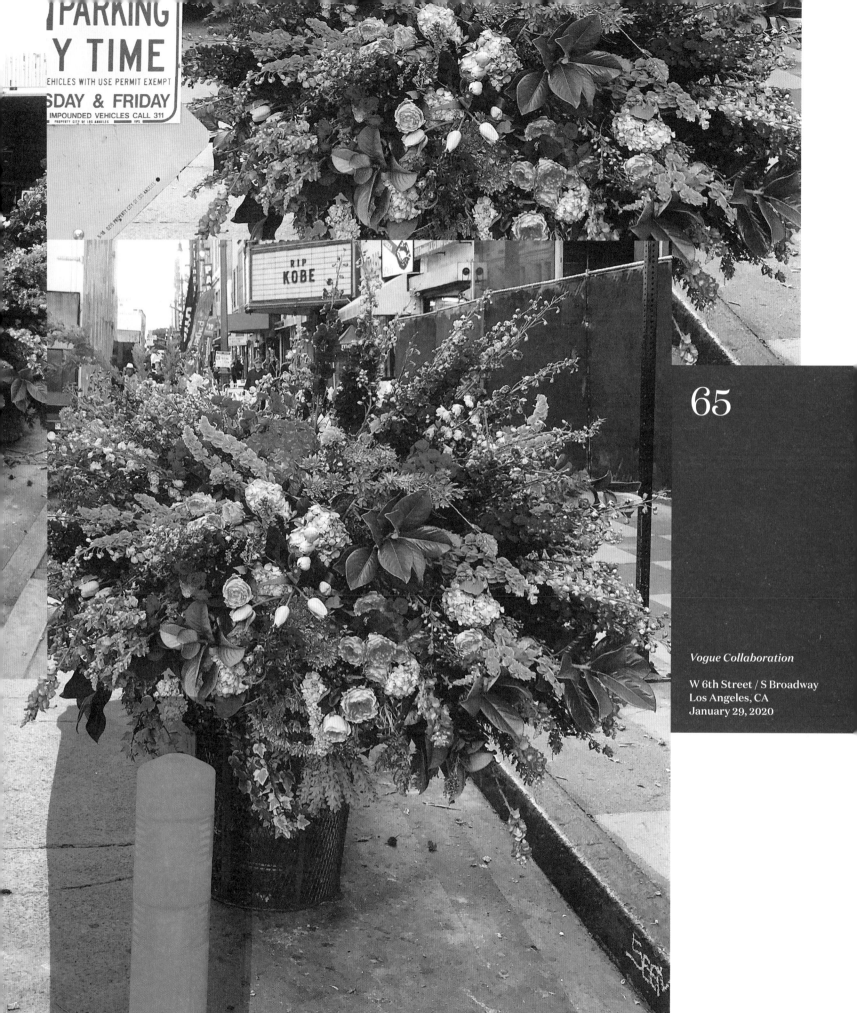

65

Vogue Collaboration

W 6th Street / S Broadway
Los Angeles, CA
January 29, 2020

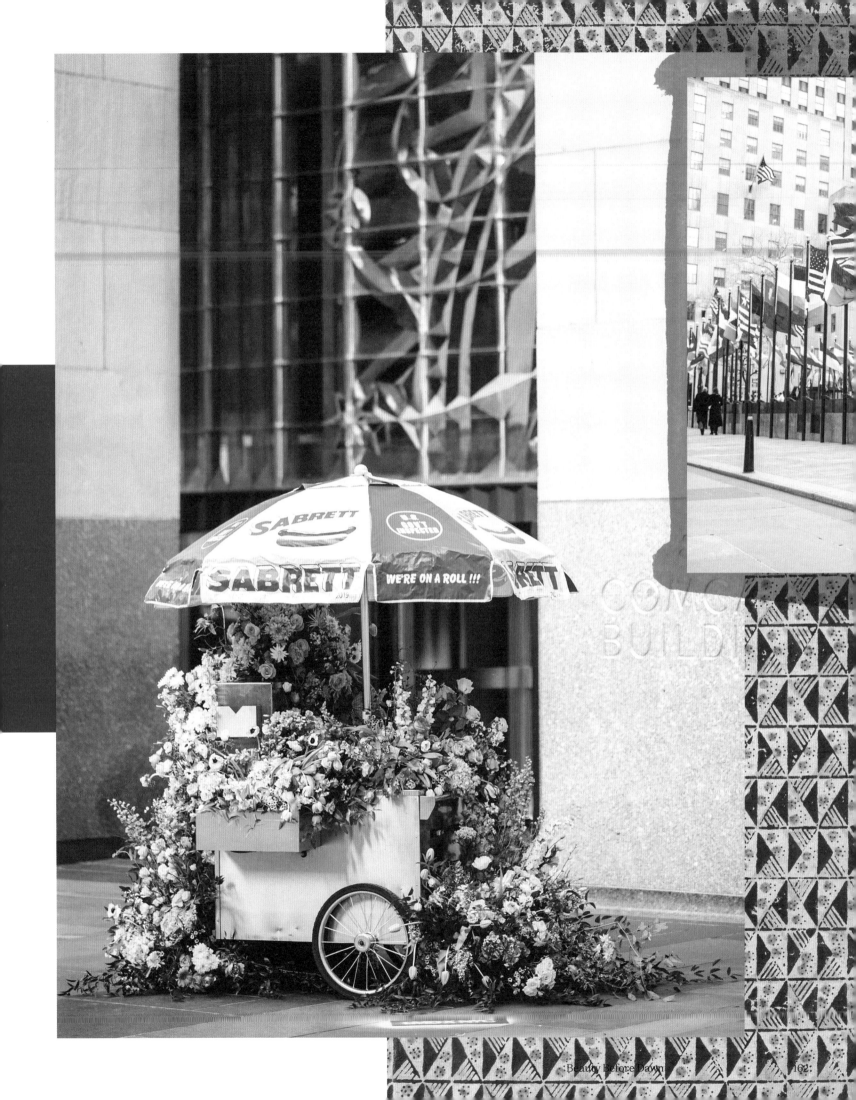

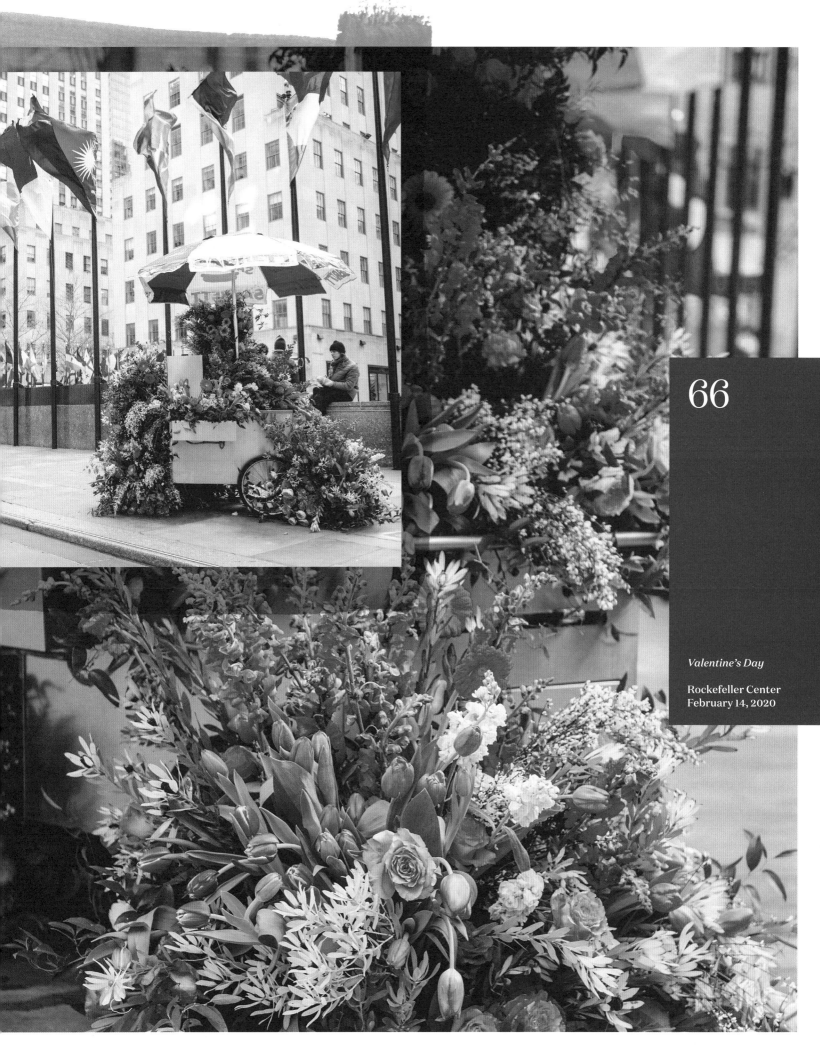

66

Valentine's Day

Rockefeller Center
February 14, 2020

BEAUTY IN
THE DARK

After the last stem is speared into a Flash, I spray-paint a stencil on the sidewalk that reads: LMD X NYC. I do this in chalk, which washes away in the rain. It's my way of saying LMD Was Here . . . for a short while.

Early on the morning of March 12, 2020, I took buckets of poppies, garden roses, flowering quince, fragrant lilac, orchids, and sweet pea and outfitted a dirty, abandoned pay phone outside the Museum of Sex on Twenty-Seventh Street and Fifth Avenue. The exquisite mix of blooms was intended for a glamorous dinner party on the Upper East Side—now canceled.

Irini was waiting for the sun to rise to document this flowering tower that resembled a vivacious, louche woman hailing a cab after a decadent night out. The irony was, there would be no more nights out for a very long time. Typically, the city on Flower Flash mornings is sleepy and quiet, but the streets on this day felt eerie and desolate. Our message to New Yorkers: Chin up! We know it's been a strange week, but there will always be Flower Flashes. And there will always be reminders that joy, hope, and beauty abound.

It was a very strange week and the weeks that followed became even stranger (and would become hard and heartbreaking). As every event on the LMD calendar was canceled or postponed, fear and anxiety began to creep in. But I knew, even at that early stage of the pandemic, that I would keep Flashing.

Flowers have an undeniable emotional power. They have been part of the human experience since the beginning of time. We rely on them to convey and declare our sincerest wishes: I Love You, Forgive Me, Thank You, Get Well Soon. When we can't find the words, they communicate for us. As New York City went into lockdown, and the weeks turned into months, flowers became my way of communicating to my fellow New Yorkers. My declarations? Stay positive. Have hope. We are in this together.

Amid the crisis, I found a renewed sense of purpose and responsibility. We would focus our first series of pandemic-era Flower Flashes around New York hospitals, dedicating these Flashes to the healthcare and essential workers fighting the coronavirus. It was a no-brainer; these people were on the front lines, risking their lives to save ours. Surprising them with an eruption of cherry blossoms on their way to work, during a very cold and bleak spring, was the least we could do. My team and I narrowed our eyes, and our random acts of beauty became focused acts of gratitude.

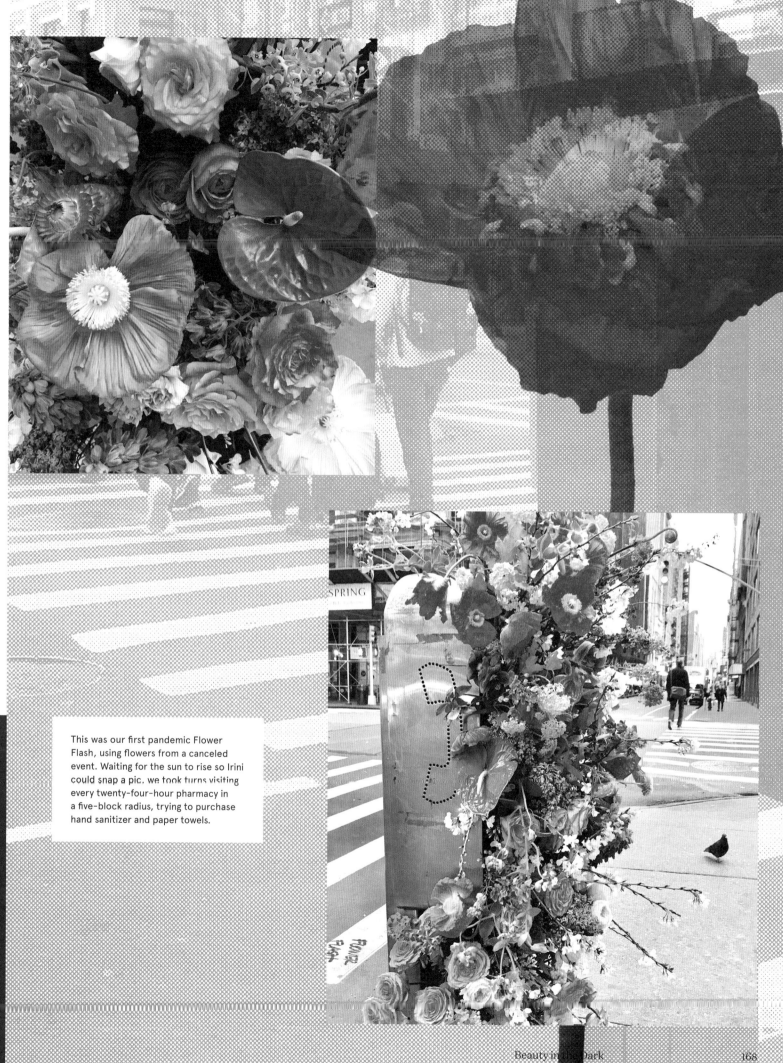

This was our first pandemic Flower Flash, using flowers from a canceled event. Waiting for the sun to rise so Irini could snap a pic, we took turns visiting every twenty-four-hour pharmacy in a five-block radius, trying to purchase hand sanitizer and paper towels.

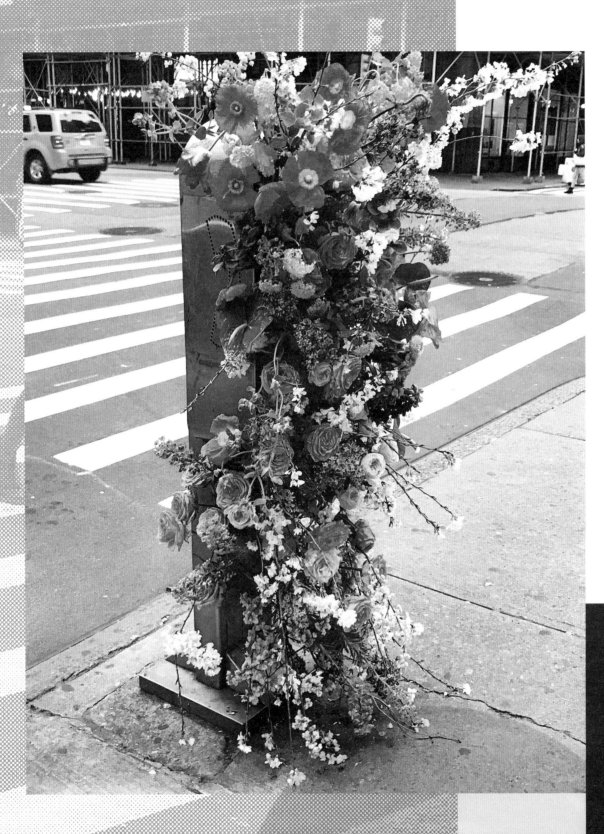

67

Museum of Sex
27th Street /
5th Avenue
March 12, 2020

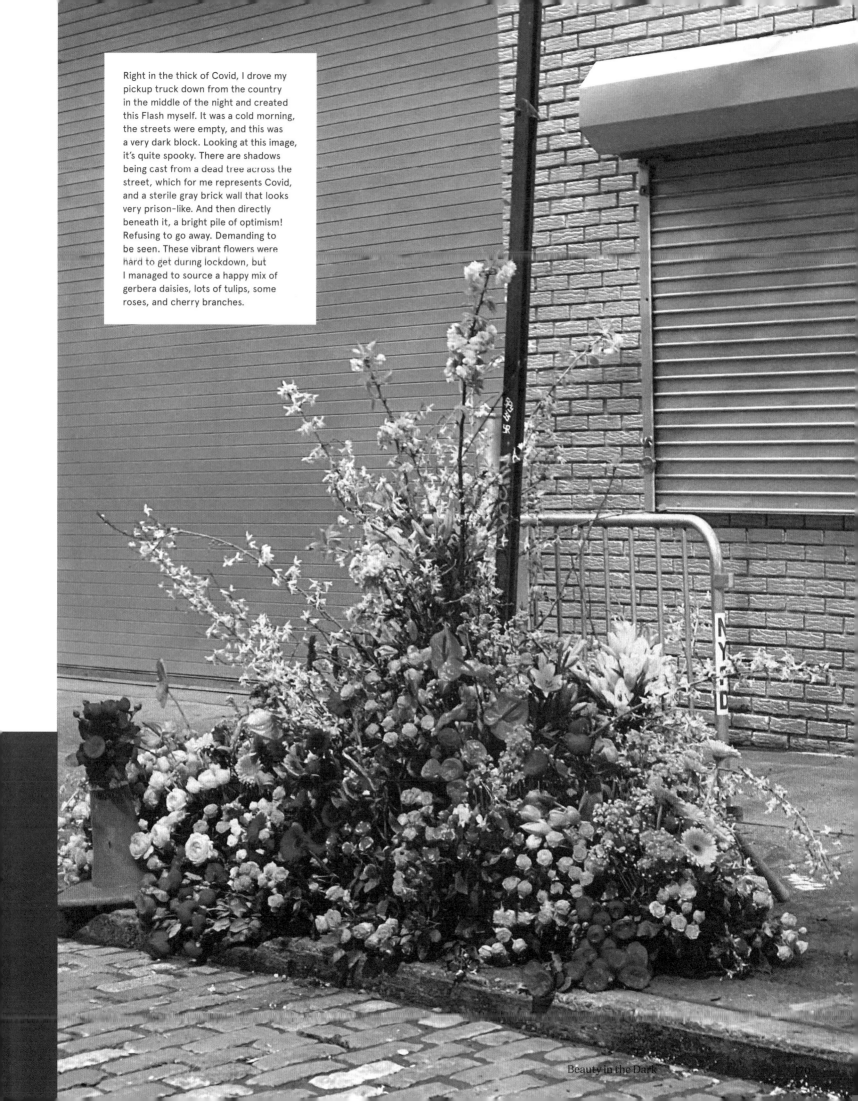

Right in the thick of Covid, I drove my pickup truck down from the country in the middle of the night and created this Flash myself. It was a cold morning, the streets were empty, and this was a very dark block. Looking at this image, it's quite spooky. There are shadows being cast from a dead tree across the street, which for me represents Covid, and a sterile gray brick wall that looks very prison-like. And then directly beneath it, a bright pile of optimism! Refusing to go away. Demanding to be seen. These vibrant flowers were hard to get during lockdown, but I managed to source a happy mix of gerbera daisies, lots of tulips, some roses, and cherry branches.

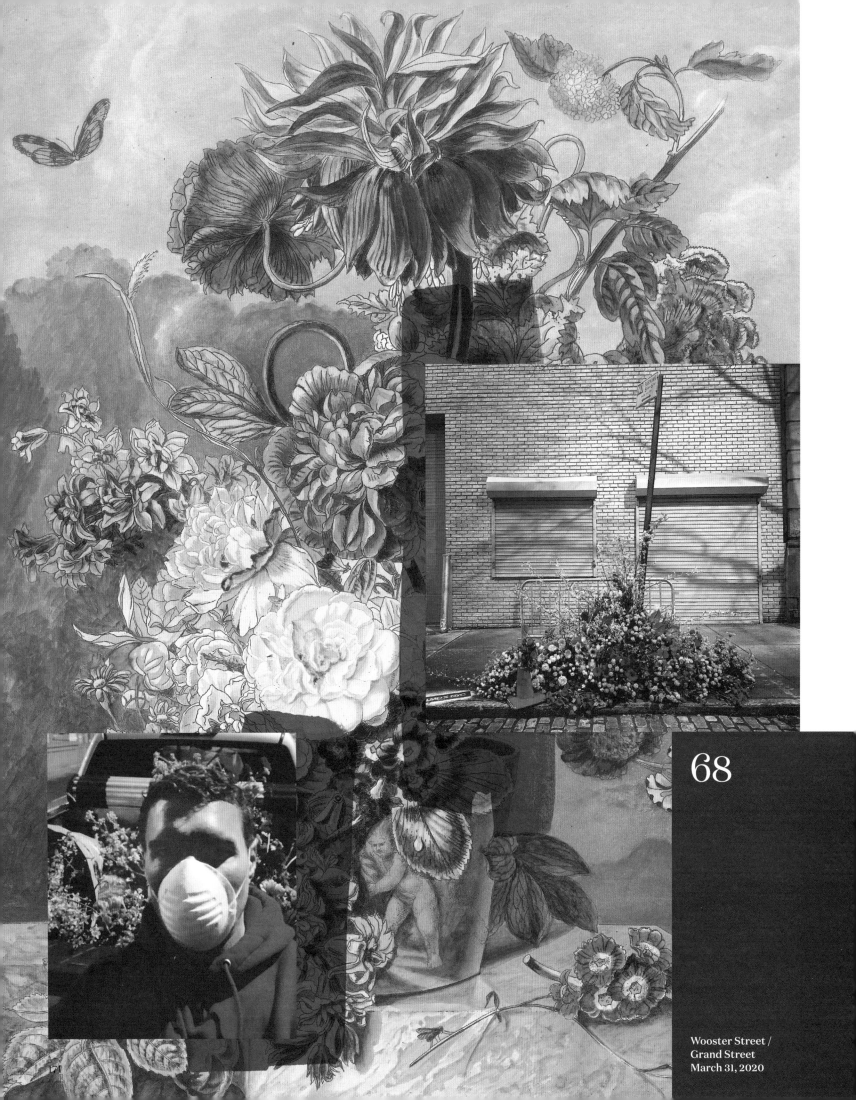

68

Wooster Street /
Grand Street
March 31, 2020

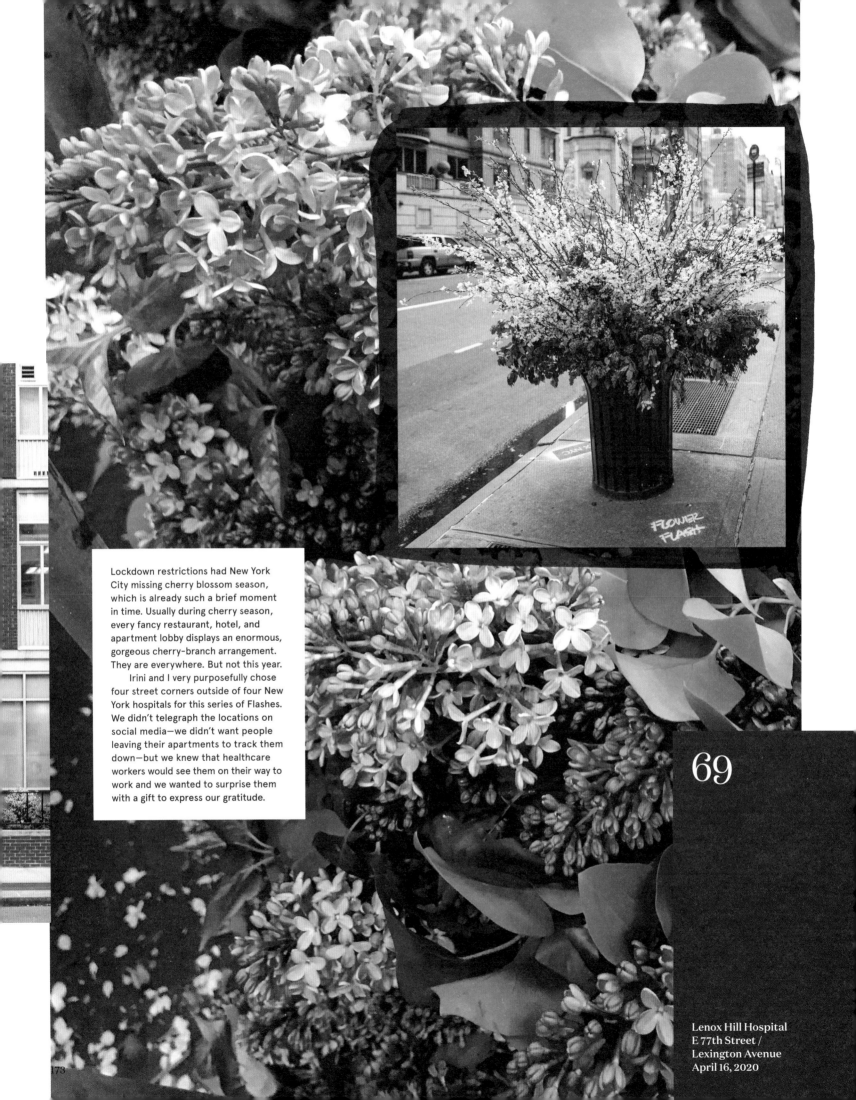

Lockdown restrictions had New York City missing cherry blossom season, which is already such a brief moment in time. Usually during cherry season, every fancy restaurant, hotel, and apartment lobby displays an enormous, gorgeous cherry-branch arrangement. They are everywhere. But not this year.

Irini and I very purposefully chose four street corners outside of four New York hospitals for this series of Flashes. We didn't telegraph the locations on social media—we didn't want people leaving their apartments to track them down—but we knew that healthcare workers would see them on their way to work and we wanted to surprise them with a gift to express our gratitude.

69

Lenox Hill Hospital
E 77th Street /
Lexington Avenue
April 16, 2020

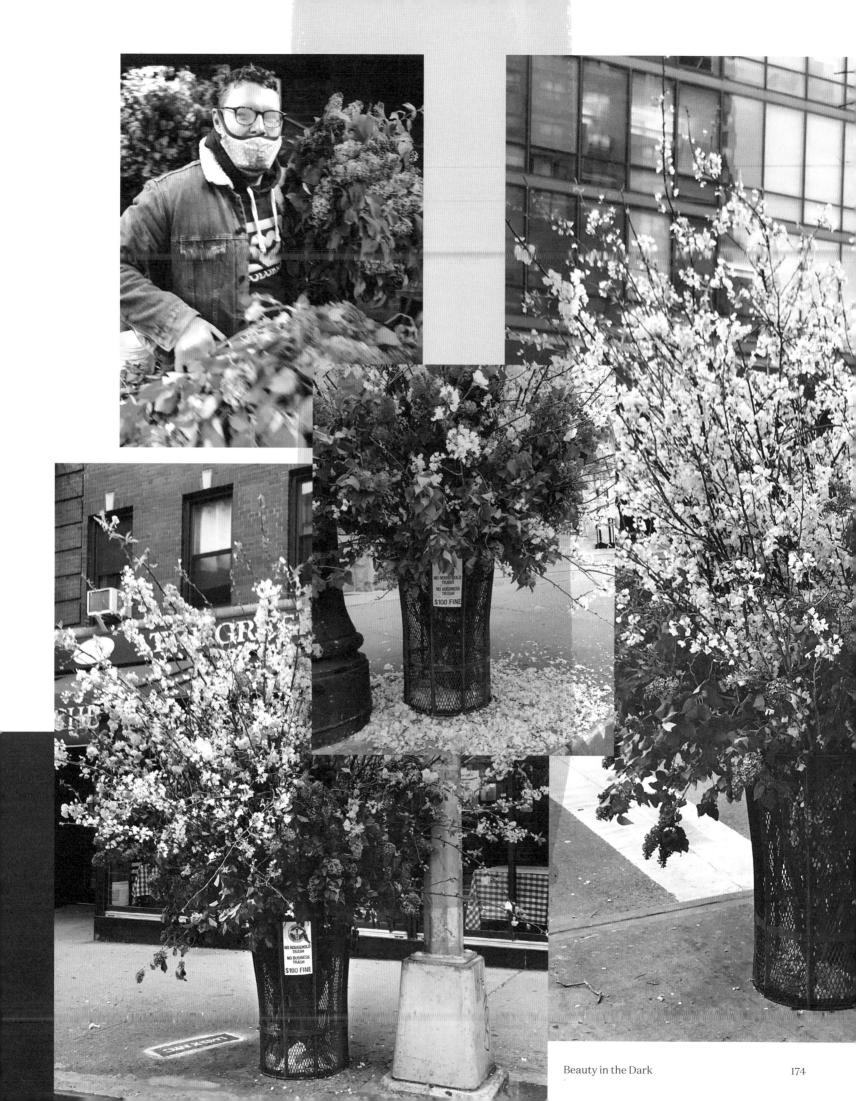

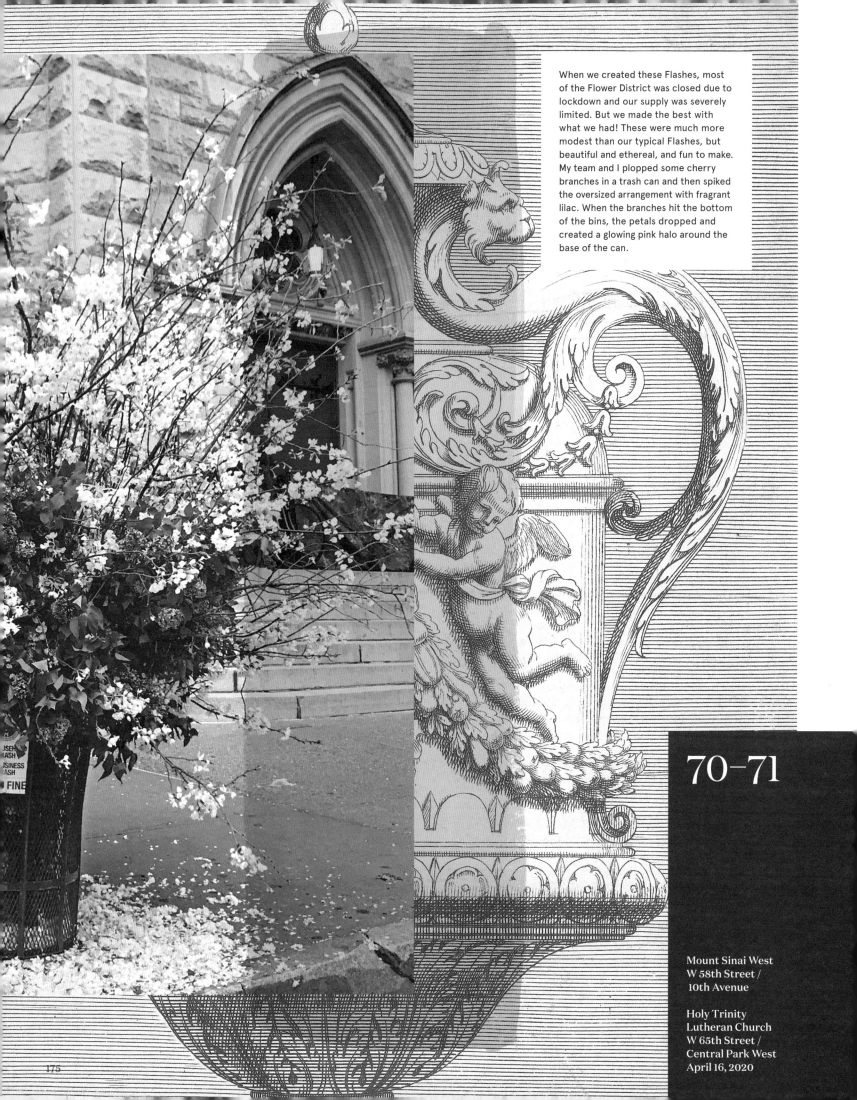

When we created these Flashes, most of the Flower District was closed due to lockdown and our supply was severely limited. But we made the best with what we had! These were much more modest than our typical Flashes, but beautiful and ethereal, and fun to make. My team and I plopped some cherry branches in a trash can and then spiked the oversized arrangement with fragrant lilac. When the branches hit the bottom of the bins, the petals dropped and created a glowing pink halo around the base of the can.

70–71

Mount Sinai West
W 58th Street /
10th Avenue

Holy Trinity
Lutheran Church
W 65th Street /
Central Park West
April 16, 2020

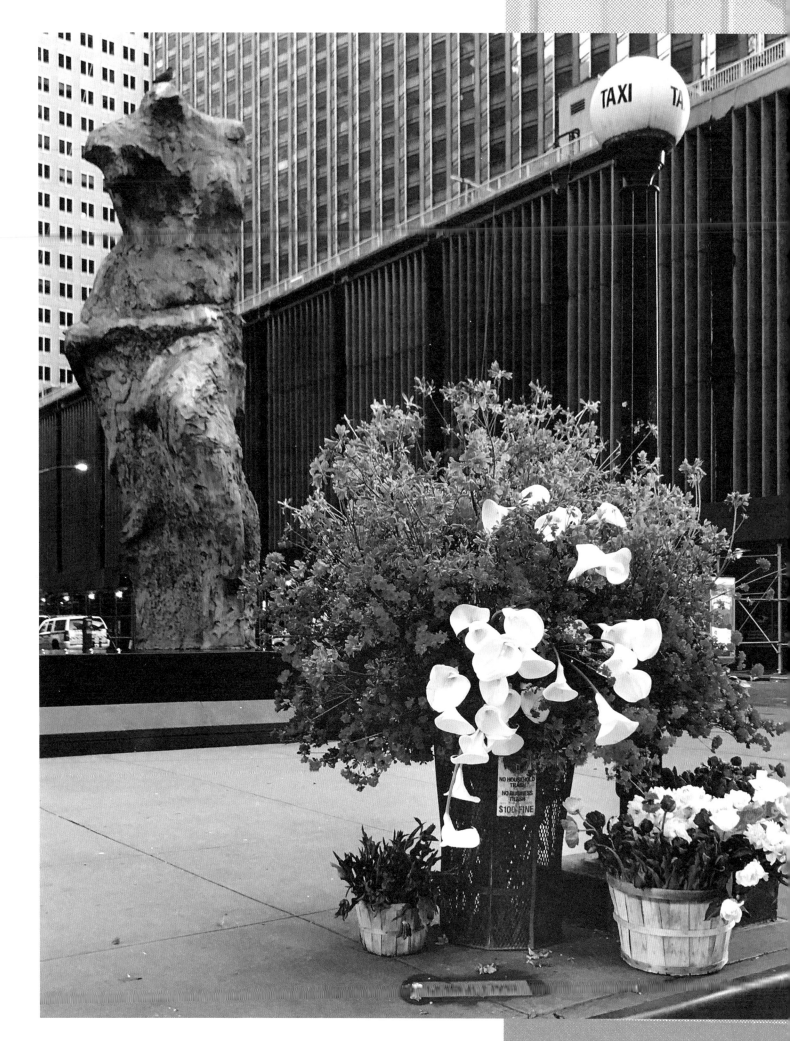

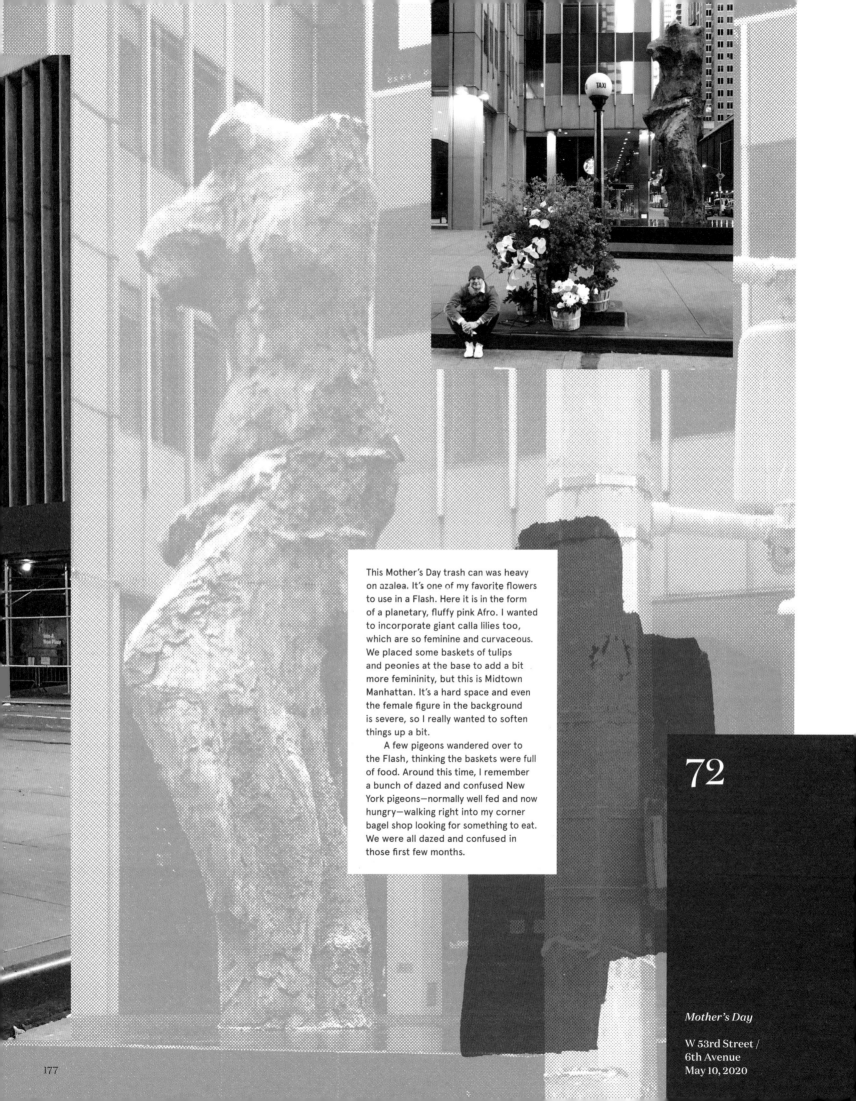

This Mother's Day trash can was heavy on azalea. It's one of my favorite flowers to use in a Flash. Here it is in the form of a planetary, fluffy pink Afro. I wanted to incorporate giant calla lilies too, which are so feminine and curvaceous. We placed some baskets of tulips and peonies at the base to add a bit more femininity, but this is Midtown Manhattan. It's a hard space and even the female figure in the background is severe, so I really wanted to soften things up a bit.

A few pigeons wandered over to the Flash, thinking the baskets were full of food. Around this time, I remember a bunch of dazed and confused New York pigeons—normally well fed and now hungry—walking right into my corner bagel shop looking for something to eat. We were all dazed and confused in those first few months.

72

Mother's Day

W 53rd Street /
6th Avenue
May 10, 2020

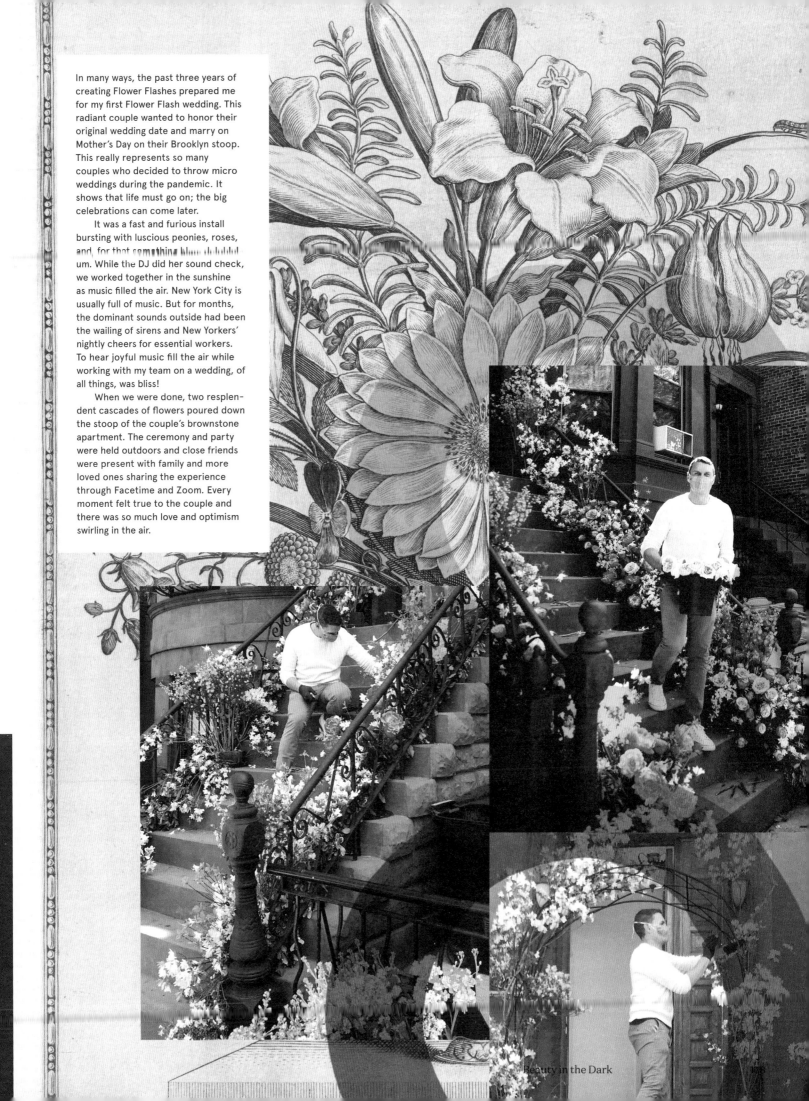

In many ways, the past three years of creating Flower Flashes prepared me for my first Flower Flash wedding. This radiant couple wanted to honor their original wedding date and marry on Mother's Day on their Brooklyn stoop. This really represents so many couples who decided to throw micro weddings during the pandemic. It shows that life must go on; the big celebrations can come later.

It was a fast and furious install bursting with luscious peonies, roses, and, for that something blue, delphinium. While the DJ did her sound check, we worked together in the sunshine as music filled the air. New York City is usually full of music. But for months, the dominant sounds outside had been the wailing of sirens and New Yorkers' nightly cheers for essential workers. To hear joyful music fill the air while working with my team on a wedding, of all things, was bliss!

When we were done, two resplendent cascades of flowers poured down the stoop of the couple's brownstone apartment. The ceremony and party were held outdoors and close friends were present with family and more loved ones sharing the experience through Facetime and Zoom. Every moment felt true to the couple and there was so much love and optimism swirling in the air.

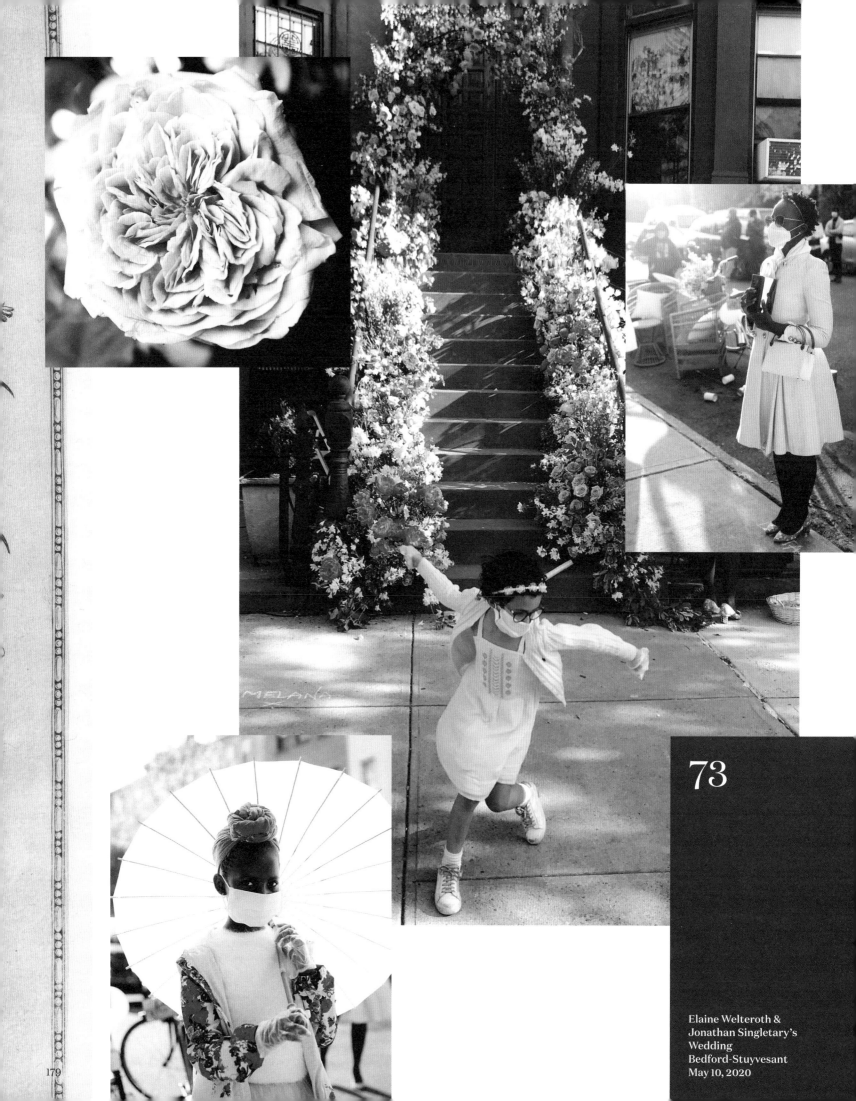

73

Elaine Welteroth &
Jonathan Singletary's
Wedding
Bedford-Stuyvesant
May 10, 2020

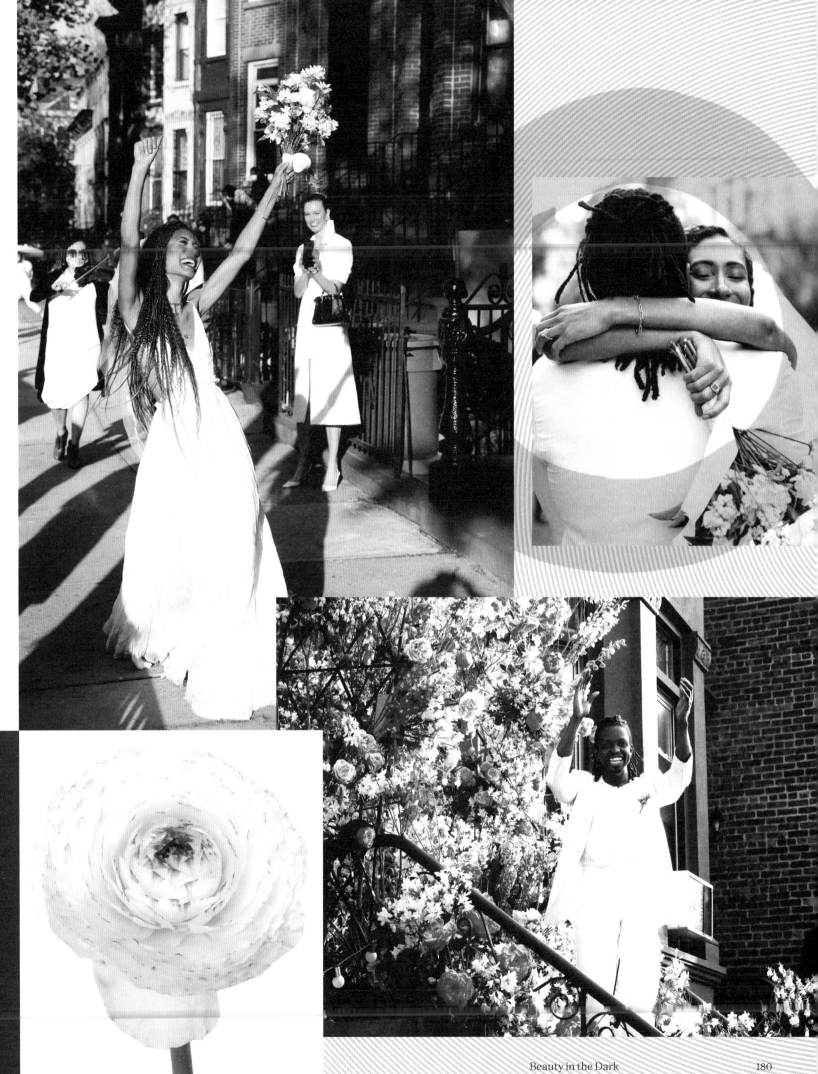

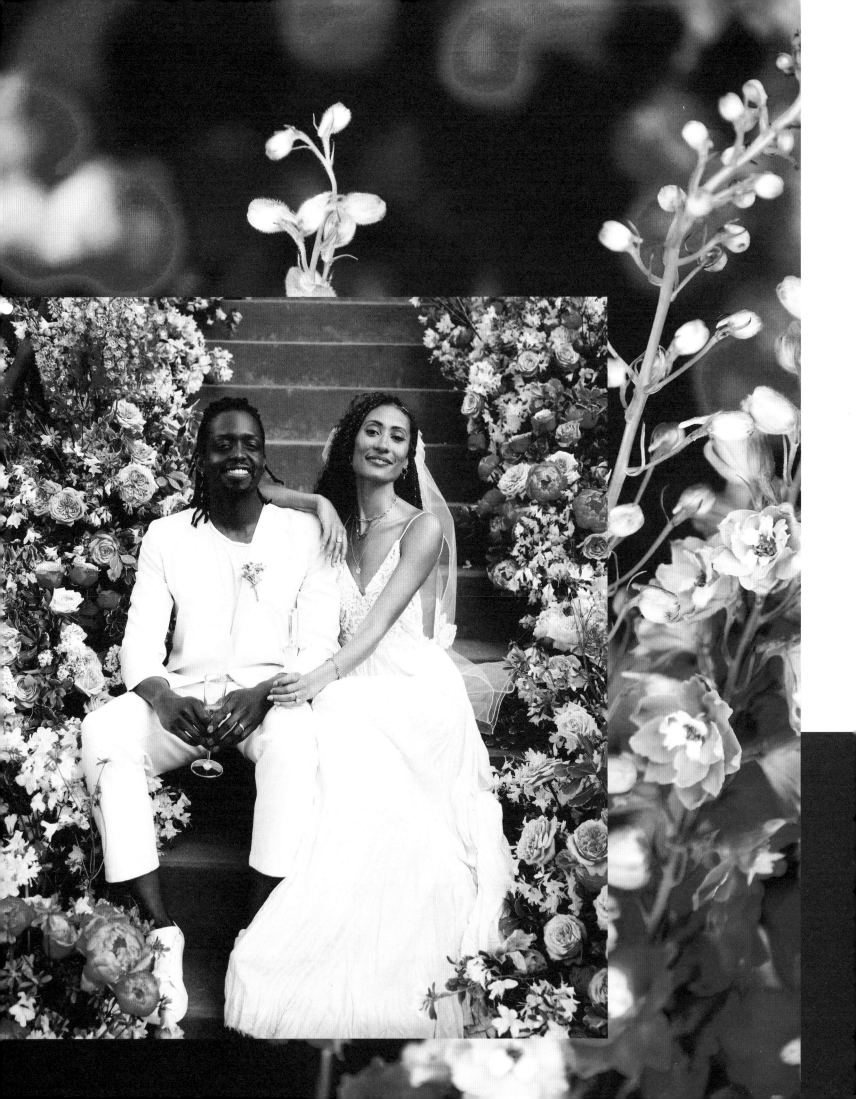

Through the spring, exhausted New York healthcare workers continued to show up and put their lives on the line to take care of those in need during Covid. We partnered with American Express to create this Flower Flash outside New York–Presbyterian Hospital to brighten their day.

This Flash reminds me of a rococo dolphin! I used azalea and cherry branches to create the form and punctuated it with lilac and hot-pink peonies. I love that classical flip of the tail, curving up and around the lamppost. But this lamppost was on hospital property! We never obtain permits and rarely ask for permission when we Flash—the Flower Flashes are spontaneous and it's important to stay true to the spirited and swift way they're made. Five minutes after we finished this one, a security guard sauntered over and had us take it down. Pivoting quickly, we converted the Flower Flash into posies and gifted them to the staff and patients at Memorial Sloan Kettering around the corner.

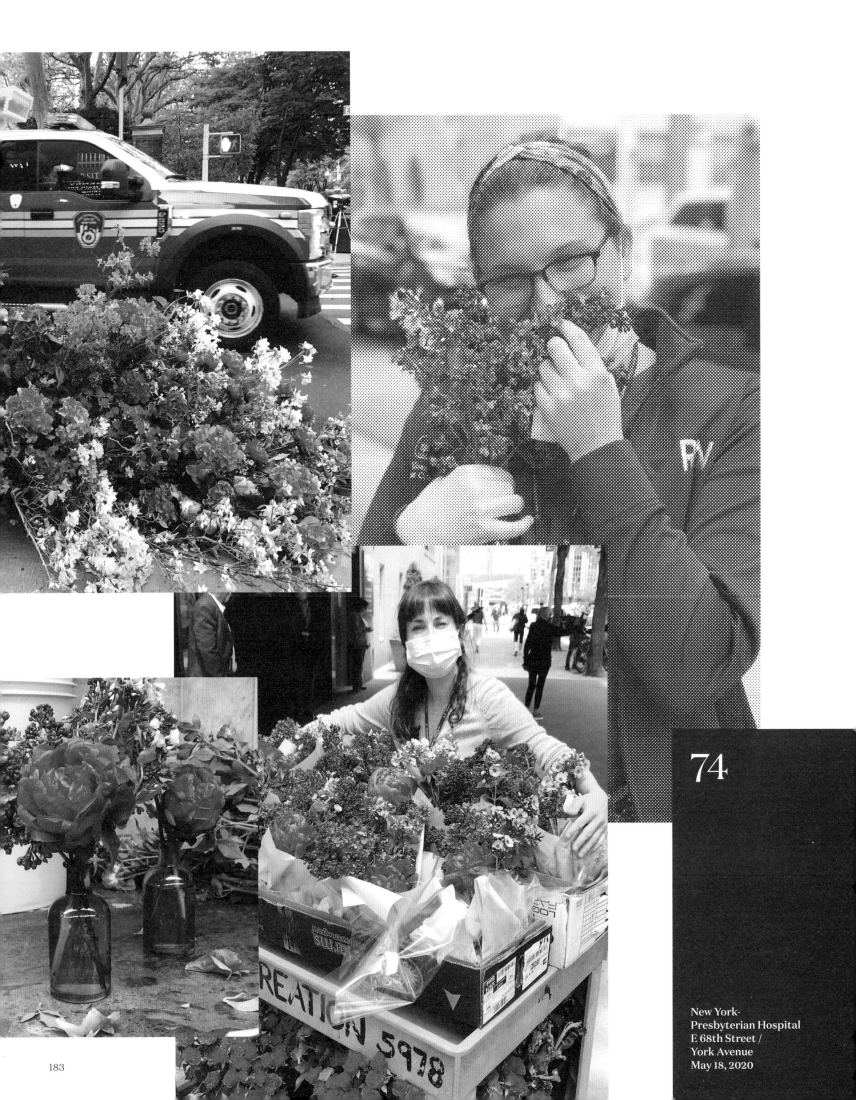

74

New York-
Presbyterian Hospital
E 68th Street /
York Avenue
May 18, 2020

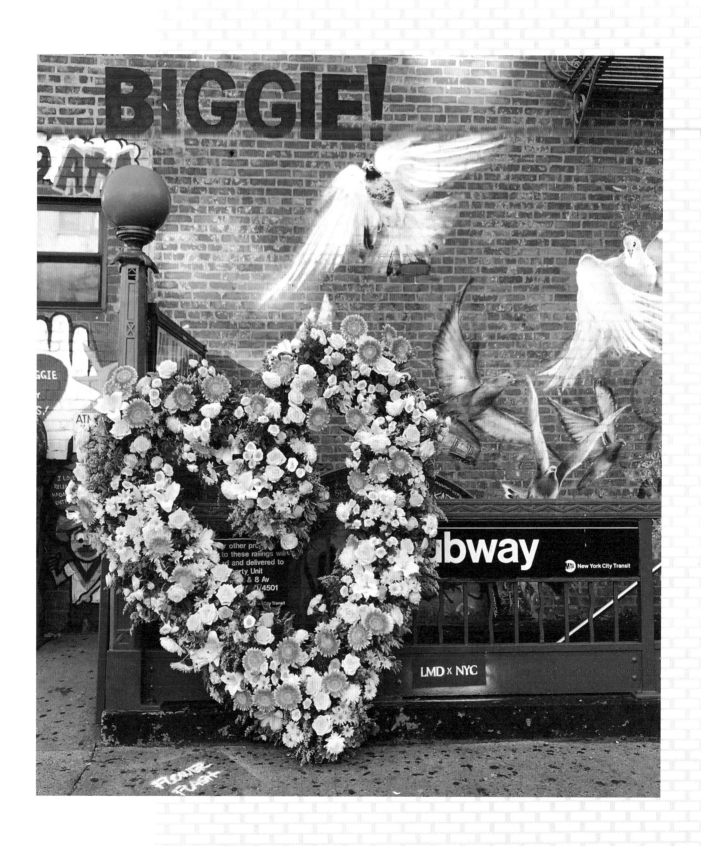

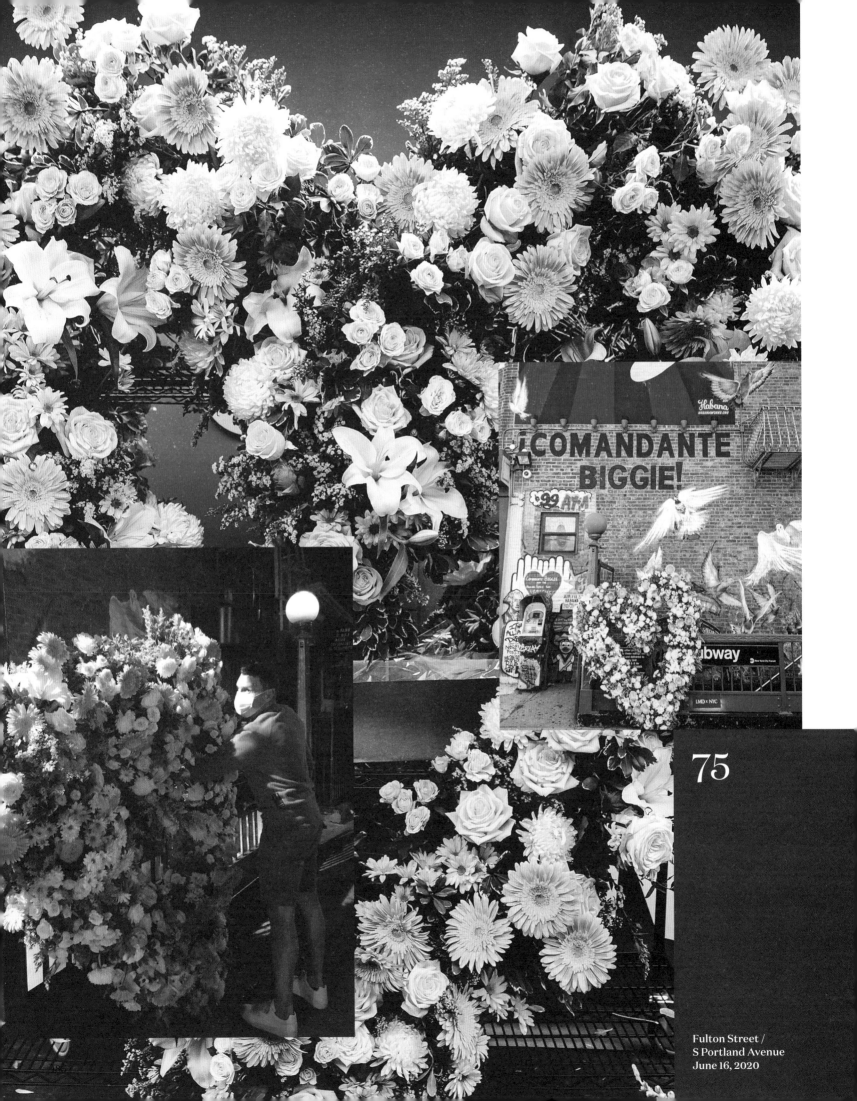

75

Fulton Street /
S Portland Avenue
June 16, 2020

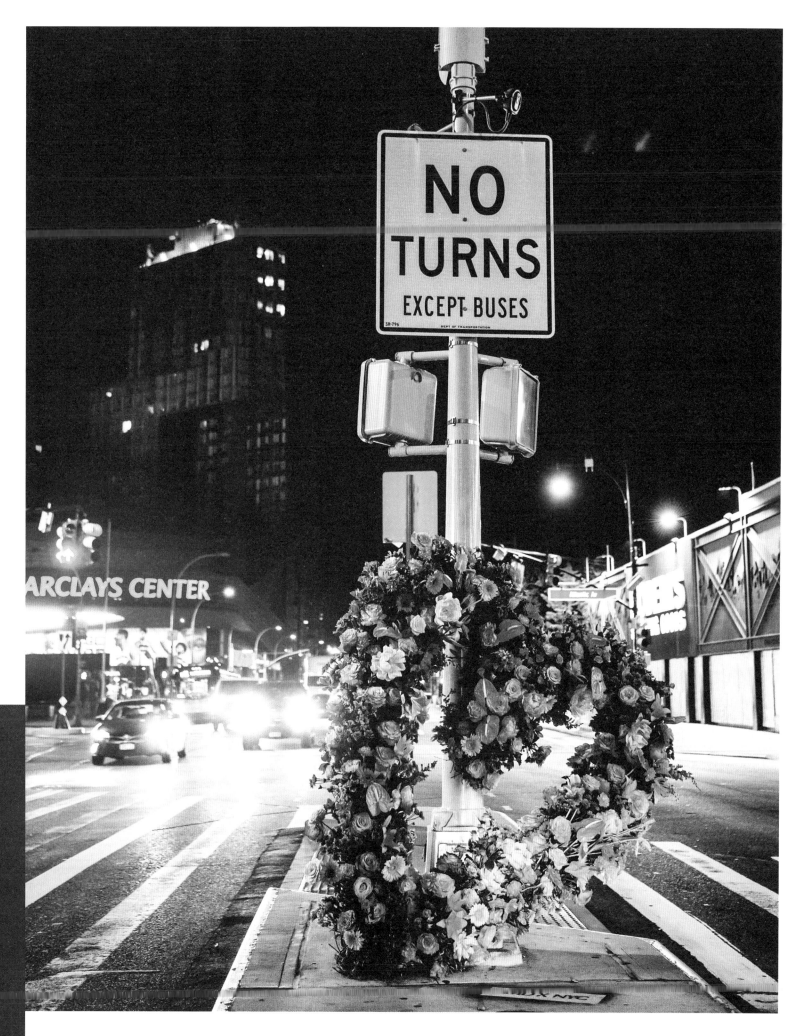

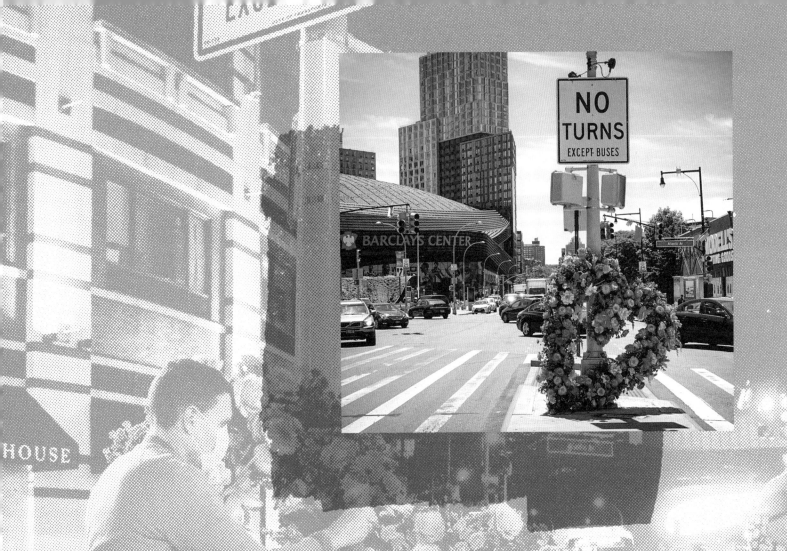

During the summer months, the city broke wide open with grief and anger. It was time to Flash the streets of Brooklyn. We chose a spot close to the Barclays Center, a central gathering place for protesters, and we wanted to show our fellow New Yorkers some love with a giant floral heart.

These streets will speak for themselves.
— Dave Chappelle

76

Barclays Center
June 16, 2020

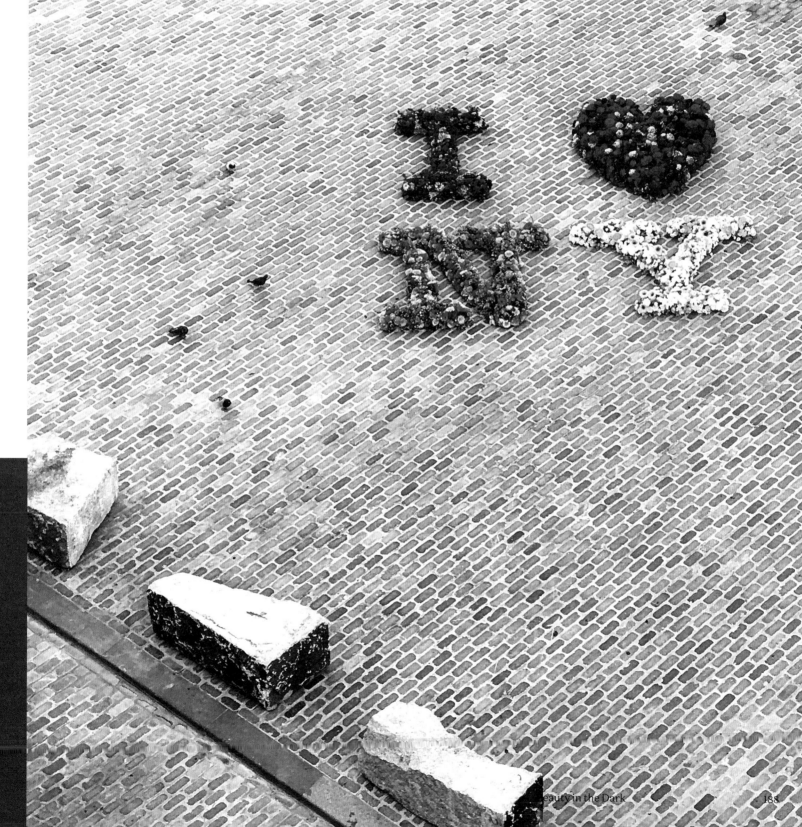

I knew I wanted to use Milton Glaser's I ♥ NY as a template to send a love letter to New York as the city was slowly starting to open up again. We laid down giant cardboard stencils on the cobblestone plaza at Gansevoort Street in the West Village. I wanted it to look like St. Mark's Square in Venice, so I sprinkled pieces of my granola bar hoping to lure over the pigeons. Glaser passed away a few days later.

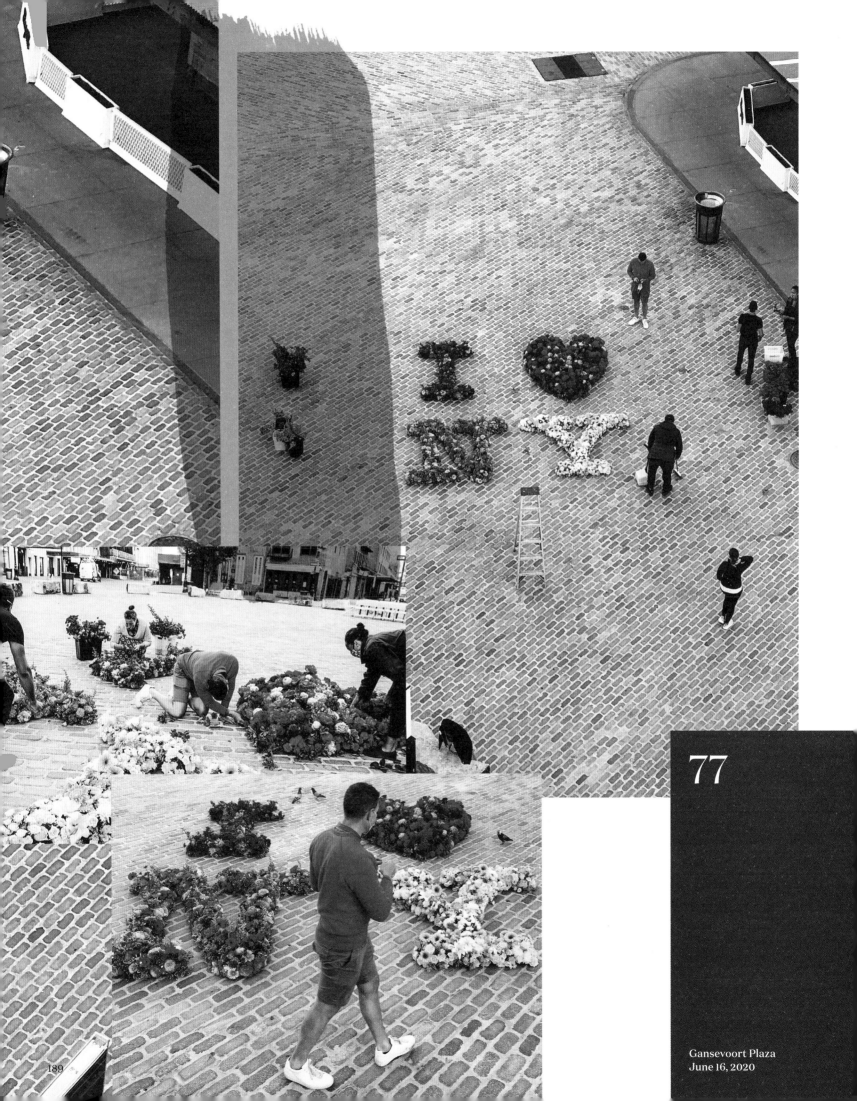

77

Gansevoort Plaza
June 16, 2020

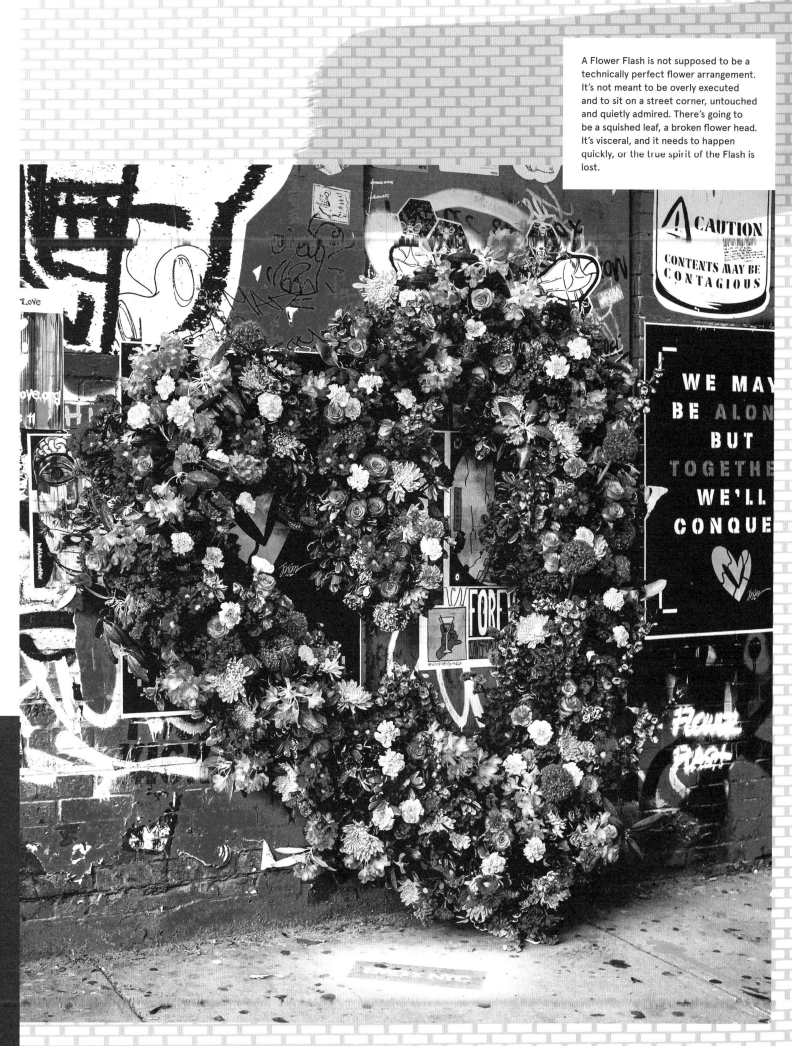

A Flower Flash is not supposed to be a technically perfect flower arrangement. It's not meant to be overly executed and to sit on a street corner, untouched and quietly admired. There's going to be a squished leaf, a broken flower head. It's visceral, and it needs to happen quickly, or the true spirit of the Flash is lost.

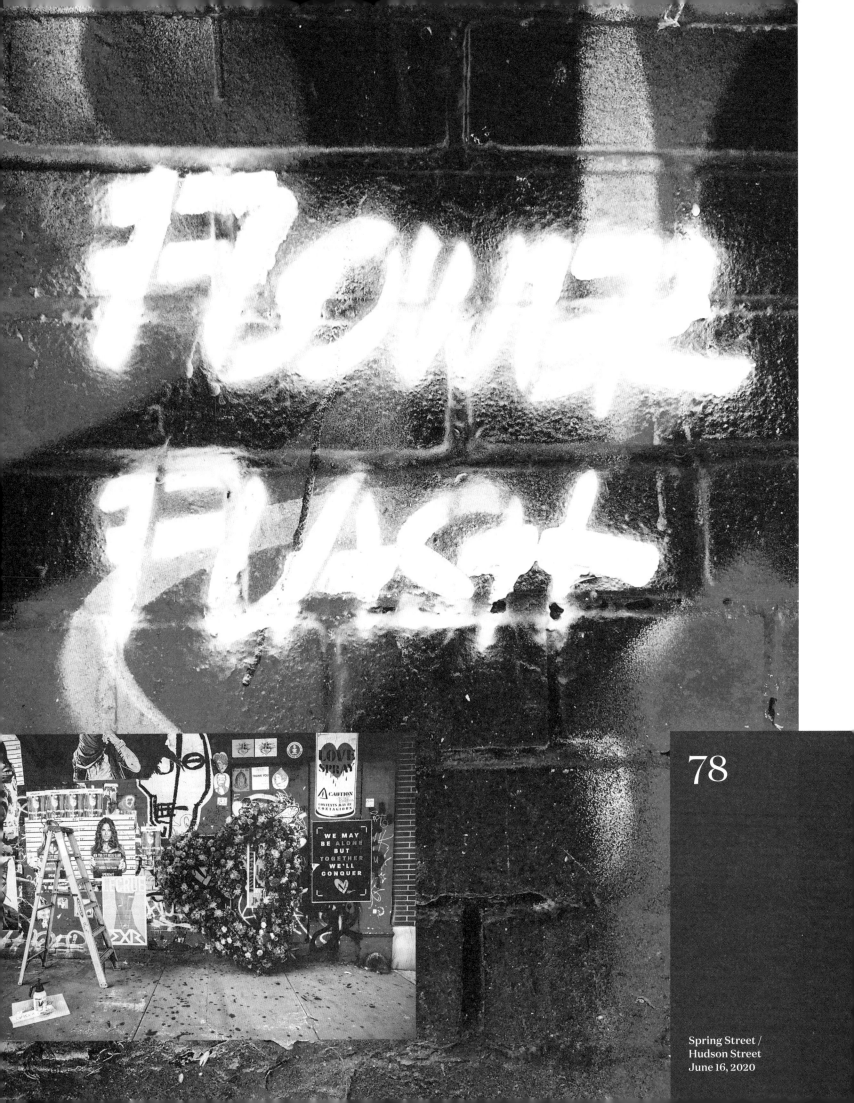

78

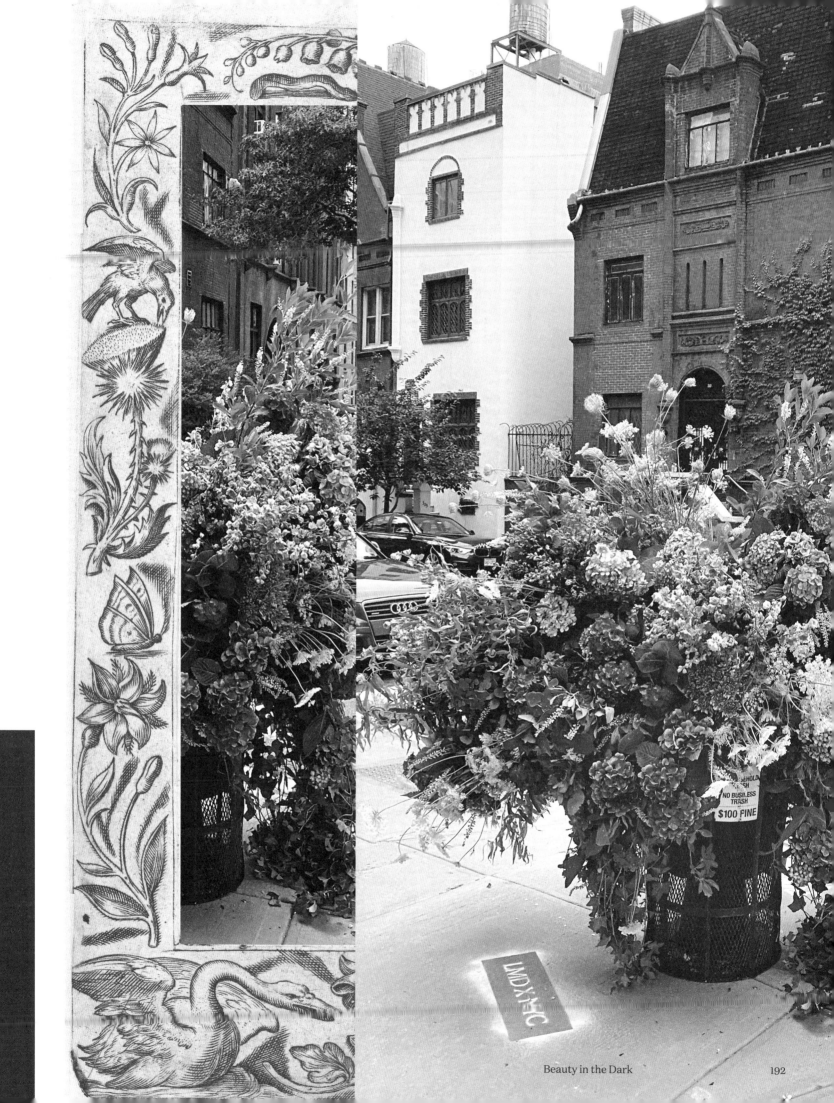

Beauty in the Dark 192

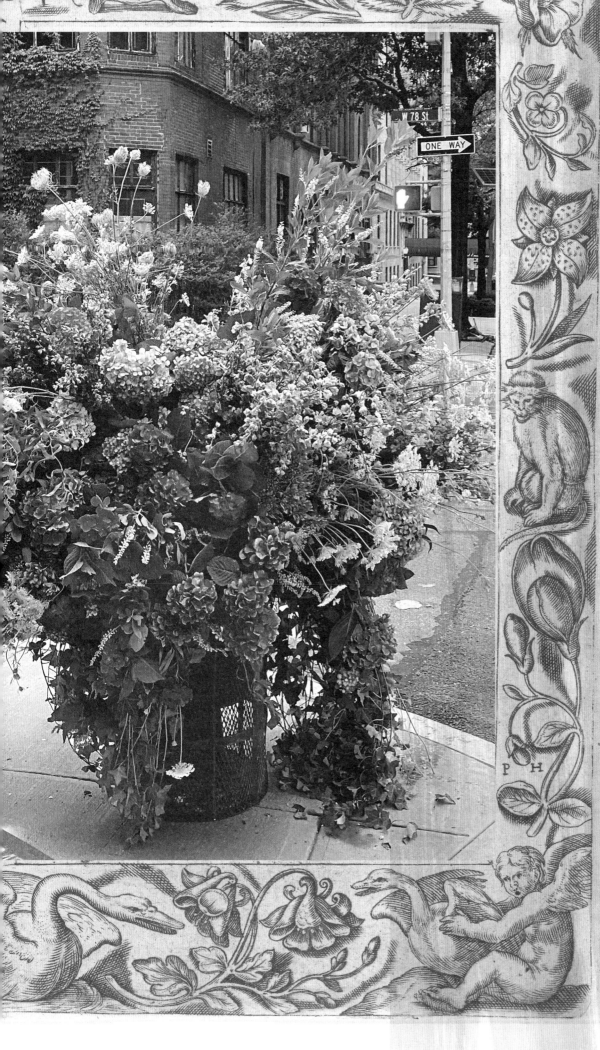

Hydrangea madness! Summer in New York City is hot and sticky, so I wanted to make something that felt fluffy and cool. I love these giant mopheads that look like blue snow cones.

79

W 78th Street /
West End Avenue
July 23, 2020

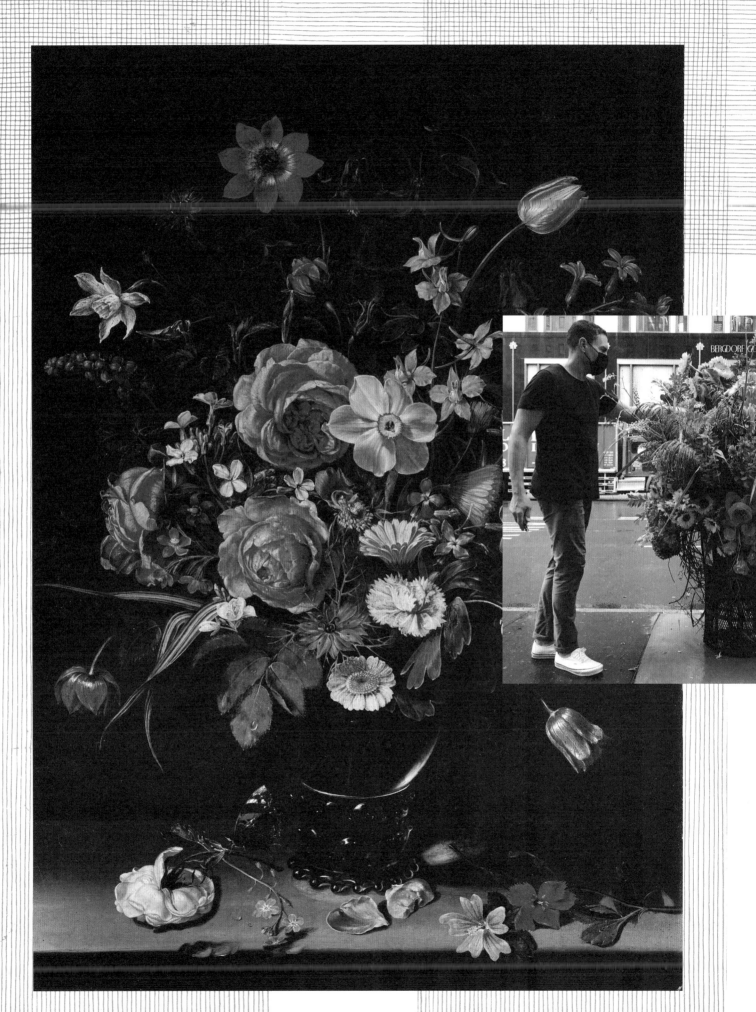

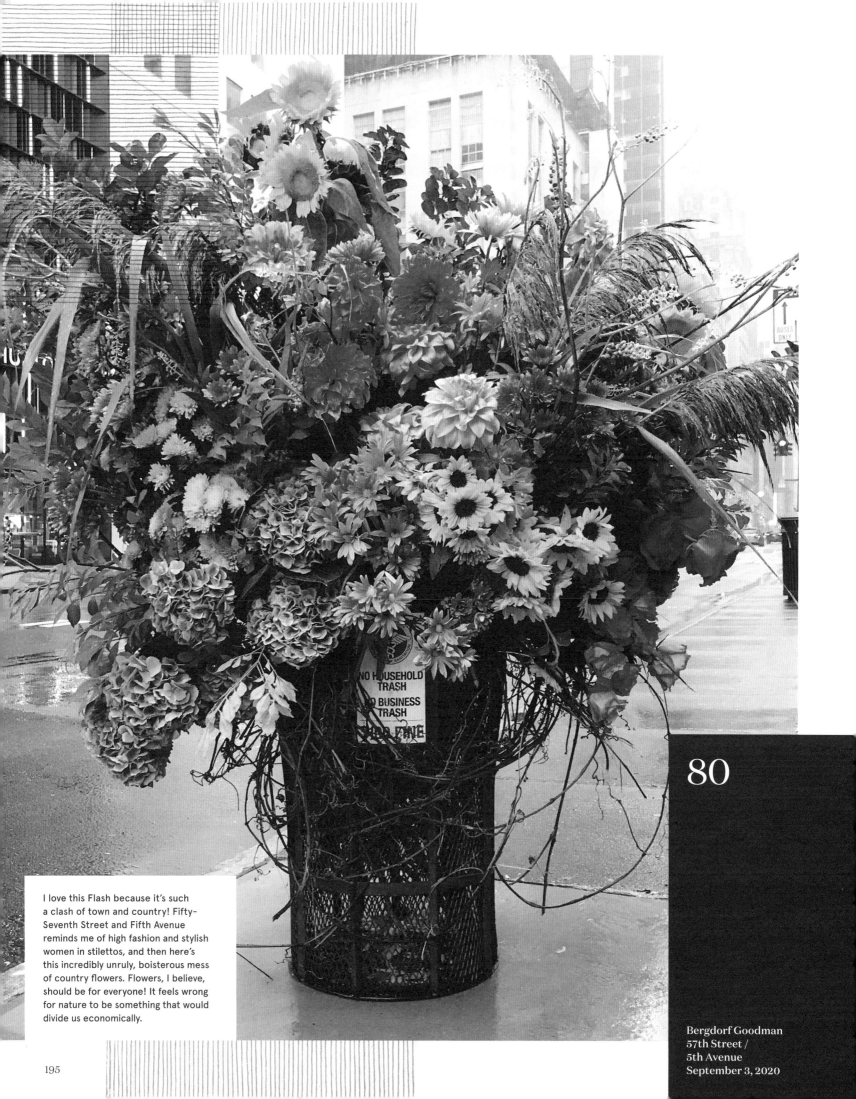

I love this Flash because it's such a clash of town and country! Fifty-Seventh Street and Fifth Avenue reminds me of high fashion and stylish women in stilettos, and then here's this incredibly unruly, boisterous mess of country flowers. Flowers, I believe, should be for everyone! It feels wrong for nature to be something that would divide us economically.

80

Bergdorf Goodman
57th Street /
5th Avenue
September 3, 2020

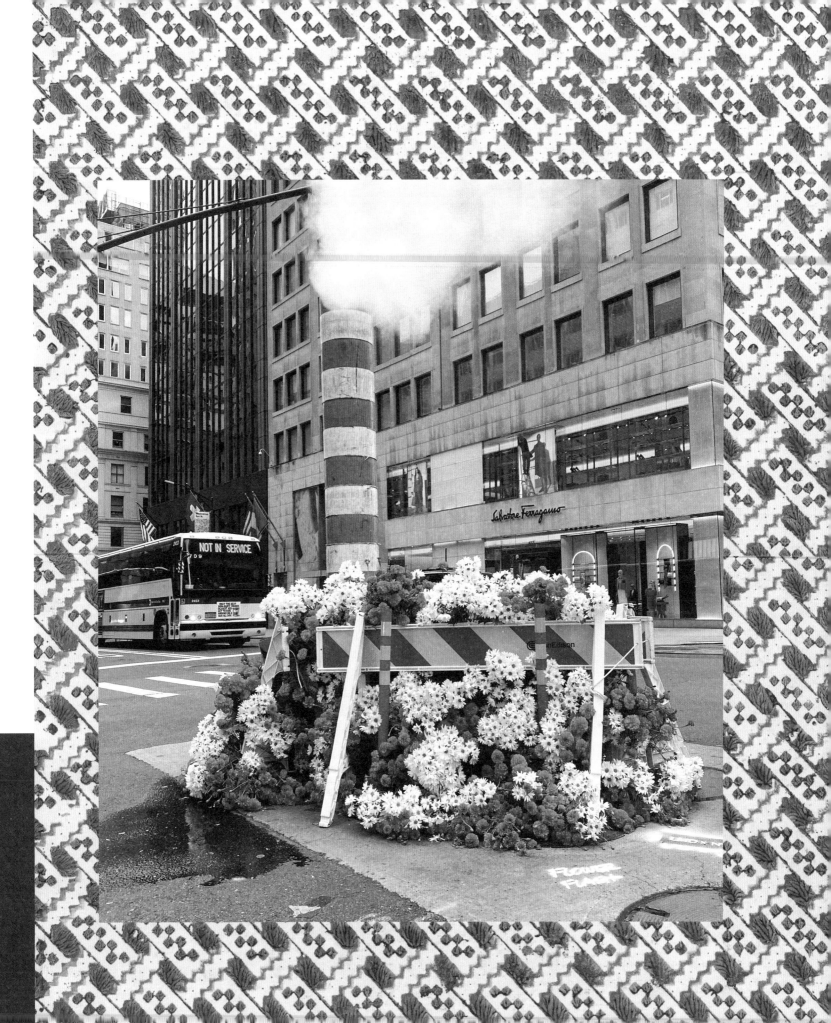

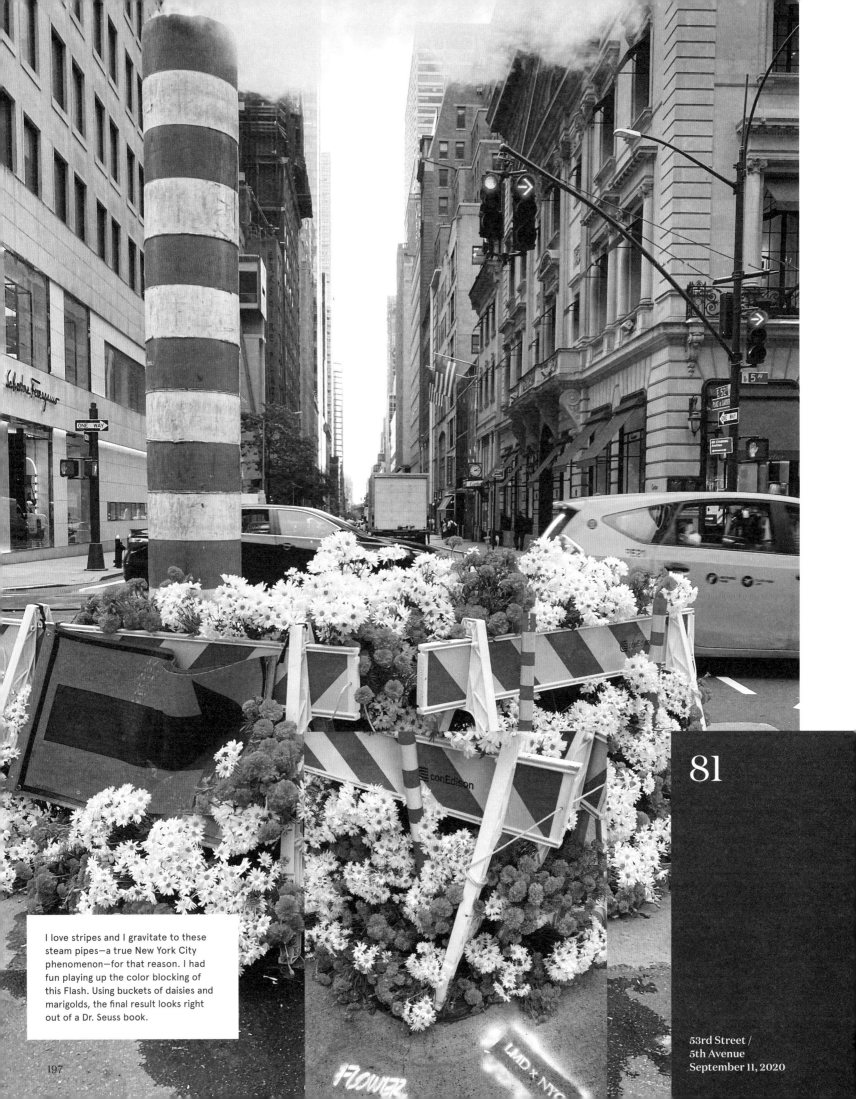

I love stripes and I gravitate to these steam pipes—a true New York City phenomenon—for that reason. I had fun playing up the color blocking of this Flash. Using buckets of daisies and marigolds, the final result looks right out of a Dr. Seuss book.

81

53rd Street /
5th Avenue
September 11, 2020

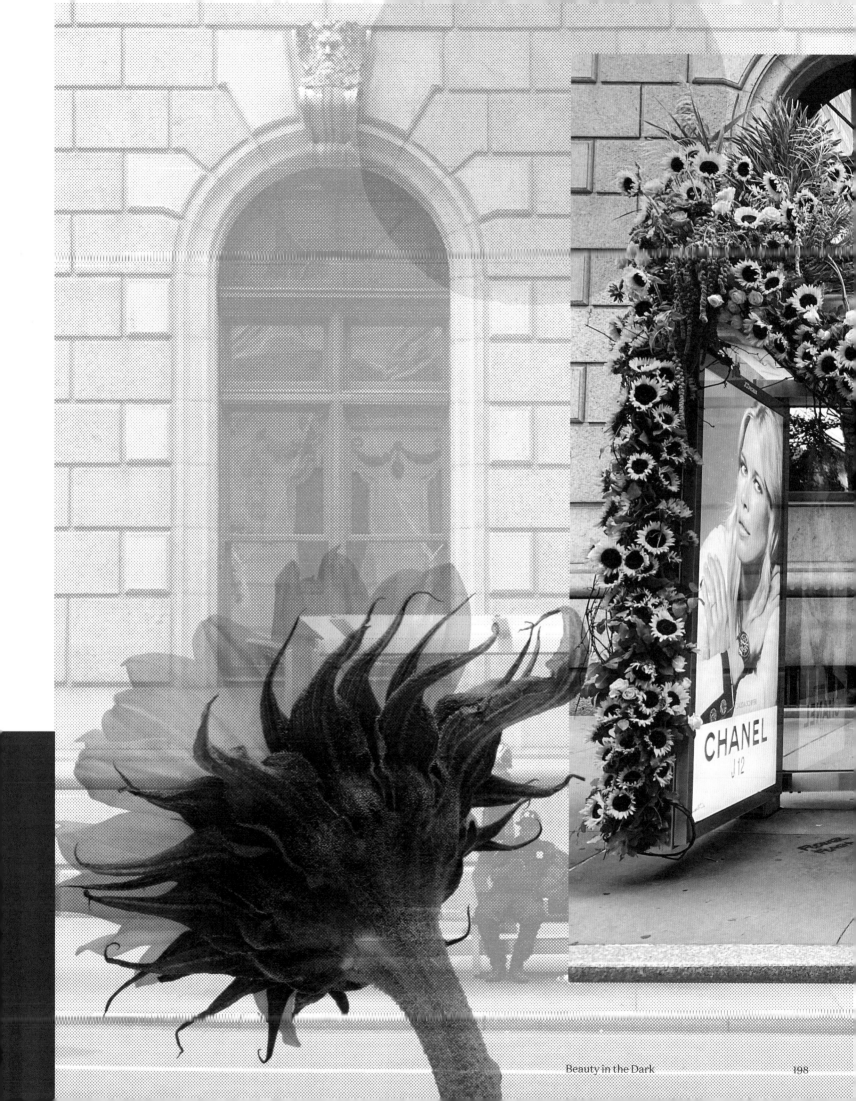

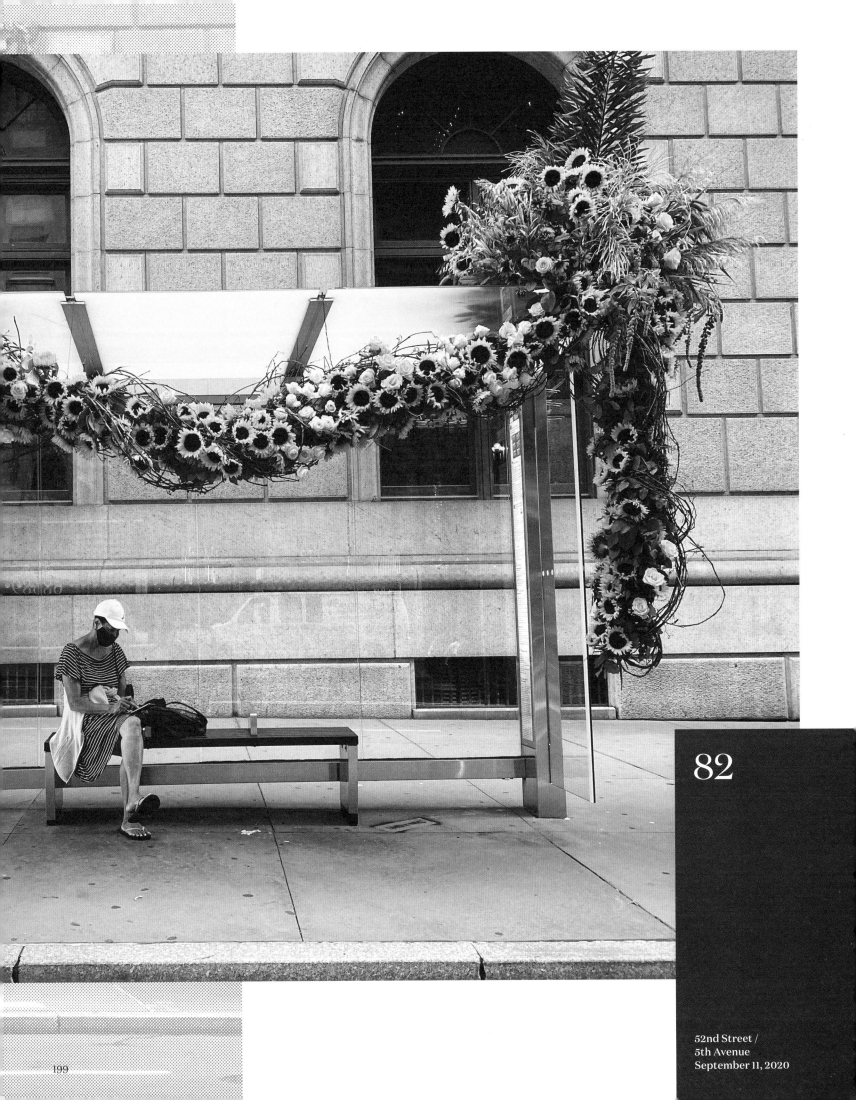

82

52nd Street /
5th Avenue
September 11, 2020

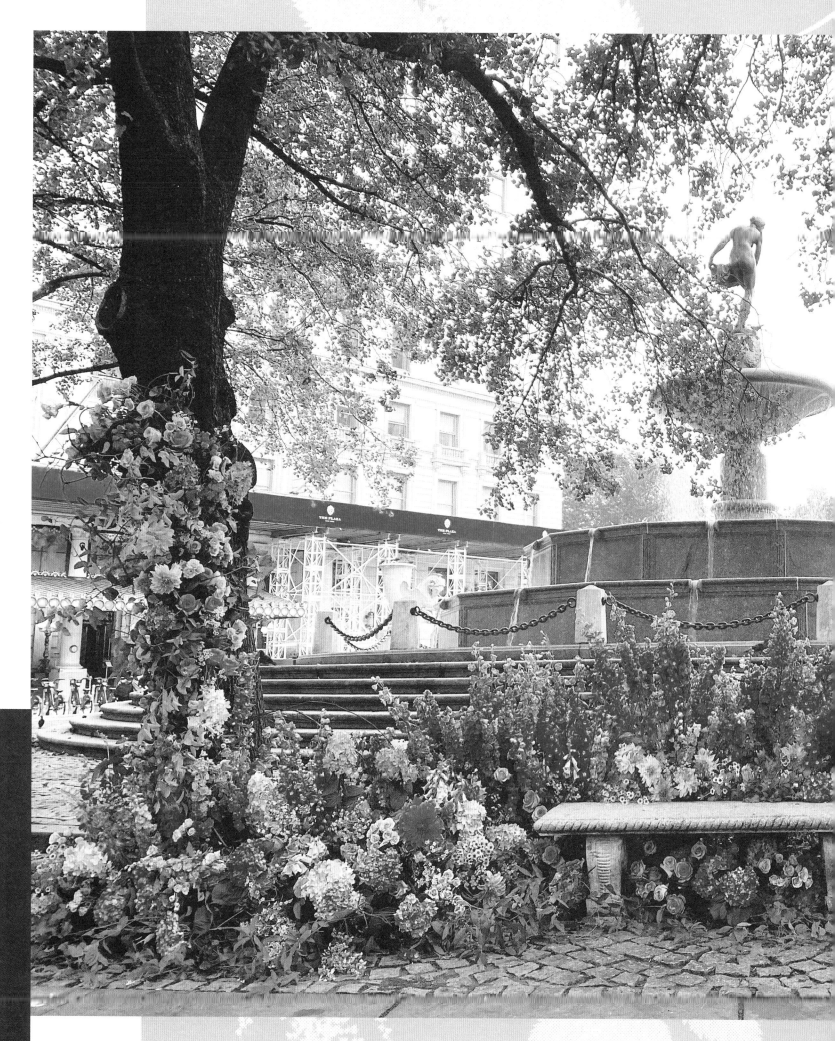

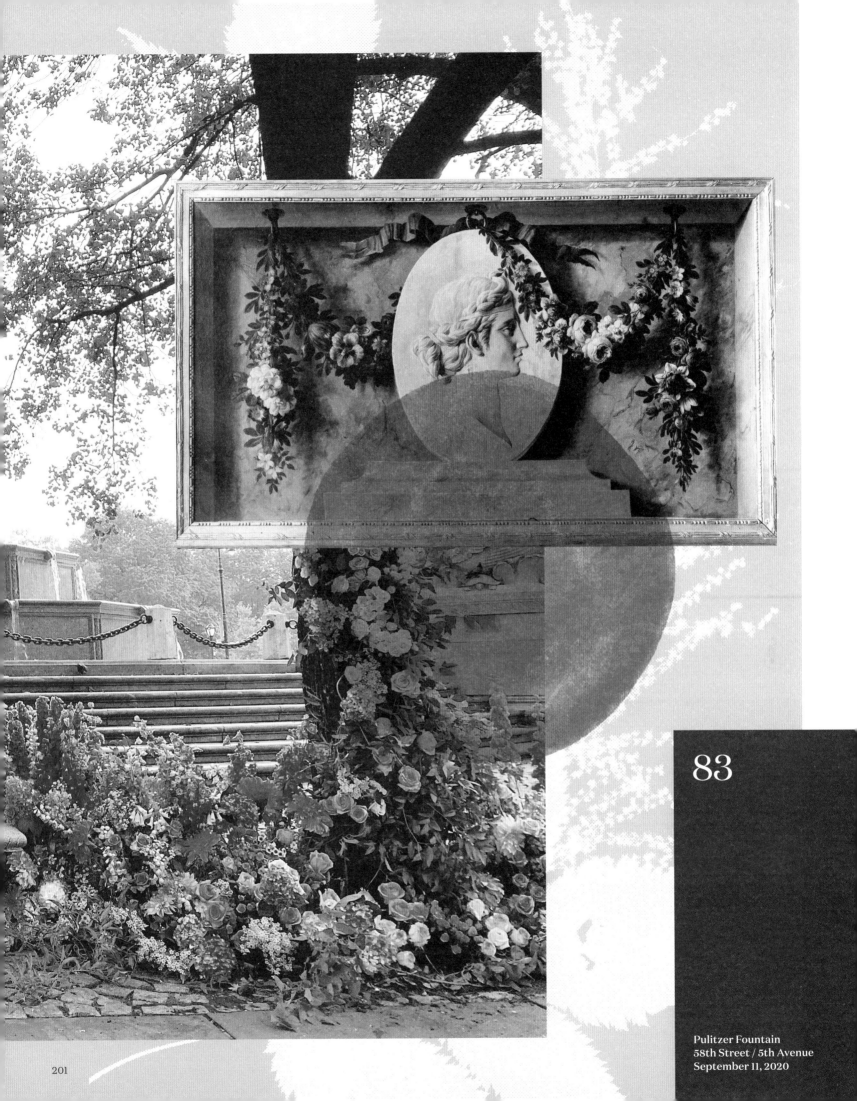

83

Pulitzer Fountain
58th Street / 5th Avenue
September 11, 2020

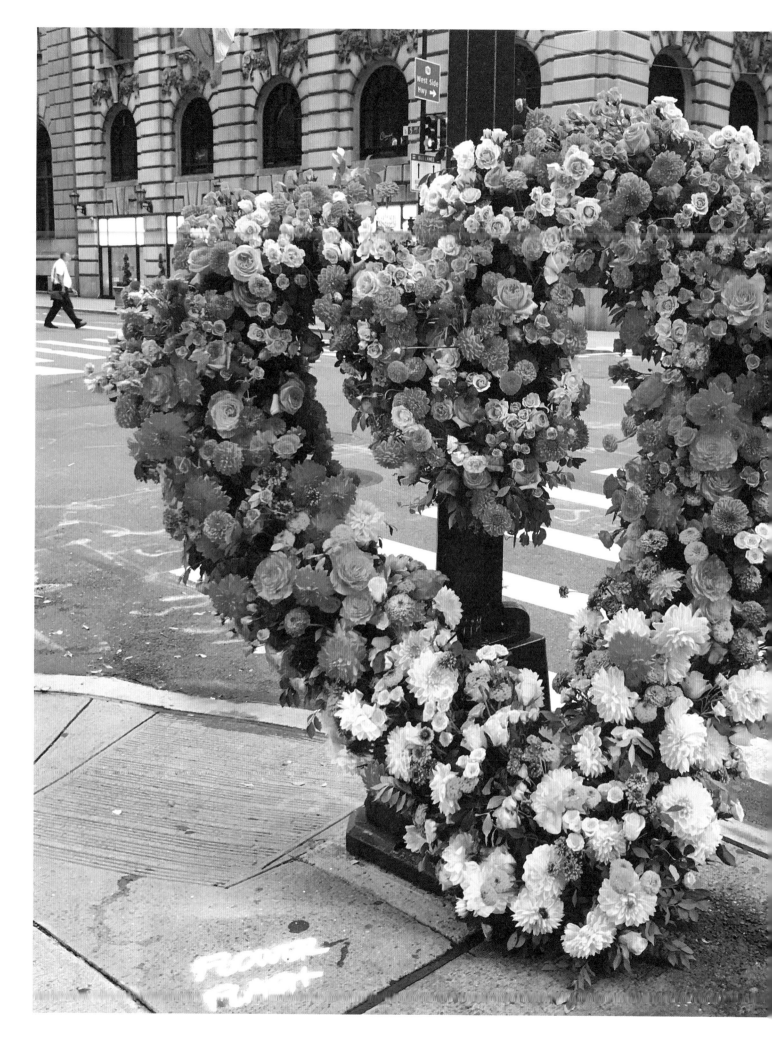

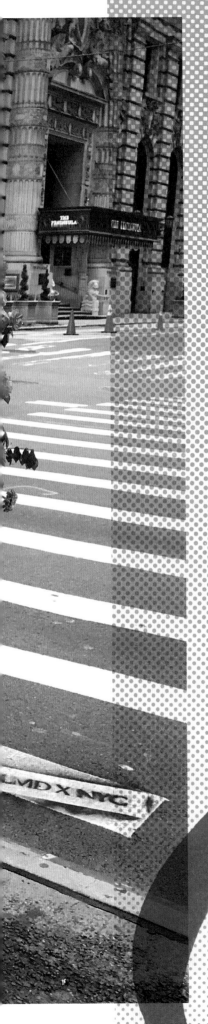

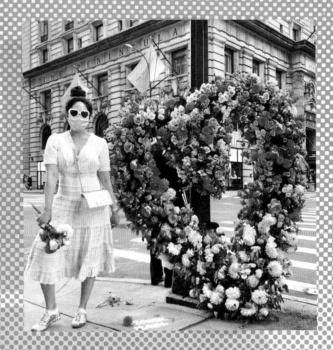

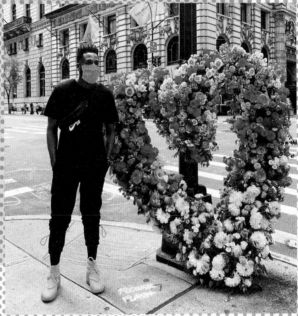

84

Six feet tall and filled with over two thousand freshly cut blooms, this ombré beauty went up at dawn on September 11, a somber day for all New Yorkers. And somehow this heart Flash became a beacon of pure joy during an especially difficult year. We hope it lifted spirits and was a gentle reminder that there is beauty in this world and that everyone is deserving of it.

55th Street/ 5th Avenue
September 11, 2020

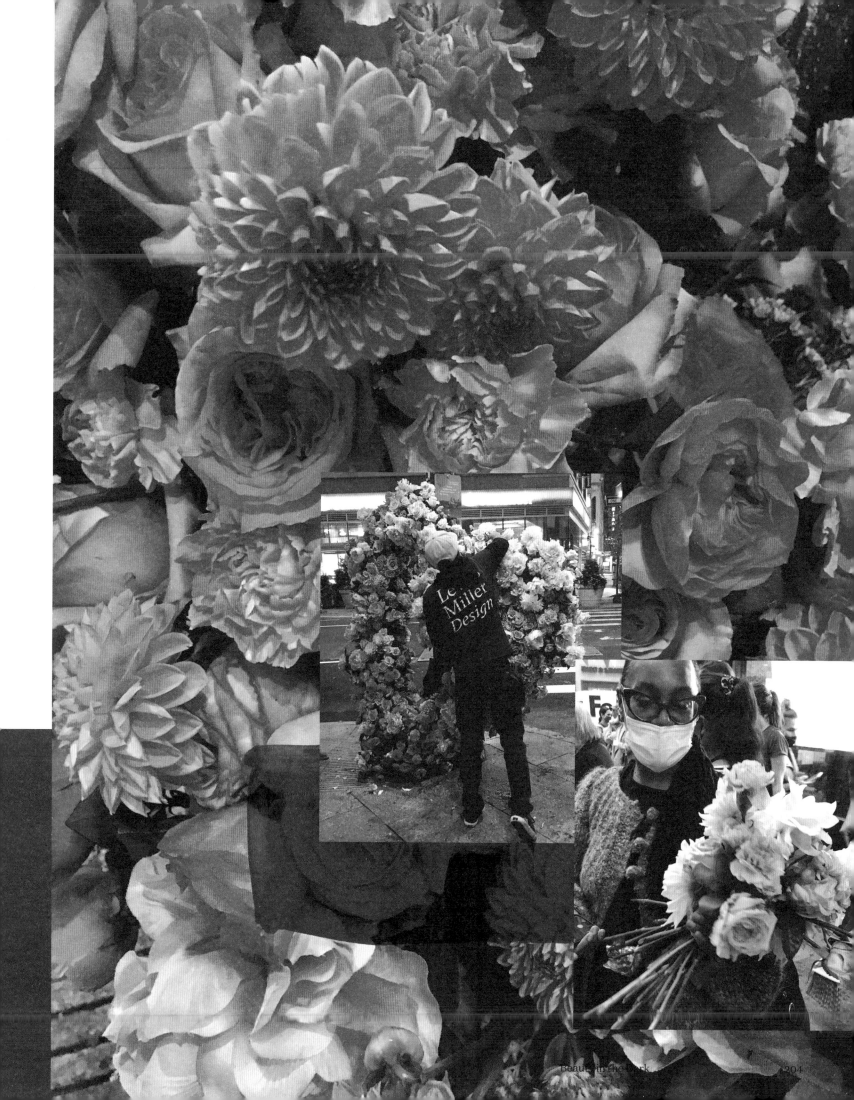

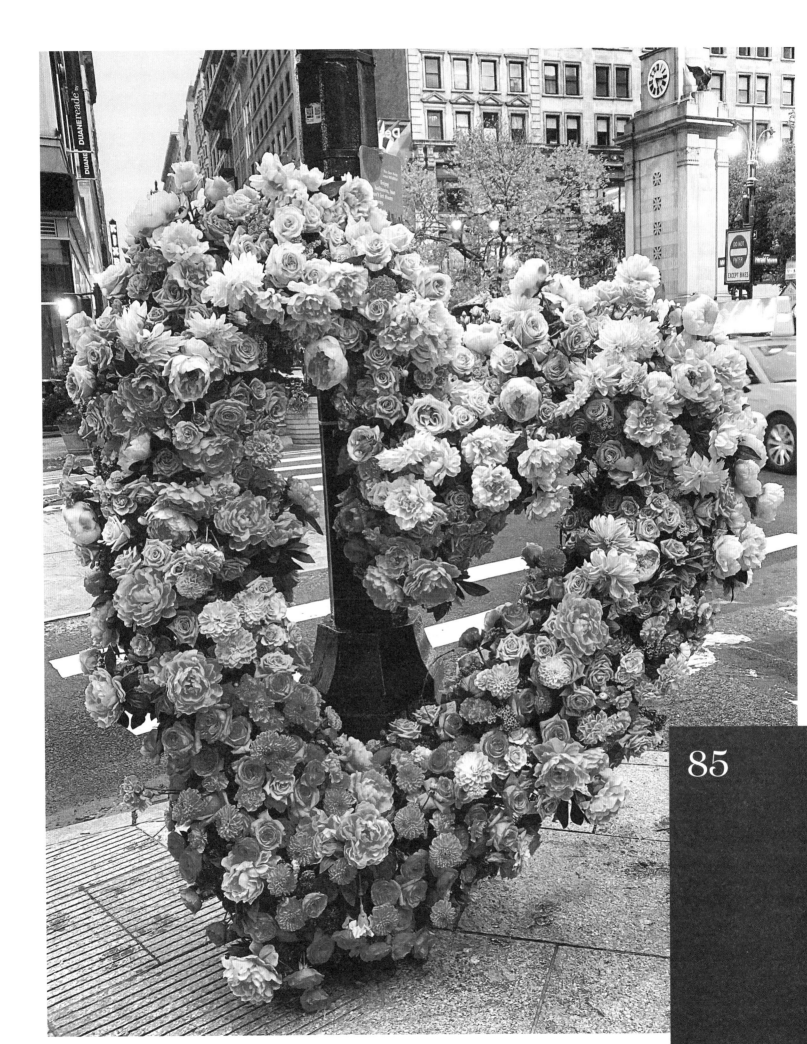

85

W 35th Street / Broadway
October 23, 2020

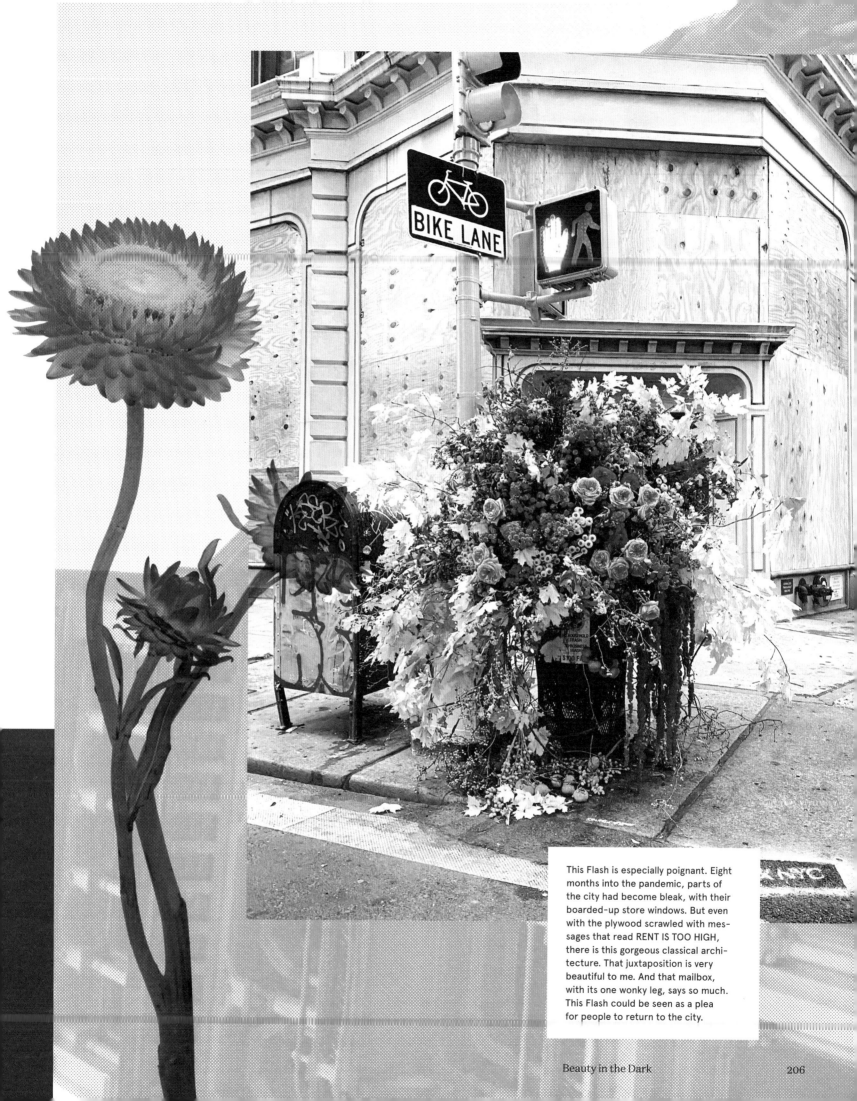

This Flash is especially poignant. Eight months into the pandemic, parts of the city had become bleak, with their boarded-up store windows. But even with the plywood scrawled with messages that read RENT IS TOO HIGH, there is this gorgeous classical architecture. That juxtaposition is very beautiful to me. And that mailbox, with its one wonky leg, says so much. This Flash could be seen as a plea for people to return to the city.

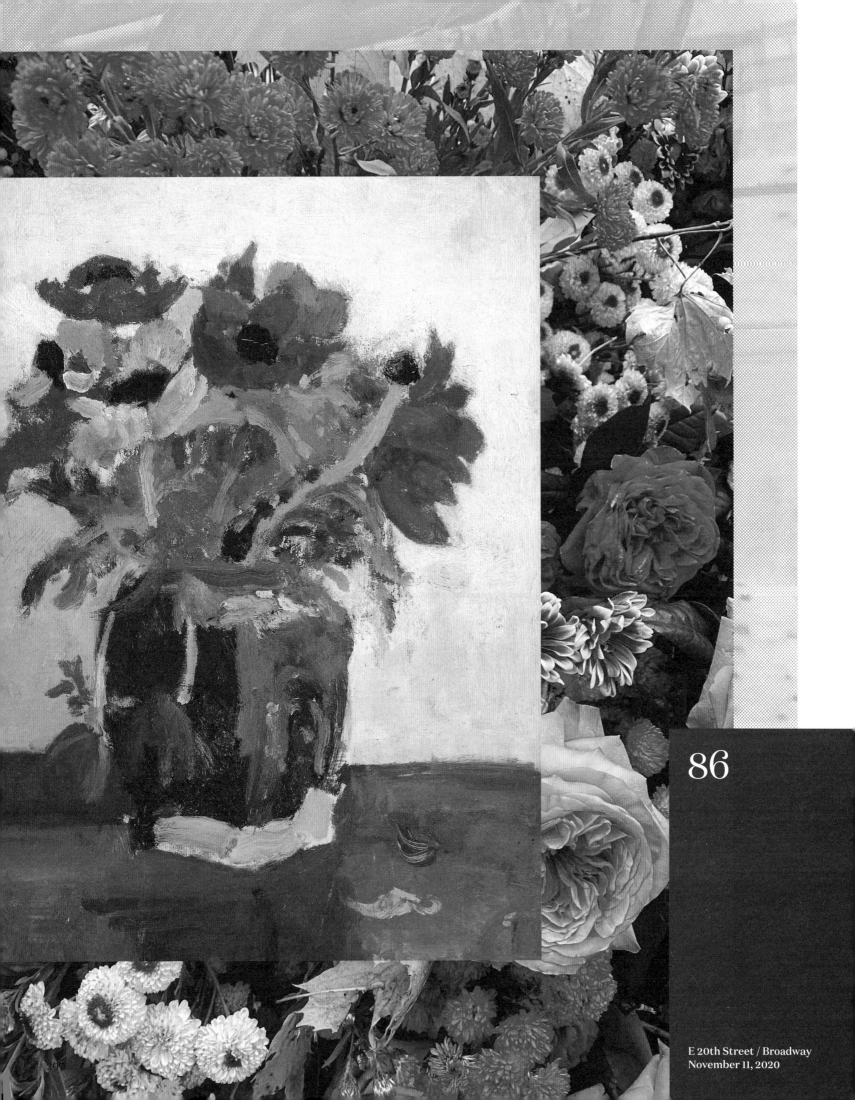

86

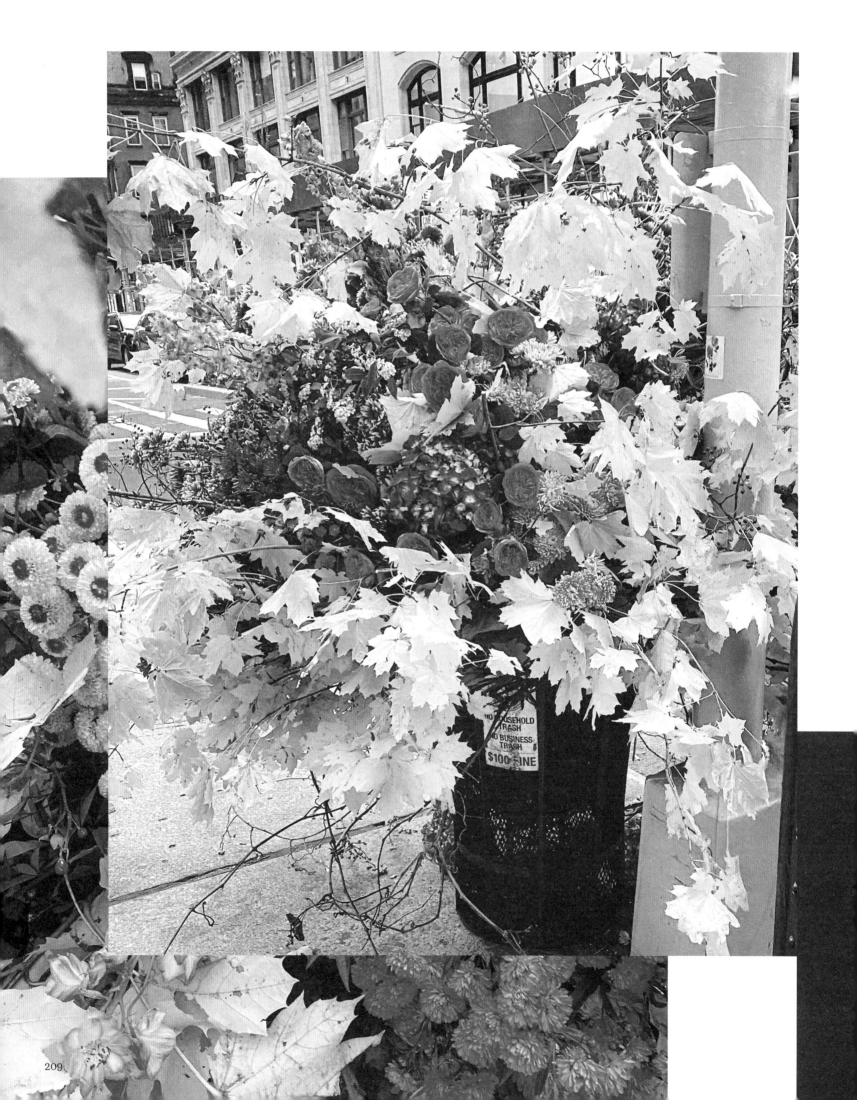

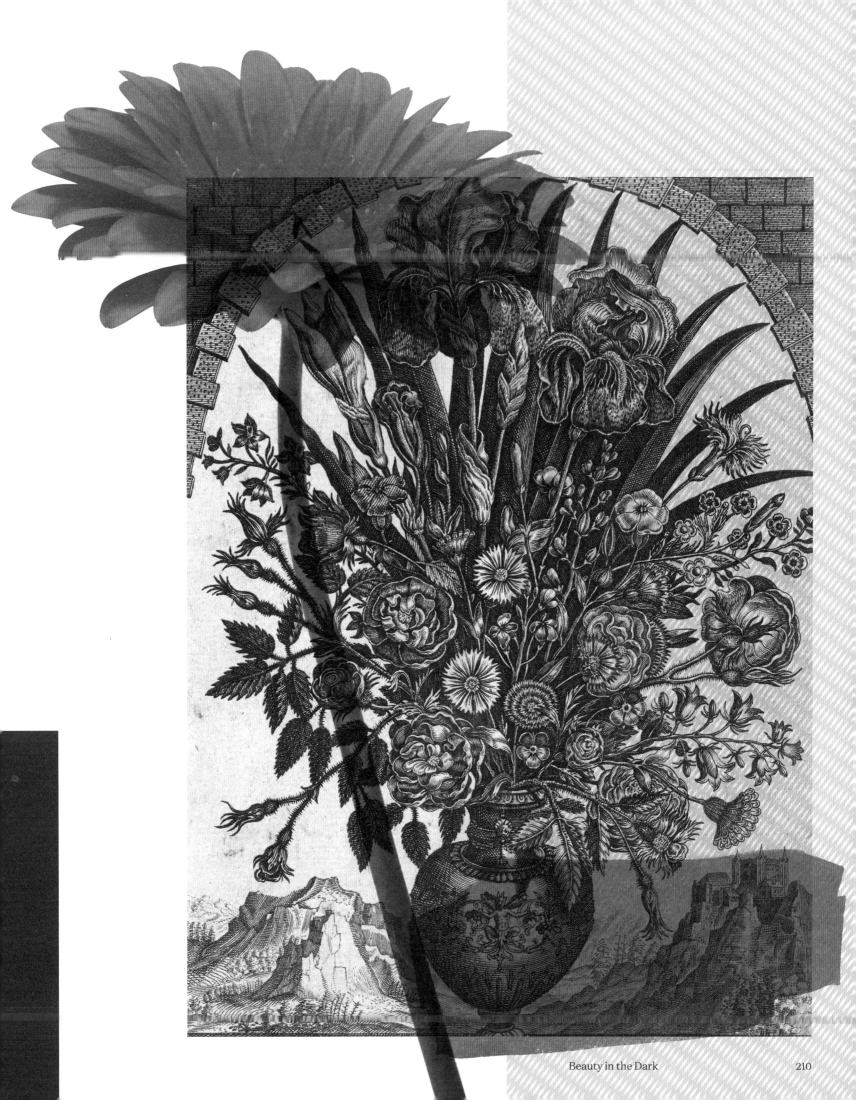

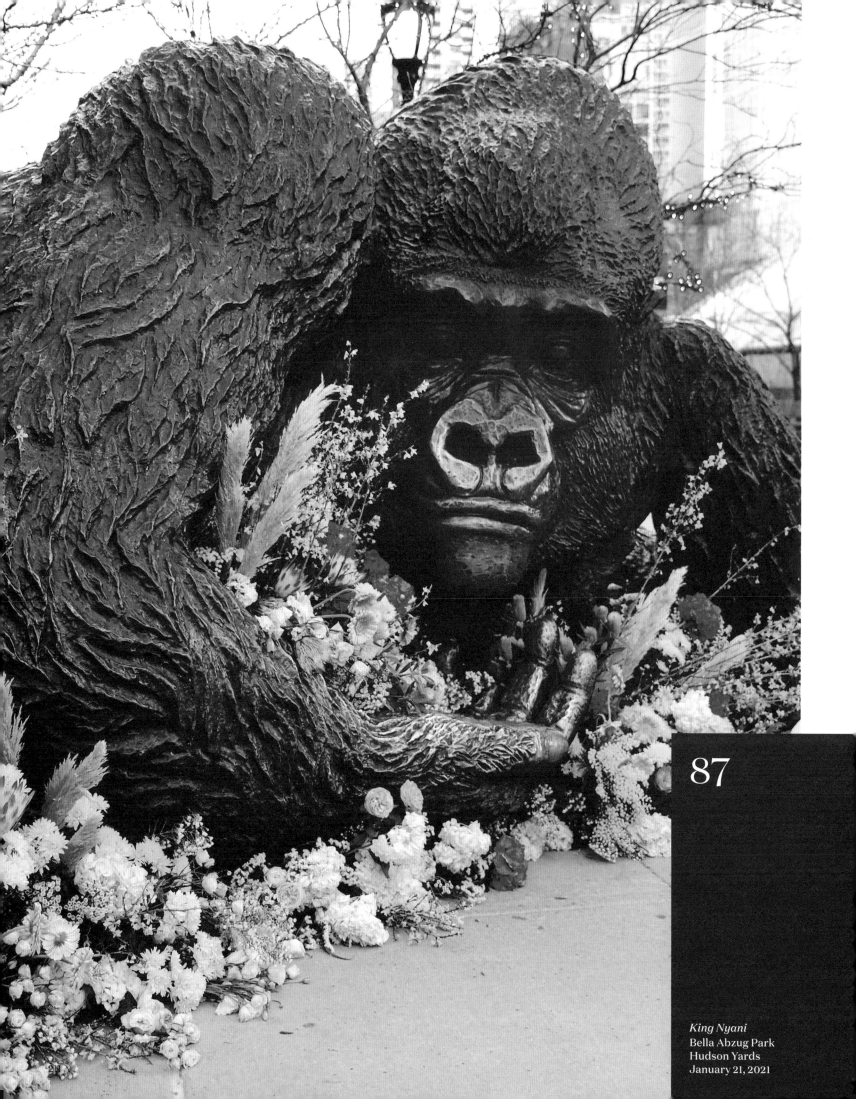

87

King Nyani
Bella Abzug Park
Hudson Yards
January 21, 2021

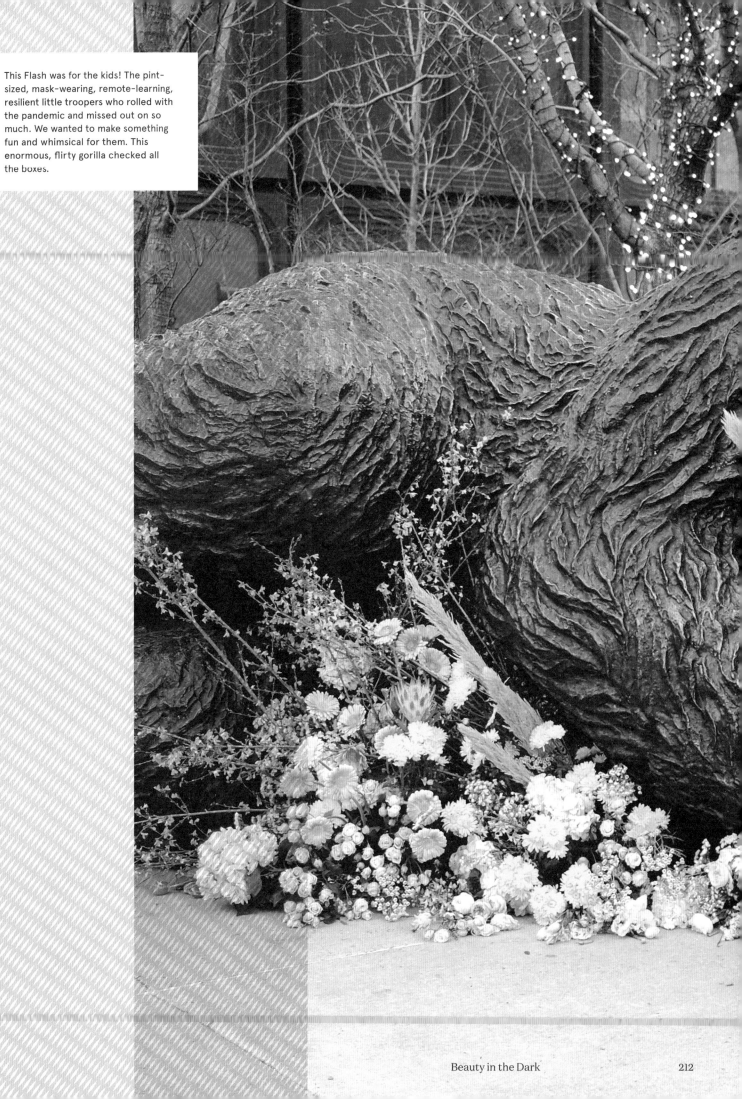

This Flash was for the kids! The pint-sized, mask-wearing, remote-learning, resilient little troopers who rolled with the pandemic and missed out on so much. We wanted to make something fun and whimsical for them. This enormous, flirty gorilla checked all the boxes.

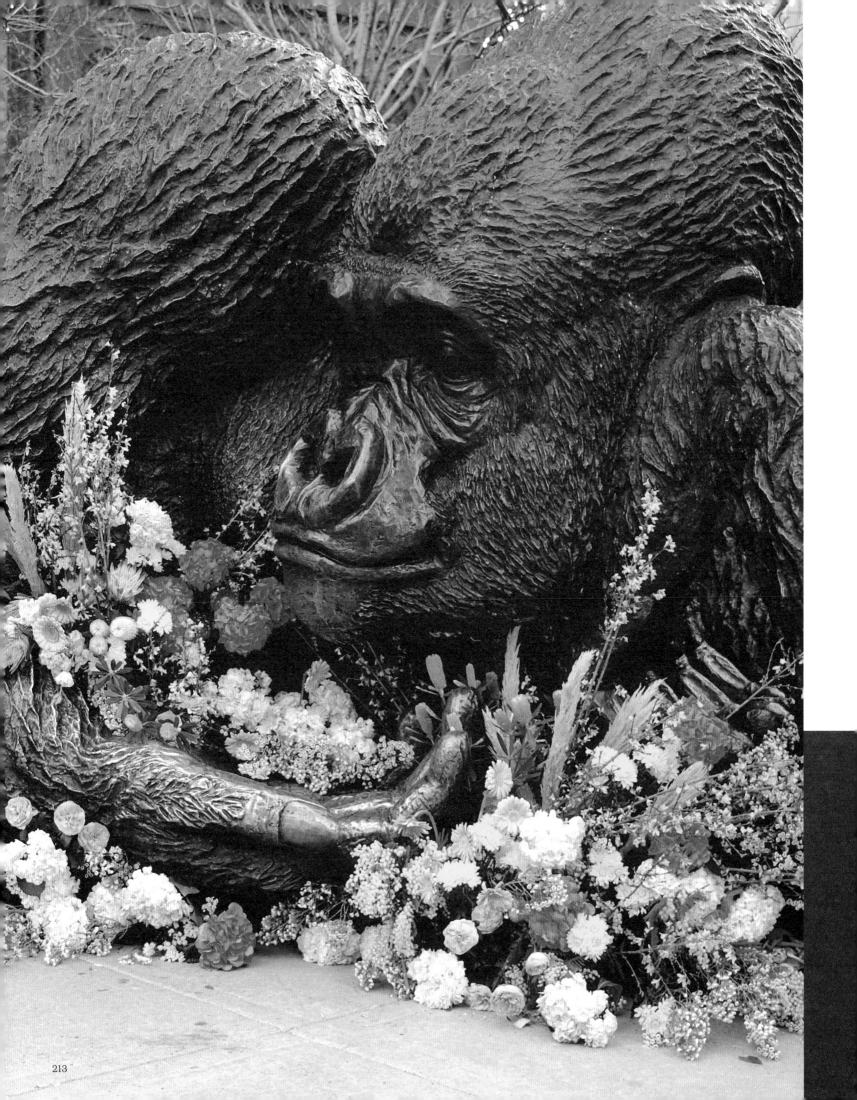

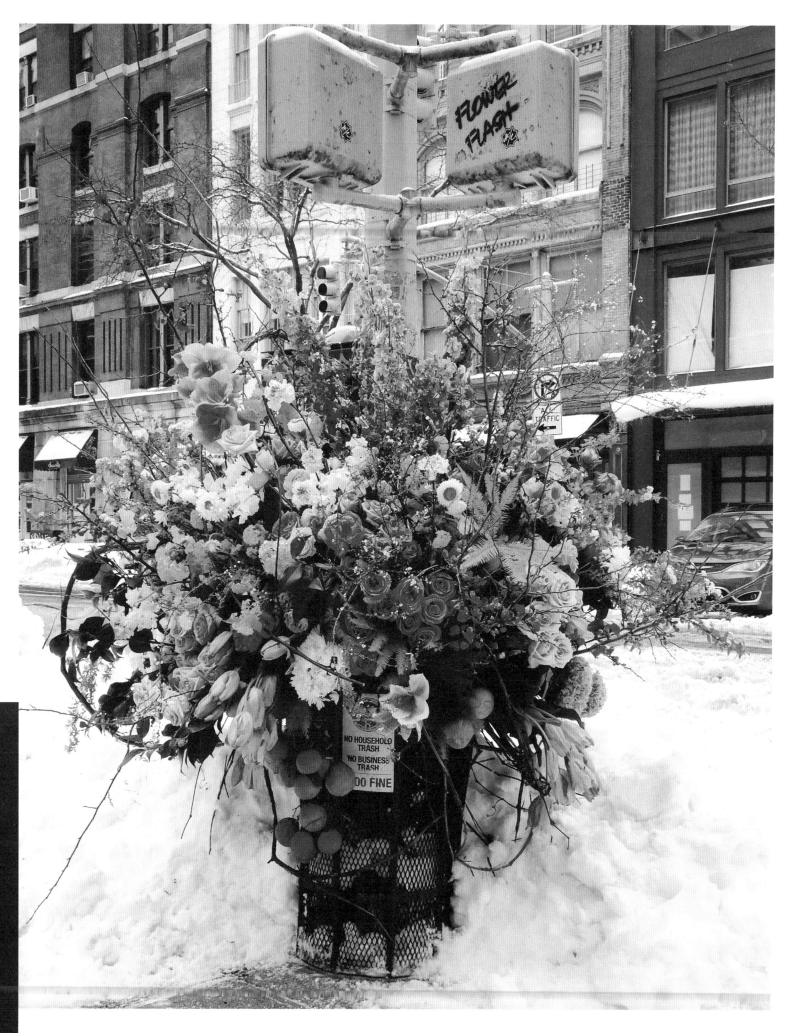

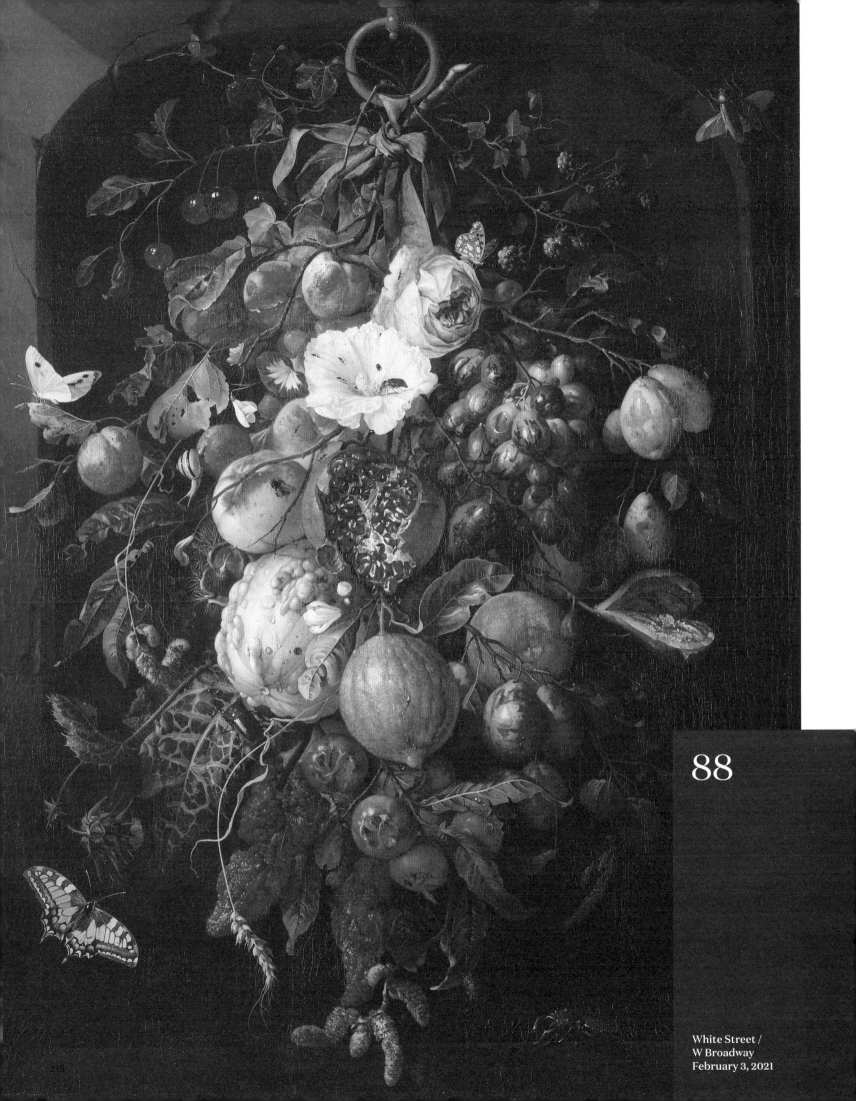

88

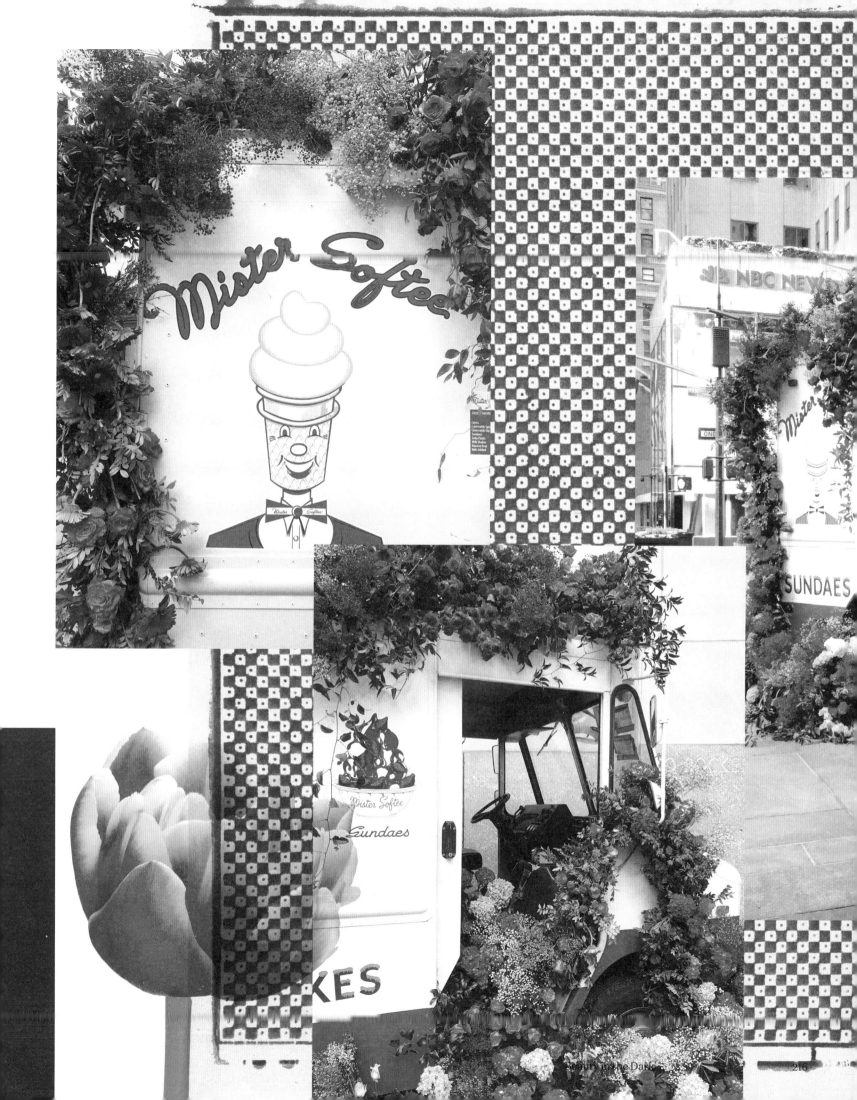

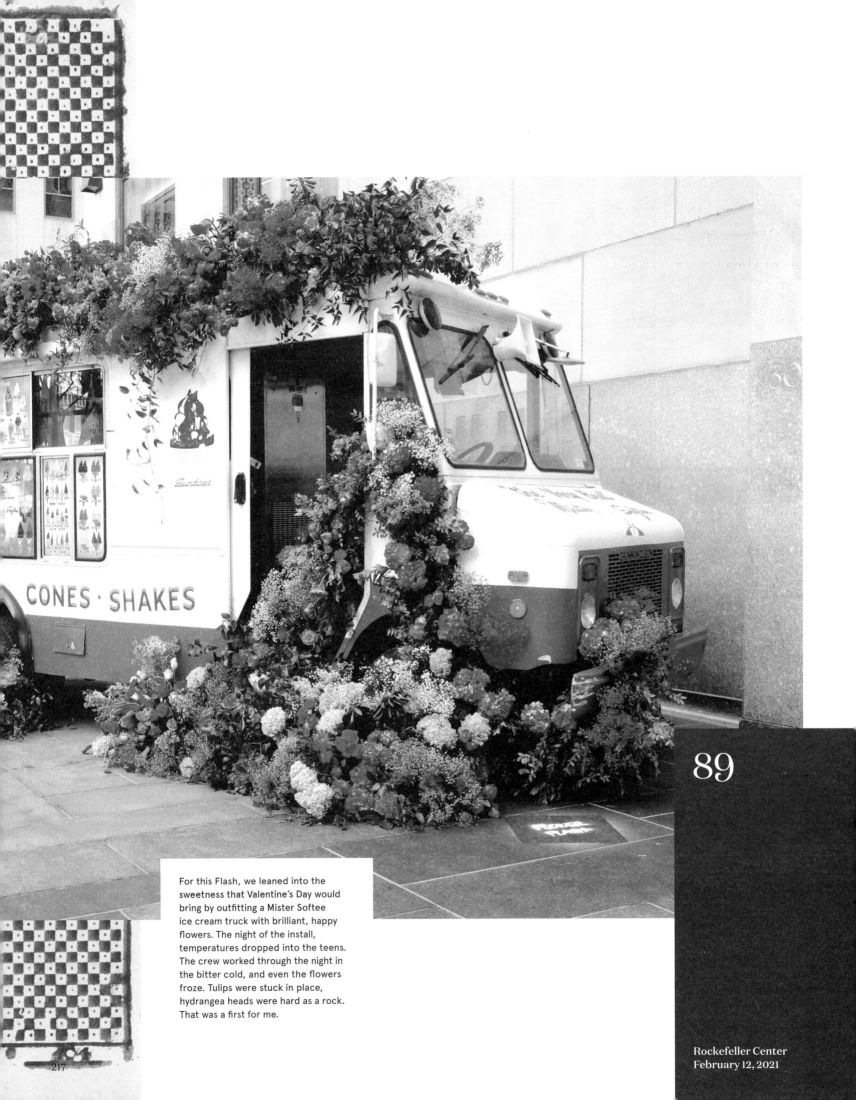

For this Flash, we leaned into the sweetness that Valentine's Day would bring by outfitting a Mister Softee ice cream truck with brilliant, happy flowers. The night of the install, temperatures dropped into the teens. The crew worked through the night in the bitter cold, and even the flowers froze. Tulips were stuck in place, hydrangea heads were hard as a rock. That was a first for me.

89

Rockefeller Center
February 12, 2021

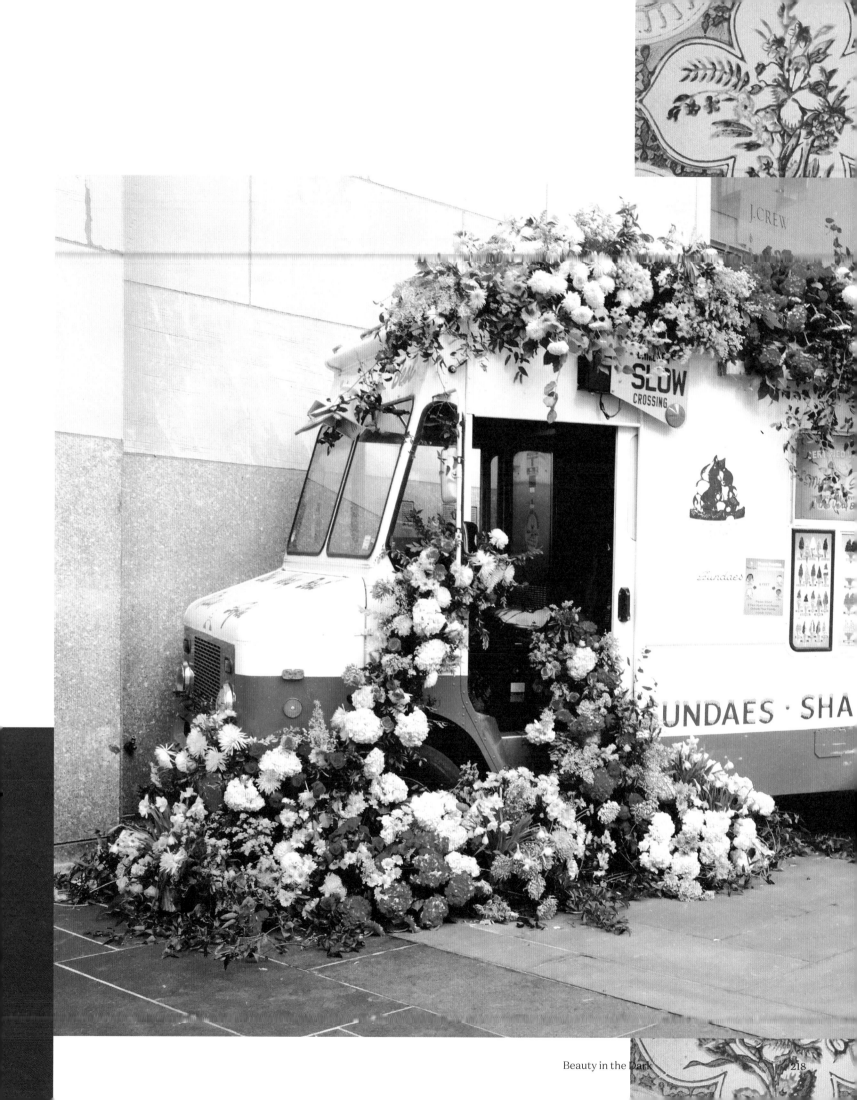

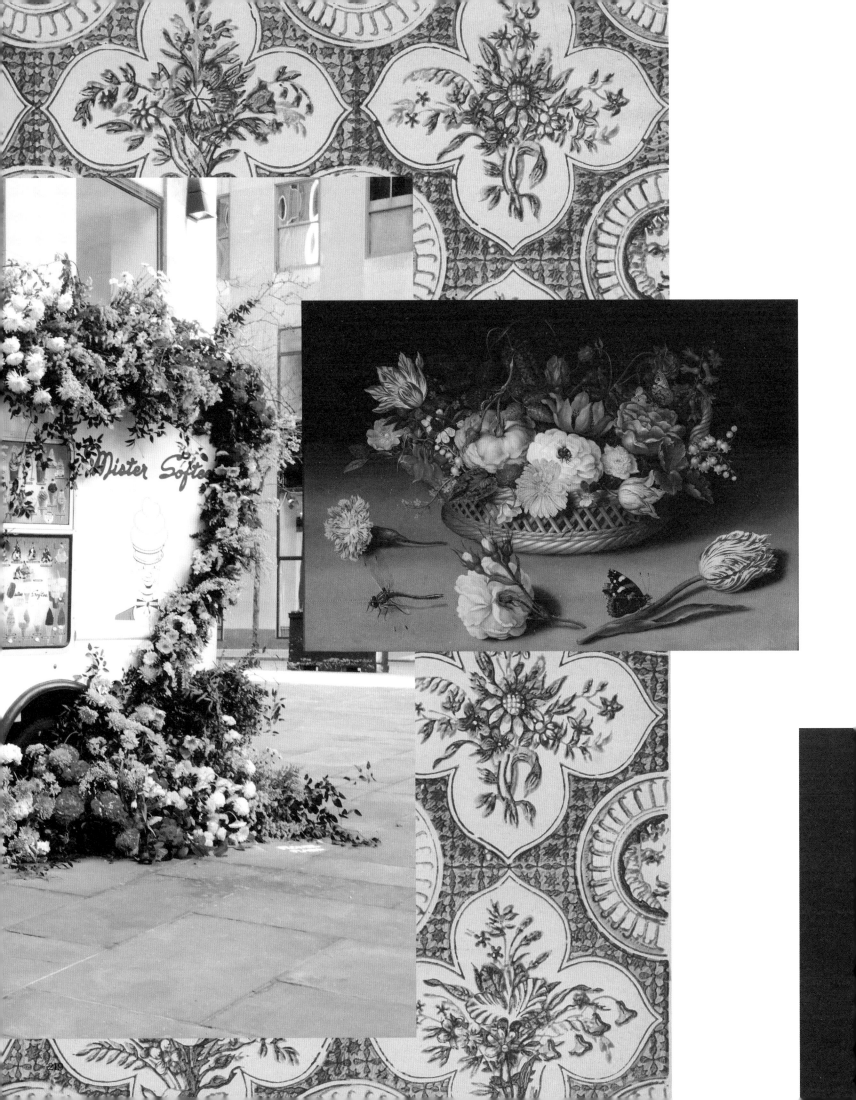

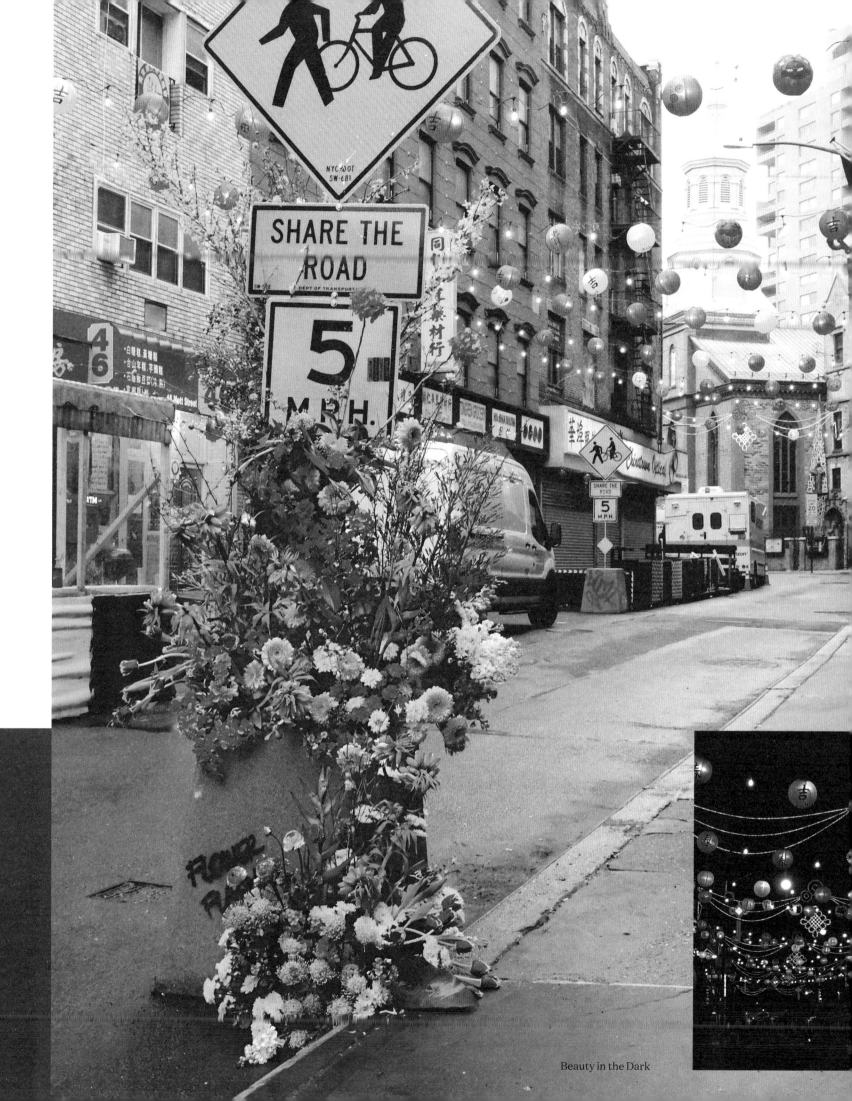

Beauty in the Dark

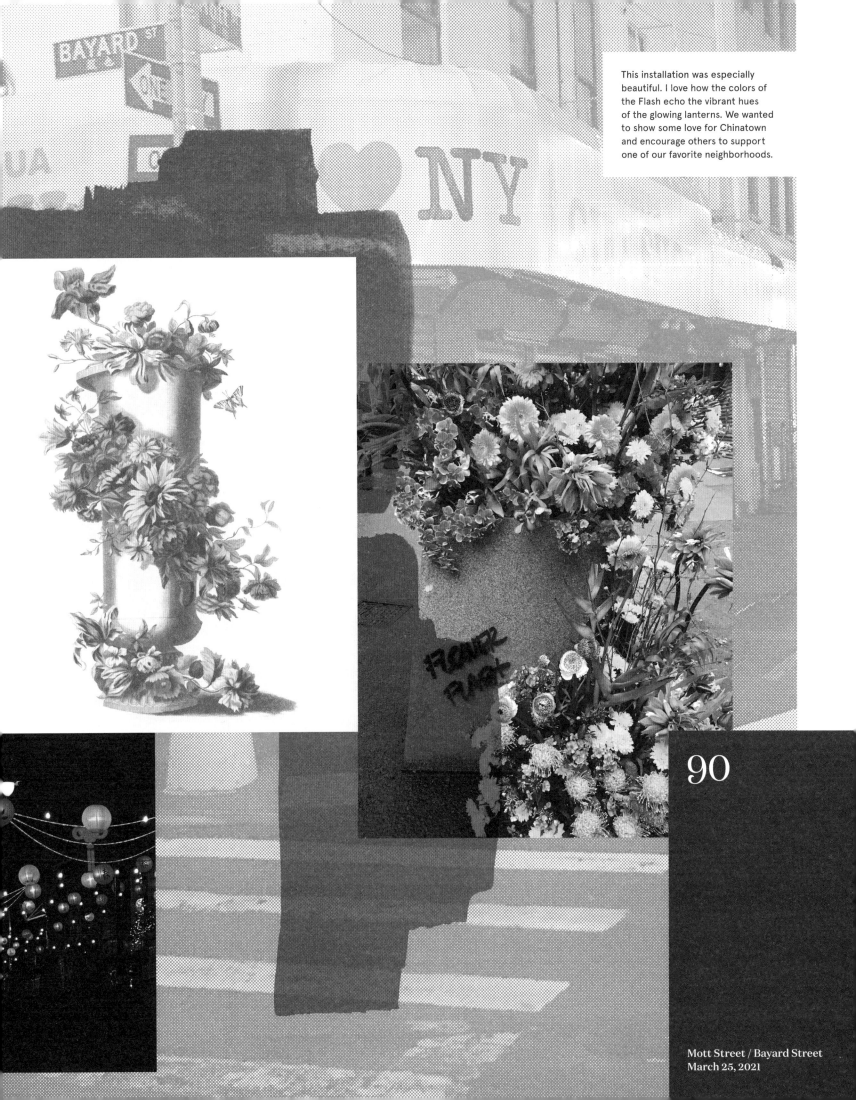

This installation was especially beautiful. I love how the colors of the Flash echo the vibrant hues of the glowing lanterns. We wanted to show some love for Chinatown and encourage others to support one of our favorite neighborhoods.

90

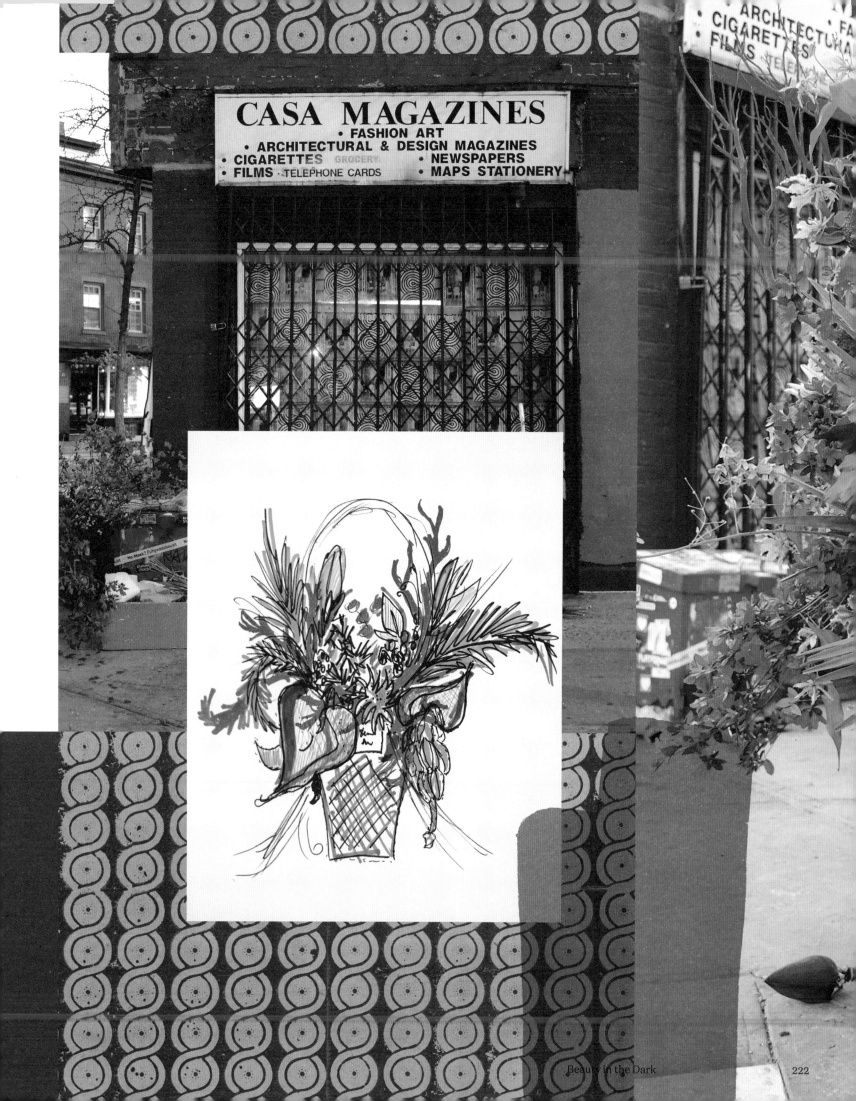

CASA MAGAZINES
• FASHION ART
• ARCHITECTURAL & DESIGN MAGAZINES
• CIGARETTES GROCERY • NEWSPAPERS
• FILMS · TELEPHONE CARDS • MAPS STATIONERY

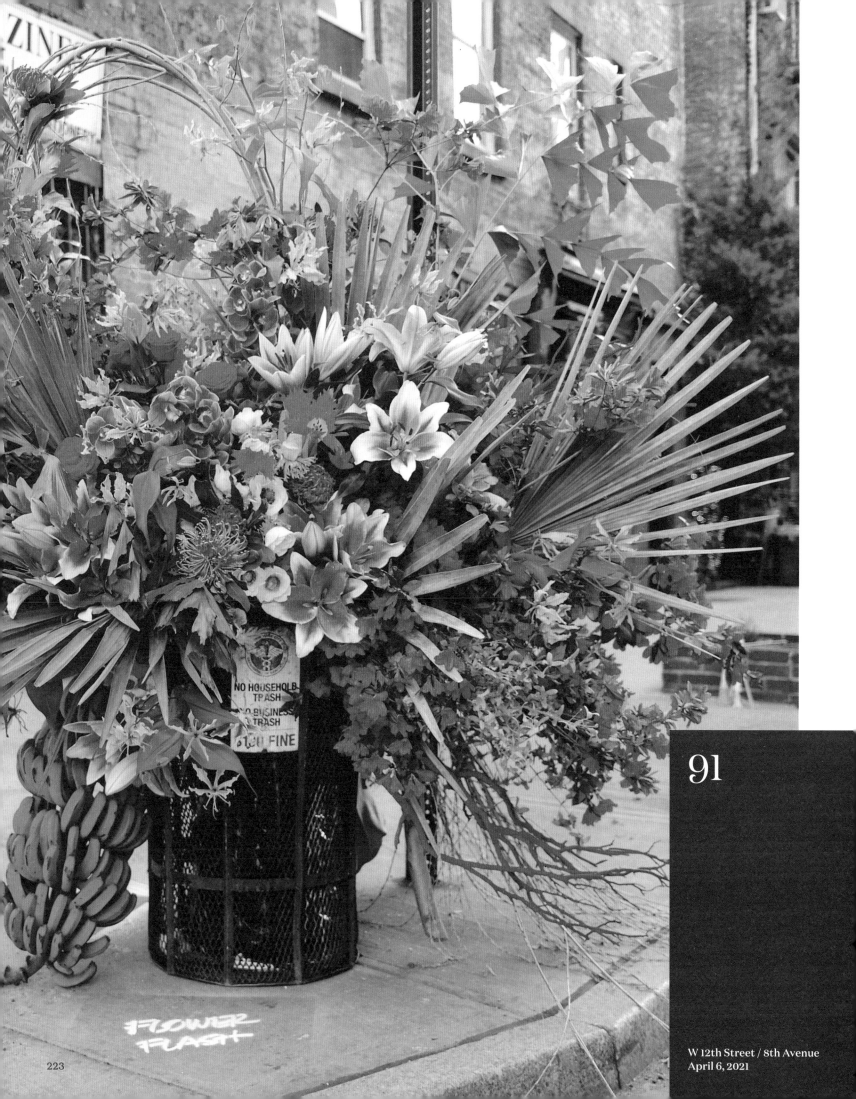

91

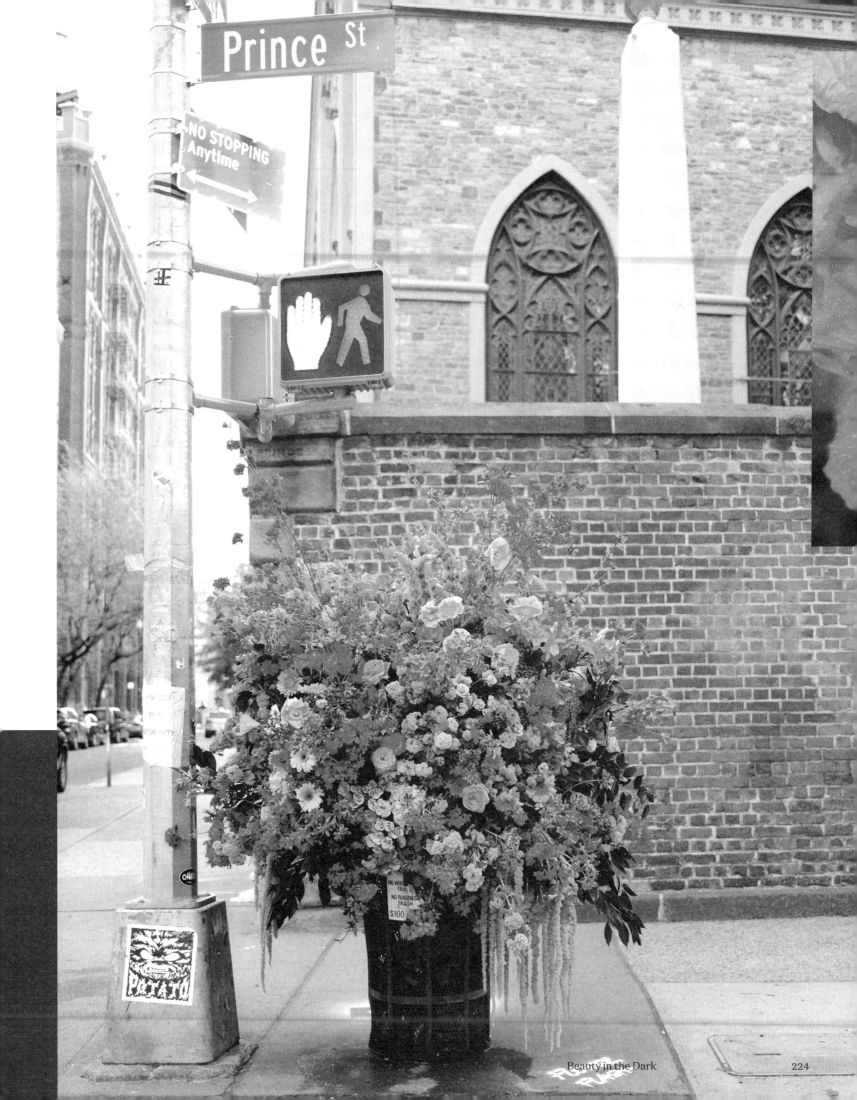

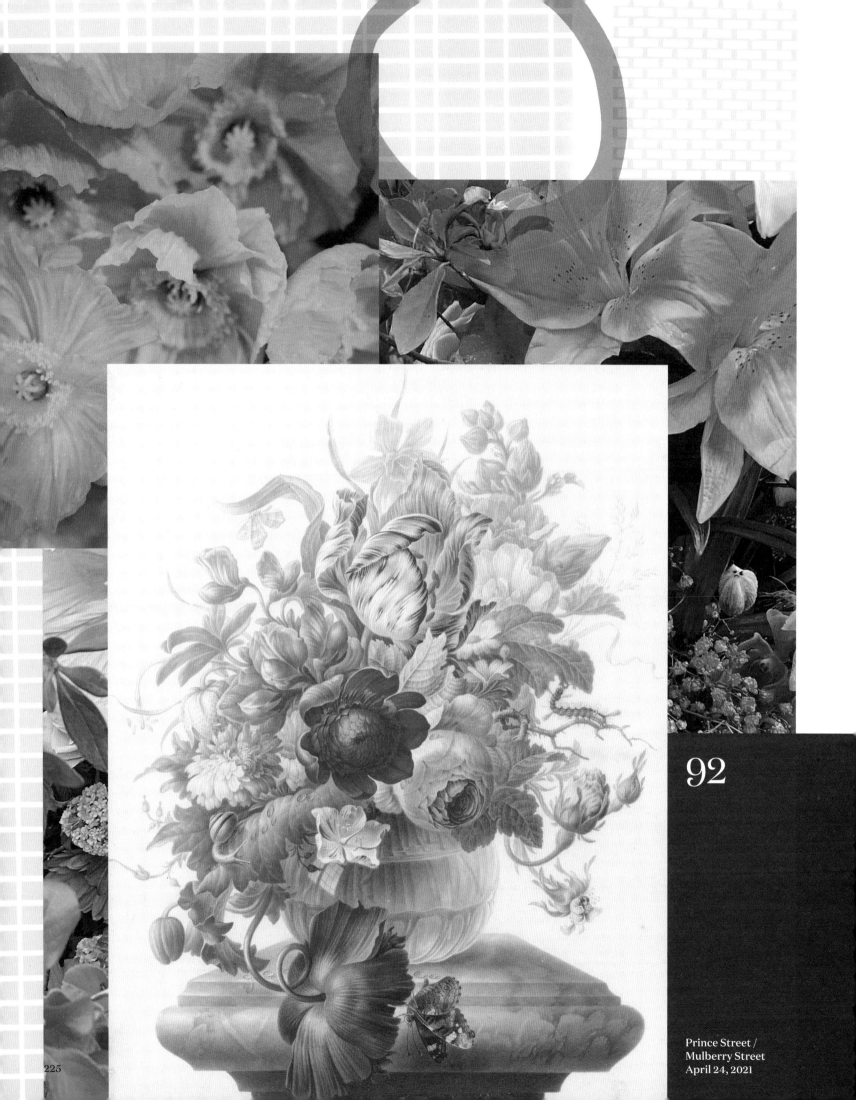

92

Prince Street /
Mulberry Street
April 24, 2021

Just because you're trash, doesn't mean you can't do great things. It is called garbage can, not garbage cannot.
—*Oscar the Grouch*

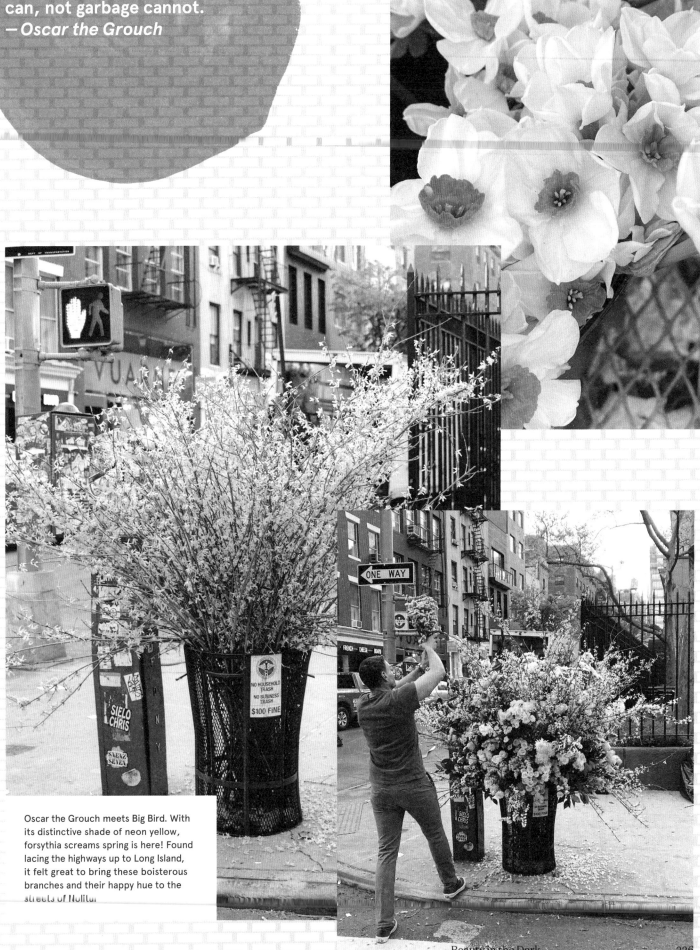

Oscar the Grouch meets Big Bird. With its distinctive shade of neon yellow, forsythia screams spring is here! Found lacing the highways up to Long Island, it felt great to bring these boisterous branches and their happy hue to the streets of Nolita.

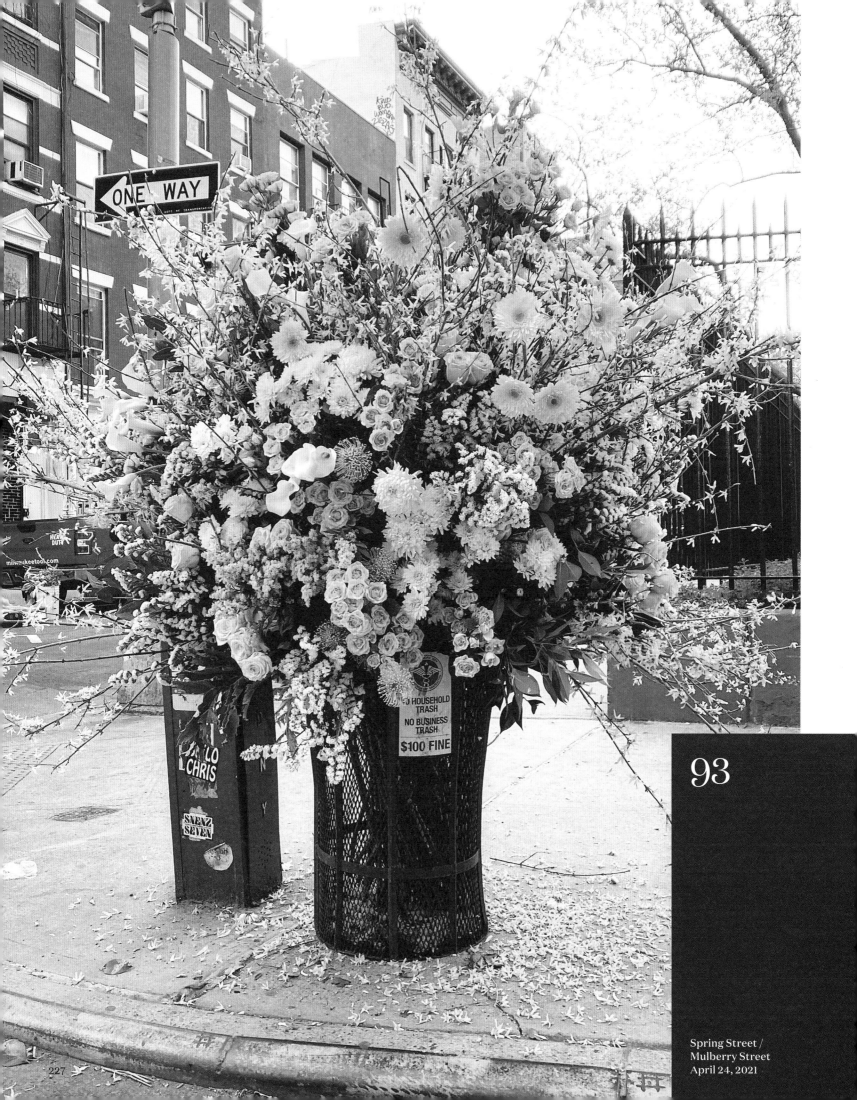

93

Spring Street /
Mulberry Street
April 24, 2021

"LOVE IS THE FLOWER OF LIFE, AND BLOSSOMS UNEXPECTEDLY AND WITHOUT LAW, AND MUST BE PLUCKED WHERE IT IS FOUND, AND ENJOYED FOR THE BRIEF HOUR OF ITS DURATION."

—D. H. LAWRENCE

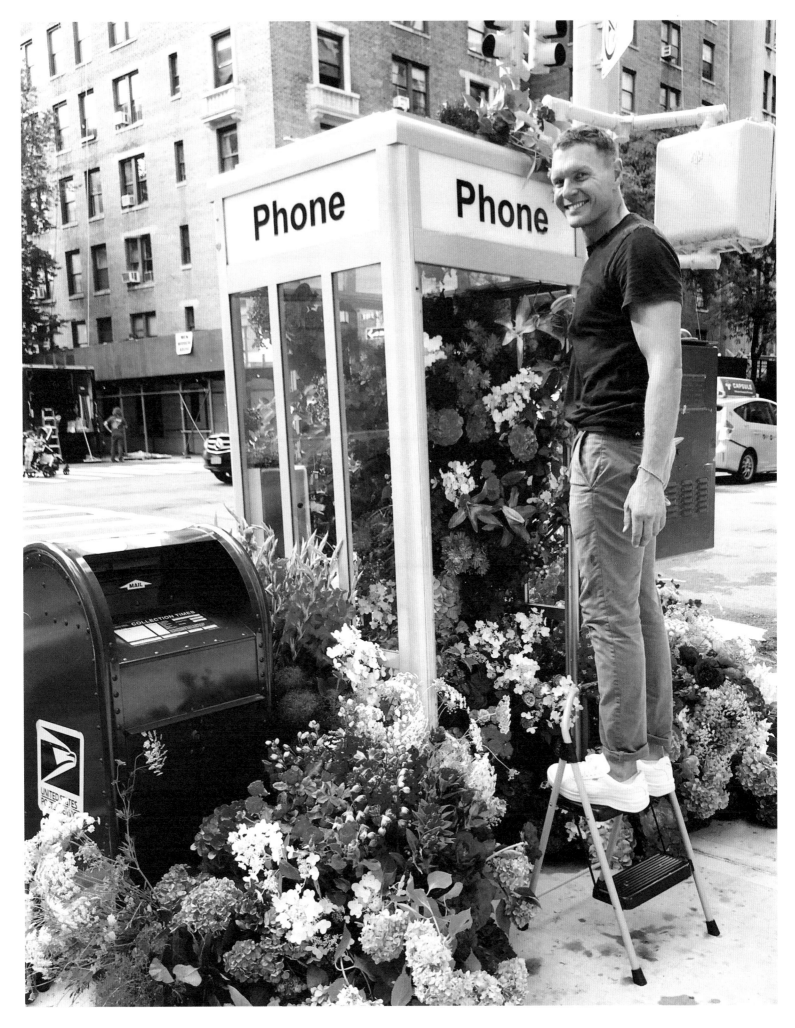

The Flower Flashes through Your Eyes

FF 10

FF 13

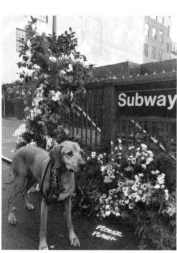
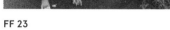

FF 23

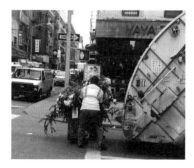

FF 24

FF 50

FF 34

FF 37

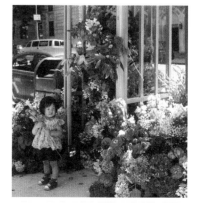

FF 52

I'm grateful to the extended Flower Flash family, a community of flower enthusiasts who have documented our Flashes from the very beginning. Your pics—of your dogs, children, and smiling faces, of the transformation of a Flash over the course of a day, of Flash flowers plucked for new arrangements—have added so much to the Flower Flash story. The journey of these blooms is quite something to behold: from an event, to the streets of New York, and into your homes, these flowers live first, second, and third lives. Thank you for your support, your unique point of view, and for all the memories.

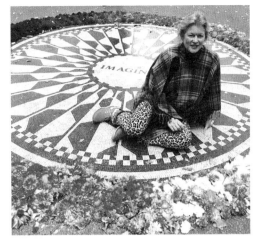

FF 1

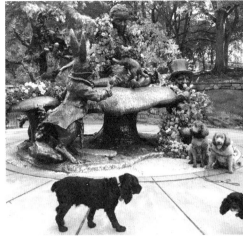

FF 2

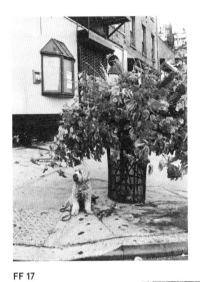

FF 17

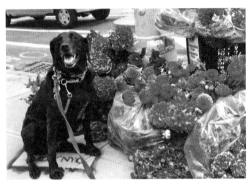

FF 18

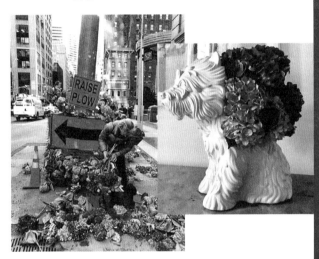

FF 22

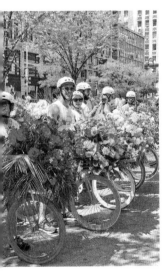

FF 38

FF 42

FF 57

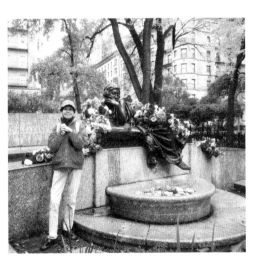

FF 44

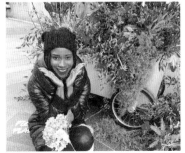

FF 47

FF 66

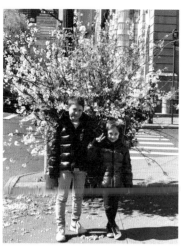

FF 70–71

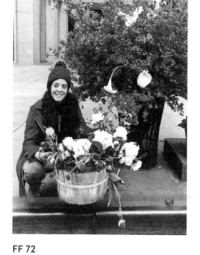

FF 72

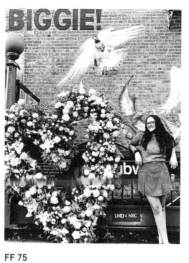

FF 75

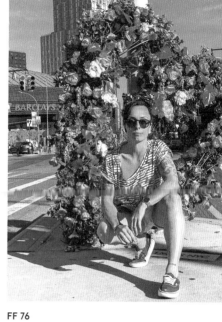

FF 76

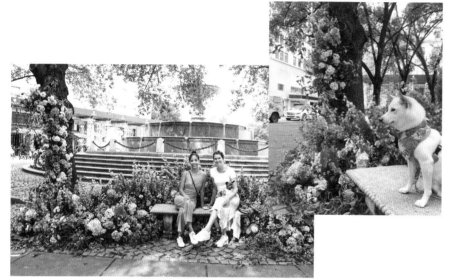

FF 83

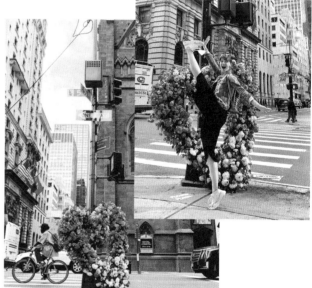

FF 84

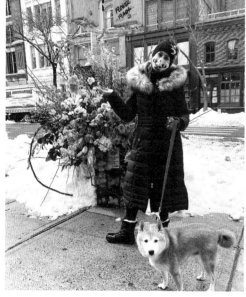

FF 88

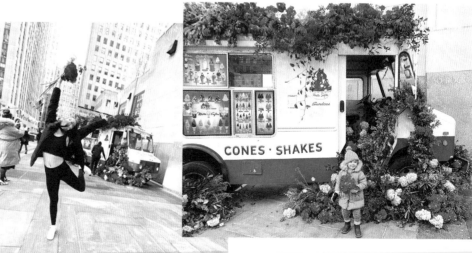

FF 89

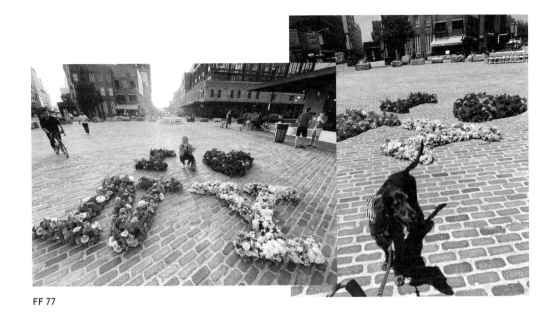

FF 77

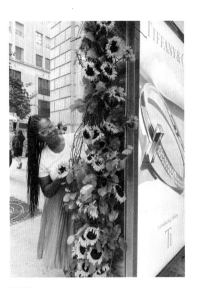

FF 82

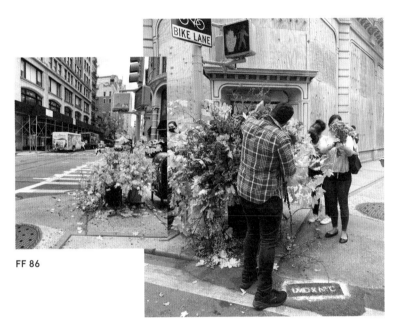

FF 86

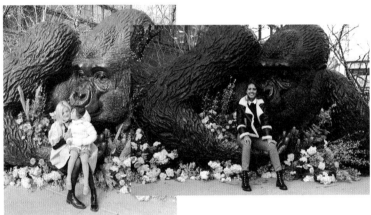

FF 87

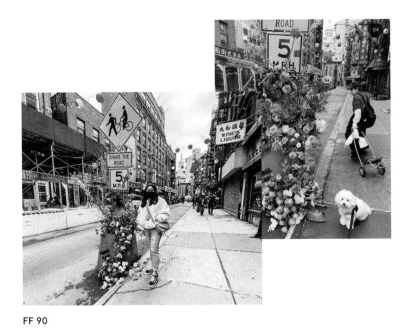

FF 90

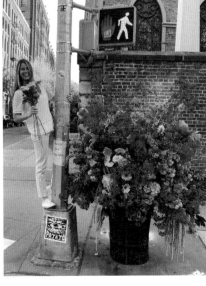

FF 92

I grew up in Midtown Manhattan, the daughter of a delicatessen owner. For a kid, I had steady hands and a good memory, so from time to time my dad would let me pour coffee during the morning rush. I remember serving a real mix of characters, from neighborhood doormen to the ladies who lived on Sutton Place, with their blue hair and big fur coats. But the most bewitching group of all were the students from the High School of Art and Design. As a young girl with a strict school uniform, I was obsessed with their outfits. Every inch of their blue jeans, jackets, and binders was covered in the most incredible doodles, often made with just a blue ballpoint pen. Their scribblings were ornate, dizzyingly personal, and utterly gorgeous.

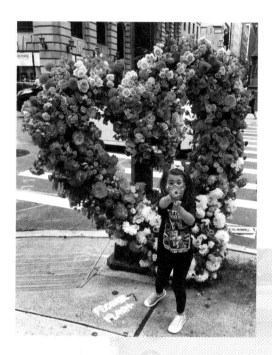

I think of those young artists a lot when I walk the streets of New York scouting Flower Flash locations. This big-hearted, resilient, and chaotic city is covered in graffiti and stickers and spray paint, a collective tapestry of messages made by strangers trying to communicate with one another and wanting to leave their mark.

Working with Lewis, photographing the Flashes, and documenting the entire process over the past four years has granted me access to his completely unique universe of dissonant beauty. For Lewis, the thick white lines of a crosswalk resemble zebra stripes and the splotches of discarded bubble gum staining sidewalks make a playful polka-dot print. His sense of New York City is deeply romantic and his aesthetic rigor is totally punk rock. Watching him and his deft ability to transform a trash can into a giant urn holding a floral wonder in less than twenty minutes, while whispering to myself, *How does all of this even stay up?* is nothing short of magic.

I have watched and shared in New Yorkers' reactions to these floral installations. As a city native who runs on community and good vibrations, these experiences have been a great gift to me. They can feel hallucinatory, disorienting in their delight; a little trepidatious, some passersby aren't entirely sure what they're seeing. And this is the genius behind Lewis's work. He is rattling the cage of his craft and bringing his decorative art out of the ballrooms and onto the streets for EVERYONE to enjoy.

The Flower Flashes are beautiful and vertiginous, a happy shock to the system. Stop! Look up from your phones! Take in this raw, unbridled, nonsensical, and fleeting work of art. It will make you smile. It will make you feel something. These ephemeral creations wake us up to the fragility and brevity of our own lives. They are an homage to nature and to our sense of humanity. Sharing in the discovery of a Flash makes us all feel connected, like the delicate root systems of flowers. And what I have found is that whether we are bound in difficult times or fortunate times, common connection and the happiness of strangers matter significantly.

Irini Arakas Greenbaum
Spring 2021

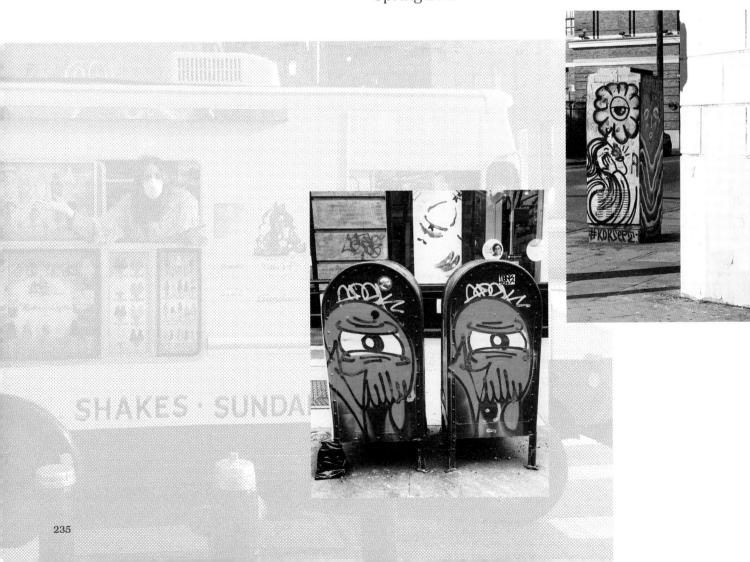

Acknowledgments

A very special thank-you to everyone who made this book possible by contributing their hard work, creative energy, positive attitude, love, and support.

To Irini Arakas Greenbaum—too many things to thank you for. You know what they are. Enthusiasm, humor, spirit, talent, and wit are just a few that come to mind.

To Jenny Florence, my book editor, for your grace and patience, and for keeping all the wheels turning. My gratitude to Keith Fox, CEO of Phaidon, and to Jeanette Abbink and Emily CM Anderson, the book designers who understood the vision and direction instantly; your contribution has made all the difference.

To my staff and all the freelancers who have set their alarms for an ungodly hour, thank you from the bottom of my heart. I appreciate your energy, limitless talents, and commitment to creating beauty. And extra appreciation to my Band of Merry Flower Bandits: to Manny Mejia—always smiling—I love our five a.m. conversations, to Tawana "T-Rex" Schlegel for "sticking it in and getting it done," and to Jess Rizzuti for your artistry and eye.

A giant thank-you to the New York City Department of Sanitation, the Central Park Conservancy, Memorial Sloan Kettering and Leelee Brown, Bergdorf Goodman, the Fifth Avenue Association and Angela Pennyfeather, the Meatpacking District, Moira Breslin and LEAF Festival of Flowers, American Express, Adeline Michèle, Jonathan Singletary, Elaine Welteroth, Karlie Kloss, Essex Market, Kate Bennis, Debi Burdick, Vivia Costalas, *Vogue* magazine, Tabitha Simmons, Lorna-Rose Simpson and Rockefeller Center, Patricia Lansing, Hudson Yards, Darcy Miller, the Stonewall Inn, Blue Tree, Amanda Minhoud, Equinox, Diana Gettinger, Katy Weil, Caribbean Cuts, Dutch Flower Line,

Louie at Major Wholesale, George Rallis Wholesale, Asiri Blooms, Bloomia, Old Navy, Tory Burch, Mercedez Singleton, Raymond Meier, Mary Hawthorne and the *New Yorker*, Nancy Hass and the *New York Times*, Fadia Kader, Farrow & Ball, Ebbie Koelle, John Labbe, Meredith Melling, VICE, Harling Ross, Kit Kemp, the Crosby Street Hotel, Don Freeman, Marcie Pantzer, Suzanne Mitchell, Nina Westervelt, each and every person who has photographed our Flower Flashes and shared their images with us, and to Melissa Spohler, LMD's greatest cheerleader, my first client, and the first person to stumble upon my very first trash can Flower Flash.

I dedicate this book to my guys, Kyle, Dutch, Tug, and Fritz, and to my favorite place in the world, New York, New York. So nice, you say it twice.

Photography Credits

Book Photography
All photographs by Irini Arakas Greenbaum unless otherwise noted
pp. 8, 13 (top), 185 (left), 186, 187 (back), 188–89 (left, center, right), 190, 191 (left), 236–37 (bottom left, right) / Nina Westervelt
pp. 13–14 (back), p. 23, 24 (right), 29, 37, 61 (bottom), 70, 77 (bottom), 87, 104 (bottom), 120, 121, 130 (top), 156 / Jess Rizzuti
p. 20 / Vivia Costalas
p. 44 / Don Freeman
p. 48 (bottom) / Meg Lewis
p. 57 (bottom) / John Labbe
p. 69 / Raymond Meier
p. 77 (top) / Nicole Hawkins Photography
p. 78 / Jewel Samad/AFP, courtesy Getty Images
p. 87 / Sam Watts
pp. 130 (bottom), 138–39 / Bhumika Sahu
p. 147 / Charlie Haugh
pp. 162–63 / Used with Permission—RCPI Landmark Properties, L.L.C. and Tishman Speyer
pp. 170, 171, 192, 193, 222 (sketch) / Lewis Miller
pp. 178 (top), 179 (top left, right, bottom), 180, 181 / Belathée Photography
p. 203 / Sur Fresh
pp. 234–35 / Robyn Baskin
p. 237 (top) / Laura Fuchs

Social Media
FF1 / Marna Ringel @theessentialflorist
FF2 / Jill Amadei @jillamadei
FF10 / Rambo Tallisman @greyscaleinteriors, Maggie Rossetti @maggiemaemary
FF13 / Nicole Bravo @sassyasfuc, Timothy McLaughlin @rubyimadog
FF17 / Alicia Kelley @aliciakelley
FF18 / @Mazzie_takes_Manhattan
FF22 / Nicole Freezer Rubens @nfrconsult, Alicia Whitaker @awhitaker196
FF23 / Kristin Postill @shethehuntress
FF24 / Virginia Wong @virginiahwong
FF34 / Lisa Angulo Reid @thelisareid
FF37 / Nicholas Vitrano @nicholasvitrano
FF38 / Mickey Blank @Mickmicknyc/New York Live with Mickey
FF42 / @bhlooberry @bhlooberrynyc
FF44 / @bhlooberry @bhlooberrynyc
FF47 / Kate Ketchem @kateketchem
FF50 / @bhlooberry @bhlooberrynyc
FF52 / Mariko Koyanagi @chibiharu0307
FF57 / Kate Bennis @katebennisstudio
FF66 / Angie Pennyfeather @angiepennyfeather
FF70–71 / Alex and Sarah @brooklyn_kids
FF72 / Mickey Blank @Mickmicknyc/New York Live with Mickey
FF75 / Rose Jorgensen @rjorgensen
FF76 / Kiara Di Paola @kiariladyboss
FF77 / @zandruh, @jamothereddog by Meredith Hirt @merdiann
FF82 / @itsjah___
FF83 / @bhlooberry @bhlooberrynyc, @winston_baby_fox
FF84 / Morgan Moore @nyc_morgan, Sasha Mart @sasha.mart
FF86 / Jennifer Seifter @jenseifter, Fran Shapiro @finallyfran
FF87 / Ashleigh Verrier @verrier_handscrafted_, Carlos and Sofia @charlieandsof.nyc
FF88 / Jazmin Grace Grimaldi @jazmingrimaldi
FF89 / Bernadette Mastrangel @bernadettemastrangel, Hollie Groves @blossomandbabe_nyc
FF90 / Simone Crystal Tsui @nvrendinluvstory, Kat Li @cotoninthecity
FF92 / Macey and Madalyn Peterson @maceyjenni @thepetersonsisters

Art Credits

Introduction pp. 12–13
Jan van Kessel (I), *Insects and Fruit* (*Sprig of White Currant with Insects*), c. 1653–61. Rijksmuseum, Amsterdam

Introduction p. 14
Jacob Vosmaer, *A Vase with Flowers*, probably 1613. Metropolitan Museum of Art, New York, Purchase, 1871

FF1 p. 21
Workshop of Maria Sibylla Merian, *Metamorphosis of a Small Emperor Moth*, after 1679. Rijksmuseum, Amsterdam

FF2 pp. 24–25
Bernhard Zan, *Square Panel with Vegetal Scrollwork, Flowers and Fruits*, 1581. Metropolitan Museum of Art, New York, Rogers Fund, 1921

FF2 pp. 26–27
Pieter Huys, *Frame with a Monkey in the Bottom Right Corner, from Frames with Flowers, Fruits, Birds, Insects, and Putti*, 1545–before 1550. Rijksmuseum, Amsterdam

FF3 p. 29
Marble pilaster capital, 1st half of 1st century A.D. Metropolitan Museum of Art, New York, Fletcher Fun, 1926

FF4 p. 34
Gabriel Huquier, after François Boucher, *Two Children, One Holding a Basket with Flowers*, 1738–45. Metropolitan Museum of Art, New York, The Elisha Whittelsey Collection, The Elisha Whittelsey Fund, 1957

FF5 p. 36 (left)
Hans Bollongier, *Floral Still Life*, 1639. Rijksmuseum, Amsterdam

FF5 p. 36 (right)
Johann Theodor de Bry, after Jacobus Kempener, *The Variance of Flowers* (*Polyptoton de Flore*), c. 1600. Rijksmuseum, Amsterdam, Purchased with the support of the F.G. Waller-Fonds

FF6 p. 38
Anonymous, *Red-White Tulip*, 1700–1800. Rijksmuseum, Amsterdam

FF7 p. 40
Johann Theodor de Bry, after Jacobus Kempener, *The Variance of Flowers* (*Polyptoton de Flore*), c. 1600. Rijksmuseum, Amsterdam

FF7 p. 41
Cornelis van Noorde, *Tulip Called Bizard Phoenix*, 1741–95. Rijksmuseum, Amsterdam

FF8 p. 42
Anonymous, Sheet with overall stripe and dot design, 19th century. Metropolitan Museum of Art, New York, Harris Brisbane Dick Fund, 1939

FF8 p. 43
Savonnerie Manufactory, *Flowers in a Golden Vase, with a Parrot*, late 17th or early 18th century. Metropolitan Museum of Art, New York, Bequest of Julie Heidelbach, 1932

FF9 pp. 44–45
Anonymous, Sheet with pattern of flowers and circles, 19th century. Metropolitan Museum of Art, New York, Harris Brisbane Dick Fund, 1939

FF9 p. 45
Master of the Die, after Raphael (Raffaello Sanzio or Santi), after Giovanni da Udine (Giovanni dei Ricamatori), Three putti before a large garland, the one in the middle rides an ostrich, from a series of tapestries made for Leo X, 1530-40. Metropolitan Museum of Art, New York, The Elisha Whittelsey Collection, The Elisha Whittelsey Fund, 1949

FF10 p. 46
Anonymous, Sheet with overall pattern of pink flowers with blue centers, 19th century. Metropolitan Museum of Art, New York, Harris Brisbane Dick Fund, 1940

FF11 p. 48
Paul Androuet Ducerceau, *Series of Small Flower Motifs*, Plate 6, 1670-85. Metropolitan Museum of Art, New York, Harris Brisbane Dick Fund, 1951

FF12 p. 50
Anonymous, Sheet with overall pattern of flowers and organic shapes, 19th century. Metropolitan Museum of Art, New York, The Elisha Whittelsey Collection, The Elisha Whittelsey Fund, 1948

FF12 pp. 50–51
Anonymous, *Oval Floral Wreath*, 1688-98. Rijksmuseum, Amsterdam, Purchased with the support of the F.G. Waller-Fonds

FF13 p. 52
Anonymous, Sheet with overall floral pattern, 19th century. Metropolitan Museum of Art, New York, Harris Brisbane Dick Fund, 1939

FF13 p. 53
Anonymous, Sheet with overall leaf pattern, 19th century. Metropolitan Museum of Art, New York, Harris Brisbane Dick Fund, 1939

FF14 pp. 54–55
Jacob Hoefnagel, after Joris Hoefnagel, *Animals, Plants, and Fruits around a Lizard*, 1693-1726. Rijksmuseum, Amsterdam

FF15 pp. 56–57
Wenceslaus Hollar, *Six Insects*, 1646. Metropolitan Museum of Art, New York, Harris Brisbane Dick Fund, 1926

FF16 p. 59
Peter Faes, *Flowers in a Stone Vase*, 1786. Metropolitan Museum of Art, New York, Bequest of Catherine D. Wentworth, 1948

FF17 p. 61
Walter Crane and Edmund Evans, End-paper design, 1909. New York Public Library, New York, The Miriam and Ira D. Wallach Division of Art, Prints and Photographs: Picture Collection, New York Public Library Digital Collections

FF18 p. 63
Karl Blossfeldt, *Plant Study*, from *Archetypes of Art*, 1928. Rijksmuseum, Amsterdam, Purchased with the support of the Paul Huf Fonds/Rijksmuseum Fonds, Baker McKenzie and the Rijksmuseum Fonds

FF19 pp. 64–65
Watanabe Seitei and Goto Tokujiro, *World of the Art* (*Bijutsu sekai*), no. 7, 1891. Rijksmuseum, Amsterdam. Gift of C. A. J. van Dishoeck

FF20 pp. 66–67
Anonymous, Sheet with crisscross pattern, 19th century. Metropolitan Museum of Art, New York, The Elisha Whittelsey Collection, The Elisha Whittelsey Fund, 1948

FF20 p.67
Hubert Quellinus, *Two Festoons with Fruit and Leaves in the East Gallery of the Town Hall on the Dam*, 1655. Rijksmuseum, Amsterdam

FF21 p. 68
Abraham Meertens, Room decoration design with a panel with a yellow oval in the center, 1767–1823. Rijksmuseum, Amsterdam

FF23 p. 72
Maple Leaves on Stripes, late 18th–mid-19th century. Cooper Hewitt, Smithsonian Design Museum, New York, Gift of Mary Rutherford Jay

FF24 p. 74
Textile (France). Cooper Hewitt, Smithsonian Design Museum, New York, Donated by Elinor Merrell

FF24 p. 75
Jules-Ferdinand Jacquemart, *Vase of Flowers*, 1862. Metropolitan Museum of Art, New York, Gift of Louis R. Metcalfe, 1928

FF25 p. 76 (left)
Nicolas Robert, after Georges Charmeton, *Vase with Lid on a Piece of Stone*, sheet 4 of *Plusieurs Vaze*, after 1676–before 1703. Rijksmuseum, Amsterdam

FF25 p. 76 (right)
Nicolas Robert, after Georges Charmeton, *Vase with Lid*, sheet 2 of *Plusieurs Vaze*, after 1676–before 1703. Rijksmuseum, Amsterdam

FF25 p. 77
Bernhard Zan, *Square Panel with Vegetal Scrollwork, Flowers and Fruits*, 1581. Metropolitan Museum of Art, New York, Rogers Fund, 1921

FF26 p. 78 (left)
Zacharias Blijhooft, *A Carnation (Hollandia liberata)*, 1675. Metropolitan Museum of Art, New York, Purchase, Brooke Russell Astor Bequest, 2013

FF26 p. 78 (right)
Anonymous, Sheet with overall red geometric and floral pattern, 18th century. Metropolitan Museum of Art, New York, The Elisha Whittelsey Collection, The Elisha Whittelsey Fund, 1948

FF26 p. 81
Anonymous, possibly by Remondini Family, Sheet with an overall zig zag pattern, late 18th–mid-19th century. Metropolitan Museum of Art, New York, The Elisha Whittelsey Collection, The Elisha Whittelsey Fund, 1948

FF27 pp. 82–83
Master of the Die, after Raphael (Raffaello Sanzio or Santi), Four putti, two embracing in front of a large garland, two behind, the one at left holding an arrow, the one at right a bow, from a series of tapestries made for Leo X, 1530-40. Metropolitan Museum of Art, New York, The Elisha Whittelsey Collection, The Elisha Whittelsey Fund, 1949

FF28 pp. 84–85
Meynert Jelissen, *Five Schweifwerk Ornaments Surrounded by Flowers*, from *Blackwork Ornaments for Gold and Silversmiths and Enamelers*, 1622. Rijksmuseum, Amsterdam, Purchased with the support of the F.G. Waller-Fonds

FF29 p. 86
Karl Blossfeldt, *Plant Study*, from *Archetypes of Art*, 1928. Rijksmuseum, Amsterdam, Purchased with the support of the Paul Huf Fonds/Rijksmuseum Fonds, Baker McKenzie and the Rijksmuseum Fonds

FF30–31 p. 88
Anna Atkins, Photogram of a sea striped fern (*Asplenium marinum*), c. 1854. Rijksmuseum, Amsterdam

FF30–31 p. 89
Julius Bien & Co., *Moths—American*, 1902. New York Public Library, New York, The Miriam and Ira D. Wallach Division of Art, Prints and Photographs: Picture Collection, New York Public Library Digital Collections

FF32 p. 90
Attributed to Giocondo (Giuseppe) Albertolli, *Candelabrum with Two Victory Figures*, from *Ornamenti Diversi*, 1782. Metropolitan Museum of Art, New York, The Elisha Whittelsey Collection, The Elisha Whittelsey Fund, 1960

FF33 p. 92
Johann Theodor de Bry, after Jacobus Kempener, *The Variance of Flowers* (*Polyptoton de Flore*), c. 1600. Rijksmuseum, Amsterdam

FF35 p. 96
Machtelt Moninckx, *Still Life of Flowers*, c. 1600–1687. Rijksmuseum, Amsterdam, Purchased with the support of the Vereniging Rembrandt

FF36 pp. 98–99
Jean-Baptiste Belin de Fontenay the Elder, *Vase of Flowers*, late 17th century. Metropolitan Museum of Art, New York, Gift of Pierpont J. Morgan, 1906

FF37 p. 100
Anonymous, Sheet with crisscross pattern, 19th century. Metropolitan Museum of Art, New York, The Elisha Whittelsey Collection, The Elisha Whittelsey Fund, 1948

FF39 p. 105
Anonymous, Trade card for the Library of the London Institution, 19th century. Metropolitan Museum of Art, New York, Gift of Bella C. Landauer, 1926

FF42 p. 110
H. Rouit, *Art-Goût-Beauté, Feuillets de l'élégance féminine*, June 1932, no. 142, 1932. Rijksmuseum, Amsterdam, Purchased with the support of the F.G. Waller-Fonds

FF42 p. 111
Pierre-Fiacre Perdoux, Sheet with chessboard pattern, 1780–1808. Rijksmuseum, Amsterdam

FF43 p. 113
Pieter Schenk (I), *Basket with Flowers*, 1670–1713. Rijksmuseum, Amsterdam

FF46 pp. 118–19
Charles Goy, *Art-Goût-Beauté, Feuillets de l'élégance féminine*, February 1926, no. 66, 1926. Rijksmuseum, Amsterdam, On loan from the M.A. Ghering-van Ierlant Collection

FF47 p. 121
Nicolas Robert, after Georges Charmeton, *Vase with Lid*, sheet 2 of *Plusieurs Vaze*, after 1676–before 1703. Rijksmuseum, Amsterdam

FF50 pp. 128–29
Stefano della Bella, *Design for a Frieze with Felines Holding up a Garland and the Medici Coat of Arms in the Center*, plate 2 from *Decorative Friezes and Foliage* (*Ornamenti di fregi e fogliami*), 1645–50. Metropolitan Museum of Art, New York, Bequest of Phyllis Massar, 2011

FF51 pp. 130–31
Johann Theodor de Bry, after Jacobus Kempener, *The Variance of Flowers* (*Polyptoton de Flore*), c. 1600. Rijksmuseum, Amsterdam, Purchased with the support of the F.G. Waller-Fonds

FF53 p. 135 (back)
Watanabe Seitei and Goto Tokujiro, *World of the Art* (*Bijutsu sekai*), 7, 1891. Rijksmuseum, Amsterdam, Gift of O.B. de Kat, Amsterdam

FF53 p. 135 (front)
Anonymous, *Sunflower*, 1688–98. Rijksmuseum, Amsterdam, Gift of Mr. Claassen

FF53 p. 137
Pieter Schenk (I), *Basket with Flowers*, 1670–1713. Rijksmuseum, Amsterdam

FF54 p. 139
Anonymous, Design for a standing border of leaves, lilacs and other flowers, for a printed fabric (toile de Jouy), 1800. Rijksmuseum, Amsterdam, Gift of Ch. Kiener, Paris

FF55 p. 140
James Bolton, One of twenty drawings depicting specimens from the natural history cabinet of Anna Blackburne, c. 1768. Yale Center for British Art, New Haven, Paul Mellon Fund, in honor of Jane and Richard C. Levin, President of Yale University (1993–2013)

FF56 p. 143
Anonymous, flyleaf, *Art-Goût-Beauté, Feuillets de l'élégance féminine*, November 1928, no. 99. Rijksmuseum, Amsterdam, Purchased with the support of the F.G. Waller-Fonds

FF57 p. 144
Anonymous, Sheet with overall geometric pattern, 19th century. Metropolitan Museum of Art, New York, Harris Brisbane Dick Fund, 1939

FF57 p. 145
Pierre François Tardieu, after Pierre Etienne Falconet, after François Boucher, Little girl holding a garland of flowers, from *Deuxième Livre de Figures d'après les porcelaines de la Manufacture Royale de France* (*Second Book of Figures after Porcelains from the Manufacture Royale de France*), after 1757. Metropolitan Museum of Art, New York, Harris Brisbane Dick Fund, 1953

FF59 pp. 148–49
Karl Blossfeldt, *Plant Study*, from *Archetypes of Art*, 1928. Rijksmuseum, Amsterdam, Purchased with the support of the Paul Huf Fonds/Rijksmuseum Fonds, Baker McKenzie and the Rijksmuseum Fonds

FF59 p. 149
Jean-Baptiste Letourmy, Sheet with alternating pattern of flowers and four points, 1750–1800. Rijksmuseum, Amsterdam

FF60 p. 151
Utagawa Kuniyoshi, Cover, shunga album. *Murasaki from Edo and Genji from the Yoshiwara*, 1830–35. Rijksmuseum, Amsterdam, Purchased with the support of the F.G. Waller-Fonds

FF61 p. 152
Anonymous, Sheet with red diamond and zigzag pattern, 18th century. Metropolitan Museum of Art, New York, Harris Brisbane Dick Fund 1926

FF63 pp. 156–57
Paul Androuet Ducerceau, *Series of Small Flower Motifs*, Plate 5, 1670–85. Metropolitan Museum of Art, New York, Harris Brisbane Dick Fund, 1951

FF64 p. 158
James Bolton, One of twenty drawings depicting specimens from the natural history cabinet of Anna Blackburne, c. 1768. Yale Center for British Art, New Haven, Paul Mellon Fund, in honor of Jane and Richard C. Levin, President of Yale University (1993–2013)

FF66 p. 162
Anonymous, Sheet with pattern of triangles, 19th century. Metropolitan Museum of Art, New York, Harris Brisbane Dick Fund, 1940

FF68 p. 171
Anthonie van den Bos, *Flower Arrangement*, 1778–1838. Rijksmuseum, Amsterdam

FF69 p. 172
Maurice Jacques, *Vases Nouveaux Composées par M. Jacque[s]*, 18th century. Metropolitan Museum of Art, New York, Harris Brisbane Dick Fund, 1930

FF70–71 p. 175
Nicolas Robert, after Georges Charmeton, *Vase with Lid*, sheet 2 of *Plusieurs Vaze*, after 1676–before 1703. Rijksmuseum, Amsterdam

FF73 p. 178
Johann Theodor de Bry, after Jacobus Kempener, *The Variance of Flowers* (*Polyptoton de Flore*), c. 1600. Rijksmuseum, Amsterdam, Purchased with the support of the F.G. Waller-Fonds

FF79 pp. 192–93
Pieter Huys, *Frame with a Columbine at the Bottom Center, from Frames with Flowers, Fruits, Birds, Insects, and Putti*, 1545–before 1550. Rijksmuseum, Amsterdam

FF81 p. 196
Anonymous, Sheet with overall orange and blue geometric pattern, late 18th–mid-19th century. Metropolitan Museum of Art, New York, The Elisha Whittelsey Collection, The Elisha Whittelsey Fund, 1948

FF 83 pp. 200–201
Anna Atkins, Spiraea aruncus (Tyrol), 1851–54. Metropolitan Museum of Art, New York, Purchase, Alfred Stieglitz Society Gifts, 2004

FF83 p. 201
French painter, Female bust in an oval medallion draped with a garland (one of a pair), 1770–75. Metropolitan Museum of Art, New York, Gift of J. Pierpont Morgan, 1906

FF86 p. 207
George Hendrik Breitner, *Ginger Pot with Anemones*, 1900–23. Rijksmuseum, Amsterdam, M.C.J Breitner-Jordan Bequest, Zeist

FF87 p. 210
Anonymous, after Adriaen Collaert, *Vase of Flowers in an Arched Window*, 1570–1618. Rijksmuseum, Amsterdam, Purchased with the support of the F.G. Waller-Fonds

FF88 p. 215
Jan Davidsz. de Heem, *Festoon of Fruit and Flowers*, 1660–70. Rijksmuseum, Amsterdam

FF89 pp. 216–17
Pierre-Fiacre Perdoux, Sheet with chessboard pattern, 1780–1808. Rijksmuseum, Amsterdam

FF89 pp. 218–19
Anonymous, Sheet with pattern of bouquets and lion heads, late 18th–mid-19th century. Gift of D. Metropolitan Museum of Art, New York, Lorraine Yerkes, 1959

FF89 p. 219
Ambrosius Brosschaert the Elder, *Flower Still Life*, 1614. J. Paul Getty Museum, Los Angeles, Digital image courtesy of the Getty's Open Content Program

FF90 p. 221
Anonymous, *Cylindrical Vase with Floral Wreath*, 1688–98. Rijksmuseum, Amsterdam, Purchased with the support of the F.G. Waller-Fonds

FF91 p. 222
Anonymous, Sheer with overall guilloche pattern, late 18th–mid-19th century. Metropolitan Museum of Art, New York, The Elisha Whittelsey Collection, The Elisha Whittelsey Fund, 1948

FF92 p. 225
Herman Henstenburgh, *Flowers in a Glass Vase with a Butterfly*, c. 1700. Rijksmuseum, Amsterdam, Gift of A.H. Beels van Heemstede-van Loon

Library of Congress Control Number: 2021938187

ISBN 978-1-58093-585-2

Design by Jeanette Abbink / Rational Beauty
and Emily CM Anderson

Cover photographs by Nina Westervelt

Cover art, detail, Jacob Vosmaer, *A Vase with
Flowers*, probably 1613. Metropolitan Museum
of Art, New York, Purchase, 1871

Printed in China

Monacelli
A Phaidon Company
65 Bleecker Street
New York, NY 10012
www.monacellipress.com